WHO I AM

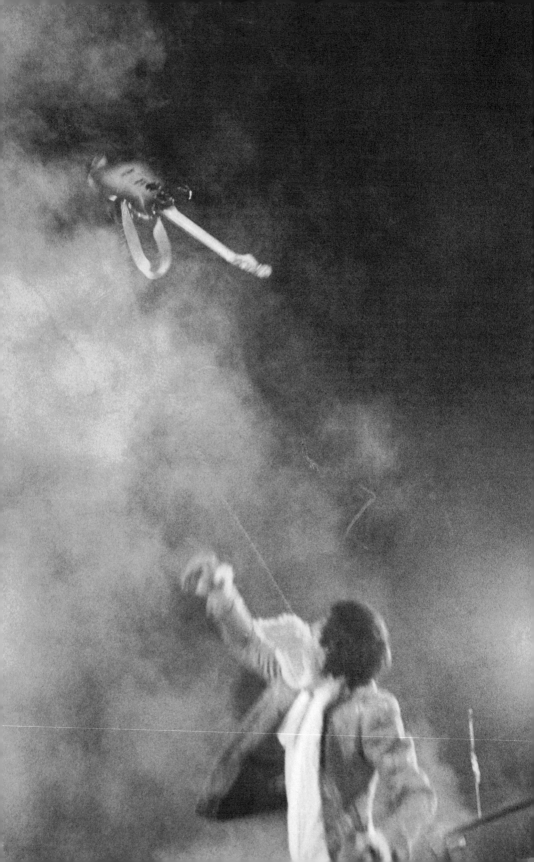

PETE TOWNSHEND
WHO I AM

A MEMOIR

HARPER PERENNIAL

NEW YORK • LONDON • TORONTO • SYDNEY • NEW DELHI • AUCKLAND

HARPER PERENNIAL

FIRST HARPER PERENNIAL EDITION PUBLISHED 2013.

The Library of Congress has catalogued the hardcover edition of this book as follows:
Townshend, Pete.
Who I am : a memoir / by Pete Townshend.—US ed.
 p. cm.
 Includes index.
ISBN: 978-0-06-212724-2 (Hardcover)
ISBN: 978-0-06-221040-1 (International Edition)
1. Townshend, Pete. 2. Rock musicians—England—Biography. 3. Who (Musical group) I. Title.
ML410.T69A3 2012
782.42166092—dc23
[B] 2012032303

ISBN: 978-0-06-212725-9 (pbk.)

13 14 15 16 17 UK-DIX/RRD 10 9 8 7 6 5 4 3 2 1

CONTENTS

ACT THREE: PLAYING TO THE GODS

WHO I AM

ACT ONE
WAR MUSIC

You didn't hear it.
You didn't see it.
You won't say nothing to no one.
Never tell a soul
What you know is the truth
'1921' (1969)

Don't cry
Don't raise your eye
It's only teenage wasteland
'Baba O'Riley' (1971)

And I'm sure – I'll never know war
'I've Known No War' (1983)

1
I WAS THERE

It's extraordinary, magical, surreal, watching them all dance to my feedback guitar solos; in the audience my art-school chums stand straight-backed among the slouching West and North London Mods, that army of teenagers who have arrived astride their fabulous scooters in short hair and good shoes, hopped up on pills. I can't speak for what's in the heads of my fellow bandmates, Roger Daltrey, Keith Moon or John Entwistle. Usually I'd be feeling like a loner, even in the middle of the band, but tonight, in June 1964, at The Who's first show at the Railway Hotel in Harrow, West London, I am invincible.

We're playing R&B: 'Smokestack Lightning', 'I'm a Man', 'Road Runner' and other heavy classics. I scrape the howling Rickenbacker guitar up and down my microphone stand, then flip the special switch I recently fitted so the guitar sputters and sprays the front row with bullets of sound. I violently thrust my guitar into the air – and feel a terrible shudder as the sound goes from a roar to a rattling growl; I look up to see my guitar's broken head as I pull it away from the hole I've punched in the low ceiling.

It is at this moment that I make a split-second decision – and in a mad frenzy I thrust the damaged guitar up into the ceiling over and over again. What had been a clean break becomes a splintered mess. I hold the guitar up to the crowd triumphantly. I haven't smashed it: I've sculpted it for them. I

throw the shattered guitar carelessly to the ground, pick up my brand-new Rickenbacker twelve-string and continue the show.

That Tuesday night I stumbled upon something more powerful than words, far more emotive than my white-boy attempts to play the blues. And in response I received the full-throated salute of the crowd. A week or so later, at the same venue, I ran out of guitars and toppled the stack of Marshall amplifiers. Not one to be upstaged, our drummer Keith Moon joined in by kicking over his drumkit. Roger started to scrape his microphone on Keith's cracked cymbals. Some people viewed the destruction as a gimmick, but I knew the world was changing, and a message was being conveyed. The old, conventional way of making music would never be the same.

I had no idea what the first smashing of my guitar would lead to, but I had a good idea where it all came from. As the son of a clarinettist and saxophonist in the Squadronaires, the prototypical British Swing band, I had been nourished by my love for that music, a love I would betray for a new passion: rock 'n' roll, the music that came to destroy it.

I am British. I am a Londoner. I was born in West London just as the devastating Second World War came to a close. As a working artist I have been significantly shaped by these three facts, just as the lives of my grandparents and parents were shaped by the darkness of war. I was brought up in a period when war still cast shadows, though in my life the weather changed so rapidly it was impossible to know what was in store. War had been a real threat or a fact for three generations of my family.

In 1945 popular music had a serious purpose: to defy postwar depression and revitalise the romantic and hopeful aspirations of an exhausted people. My infancy was steeped in awareness of the mystery and romance of my father's music,

which was so important to him and Mum that it seemed the centre of the universe. There was laughter and optimism; the war was over. The music Dad played was called Swing. It was what people wanted to hear. I was there.

2

IT'S A BOY!

I have just been born, war is over, but not completely.

'It's a boy!' someone shouts from the footlights. But my father keeps on playing.

I am a war baby though I have never known war, born into a family of musicians on 19 May 1945, two weeks after VE Day and four months before VJ Day bring the Second World War to an end. Yet war and its syncopated echoes – the klaxons and saxophones, the big bands and bomb shelters, V2s and violins, clarinets and Messerschmitts, mood-indigo lullabies and satin-doll serenades, the wails, strafes, sirens, booms and blasts – carouse, waltz and unsettle me while I am still in my mother's womb.

Two memories linger for ever like dreams that, once remembered, are never forgotten.

I am two years old, riding on the top deck of an old tram that Mum and I have boarded at the top of Acton Hill in West London. The tram trundles past my future: the electrical shop where Dad's first record will go on sale in 1955; the police station where I'll go to retrieve my stolen bike; the hardware store that mesmerises me with its thousands of perfectly labelled drawers; the Odeon where I will attend riotous Saturday movie matinées with my pals; St Mary's Church where years from now I sing Anglican hymns in the choir and watch hundreds of people take communion, but never do so myself; the White Hart pub where I first get properly drunk in

1962 after playing a regular weekly gig with a school rock band called The Detours, that will one day evolve into The Who.

I am a little older now, my second birthday three months past. It's the summer of 1947 and I'm on a beach in bright sunshine. I'm still too young to run around, but I sit up on the blanket enjoying the smells and sounds: sea air, sand, a light wind, waves murmuring against the shore. My parents ride up like Arabs on horseback, spraying sand everywhere, wave happily, and then ride off again. They are young, glamorous, beautiful, and their disappearance is like the challenge of an elusive grail.

Dad's father, Horace Townshend (known as Horry), was prematurely bald at thirty, but still striking with his aquiline profile and thick-rimmed glasses. Horry, a semi-professional musician/composer, wrote songs and performed in summer entertainments at seasides, parks and music halls during the 1920s. A trained flautist, he could read and write music, but he liked the easy life and never made much money.

Horry met Grandma Dorothy in 1908. They worked together as entertainers and married two years later, when Dot was eight months pregnant with their first child, Jack. As an infant, Uncle Jack remembered his parents busking on Brighton Pier while little Jack watched nearby. A grand lady walked up, admired their efforts and threw a shilling into their hat. 'For which good cause are you collecting?' she asked.

'For ourselves,' Dot said.

Dot was striking and elegant. A singer and dancer who could read music, she performed at concert parties, some-times alongside her husband, and later contributed to Horry's songwriting. She was cheerful and positive, though rather vain and a bit of a snob. Between performances Horry and Dot conceived my father, Clifford Blandford Townshend,

who was born in 1917, a companion for his older brother Jack.

Mum's parents, Denny and Maurice, lived in Paddington during Mum's early childhood. Though obsessive about cleanliness, Denny was not a careful guardian. Mum remembers hanging out the upstairs window with her baby brother, Maurice, Jr, waving at her father driving past on his milk float. The little boy nearly slipped out.

Granddad Maurice was a sweet man who was cruelly jilted when Denny – after eleven years of marriage – abruptly ran off with a wealthy man, who kept her as his mistress. On that day Mum came home from school to an empty house. Denny had taken all the furniture except for a bed, leaving only a note with no address. It took Maurice several years to track the wayward woman down, but they were never reconciled.

Maurice and the two children moved in with his mother, Ellen. Mum, just ten, contributed to running the house, and fell directly under her Irish grandmother's influence. Mum was ashamed of the mother who had abandoned her, but proud of her grandmother Ellen, who taught her to modulate her speaking voice to round out the Irish in it. Mum became adept at mimicking various accents, and showed an early aptitude for music.

Eventually, as a teenager, Mum moved in with her maternal Aunt Rose in North London. I remember Rose as an extraordinary woman, self-assured, intelligent, well read; she was a lesbian, living quietly but openly with her partner.

Like me, Dad was a teenage rebel. Before the war he and his best friend were members of Oswald Mosley's fascist Blackshirts. He was ashamed of this later, of course, but forgave himself – they were young, and the uniforms were glamorous. Instead of staying with Prokofiev's clarinet studies,

through which he'd brilliantly stormed for two hours every morning, Dad at sixteen chose to play at bottle parties, an English variant on the speakeasy. The musicianship required of him at these gigs demanded little of his skill. Throughout his life he was over-qualified, technically, for the music he played.

Within a few years Dad was performing around London with Billy Wiltshire and his Piccadilly Band, playing music for dancing or lounging at bars – 'bar-stooling', as it was known. In the interval between two world wars, sophistication, glamour and light-heartedness obscured an underlying fear of extinction. The big issues were hidden in clouds of cigarette smoke and innovative popular music. Sex was, as ever, the ingredient that would calm the anxious heart. Yet in the music of my father's era, sexual energy was implied rather than displayed, hidden behind the cultivated elegance of men and women in evening dress.

War and music brought my parents together. Dad enlisted in the RAF in 1940 and played saxophone and clarinet in small bands to entertain his colleagues as part of his duties. By 1945 he was playing in the RAF Dance Orchestra, one of the largest in any of the services. Recruited from enlisted men who had been members of well-known bands and directed by Sergeant Leslie Douglas, it has been described as the greatest dance orchestra Britain ever produced. It was, in its own way, revolutionary. Its secret weapon was Swing, still not generally acceptable to society at large, but the common people loved it. Dad had secured the job because Vera Lynn's husband, saxophonist Harry Lewis, although in the RAF, was afraid of flying and didn't want to fly to Germany. And in fact when the motorcycle messenger shouted out the news of my birth from the footlights, Dad was away in Germany, playing saxophone for the troops.

Mum falsified her age to enlist in 1941. A gifted singer, she became a vocalist in Dad's band. A concert programme for 18 June 1944 at Colston Hall, Bristol, lists her singing 'Star Eyes', 'All My Life' (a duet with the handsome Sergeant Douglas) and 'Do I Worry'. Dad is featured as the soloist on 'Clarinet Rhapsody' and 'Hot and Anxious'. According to a sleeve note, the RAF Dance Orchestra directed the ear of the public. 'From slush to music with a beat, the rhythm had flexibility, the soloist more room for expression.'

When the war ended the band chose to go by its popular name: the Squadronaires.

According to Mum, the early years of her marriage were lonely. 'I never saw Dad. He was never there. And when he was, he was over the road in the bloody White Lion or up at the Granville.' Cheerful, good-looking and quick to buy a round at the bar, Dad was popular in the local pubs, where his musical success made him a bit of a celebrity.

Mum's loneliness may help explain why she was so angry with my father for being absent at my birth. Mum, who had been living with Dad's parents, showed her resentment by moving out. She knew a Jewish couple, Sammy and Leah Sharp, musicians from Australia, who lived with their son in one big room, and Mum and I moved in with them. Leah took me over. I don't remember her, but Mum described her as 'one of these people who loved to do all the bathing and pram-pushing and all that lark'. Mum, less interested in 'all that lark' – and still working as a singer – was grateful for the help.

In 1946 my parents reconciled, and the three of us moved to a house in Whitehall Gardens, Acton. Our next-door neighbours included the great blind jazz pianist George Shearing and the cartoonist Alex Graham, whose studio, with its adjustable draughting board, huge sheets of paper, inks and

complicated pens, fascinated me, and planted the seeds that later inspired me to go to art college.

We shared our house with the Cass family, who lived upstairs and, like many of my parents' closest friends, were Jewish. I remember noisy, joyous Passovers with a lot of Gefilte fish, chopped liver and the aroma of slow-roasting brisket. Each family had three rooms, a kitchen and a bathroom, but no inside toilet. Ours was in the back yard, and our toilet paper was a few squares of newspaper hung on a nail. Between the cold and the spiders, my trips there never lasted long.

I slept in the dining room. My parents seemed to have little sense of the need to provide me with a place of my own, where I could leave my toys or drawings out without feeling I was encroaching on adult territory. I had no sense of privacy, or even any awareness that I deserved it.

Mum gave up singing and later regretted it, but she always worked. She helped run the Squadronaires from their office in Piccadilly Circus, and often took me on the tour bus, where I basked in the easygoing attitude of the band and looked after the empty beer bottles. Our road trips always ended at a small seaside hotel, a holiday camp or an ornate theatre full of secret stairways and underground corridors.

Charlie, who managed the road crew, was the butt of numerous practical jokes, but the Squadronaires clearly loved him. The impact of Mum and Dad's daily influence on me waned a little in the presence of the band, which was like a travelling boys' club. Mum was the singing doll in residence, and Dad's musicianship gave him a special status among his peers. Dad always worked for at least an hour on scales and arpeggios, and his morning practice seemed magical in its complexity. In rock today we use simpler language: he was *fast*.

* * *

The holiday camp was a peculiarly British institution – a working-class destination for a summer week of revelry that often included entertainment in the form of a band like the Squadronaires. The one-family-per-hut layout of the camps didn't seem ideally suited to illicit sexual liaisons. But if, instead of a family in one of these huts, you imagine a small group of young men in one, and young women in another, you begin to understand the possibilities.

There was an egalitarian feeling about holiday camps, but I always felt a little superior to the ordinary folk rotating through. After all, I was with the band, and I was there for the whole summer, sometimes as long as sixteen weeks. From behind the stage curtain I discovered the magic of capturing the campers' attention. I grew up with a feel for what entertains people, and saw the price this sometimes demanded. As a stunt to amuse the camping plebs, each afternoon at two o'clock Dad was pushed from the highest board into the swimming pool below, fully dressed in his band uniform. Emerging from the water still playing his old clarinet, he pretended to be sad, defeated. As a child I felt this rather too deeply. My shining Dad is humiliated, I used to think, so you camping plebs can get a laugh.

I learned to set myself apart from those ordinary folk, the customers who indirectly paid for our keep. To this day when I go to a concert in which I'm not performing I always feel a little lost. And I always think of my dad.

In September 1949, aged four, I attended Silverdale Nursery in Birch Grove, Acton, which probably appealed to Mum because she thought I looked cute in the school uniform, a red blazer and hat. Mum herself was naturally glamorous, and when clothes rationing ended after the war Mum outfitted herself like a Hollywood film star. Her in-laws disapproved. Why was she spending Dad's hard-earned money on clothes

and sending me to private school when she should have been pushing a pram?

I was happy, though. Whitehall Gardens was one of a series of streets overrun with little boys my own age. Our gang was led by my best friend who we all called Jimpy, after a character with a similar quiff in a popular *Daily Mirror* cartoon. Like all kids, we played football, cricket, hide-and-seek and cowboys and Indians – our favourite game. War games were limited to toy soldiers or model vehicles: the real thing was still too raw a memory.

Our fantasies were inspired by films we saw on Saturday matinées: Roy Rogers, Hopalong Cassidy, Flash Gordon, The Three Stooges, Charlie Chaplin, Laurel and Hardy, *Looney-Tunes*, Disney cartoons and the rest. Laurel and Hardy were the funniest people on the planet. Chaplin seemed out of date to me, but then practically all the films we saw had been made before the war.

Once we got out of the house we could do pretty much what we liked. We sneaked under fences, onto railway sidings, scrumped apples from trees in people's gardens, threw stones at ducks, opened any garage door left unlocked (cars were a great curiosity), and followed the milkman and his horse-drawn cart all the way to Gunnersbury Park, a round trip of about ten miles.

Jimpy and I both had tricycles, and one day, still only four, we both rode mine to the park to attempt a new downhill duo speed record on the steep path in front of the manor house. I stood on the back axle and Jimpy steered. The bike became uncontrollable at high velocity so we could only go straight ahead – crashing right into a raised brick planter at the foot of the hill. We ended up with our faces in the soil, shocked and bloody. The bike was so badly bent we couldn't ride it back home. My nosebleed lasted two days.

* * *

In 1950, when I turned five, I didn't go to the local free state junior school with my pals. Mum, still thinking I looked cute in uniform, sent me to the private Beacon House School, two-thirds of a mile from our home. I knew none of the children there, remember no one I met there and hated almost every minute of it.

The school occupied a single-family house, and assembly was held in a small back room into which we marched each morning singing 'Onward Christian Soldiers' like a bunch of brainwashed Chinese Communists. After an inedible lunch we were expected to nap at our desks for fifteen minutes. If we moved a muscle we were scolded; further fidgeting could lead to ruler slaps, or worse. I was caned several times, and whacked with the teacher's rubber-soled slipper.

On one occasion I was so hurt and humiliated that I complained to my parents. They spoke to the headmistress at the school, who responded by singling me out for especially cruel treatment. Now I wasn't even allowed to go to the toilet during the day, and I sometimes helplessly soiled myself on the long walk home from school. Afraid of even worse retribution from the school, I didn't say another word about it to my parents. I went to Jimpy's and received the sympathy – and fresh underpants – that I couldn't find at home.

Around this time Mum started taking me to ballet lessons. I walked into a room and saw twenty toe-twinkling girls in tutus, giggling at me. I was one of only a few boys in the group. One day, after I misbehaved, the teacher pulled down my tights, bent me over a bathtub and spanked me while the girls gathered excitedly around the bathroom door.

Perhaps perversely, I enjoyed ballet classes. I am almost a dancer today because of them. Although even now, in my sixties, I am prone to slouching like an adolescent – indeed a photograph of me as a young man is used in a book about the Alexander Technique as an example of 'post-adolescent

collapse' – I can move well on my feet, and a lot of my stage-craft is rooted in what I learned in those first few ballet classes. But Dad voiced his uneasiness at Mum taking me, so she stopped.

Towards the end of the Squadronaires' summer touring season, the band's busiest period, Mum got a phone call from Rosie Bradley, a good friend of my grandmother Denny's brother, my Great Uncle Tom. She lived in Birchington, on the corner opposite Denny's bungalow, and had been passing increasingly troubling news of Denny on to Mum.

During the summer of 1951 Denny was acting in a bizarre way and Rosie couldn't tell how much of it was due to menopause. Mr Buss, Denny's wealthy lover, had responded by sending money. Rosie thought Mum should go down and see to her. Rosie described a recent delivery Denny had received, prompting her to call over the road, 'Rosie, Rosie! Come and have a look at this!' In the boxes were four evening dresses and two fur coats, yet Denny was still walking around the streets in a dressing gown in the middle of the night. Rosie described Mum's mother's behaviour as 'quite bonkers'.

After contacting my parents, Rosie persuaded Mr Buss to rent a two-bedroom flat for Denny above a stationer's shop in Station Road, Westgate. Still, Mum worried. 'Cliff,' she said to Dad, 'I think she's going batty. Do you think perhaps Pete could go down there? He could go to that little school, St Saviours. That might sort it all out.' And this, strange as it may seem, is how I got sent to live with my grandmother in Westgate, and descended into the darkest part of my life.

Denny's domestic notions were downright Victorian. She ordered her own day, and mine, with military precision. We woke up before six and had breakfast, toast for her and corn-flakes and tea for me – unless I'd done something wrong; her

favourite punishment was denying me food. She granted me affection only when I was silent, perfectly behaved, utterly compliant and freshly washed – which is to say, never. She was a perfect wicked witch, even occasionally threatening me with gypsy curses. What had been in my parents' minds when they chose to send me to live with her?

When I began at St Saviours at age six I came bottom of the class for reading and writing. By the time I finished I was on the top desk. That, I suppose, was the good part of going to live with Denny. I wrote a letter to Aunt Rose, Denny's older sister, who returned my letter covered with red spelling and grammatical corrections. I was hurt by this, but Aunt Rose also told Denny that I was too old to be unable to read and write properly, and suggested Denny read me half of a suspenseful book, then stop and give it to me to finish. Denny read me *Black Beauty* by Anna Sewell, and the ploy worked. Caught up not just in the story but also in the unfamiliar comfort of being read to, I immediately picked up the book and finished it off.

I don't remember any other books from my time with Denny. One of my few amusements was playing with the knobs on a chest of drawers, pretending they were the controls of a submarine. I also listened to *Children's Hour* on the radio; the 'Toytown' adventures with Larry the Lamb and Dennis the Dachshund were pretty good.

Opposite our flat was the bus station. Denny would call out the window and invite the drivers to come up for a cup of tea. Sometimes she'd take tea over to them, or send me. Denny saw nothing unusual about going out into the street in her nightdress under a dressing gown, and I didn't mind crossing the street in my pyjamas to give a cup of tea to a bus driver, but I was upset when she asked me to go further, to the local newsagent or grocer, where I would come upon grown-ups on their way to work, looking at me oddly.

Denny would get me up at five in the morning and she'd pack various items of food prepared the night before, including sponge cakes in baking tins. We'd march to various prearranged assignations, usually with American Air Force officers. There were brief exchanges, Denny passing over a sandwich or a tin, but what she received in return I don't know. I remember large flashy cars with half-opened windows. I also vaguely remember a man I had to call 'uncle', who was deaf in one ear, staying the night a few times. He had a little Hitler moustache.

The whole affair left me angry and resentful. I've spent years of psychotherapy trying to understand it. In 1982 my therapist urged me to try to push through to some clearer level of recall by writing about these morning exchanges. I started to write, and as I began describing a meeting – the Air Force officer winding down his window, Denny leaning in – I suddenly remembered for the first time the back door of the car opening. I began to shake uncontrollably and couldn't write any more, or remember anything else. My memory just shut down.

Our flat opened onto the first-floor landing, and my room was never locked; the key was kept on the outside. When I was afraid at night I'd run to Denny's room. If her door was unlocked, she shooed me away; if it was locked, she'd feign sleep and wouldn't respond. To this day I still wake up terrified, sweating with fear, shaking with rage at the fact that my door to the landing was always kept unlocked at night. I was a tiny child, just six years old, and every night I went to sleep feeling incredibly exposed, alone and unprotected.

In addition to the buses, we also had a view of the train station. I loved to look at the magnificent steam engines, fantasising about sharing the moment with a friend, brother, sister – someone. My last thoughts before sleep often focused on longing for physical affection. Denny didn't touch me apart

from slapping me, brutally scrubbing my body in the bath or ducking my head under the water to wash off the soap. One night, when Denny lost her temper, she held my head under for a long time.

At St Saviours there were a few children from the nearby American air base. One tall, lanky boy came to school wearing a jaunty seersucker suit – still *de rigueur* in certain parts of the USA. His parents were oblivious to any ridicule this might provoke. That is, until Rosie Bradley's son Robert and I taunted him to the point of tears while his hapless mother walked him home. The fact that I took part in this bullying shames me to this day.

The school's fat, balding, insincerely jolly headmaster was Mr Matthews. The window in Mr Matthews's study faced the playground, and his favourite ritual was to cane children at his desk with an audience of jeering children gathered outside. I ended up at his desk one day, I can't remember what for. I bent over the desk, facing the window full of eager, greedy faces ready to feed on my pain, but to their great disappointment Mr Matthews let me off.

When Mum paid the occasional visit to Denny and me at Westgate, she gave off an aura of London glamour and of being in a hurry, but also of being unreliable. Meanwhile Denny was running after bus drivers and airmen, and I was miserable. I had lost my beautiful young parents to a life of Spartan discipline with a pathetic woman desperately watching her youth slip away. Denny's feelings for me seemed vengeful, as did Mum's abandonment. The deaths or disappearances of the beloved men in my life – my absent father and the recently departed George VI – seemed vengeful too. At the age of seven, love and leadership both felt bankrupt.

During this time Mum became romantically involved with another man. I remember sitting in the back seat of a

Volkswagen Beetle, waiting at an intersection on Gunnersbury Avenue. Mum is introducing me to the driver, Dennis Bowman; she says he means a great deal to her – in fact, he's going to be my new father.

'I like you better than my other dad,' I say to Mr Bowman. 'You've got a car.'

The car is light green; the traffic lights change to green and I'm giving Mr Bowman the green light.

3
YOU DIDN'T SEE IT

The memory of Mr Bowman came back to me when Mum told me about him years later. Rosie Bradley had kept Mum informed about Denny's worsening state of mind, and in the end Mum asked Dad to go down there with her. Shocked at Denny's erratic behaviour, Dad announced: 'This is ridiculous – he can't stay with her there – she's completely round the twist.' They decided instead that Denny had to come and live with us, until she got better. I sometimes think that if it weren't for Denny's obvious madness I might never have returned home from Westgate.

In July 1952 Mum came to collect me from Westgate on the train – not with Dad, but with Dennis Bowman and Jimpy, whom I was delighted to see. On the way back on the train, though, it was clear my mother hadn't prepared herself for having me back. My fidgeting irritated her, and so did my runny nose. Nothing I did seemed right. Dennis Bowman said quietly to her, 'That's a really dear little boy you've got there. Why don't you leave him alone?'

While I'd been away the kids my age in Acton had fallen into two gangs. Jimpy was leader of the larger group, his authority renewed by a weekly running race he always won. On the day I returned, by some miracle I nearly beat him, and was instantly promoted to Jimpy's second-in-command. After the race I went over to the playground climbing frame, which was

occupied by a menacing-looking boy who sneered at me. 'You're not getting on here, mate.'

Normally I would have turned tail, but a new courage compelled me to challenge him. I climbed up, and when the boy pushed me I pushed back so hard that he fell. As he dusted off his trousers I could see he was considering teaching me a lesson, but someone whispered in his ear. He skulked away, almost certainly having been told I was a friend of Jimpy. Even then I felt happy and safe in a gang of boys, protected by a dominant male.

Just as my childhood status was improving, the ground under me shifted again. It seemed I was going to lose one of my beloved parents. I didn't get the details until years later.

'Dad had agreed to let me go, and to let me take you with me. Then Dennis got a new job in the Middle East,' Mum explained. 'Dennis was an ex-RAF officer with qualifications abroad, very presentable, and because of the mess he got me into here he put his name down for a job outside the country. He finally got a position in Aden. Big money.'

But then Dad had a change of heart.

'As soon as Cliff knew it was Aden I was taking you to, he came back and said, "Sit down, I want to tell you something." I had our tickets, yours and mine. Cliff said, "I've changed my mind; you're not taking Peter. It's too far away. Think about it, do you still want to go?" So I thought about it, and in the end I decided to give things one more try with your father.'

I wondered what Mum meant by 'the mess' Dennis Bowman had got her into? Had she become pregnant? 'Yes. I was in very bad shape in that respect.' She hesitated. 'I'd had some miscarriages.' She paused for a long moment. 'Self-inflicted miscarriages.' After having one back-street abortion Mum had

decided that from then on she would end her pregnancies herself. 'I did it five times.'

I was seven, and happy to be home again, back in the noisy flat with a toilet in the back yard and the delicious aroma of Jewish cooking from upstairs. It was all very reassuring. Jerry Cass still played his radio – the BBC Third Programme, classical music, mainly orchestral – incredibly loudly for fifteen minutes every morning as he shaved. (I still like to wake up to Radio 3, as it's now called.) As I settled back into my old routine, life seemed full of promise. Dad was still often away on tour or at one-night-performances, but Mum was always around, sometimes distracted, but no longer willing to rely on Denny to look after me.

In 1952 the Squadronaires began a regular summer engagement at the Palace Ballroom in Douglas, on the Isle of Man, that would continue for ten years. That first season we rented a flat for the entire holiday, and Mum, still extricating herself from her love affair, got a secret box number at the post office where she would collect Dennis Bowman's daily letter.

The one-bedroom holiday flat we stayed in was on the lower-ground floor of a large block. My bed was in the living room, an upgrade from the dining room. I would wake occasionally to Dad creeping about in bare feet, coming in late from a night in the bar, or trying to slip out.

I loved Jimpy like a brother. He and I played fantastical and elaborate games. We were also great explorers. In Douglas, the capital of the Isle of Man, where Jimpy was staying with us, we discovered a crumbling old mansion surrounded by high walls that we climbed to steal apples. The house seemed abandoned. We managed to get into an outside room and, peering through a keyhole, could see an old vintage car. Through another keyhole we saw a table covered in what

appeared to be treasure – old watches, tools, chains. We tried to force the doors, but they were absolutely secure.

Being explorers was fun, but the biggest treat of all was watching the Squadronaires. This meant dressing up smartly and getting a few shillings from Mum for crisps and milkshakes. Before the dances began we'd stand in the middle of the huge empty floor and bounce gently up and down – the entire floor was on springs. Then we were free to wander, listen to the music and watch the bouncing hemlines of the teenage girls dancing. Sometimes we'd practise dance steps of our own at the edge of the oak dance floor.

On Sundays there were concerts at the Palace Theatre next to the ballroom, where the Squadronaires would accompany visiting artists, some quite special: Shirley Bassey, Lita Roza, Eartha Kitt, Frankie Vaughan, the Morton Fraser Harmonica Gang, and a string of comedians – even, I think, George Formby plunking away at his silly little banjo. I remember a novelty guitar player who strummed an electric guitar while playing a tiny harmonica in his mouth. He looked ridiculous, and the harmonica was so high-pitched it sounded like a squeaking mouse trapped between his teeth. However, he became a regular at these concerts, so it obviously went down well with the crowd.

Seeing this, I became keen on learning the harmonica, and began playing Dad's quite seriously.

There were wonderful times on the Isle of Man that year. I fell in love with the younger blonde girl who lived next door. One day, while playing at 'Mums and Dads', I had her wrapped in my arms in a play-tent and felt for a moment like a real adult. I remember her mother telling me later that the little girl would be a 'heartbreaker' when she grew up. I had no idea what she meant, despite my own rapidly beating heart.

Near the end of this first Isle of Man holiday, Mum brought Denny over and left me in her care while she returned to

London to end her affair with Dennis Bowman. Mum and Dad began to put their love life back together that autumn. They tried hard to have a second child to stabilise the family and provide me with a sibling. I know now that the reason it took so long – my brother Paul wasn't born until five years later – was Mum's battered reproductive system. She might not have put herself through all that abuse had she been clearer about which man she was going to settle on.

It must have been difficult for my proud father to take Mum back after Dennis Bowman. I don't believe he knew about her abortions, but if he had, or even suspected anything, it might help explain his drinking and his absences. It could also explain why, after they reconciled, he seemed most at ease with his wife and family when he was tipsy; only then could he express words of love.

In September 1952 I started at Berrymede Junior School. I remember coming home to Denny's face peeping out through the french windows like a strange, trapped animal. Mum and Dad had given her their bedroom, which she'd filled with the sad booty of her years as Mr Buss's mistress – sterling silver hairbrushes, manicure sets and Ronson table-lighters. I wish I could say I felt sorry for her, but I don't believe I did.

Around this time I became a fire-starter. I went door-to-door borrowing matches from neighbours, claiming Mum's oven had gone out. I didn't set light to any houses, just to piles of rubble on bomb sites, or old cars. One day I misjudged things: I created a city with building blocks underneath a refrigerated van I took to be abandoned, then stuffed the city with paper and set it alight. The van's occupant came out screaming: 'Petrol! Petrol! You'll kill us all!'

On another destruction-minded day Jimpy and I laid a huge piece of steel across the railway tracks under the bridge and stood back. As the train approached we ran away, waiting to

hear the sound of a terrible train crash. This could have not only injured or killed a lot of people, but led us into a very different life, in the penal system. Thank God the train passed without derailing.

At home our chief entertainment was radio. Television had arrived on the scene in 1952, but our family, like millions of others, waited until 1953 and the Queen's Coronation before buying a TV set. I also read a lot of comics and enjoyed Enid Blyton's Noddy books, which first appeared in 1949 and were still pretty new. Dad made a model sailing boat that we sometimes took to the Round Pond in Hyde Park on Sunday. He also took me greyhound racing, which I found magical, especially at White City Stadium. And he always gave me far too much pocket money.

Berrymede was in a poor neighbourhood of South Acton, and one day in my first term at school I told a boy in the playground that Dad earned £30 per week. He called me a liar – the average wage was less than a third of that – but I stuck to my guns because I knew it was true. We nearly came to blows over it before a teacher intervened, warning me to stop telling lies: 'No one earns that much money. Don't be stupid!'

Dad may have been well paid, but there was little sign of it in our lifestyle (beyond Mum's clothes). I wore grubby grey shorts and a Fair Isle pullover, with long grey woollen socks drooping around my ankles, muddy shoes and a white shirt that was never quite white. We had no car, lived in a rented flat and rarely went on holiday or travelled unless it was part of Dad's work; we had a gramophone but listened to the same twenty records throughout my entire childhood, until I started buying new ones myself.

One of the only children's records available was 'The Teddy Bear's Picnic', backed with 'Hush, Hush, Hush! Here Comes the Bogeyman' by Henry Hall with the BBC Dance Orchestra.

I played it a lot, but even then I preferred the sound of the modern big bands, including the orchestras of Ted Heath, Joe Loss and Sidney Torch, with whom Mum was guest vocalist for a time before her marriage. My life with Denny in Westgate had left me disliking Broadway musical tunes: every day I was there the eerie strains of 'Bali Hai' from *South Pacific* had crackled from Denny's big radiogram, a gift from Mr Buss. There was only one *South Pacific* song I liked at the time – 'I'm Gonna Wash that Man Right out of My Hair' – but thanks to Denny's bathroom brutality, even that had sinister overtones.

1953 was turning out to be one of the happiest years of my life – but then Jimpy moved away. Until then, even though we were no longer going to school together, he had still been the centre of my existence. Now he was gone. My parents decided to replace him with a Springer Spaniel puppy. I remember waking up sleepily on my birthday and being introduced to this adorable, snoozing puppy curled up in an armchair. We called him Bruce.

Bruce became my great joy, although he was shamelessly disloyal. If someone in my gang of friends or a neighbour down the street called Bruce, the disgraceful creature would immediately run to him; no matter what I did he would refuse to return to me. It never occurred to anyone in my family to attempt to train the dog, and as a result Bruce spent a lot of time running around the neighbourhood, barking.

One summer day a local photographer took a photo, reproduced in the *Acton Gazette*, of my Jimpy substitute and me in the afternoon sunshine, leaning against a wall, almost dozing. In those days the pavement was a long, limitless bench to sit on. Like apprentice winos, wherever we sat in our neighbourhood, we appeared to preside over and size up all who passed.

We were getting more adventurous as a gang and as we got older we used to sit under West Acton bridge on the GWR fast

main line to the West. The Twyford Avenue gate there was left open, and under the bridge, out of the rain, we could wait for the West Country and Welsh expresses from Paddington to thunder by as they approached at full speed. As one train approached, I absent-mindedly threw a stick across the tracks. Bruce – ever the instinctive retriever – leapt after it, the thundering locomotive ran over him, and I felt sure he must be dead. Suddenly, with the stick in his teeth, he appeared between the large driving wheels, his head going up and down with the driving shaft, and somehow managed to jump through without getting hurt, dropping the stick at the feet of Peter S, a favourite neighbour of his, while I looked on amazed at both his impregnability and his disloyalty.

One day I came home to find Bruce was gone. He'd been returned to his kennel of origin – or so Mum said. I knew deep down he'd been destroyed, but I went along with the pretence so that Mum wouldn't be upset that I was upset. I tried consoling myself with the thought that if Mum hadn't had him destroyed he would probably have died in any case.

Bruce was more than a companion. When he was suddenly gone I was heartbroken – not just over the dog, but for what he was supposed to have replaced. When Jimpy had been around we'd felt like a proper family.

In June 1953 we watched the Coronation at Westminster Abbey live on our brand-new, nine-inch television set, the images barely visible unless all the lights were out and our curtains drawn. Until then my parents had to take me with them if they wanted to go to the pub, or hire a babysitter. Now, with TV to entertain me, they could let me stay home alone.

On my own, terrified, I watched the scary science-fiction serial *The Quatermass Experiment*. Returning to Earth, the sole survivor of a space mission, 'infected' by aliens, gradually

and horrifyingly turned into a monstrous vegetable. Although the 'special effects' were primitive, their psychological impact was genuinely disturbing and realistic and I began having terrible nightmares. Perhaps in a subconscious effort to make my parents come home, I'd fiddle with the electric fire, folding up slivers of newspaper and lighting them on the red-hot bars. Luckily I never set the house alight.

My parents were still trying to rebuild their marriage, I expect, and the pub and the circle of friends they shared there were vital in this process. It was more normal in those days to leave children alone, but I won't pretend that I liked it, or that it *felt* normal. The truth is, though, that my experience of feeling alone, different, alien, was much more 'normal' than I realised.

I have always been a dreamer. My new teacher, Miss Caitling, noticed this and helped me. She caught me out once or twice telling lies and let me know she knew, but never made a great deal out of it. The way this clever woman handled me denied me the option of blaming someone in authority for my sense of shame over making things up; I had no choice but to see it as self-inflicted.

Miss Caitling wasn't conventionally beautiful or pretty. She was stocky with short, dark hair, a little mannish, and wore sensible shoes. But her dark eyes were full of warmth and understanding. She was a champion of the underdog, a perfect teacher for the run-down neighbourhood South Acton had become by then. She was neither an unreliable vamp (like Mum) nor a wicked witch (like Denny); she was an altogether new kind of woman.

As far as girls my own age went, I relied entirely on my peers for guidance. They knew less than I did. Even Dad wasn't much help. Drunk one night, Dad told me the facts of life. 'The man does a kind of pee into the woman,' he said.

The rest of the details were explicit, so I don't know why he fudged the critical bit. I remember passing the facts, as I understood them, to a young friend of mine, and his astonishment that we should all have been synthesised from urine.

On 8 May 1955 Dad was playing at Green's Playhouse in Glasgow when he was sent a telegram from Norrie Paramor of Parlophone Records, part of EMI, offering him a solo record deal. Dad's record, 'Unchained Melody', was released on 31 July 1956. His handsome face was plastered all over the local record shops. Although it was never a hit, 'Unchained Melody' was covered by at least five other artists, three of whom I think charted simultaneously. My father, the pop star! I wanted to be like him.

That summer we all went as usual to the Isle of Man. On one occasion while the band played at the Palace Ballroom, two teenage girls sat either side of me and began to tease me. They were dressed in the full skirts and petticoats of the day, with pretty shoes and low-cut bodices. I felt very much the little boy, my eyes darting back and forth between their heaving cleavages as they discussed which member of the Squadronaires they fancied. One girl immediately claimed the drummer. The other took her time and eventually selected the sax player.

'That's my dad!' I shouted. Her disappointment at this confused me.

The incident served to do two things: it set my heart on becoming a performing musician, and prejudiced me for ever against drummers with their fast-pedalling sex appeal.

In 1956 popular music did not yet mean rock 'n' roll. But *The Goon Show*, which Dad and I listened to, featuring Peter Sellers, Spike Milligan and Harry Secombe, did include some early BBC broadcasts of rock performances. One of the

show's resident musicians was Ray Ellington, a young English drummer–vocalist and cabaret artist. With his quartet he sang songs like 'Rockin' and Rollin' Man', which he composed specially, and rather hastily I think, for the show. I thought it some kind of hybrid jazz: swing music with stupid lyrics. But it felt youthful and rebellious, like *The Goon Show* itself.

I was regarded by my parents as having little musical talent other than a thin, nasal, soprano voice. I was forbidden to touch Dad's clarinets or saxophones, only my harmonica.

On my first Isle of Man fishing trip, I had a fiasco with a huge trout and was consoling myself by playing harmonica in the rain. I got lost in the sound of the mouth organ, and then had the most extraordinary, life-changing experience. Suddenly I was hearing music within the music – rich, complex harmonic beauty that had been locked in the sounds I'd been making. The next day I went fly fishing, and this time the murmuring sound of the river opened up a well-spring of music so enormous that I fell in and out of a trance. It was the beginning of my lifelong connection to rivers and the sea – and to what might be described as the music of the spheres.

I was always drawn to the water. A friend at school was a Sea Scout, and at the age of eleven I was impressed by his smart uniform and badges. He took me to meet the troop leader, and I was immediately signed up for a 'bunkhouse weekend' in order to acquaint myself with the camp. Dad interviewed one of the leader's assistants and was very suspicious. He told me the fellow didn't know which way to fly the Union Flag, and doubted he could ever have been any part of the Navy. When I pressed Dad he said he thought the man was 'bent', an expression I didn't understand.

Dad eventually agreed to let me go for the weekend. The troop's headquarters were on the River Thames, where a large

shed was laid out as a dormitory, and a large rowing boat was moored – an old ship's lifeboat in which the boys were taken for trips. We arrived on Saturday and spent the afternoon trying to tie nautical knots from a chart, which the two adults present couldn't manage. After a fry-up lunch the light began to fade and we were hurried to the boat for a short trip on the river.

The tide was high and it wasn't safe to row, so the men fitted an ancient outboard motor to the stern and fired it up. As we swept past the Old Boathouse at Isleworth once again I began to hear the most extraordinary music, sparked by the whine of the outboard motor and the burbling sound of water against the hull. I heard violins, cellos, horns, harps and voices, which increased in number until I could hear countless threads of an angelic choir; it was a sublime experience. I have never heard such music since, and my personal musical ambition has always been to rediscover that sound and relive its effect on me.

At the very height of my euphoric trance the boat ran up against the muddy shore at the troop's hut. As it stopped, so did the music. Bereft, I quietly began to weep. One of the men put his coat around me and led me up to the camp, where I was settled by the stove to warm up. I kept asking the other boys if they had heard the angels singing, but none of them even responded.

A few moments later I was standing naked in a cold shower set up behind the bunkhouse. It was almost dark; there was a stark light bulb behind the two men who stood watching me shiver as the freezing water sprayed over me. 'Now you're a real Sea Scout,' they said. 'This is our initiation ceremony.' The only thing ceremonial about it was the wanking these two chaps were doing through their trouser pockets. I was freezing, but they wouldn't let me leave the shower until they had each achieved their surreptitious climax. I felt disgusted, but

also annoyed because I knew I could never go back: I would never get my sailor's uniform.

I remember only one truly terrible row between my parents, and sat terrified in the dining room as cups were smashed in the kitchen; I believe Mum flourished a knife. I intervened, weeping like a child actor, only to be told off by Dad who hated the melodrama to which I was contributing. There were also parties, and Dad invited musicians sometimes; their playing kept me awake and I annoyed and embarrassed Dad by bursting in on them and crying, telling him off in front of his friends for the disturbance; Dad told me off in return, but it was terribly exciting. The smell of cigarettes, beer and scotch floated down the hall.

Maybe to compensate for being kept awake at night by wild parties, I was given a small black bike which I hired every day to my friend David for his paper round. He paid me sixpence a week, but I caught him one day bumping it against a curb violently and ended the arrangement.

Once I had a bike I gave full vent to my local wanderlust; there was hardly a street or alley I didn't explore in an area over two or three square miles. But I was one of the few boys in the gang with a bike, and my solo excursions deepened my solitary feelings. I often went into a trance-like state when cycling. I was nearly killed by a dustmen's lorry at the top of my street as I swerved in its path, my head full of angelic voices.

I laboriously learned the tricky harmonica theme of *Dixon of Dock Green*, played by Tommy Reilly, on my own first chromatic instrument. No one was even slightly impressed by my achievement and I realised I was playing the wrong instrument if I wanted superstardom.

Like many of my peers I spent long, boring hours outside various pubs, a packet of crisps and fizzy drink in my hand,

wondering why I was permitted such luxuries only when my parents were getting drunk. I was caught shoplifting once. I had gone into a bookshop for some Observer books I was then collecting. I paid for two, and tried to walk out with six. What's strange is that I knew I'd be caught. The police were called, and I was questioned before being released.

Dad said nothing about the incident. It was the not unkind warning of the police officer I remember: 'This is the first time, son. Make it the last – it's a terrible road you've set out on.' A terrible road? He was a good copper, but I thought it was obvious that I was simply filling the time, bored, up to no good. I began to collect things to settle myself down: model trains, Dinky cars, comics, postage stamps.

I was determinedly non-academic, although I wrote stories constantly and drew hundreds of pictures, mainly of military battles. I became obsessed with drawing plans for a fantasy fleet of huge, double-decked touring buses. My fleet of buses contained schoolrooms, playrooms with electric train sets, swimming pools, cinemas, music rooms, and – as I approached puberty – I added a large vehicle that contained a nudist colony with a cuddling room.

For a few years I attended Sunday school, regularly singing in a church choir. As I fell asleep at night I sang my prayers into the mouth of my hot-water bottle, which I held like a microphone. My parents still resisted the idea that I had any musical talent. No matter, I was already a visionary. A mobile nudist colony with a cuddling room? I'll bet even Arthur C. Clarke hadn't come up with that at my age!

Whenever we made a family visit to Horry and Dot's, I got to see not only my beloved grandparents, but also Aunt Trilby, Dot's sister. Trilby was single when I met her, and kept a piano in her flat. It was the only one I had a chance to play. Tril read music, and played light classics and popular songs, but never

tried to teach me much. Instead she entertained me with palm-readings and interpretations of the tarot, all of which indicated I would be a great success in every way – or at least enjoy a 'large' life.

Aunt Trilby provided me with drawing paper and complimented my rapid sketches. After a while I would drift to the piano and, after checking to see that she was engrossed in her knitting or a book, begin to play. The instrument was never quite in tune, but I explored the keyboard until I found whatever combination I was after.

One day I found some chords that made me lightheaded. As I played them my body buzzed all over, and my head filled with the most complex, disturbing orchestral music. The music soared higher and higher until I finally stopped playing, and came back to the everyday world.

'That was beautiful,' said Tril, looking up from whatever she was doing. 'You are a real musician.'

Because of Tril's faith in me, I became a bit of a mystic like her. I prayed to God, and at Sunday school I came to genuinely love and admire Jesus. In heaven, where he lived, the strange music I sometimes heard was completely normal.

Miss Caitling continued to encourage me to link my fantasies with the real world through creative writing and art. She began inviting me to tell serial stories to the class, which I made up as I went along. Looking back, I understand that my classmates were as gripped by the thrill of seeing how I would escape my tangled plots as they were by the stories themselves. Sometimes, if I got in too deep, I simply dropped a nuclear bomb on my characters and started all over.

I felt natural standing in front of an audience. I also discovered that I could think quickly on my feet. If I didn't know something, I could often bluff my way around it. In my last year at Berrymede I told anyone who asked about my ambitions to be a journalist.

In summer 1957 on the Isle of Man, Jimpy came for another visit. We had a great time together, and Dad took us to the cinema to see a musical film. I asked Dad what he thought of the music. He said he thought it had some swing, and anything that had swing was OK.

For me it was more than just OK. After seeing *Rock Around the Clock* with Bill Haley, nothing would ever be quite the same.

4

A TEENAGE KIND OF VENGEANCE

I was still playing the harmonica, and getting good at it, but it was clear that the guitar was the instrument that mattered. Jimpy and I had been mesmerised by *Rock Around the Clock*, and Haley's band only had a single sax player. They marked their Country & Western heritage with a pedal-steel guitar, and the swing was jaunty and extremely cheerful, bordering on manic. The words were often nonsensical. Today almost every early rock lyric has been interpreted as having some secret meaning to do with sex, but if they did I never noticed.

I only liked Bill Haley for a few months, but Jimpy was totally hooked and bought several Haley and Elvis records. While Jimpy was still with me on the Isle of Man, he and a pretty girl named Elaine – with whom we had both fallen in love – started singing Elvis songs together. They lost me there. To my ear Elvis sounded corny, a drawling dope singing about dogs. I just didn't get it. Unfortunately I had missed his first masterful releases like 'That's Alright Mama' and 'Heartbreak Hotel', and had come in directly on 'Hound Dog' and 'Love Me Tender', a song that made me want to vomit, especially when Jimpy and Elaine crooned it at one another. In his movies (apart from *Jailhouse Rock*) Elvis confirmed my view of him as a chump.

After the holidays I started my second year at Acton County Grammar School. To my parents' enormous joy, my mother finally got pregnant, and my brother Paul was born. Mum and

Dad made plans to move to a bigger flat, and found one on the same street where Dad's parents still lived on Uxbridge Road. It seemed good karma all round. In the new flat, on Woodgrange Avenue, I sat on a ladder in the empty dining room, playing my harmonica. I knew this was going to be a lucky place. I had my own room with a door, and Paul was the sibling I'd always wanted.

That autumn Dad got tickets for Jimpy and me to see Bill Haley live at the old Regal cinema at Marble Arch. I went along mostly for Jimpy's sake. We had seats in the highest gallery, the very back row, where we were surrounded by rowdy older teenagers. The cinema had been structurally weakened by bombs, so when the audience bounced enthusiastically to the beat the gallery literally shook. (The building was demolished a few months later.)

Several boys at school had got the rock 'n' roll bug, but their interest seemed confined to whistling whatever record was number one at the time. Jimpy got his father to make him a guitar. He stood in front of the mirror, wiggling like Elvis, strumming at the tuneless piano wire with which Fred had strung the homemade instrument. One day I grabbed the wooden box and, not quite knowing what I was doing, picked out a tune. Jimpy was gobsmacked. He ran into the other room where both our dads sat drinking, and brought them in to hear me. Dad didn't say much, but Fred Beard said, 'If he can play that thing, he could do really well with a proper guitar.'

Dad wasn't convinced. I badgered him, but because I'd never followed his advice and learned to read music he wouldn't take my aspiration seriously. (Without a piano in the house I'm not sure how he thought I would be able to learn.)

Ironically, it was Denny who stepped in. She bought me a guitar that she saw hanging from the wall of a restaurant, whose owner was a friend of hers. It was an awful instrument,

almost harder to play than the one Fred had made for Jimpy, but I was delighted. After I got it correctly strung, I started learning a few chords. Within minutes three strings had broken and the neck of the guitar started to bend, but I just reduced the tension and made do with the three remaining strings.

One day I was strumming when Dad's trumpet player friend Bernie Sharpe heard me in my room and looked in. 'You're doing well, Pete,' he said. 'Isn't he, Cliff?' No response from Dad, but alone in my room picking out notes on my guitar I had visions of leaving him and his glorious musical traditions behind. Deep down, I suspected that my father had had his day.

In 1957 Chas McDevitt had a UK hit with a song called 'Freight Train'. I first heard the song on BBC TV sung by Nancy Whiskey. Listening to the homespun campfire sound of skiffle I realised that with a guitar and a few chords you could make hit records.

Because of the very real and immediate threat that skiffle music posed to Dad's recording career – and thus to my family's security (for now I never seemed to see a saxophone or clarinet player on the TV) – I had a unique window on how society was subtly changing. After decades of dealing with military threats, our parents now faced a danger from within. 'Youth' was what it came to be called. I had joined an army of my peers by picking up the guitar, that instrument that threatened my father's career. Perhaps that's why I delayed by picking up the banjo for a while, playing Dixieland jazz.

The group of school friends with whom I played music was full of potential Jimpy substitutes. Chris Sherwin was a student drummer, and with Phil Rhodes on clarinet and John Entwistle playing trumpet we met each week to rehearse a quartet in which I played banjo. We called the group The Confederates. In spring 1958, when we began, I was still only twelve years old, but they were already teenagers. I knew John Entwistle a

little, and enjoyed his sense of humour. Chris Sherwin acted like the band's leader, partly because our rehearsals were held at his father's house on Ealing Green.

Our first gig with The Confederates was at the Congo Club at the Congregational Church in Acton on 6 December 1958. We played for about ten people. I was frozen with nerves as we played a tune we'd made up together, based around a banjo 'C' chord I picked out. We went on with 'Maryland' and 'When the Saints Go Marching In', featuring Chris Sherwin's explosive drum solo. After we finished I watched in complete amazement as John Entwistle and the other boys jived with girls. One girl tried to teach me the steps, but I just couldn't hit her marks. I still can't jive today.

And when the lights went down and the snogging started, I slid away home.

One day, while looking through the junk shop, Miscellanea, that my parents were now running, I found a mandolin, which whetted my interest in the so-called antique trade. Dad enjoyed the simple rhythm and informality of running the shop – it was often 'closed for lunch' while he went to the pub. In the summer I stayed with Dad for the few weeks he was playing on the Isle of Man, and when I got home I realised that while I'd been developing my banjo skills other boys also had been getting on with their music.

John Entwistle, Chris Sherwin, Phil Rhodes and Rod Griffiths were rehearsing regularly with Alf Maynard's jazz band. Alf was a great fellow, but he played banjo, which made me redundant, although I remember playing duelling banjos with Alf at Christmas, when the band of six took in £18. I was briefly part of their brave, grown-up world and could even afford my first decent guitar. Purchased from my parents' junk shop for £3, it had been built in Czechoslovakia and had a thin but pleasing tone.

I saw less of John Entwistle while he was playing in Alf's band, and I left music itself behind for a while as Chris tried to help me catch up with the march of adolescence all around me. He took me to my first X film, *Peeping Tom* (which turned out to be elegant film noir rather than the smut I'd hoped for). He also arranged a doubled paper round for me, earning 30 shillings a week, which seemed a colossal sum of money. It was a difficult round, though, taking in most of the big houses around Ealing Common, and it was awful in winter. One cold wet morning I slept through my alarm and was sacked.

My parents gave me extra pocket money for looking after my brother Paul, but he was a wonderful little boy and I enjoyed it. Denny lurked in the wings like a vampire, but I gave her dark looks, warnings that she wouldn't get her evil hands on my little brother as long as I was around. Paul's arrival had made us feel like a real family, and no one was going to take that away from me.

My parents were obviously lovers again. They spent a lot of time at the local pub, which I didn't understand at the time but I now know that they both had drink problems. Dad needed booze to feel comfortable with his peers, and Mum was trying to deaden the lifelong pain of being abandoned by her mother. She became pregnant again, and my brother Simon was born at home in October 1960, when I was fifteen.

In the last term of grammar school in spring and summer 1961, I continued to count Chris Sherwin as one of my closest friends. He was sweet to my baby brother Simon, and I knew he had a soft heart, but Chris began to harp on my failures with girls. One day, as we headed home from the pool, I lost my temper and said I would fight him. A big fellow, he just laughed and turned away.

I swung my school bag and hit him over the head; to my amazement he dropped to the ground. Assuming he was being silly, I walked off, still angry. Seconds later I felt his fist smash into the side of my head from behind. 'You knew I had a concussion,' he shouted. He spread word of my 'cowardly act' all over school, which sullied my reputation to the point where John Entwistle seemed the only one who would have anything to do with me.

Then, if possible, my social standing fell even lower. I was cycling home one day, past some boys from my school throwing stones at an old man's windows, when a policeman showed up. The boys escaped but the copper grabbed me. Incriminated by wearing the same school uniform as the vandals, I was arrested and persuaded with the usual threats of prison to give up the boys' names.

Next morning the headmaster called out the names I had supplied, and after a pause added my own. We all received the cane, naturally. But this was a new low point for me, as rumours circulated that I had 'grassed' on the stone-throwers. Mum remembers seeing me sitting hangdog in a small public park next to the school; it was raining, but still I wouldn't go in. Dad was so worried he came to speak to me, but I was too ashamed to tell him my problems. My schoolwork slumped, and I locked myself away with my guitar, swearing to go it alone somehow.

By the end of the spring term I had electrified my Czech guitar and bought a small amplifier. John had made his own bass, and we rehearsed together at my house. We would visit a fish-and-chip shop in Acton and walk back to Ealing with our tongues scalded by the hot oil, sharing dreams.

One day Denny burst into my room while John and I were playing music. 'Turn that bloody row down,' she shouted.

I looked at her coolly, not replying, but picked up my small blue amplifier and threw it violently against the wall. 'Fuck off,' I said, feeling very calm as the amp smashed to the floor.

Denny went pale and left the room.

'Great,' John said dryly.

John was playing bass guitar with a group started by our school friend Pete Wilson, a fan of Cliff Richard and The Shadows. Pete's guitar playing was enthusiastic but clumsy, so when I was invited to join the band I was flattered but ambivalent. Having grown up with the notion that I was going to be an artist of some sort, the idea of playing Shadows songs didn't set me on fire, but Pete became a friend and he was an encouraging, natural leader.

Mick Brown, our drummer, was a competent musician and one of the most amusing people I've ever met. He also had a tape recorder, the first I'd ever come across, and I realised immediately that this was an extraordinary creative tool. He made the first recording of me as I played The Shadows' 'Man of Mystery' solo on my Czech guitar. It sounded good, and I soon got hold of a basic tape machine of my own.

I loved cartooning and drawing – my childhood tour buses had earned praise from Alex Graham, the creator of the famous British cartoon Fred Basset – and I did very well in my art classes at grammar school. The art master encouraged me to take some extramural classes, so in my last term at Acton County in 1961 I became a part-time art student at Ealing Art College. There I began attending Saturday morning introductory lessons with my friend Martin and his next-door neighbour Stuart, hoping to draw nude models and make pots. Martin gave up after a while, but Stuart and I carried our portfolios over the Common together, and tried to dress in what we thought was a bohemian manner.

To make money I worked in Miscellanea. Mum and I often moved furniture together, sometimes entire houses full, and I became strong and wiry. I also began to learn about human nature as it applied to business. Most customers haggled, and some, if they got a bargain, visited regularly to crow about it. The dealers were always quietly looking for a steal.

In the last few weeks of school, exams behind us, the atmosphere changed for the better. It seemed everyone except Chris had forgiven me, and even he had stopped glaring. The Dixieland band I had been excluded from practised as they walked back and forth outside school, and because Alf wasn't allowed into the school (he was older and had a job) I was invited to step in on banjo. After the months I'd been away from the band one thing became clear: I had progressed faster than the others. At school, for the first time, I felt a part of the human race.

Roger Daltrey had been expelled for smoking, but was still impudently showing up on campus to visit his various cronies. I'd first met him after he won a playground fight with a Chinese boy. I'd witnessed the fight, and I'd thought Roger's tactics were dirty. When I'd shouted as much, he had come over and forced me to retract. Since then I'd seen Roger around at the foot of Acton Hill, carrying an exotic white electric guitar he'd made himself. He was usually with Reg, a friend I knew from infancy, who carried a 15-watt VOX amplifier. Serious stuff.

I was outside our classroom talking to the form teacher for the final year, the redoubtable Mr Hamlyn, when Roger swaggered up in his Teddy Boy outfit, his hair combed into a grand quiff, trousers so tight they had zips in the seams. Mr Hamlyn welcomed Roger with the weary patience of one who knew there was little point enquiring why Roger had returned to an institution that wanted nothing to do with him. Until he was

expelled Roger had been a good pupil, and I think Hamlyn begrudgingly respected him.

A few boys looked over at us with interest, curious to see whether Roger still bore me any ill will. He simply informed me that John had told him I played guitar pretty well, and if an opportunity came up to join his band, was I interested? I was stunned. Roger's band, The Detours, was a party band. They played Country & Western songs, 'Hava Nagila', the hokey-cokey, the conga, Cliff Richard songs and whatever was high in the charts at the time. Roger ruled The Detours with a characteristically iron hand. Judging by the faces of those around me, just the fact of Roger speaking to me meant that my life could very well change.

As calmly as I could I told Roger I was interested. He nodded and walked away, but I wouldn't hear from him again until months later. By that time I had enrolled in Ealing Art College.

5

THE DETOURS

Ealing Art College was a revelation in so many ways: socially, creatively, sexually and musically. The first life-changing event that hit me was the sight of an especially pretty girl across a crowded classroom, and I soon discovered, to my delight, that she adored Ella Fitzgerald and also seemed to like me.

I had very clear musical taste that was more balanced than that of most of those around me. I was impressed by the new trends in commercial music, but not overcome. Elvis was OK, but he was no Sinatra. Connie Francis had an erotic kittenishness but was nothing compared to Ella. Ealing offered lunchtime clubs dedicated to Bebop, Dixieland, orchestral music and opera, played in the lecture theatre on a large, high-quality speaker system. Enthusiasts would make remarks or give short, unpretentious lectures. I attended all of them. But I didn't just *think* about music. I also had the ability to create alpha-state music in my head, go into a creative trance, have musical visions, and after nearly six years of dormancy this gift was restored by hearing orchestral music again.

Back then I had no idea what all this music was, nor did I have a good working sense of different composers, but listening to Jerry Cass's radio and growing up with my parents had fed my musical imagination.

I could play a little jazz on guitar, but I told the girl I had a crush on that I sometimes played in a jazz group. This was stretching the truth: I had performed some local sessions, but

only with pop bands that played crude jazz to encourage the audience to go home at the end of a long evening.

At one point this girl and her older boyfriend had a tiff, and she sought me out for some intimate time together. When she tilted her head for me to kiss her, I didn't know what to do. When it came to girls I was still living in a fog of insecurity. When she turned to someone else in our class for comfort, I was crushed. In my imagination she was perfect. Of course, that was the problem. I was living in my imagination, whereas she was real, with a young woman's needs and desires.

In early 1962, after receiving the call I'd been waiting for, I approached Roger's house to audition for The Detours. Before I got there, a blonde girl opened the front door and began slowly walking towards me. She was weeping, but when she saw my guitar case she stopped and pulled herself together.

'Are you going to Roger's?'

'Yes.'

'Well, you can tell him this: it's either me or that bloody guitar of his.'

I knocked on Roger's door and delivered the message, fully expecting him to break down in tears himself and run after the divine creature, promising never to touch a guitar again.

'Sod her,' he said. 'Come in.'

We went straight upstairs to Roger's bedroom. He was distracted, and it later turned out that one of the criminals he hung around was hiding from the police under the bed where I sat down to play. The audition was very quick. 'Can you play E? Can you play B? Can you play "Man of Mystery" by The Shadows? "Hava Nagila"? OK, then. See you for practice at Harry's.'

* * *

The first show I played with The Detours was at a hall next to Chiswick Swimming Baths in early 1962. I was replacing Reg Bowen, a guitarist who wanted to become the band's road manager. Roger was a sheet-metal worker by day, and had cut his fingers badly that morning, so he disappeared offstage almost as soon as I arrived. I was left to play fumbling lead guitar.

Most of the first gigs I played were arranged by our drummer, Harry Wilson, or his father. We liked Harry. When he made a mistake he'd blush, rage, apologise, analyse, then cheerfully carry on. We rehearsed in his West Acton home, and Harry's father's van carried us to our little shows.

I had a single-pickup Harmony solid-body Stratocruiser guitar that Roger had sprayed red for me. We executed fancy choreographed foot movements as we played songs by Cliff and The Shadows (John was especially good at this, Roger especially bad), and we travelled around Greater London and occasionally beyond, performing at weddings, company functions, birthdays and pubs. At one wedding a pianist hired for the intermission laughingly explained that when he was drunk – which was most of the time – he could only manage to control his left hand, the one looking after accompaniment. His right hand took off searching for the melody with a mind of its own. It was one of the funniest things I ever saw, and I worked hard to learn how to do it. At another wedding we received a £50 tip from the bride's father, and with this astronomical sum we were able to think about buying our own van for the first time.

Although The Detours was Roger's band, the singer then was Colin Dawson, a handsome young man with a strong conventional pop voice. At an engagement party the bride-to-be tipsily fell for Colin, and there was a moment when the prospective bridegroom threatened a fight. We saw fighting aplenty, and I have Roger to thank for the fact that no one ever laid a hand on me. Even a nasty drunk knew better than to provoke him.

Everyone around me in The Detours drank. Colin's girl-friend Angela turned eighteen and threw the first teenage party I'd ever attended. People arrived, drank half a bottle of beer and pretended to be drunk so they could spend the rest of the evening snogging whoever they could lay their hands on. It didn't work for me.

A girl in my class at Ealing took an interest, though, and one day I found myself holding hands with her as we walked through an art gallery. A few days later we went to a party, where she quickly got drunk and started kissing me. This was my first kiss, and I'm not sure it's fair to say I enjoyed it. I felt more like being eaten alive. A few moments later she kissed another boy from our class, and then disappeared.

It was an excruciating journey home alone on the train; the girl in question was nice enough, but her betrayal didn't begin to explain the astonishing pain I felt.

Towards the end of my first art-school year The Detours played our first club dance at the Paradise Club in Peckham. We brought in a new drummer, Doug Sandom, and though we were sorry to see Harry go, Doug focused us. He was about ten years older than we were, and he acted like a proper professional musician. One summer evening at Peckham we clustered the equipment closely around his drumkit, turned our overall sound down and achieved a decent balance for the first time. I began to feel we might really have a chance to make some money with The Detours.

Maurice Plaquet, a musician friend of Dad's, set himself up as agent for our band and got us a date at Acton Town Hall on 1 September 1962, supporting the Ron Cavendish Orchestra. We were billed in the newspaper as The Detours Jazz Group. The accompanying photograph shows us standing close together in suits, ties and professional grins. It was the best photo of me I'd seen thus far and I quickly came to

understand the importance of such images: Roger's pretty younger sister Carol saw it and began to nag him to get us together.

On display in Ealing Art College's corridors were interactive wooden collages created by our course leader, Roy Ascott, various parts of which the viewer could rearrange. We were to spend a year being disabused of our preconceptions about art, art schools, art teaching and all forms of design. I realised the holes in my education were spectacular.

The school included both the new guard and the old. The latter were tweedy draughtsmen, calligraphers, bookbinders and the like – who tended to be fastidious. The former were denim-clad, in their twenties and thirties, and bohemian. During our first lesson in draughtsmanship the man in charge was old guard. He instructed us how to sharpen our pencils, which hardness to select for which task, how to clip our paper to our boards, how to sit, hold our pencils and measure a set of distant relative scales.

'Draw a line.'

We each drew a line and were subjected to the harshest possible criticism from the lecturer, who pointed out that the first line should be north-to-south, six inches long, of uniform thickness and drawn with a 3B pencil without a rule; any variation represented self-indulgence unworthy of Ealing Art College students.

The second lesson was conducted by a member of the new guard. It was quite simple, a test to assess the degree of our preconceptions.

'Draw a line.'

No problem. As if choreographed we each drew a line, north-to-south, six inches long, of uniform thickness, etc. Our lecturer, young Anthony Benjamin, left the room and returned with sculptor Brian Wall. They started to rant around the

room, shouting at us. At one point Benjamin produced a small penknife and pricked his finger, dragging blood across a white sheet of paper. '*That's* a line. Do you understand?' Of course we understood. We were the innocent victims of a struggle between the old and the new.

Another guest lecturer was Larry Rivers, the first gay American junkie sax-playing painter I'd ever met. I felt through him I'd come as close as I ever would to the late Jackson Pollock, some of whose stunning, profoundly chaotic work had actually been exhibited in the corridors of the fine art school for a few weeks. Later I discovered that Peter Blake – my favourite painter – had a studio in Bedford Park, close to my college, which deepened my sense of identification with him.

I experimented with colour and semiotics, and a group of us built a large structure in our classroom, in which we intended to create an Experience Shed. My first attempt at installation sculpture, it felt like a fairground ghost train.

In autumn 1962 none of the people in or around The Detours had much idea what I was up to at art school, and I found it difficult to say much about the band to my art-school friends. Despite starting to make good money with The Detours, I felt they were uncool. I was still living with my parents, but the time was approaching when I'd need to 'come out', in both areas of my life – to the band and to my art-school friends. I needed to get myself into perspective.

In the middle of the first term of my second year, the Cuban Missile Crisis erupted. On the critical day in October 1962 I walked to college absolutely certain that life was over; why was I even bothering to attend class? When the end didn't come, I was glad not to have been one of those who had panicked, wept or chattered compulsively until the good news was announced.

Somehow the message I took from this near-apocalyptic event was that I should give the patiently persistent Carol Daltrey a chance. I took Carol for the occasional walk, tried to talk to her about what I was doing at art school, kissed her whenever and for as long as I could in the hallway of the Daltrey homestead, and – through chats with Roger's older sister Gillian and her sharp boyfriend – heard about a new youth group emerging in West London, the working-class Mods. In the early Sixties in England the teenage Teddy Boy subculture was giving way to two new groups – Mods and Rockers. Mods were into fashion, R&B, motor scooters and showing off the latest dance moves, where Rockers tended towards machismo, exemplified by Marlon Brando's motorcycle gang leader in *The Wild One*.

Gillian's boyfriend had a black PVC coat and rode a Vespa scooter like a young Italian from Rome. Carol Daltrey said I had a real 'Modernist' look, and encouraged me to buy a PVC coat. Sitting with her and kissing her for hours was especially romantic as snow outside ushered in the Christmas holidays. This Mod conspiracy was happening virtually under Roger's nose, he being more of a Rocker. As I walked home that night, fresh snow falling, I was as happy as I'd ever been, although I knew Carol wasn't right for me. It wasn't that she was too young (I was, at seventeen, just two years older), but I was aware that she wouldn't fit into the art-school part of my life. I wasn't even sure of my own ability to straddle the two distinctly different worlds of visual arts and music.

Meanwhile The Detours were busy. After Christmas, Leslie Douglas, in whose band Mum had sung in the late Forties, arranged for us to play a lucrative Sunday afternoon slot at the American Officers' Club in Queensway in London. A number of good local bands played the circuit we were moving into: Cliff Bennett and the Rebel Rousers, The Beachcombers and The Bel Airs. I began to play lead guitar when Roger took

the microphone to sing his favourite Johnny Cash medley – always a hit with homesick Yanks.

Roger bought a van that I decorated with my Detours logo, using an arrow on the 'o'. In one photo the four of us are standing by the van looking like dustmen in our black leather collarless jackets. In January 1963 we played five or six shows, but in February the number jumped to eleven or twelve, including our first date at the Oldfield Hotel in Greenford, which became a mainstay for us. By March we were playing seventeen or eighteen shows per month, and we kept up that busy schedule for quite some time.

In a good week I was taking home nearly £30, which in 1963 was an absurd sum of money. By comparison my art-school grant for the whole year was £140, to be divided over three terms. With money in my pocket I was able to take a trip up to Selmer's music shop in London's Charing Cross Road and buy a Fender Pro Amp with a 15-inch speaker. It was loud, trebly and sexy. The salesman who talked me into it was John McLaughlin, who would become a jazz-fusion guitar legend.

Early in spring 1963 I got to know Richard Barnes, whom everyone called Barney. He became a lifelong friend, ally and The Who's principal authorised biographer. We hit it off quickly and I loved his dry, barbed humour. My awkwardness and self-absorption made me slow to learn from those around me, but Barney was forgiving of this – and every other – defect. I also knew that Barney was aware of my very real musical talent, perhaps even more than I was.

I suffered my first desperate hangover after our drummer Doug introduced me to serial beer drinking at one of our regular gig nights at the White Hart pub. After this I began to show off a little at college, carrying a quarter bottle of whisky around in the back pocket of my Levi's. Still, I knew that in

almost every respect I was lagging behind my peers. The other boys in the band had steady girlfriends, even wives. I had occasional snogs in the back of the band's van, but my attempts at more serious sexual experiments met with frustration.

My college friends Nick Bartlett and Barney came to see The Detours for the first time at a gig on 29 March at a college in London. They seemed impressed. Barney had a steady girl-friend, Jan, who was very pretty, her dark hair cut in a mid-length bob, her eyes made even more dramatic with Egyptian-style kohl eyeliner. It was she who first mentioned the success of a band called The Rolling Stones. On behalf of The Detours, who were too busy to watch other bands, Barney and Jan began to investigate the music scene beyond our insular pub circuit.

There was a lot to explore, although it turned out that the Stones were at the top of the local heap. Ealing had been the birthplace of British R&B a year before. Alexis Korner, father of the genre, had begun a regular gig at the basement Ealing Club, with the legendary Cyril Davies on blues harmonica. Brian Jones sat in from time to time, playing slide guitar. Jack Bruce played upright bass, while Mick Jagger sang Chuck Berry songs. By autumn 1962 The Rolling Stones had evolved into the band we know today, and had taken over the weekly Ealing Club R&B date. Occasionally we local art students would catch sight of them wandering around before the gig. By 1963 rumours about the Stones had become legend; there was no doubt in our minds that – The Beatles aside – this was the band to watch.

In the spring of 1963 two photography students started putting 7-inch R&B singles onto the jukebox in Sid's café opposite the college. One stood out: 'Green Onions' by Booker T and the MGs. I must have played it fifty times, and I finally arranged a version for lead guitar rather than organ, which

The Detours added to its repertoire. On 17 May 1963 the band played at the Carnival Ballroom at the Park Hotel in Hanwell, which was near Ealing, so all my college chums turned out. Some pretty girls from the fashion school stood at the front of the stage, pretending to scream at me like Beatles fans; they were teasing, but everyone was impressed, especially when we played the slightly funkier R&B tunes I'd managed to sneak into our otherwise catholic repertoire.

This was a formative moment for me. My friends from college could see the band I had been so reluctant to talk about; John, Roger and Doug could see my art-school friends, and how broad-based my fellowship was there. I was still uncomfortable that some of the songs we played were chart hits by The Beatles, Gerry and The Pacemakers, Johnny Kidd and Buddy Holly. But I also knew we played enough R&B material to attract interest from some of the more discerning college musos.

Sixty shows later, Commercial Entertainments booked us to play at St Mary's Ballroom, Putney, several times. We supported Johnny Kidd and The Pirates once. They were a truly tight band, achieving a powerhouse sound with just lead and bass guitars and drums. We decided to go the same way, Roger allowing me to take over lead guitar so he could concentrate entirely on singing. He sold me his Epiphone solid-body guitar. Working from my Chet Atkins study pieces I began to master The Pirates' rockabilly fingerpicking technique played by Mickey Green. I started playing a mix of rhythm and lead – what came to be called power chords – often with a jangling open string added to give the sound more colour.

We also met our future engineer and producer Glyn Johns. He sang with The Presidents, who were popular at the venue, and was very positive about our new stripped-down line-up. Roger met his first wife Jackie at that gig, and started seeing her regularly. I dated her shapely best friend for a while. When

I first got my hands inside her blouse I thought I'd gone to heaven. One day we tried to have sex. She took me to her cousin's house where her uncle had been doing some decorating. I was wearing my best Mod outfit, with a special new pair of suede desert boots. I lay on top of her as she fiddled with my trousers, but suddenly I felt my feet go cold – literally. I'd put both of my precious new boots into a bucket of wallpaper paste.

Jackie became pregnant in the winter, and Roger married her in March 1964, five months before their first son Simon was born. Nick was seeing Liz Reid, a pretty, blonde Scottish girl from fashion school. A few months before, he had gone out with a stunning Irish girl, also from fashion school. She had just ended a relationship so we went out as a foursome to eat Chinese food. On a tube train home that night she whispered in my ear that she wanted to sleep with me, and then, outside Ealing Common station, we smoked pot; for me it was the first time. I remember feeling I had discovered something quite important, but wasn't precisely certain what it was.

At home in my bedroom, Nick and Liz lay together on my bed in the dark. I was on the floor with the Irish girl. This was my first genuine sexual encounter, so the rock 'n' roll components of sex and drugs arrived simultaneously for me. My orgasm came in seconds. The next morning, in Sid's café, I overheard the Irish girl a few tables away laughing good-naturedly about my sexual inexperience, but I didn't care. Skill didn't matter, there was plenty of time for that. I had arrived at last.

I wanted to be a sculptor, but Ealing Art College lost its diploma status for Fine Arts and Sculpture, and my parents were concerned I might emerge from college without any qualification. The band still felt like a side-project to me, so I considered moving to another college. I was particularly

interested in kinetic sculpture: installations combining vibrant colour, lighting, TV screens and complex, coded music. All this, I imagined, would be interactive, brought to life by the computers that Roy Ascott talked about.* However, I knew I would miss my friends if I left Ealing, and so, with Barney, I decided to switch to Graphic Design.

Everything changed when I met Tom Wright, the stepson of an American Air Force officer stationed nearby. It turned out that he and his best friend Cam had been the ones responsible for adding R&B singles to the café jukebox. They were notorious for having introduced marijuana in their circle, and for their enormous record collection. One of their buddies had heard me playing blues guitar in the classroom one day and ran to bring Tom to hear me.

I had already bought a number of blues albums of my own – by Leadbelly, Sonny Terry and Brownie McGhee and Big Bill Broonzy. I had heard Chuck Berry, but only his pop-chart stuff. Tom and Cam had albums by Lightnin' Hopkins, Howlin' Wolf, John Lee Hooker, Little Walter, Snooks Eaglin and other blues artists entirely new to me. As long as I'd play my guitar sometimes, they'd let me come back. Every album was a revelation, but the real richness of their collection was on its fringes: Mose Allison sat alongside Joan Baez; Ray Charles alongside Bo Diddley; Jimmy Smith alongside Julie London.

The mainstay of the collection was Jimmy Reed. They had every recording he'd ever made, and 'Big Boss Man' and 'Shame, Shame, Shame', big R&B hits in the US in the late Fifties but unheard in the UK. Simple riffs supported basic

* Ascott's personal manifesto emerges in his course description: 'The Questioning of Preconceptions. Analytical study of Nature and Machines introduces the student to structure, growth and form, cyclic and serial situations, and environmental problems. These practical activities are complemented by seminars in Cybernetics, Semiotics, Psychology ...' For more details, see www.frieze.com/issue/article/degree_zero

lyrics provided by his wife. Steady low bass, chugging rhythms and shrill harmonica solos set the scene for Reed's whining, wavering, old man's voice. But there was something absolutely unforgettable about the music, especially when you listened to several albums in series, a little stoned.

I was also drawn to the jazzier side of R&B, especially at first. I had grown up with Ella, Frank, the Duke and the Count, so I liked Ray Charles, Jimmy Smith and Mose Allison. But I couldn't play keyboards, had no access to one and was still a fairly rudimentary guitar player. But you didn't have to be fast or clever to play R&B guitar blues. You had to be prepared to really listen, and ultimately really feel the music. This seemed less absurd for a young middle-class white boy in 1963 than it does today, so I proceeded without difficulty to learn to play the blues, especially rhythmic blues. I loved emulating Jimmy Reed, John Lee Hooker and Hubert Sumlin, Howlin' Wolf's guitarist, and I started to develop my own rhythmic style based on a fusion of theirs.

If I felt torn, I'm sure the other members of the band felt the same. They had regular jobs. Doug was a bricklayer and a father. Roger worked in a factory that cut tinplate for specialist equipment boxes and recording studio racks. John worked at the local tax office. I was an art student – and I was also becoming a recreational drug user, smoking several times a week. Lately Roger needed to bully me out of bed to get me to gigs. I was often very sarcastic about the music the band members wanted to play, and Doug had to come to my rescue a couple of times when Roger and I nearly came to blows over the musical direction of the group. I kept pushing because I felt that if we didn't change we'd never appear cool to my art-school friends. On the other hand, the chart-type songs I was trying my hand at writing for us to perform were really quite corny.

We recorded my first song, 'It Was You', in late 1963 at the home studio of Barry Gray, who wrote music for children's TV puppet series like *Thunderbirds* and *Fireball XL5*. Dick James, The Beatles' co-publisher at the time, heard 'It Was You' and signed me to his company.

> *I was a guy who thought love would pass him by.*
> *Then I met you and now I realise*
> *It was you, who set my heart a-beating.*
> *I never knew, love would come with our meeting.*

The song was recorded by The Naturals, a Merseybeat-style band (actually from Essex), and a couple of other groups. It wasn't a hit, but the fact that it was published at all gave me tremendous confidence. I felt I now had a right to speak up about the band's musical direction, and even get bossy about it. Roger was definitely in charge, but there was a new tension between us. We were both really keen to make it and had our own ideas about how to do so. Still, we developed a grudging respect for one another that would last a lifetime.

On top of our daily work schedule we were doing gigs every couple of days, sometimes several in a row. Our audience was mainly Mods. A few venues, like the Notre Dame Church Hall in Soho and the Glenlyn Ballroom in Forest Hill, were true Mod strongholds where fashion leaders, called Faces, displayed new outfits and dances like fashion models. Roger and I were probably hipper to what was going on than most because his sister Gillian and her boyfriend were still so solidly in the Mod front line. There were some lovely Irish Mod girls who went to the Goldhawk, the historic music venue in Shepherd's Bush. I managed, on occasion, to even keep my feet out of paste buckets.

Tom and Cam were caught dealing pot, and deported, leaving their entire record collection behind in our care. I finally

moved into my own place with Barney as my roommate, where we set ourselves up as Tom and Cam's heirs. For the first fortnight that we shared the flat Barney and I thought we were doing very well looking after ourselves, but it turned out later that the landlord had let Mum in every day to tidy up, vacuum, do the laundry and washing up. She still liked to have a protective, maternal role in my life in a way that, as a young, independent man who had flown the nest, I wasn't willing to acknowledge. I may not have even wanted her to clean up after me, but of course 'at least I'd get my washing done'.

Jimmy Reed played constantly, and some great girls began to show up. If Roger had had difficulty controlling me when I lived at home with my parents, he was in big trouble now. All I wanted to do was get stoned, listen to records, play my guitar and wait for the doorbell to ring. After a hard day at college I would often decide to forget the band altogether, and if Roger had been less forceful I would have stayed home in my cloud of pot smoke.

We were scheduled to support The Rolling Stones in Putney at the end of December 1963 and I was prepared to be cynical; without hearing them play, I'd decided their reputation must be based on their hairstyles. Instead I was blown away. Our producer, Glyn Johns, introduced me to Brian Jones and Mick Jagger, who were courteous and charming. From the side of the stage I watched them play and became an instant and life-long fan. Mick was mysteriously attractive and sexually provocative, possibly the first such talisman since Elvis. As Keith Richards waited for the curtain to open he limbered up by swinging his arm like a windmill. A few weeks later we supported them again at Glenlyn Ballroom, and when I noticed that Keith didn't use the windmill trick again I decided to adopt it.

A band called The Yardbirds, with Eric Clapton playing lead, was hot, and Roger had seen a rehearsal of a band called The Trident, whose guitar player he raved about – young Jeff Beck. In both cases we had real competition right in our back yard.

In February we supported The Kinks for the first time at the Goldhawk. They all had long hair, funny outfits, frock coats and frilly shirts, but the Mod girls screamed at them just the same. Their music was powerful, and Dave Davies's guitar playing was special indeed. I tried some of my new feedback tricks that night and it turned out he was doing the same. Ray Davies was almost as appealing as Mick Jagger, and for the same reasons: he was delicate, slightly androgynous and very sexy. The Kinks were playing quite a few of the same R&B songs that we did, and they somehow managed to be poetic, wistful, witty, wry and furiously petulant all at once. Along with the Stones, I will always regard them as a primary influence.

That February, John Entwistle heard that another band was also called The Detours, so we came back to Sunnyside Road after a local show and brainstormed band names for hours. Barney suggested The Who; I suggested The Hair. For a while I hung on to my choice (could I have somehow had an intuition that the word 'Hair' was going to launch a million hippies a few years later?). Then, on Valentine's Day 1964 we made our choice.

We became The Who.

6

THE WHO

In 1964 I began playing guitar the way I was always meant to play it. The sound I had favoured until then borrowed liberally from American prodigy Steve Cropper's guitar solo on 'Green Onions' – a cold, deeply menacing, sexual riff. This, I suppose, is how I imagined myself at eighteen. Now, at the flick of a switch the central pickup, which I had set close enough to the strings to almost touch them on my modified Rickenbacker 345S guitar, cut in to boost the signal 100 per cent. The guitar, with a semi-acoustic body I had 'tuned' by damping the sound holes with newspaper, began to resonate.

By April I was so tired and distracted at school that the lecturer running the Graphic Design course at Ealing, a big-shot ad-man, asked about my health. In my second year of Graphic Design, my fourth year at college, I was, according to him, producing good work. I told him my work with the band was exhausting me.

'Do you like it?' he asked.

'Yes.'

'Well, how much do you earn?'

When I told him around 30 quid a week, he was stunned. At nineteen I made more money than he did. He suggested I might be better off pursuing the band, which was the beginning of the end. After gigs I found it harder and harder to get up the next morning for class, and at some point before the summer break of 1964 I stopped going to college at all.

My musical self-certainty drove me blindly forward. I felt I was hauling a band behind me that was ill-suited to the ideas drummed into me at college, but it was a better vehicle than the conventional life of a graphic designer. I wasn't trying to play beautiful music, I was confronting my audience with the awful, visceral sound of what we all knew was the single absolute of our frail existence – one day an aeroplane would carry the bomb that would destroy us all in a flash. It could happen at any time. The Cuban Crisis less than two years before had proved that.

On stage I stood on the tips of my toes, arms outstretched, swooping like a plane. As I raised the stuttering guitar above my head, I felt I was holding up the bloodied standard of endless centuries of mindless war. Explosions. Trenches. Bodies. The eerie screaming of the wind. I had made my choice, for now. It would be music.

The time had also come when we realised we had to work full-time as musicians or we would be unable to compete with the likes of the Stones, The Beatles and The Kinks. Moonlighting was no longer enough. It had become essential, too, that we get our sound right.

I sought the wisdom of Jim Marshall, who would become the inventor of the Marshall stack, the high-powered amplifier systems used by most heavy-rock guitarists since the mid-Sixties. Jim ran his music shop in West Ealing. John Entwistle, one of Marshall's first customers, was very happy with his new cabinet of four 12-inch speakers intended for bass guitar. I was less thrilled. John, already very loud, was now too loud. I bought a speaker cabinet and powered it with a Fender Bassman head. John bought a second speaker cabinet to stay ahead of me. I quickly caught up with two Fender amplifiers, the Bassman and a Pro-Amp driving two Marshall four-by-twelve speaker cabinets. John and I were in a musical arms race.

I was the first electric guitar player on our circuit to use two amplifiers at the same time, and I only heard much later that my then hero Steve Cropper of Booker T and the MGs sometimes recorded with two amplifiers back to back. The distortion factors introduced by each amplifier became much more complex and rich when fed back reciprocally. I had also begun to pile one Marshall speaker on top of the other to emulate the conditions at the Oldfield Hotel hall where I had first put a speaker on a piano in very close proximity to where I stood playing the guitar, creating feedback. This configuration is what later became known as the Marshall stack. I remember Jim trying to talk me out of it at first, telling me they could topple over and kill someone. The first cabinets I had were clipped together with heavy luggage clips he provided. Over a period of months I persuaded Jim and his team to make his amplifier not just louder but also brighter sounding, and capable of more distortion when pressed hard.

In rock 'n' roll the electric guitar was becoming the primary melodic instrument, performing the role of the saxophone in jazz and dance music, and the violin in Klezmer. I began using feedback more creatively; sometimes my guitar solo would simply be a long, grinding howl full of evolving harmonics and whistles. But in its enormity I discovered something euphoric, a sound full of movement and cascading melody. This is something that later exponents of electric guitar feedback explored far better, especially Jimi Hendrix.

Oddly, I felt some shame too during these droning moments, but not for any self-indulgent act of musical desecration. In truth I had no idea what the origin could be of all the contradictory emotions I felt when creating these warlike sounds. Something was bubbling up from my subconscious mind.

Jim Marshall had struggled to impress his father, a boxer, and failed. By one of those strange quirks of fate, on the occasion of Jim's last performance as a drummer my dad was

playing with him in a small orchestra Jim had put together. Jim's father arrived drunk, and began to taunt his son from the floor. Suddenly Jim lost his temper, flew at his father and beat him badly, even though the older man was much more powerful. Jim never played the drums professionally again.

I was experimenting all the time, trying to find new ways to play my guitar on stage, inspired directly by Malcolm Cecil. He had demonstrated unusual ways of playing his double bass, in one case breaking a string, then being challenged by being given a woodsaw which he bravely used to cut through the rest of the strings, damaging the surface of his instrument. I fell upon my Rickenbacker with all manner of scraping, banging, bending and wrenching, which resulted in howling acoustic feedback. Encouraged too by the work of Gustav Metzger, the pioneer of auto-destructive art, I secretly planned to completely destroy my guitar if the moment seemed right.

The Who still seemed like a temporary, disposable part of my private plan. We would chop away at our own legs. Certainly, R&B on its own didn't seem to me enough of a new idea; it was just the emerging bandwagon predicted by the music papers. On stage I was becoming increasingly anarchic and narcissistic; film of the period shows me spending more time moving my hips than fingering notes. But I also copied neat solos by Kenny Burrell, the jazz guitarist. Had I studied properly and practised more conventionally in these years, I would have become a more proficient guitar player and less of a showman.

During this period I often looked effeminate. Since I'd never really had a steady girlfriend, rumours went round that I might be gay. In some ways I felt happy with this. Larry Rivers proved to me that a gay man could be wild, attractive and courageous; in any case one's sexuality was becoming less of an issue every day. One of the great things about the British

Mod movement was that being macho was no longer the only measure of manhood. I myself had no interest in appearing attractive, much less sexual, on stage; in the end all the disturbing experiences of my childhood went into my composing.

One day a girl came to claim all the albums that belonged to Cam, bringing a letter from him confirming that this was his wish. It affected our collection badly. A little later we received instructions from Tom to package his albums and send them to him in Ibiza. These back-to-back losses were difficult to deal with. Suffering from music withdrawal, I began to collect albums myself, replacing all I could find, but many were rare. Barney and I discovered Bob Dylan, and listened intently to his first two albums. There was something extraordinary there, but I wasn't sure what it was.

Barney and I had been living in total squalor, and then we lost the lease to the flat altogether. Mum, always alert to a way to fix things for other people, discovered that the tenant in the apartment immediately above the Townshend homestead at Woodgrange Avenue was leaving. She secured the lease and Barney and I moved in. It was a splendid, rambling place. The rent was £8 a week, and we had five wonderful rooms, a bathroom and kitchen. I began drawing elaborate, ambitious plans to develop the place into art rooms, a recording studio and recreation rooms. But it was hard snapping out of our squalid living habits. We didn't purchase a single item of furniture and slept on single mattresses on the floor. We discovered an extremely heavy material in sheet-board form that we intended to use to soundproof one of the rooms and we filled one entire room with it, but never even started any of our schemes.

We continued to get stoned and listen to records in bed, allowing the detritus of our existence to pile up until we could persuade someone else to tidy up for us. Newspapers, food cans, cigarette butts and dirty coffee cups littered the room we

slept in and used to entertain visitors. When hungry I simply went downstairs and took food from my parents' cupboards. People came and went – art-school mates, girls we knew, and occasionally a compliant waif-fan from a show. I was still quite shy, and although no girl complained when we did have sex, I never really felt on a par with the other guys in the band who seemed such old hands.

I developed quite an unpleasant streak at this time (I have this on good authority from my friends). I became increasingly critical and cynical, and in arguments often twisted the facts to fit my brief. I adored Barney, but he too was growing cynical. Perhaps we were smoking too much grass. I remember the apartment we shared shrouded in a grey pall. The stuff we were buying was certainly getting stronger.

Doug Sandom's sister-in-law Rose found us a benefactor in Helmut Gorden, a single man who wanted some excitement in his life. He became our manager, bought us a van and introduced us to some major agents who booked us shows here and there. Otherwise we continued to play the local pub circuit in our immediate neighbourhood. Unknown to us, Commercial Entertainments, who had promoted most of these local shows, had decided to put The Who under contract, but my parents had refused to sign anything on my behalf.

Helmut Gorden managed to get us an audition with Fontana Records, not knowing that Jack Baverstock, chief of the company at the time, was one of Mum's closest friends. She put in a word for us. Fontana's A&R man, Chris Parmienter, heard us play in a rehearsal room and liked us, but he felt our new drummer, Doug Sandom, was too old.

Seeing our chance at a record deal fading, I cold-bloodedly announced to the band that I felt sure Doug would want to stand down. Doug was deeply hurt by this, especially because, unknown to me, he had defended me against my being thrown

out of the band a few months earlier when another audition-
ing agent said I was gangly, noisy and ugly. Doug did stand
down, with some dignity, so we got our break. It is one of the
actions of my career I most regret. Doug had always been a
friend and mentor to me, not to mention he was the first
person to get me really drunk.

We tried a few new drummers, including Mitch Mitchell, who
went on to play with Jimi Hendrix. But Keith Moon appeared
one day at one of our regular dates at the Oldfield Hotel in
Greenford, and as soon as he began to play we knew we'd
found the missing link. He told us his favourite drummer was
Buddy Rich, but he also liked British bandleader Eric Delaney,
who used twin bass drums. He failed to mention until much
later that he was an obsessive fan of Californian surf music,
but the band he was playing with was called The Beachcombers,
so we should have guessed.

Keith had been taking lessons from Carlo Little, the drum-
mer with Screaming Lord Sutch, who was a performer from
the previous wave of novelty bands on the small gig circuit.
An eccentric player, Keith seemed to be showing off all the
time, pointing his sticks up in the air and leaning over the
drums, face thrust forward as if to be nearer the front of the
stage. But he was loud and strong. Slowly, too, we realised
that his fluid style hid a real talent for listening and following,
not just laying down a beat.

Roger tried to befriend Keith, but Keith kept his distance.
He also seemed to see Roger's success in pulling girls at our
gigs as a challenge. They sometimes chased the same girls in
those early days, and it was never clear to me who was
winning. I wasn't sure how Keith felt about me in the first few
months he was in the band, nor whether he'd support my arty
manifesto; time would tell. Keith's main pal in the band
became John. They were hysterically funny together, and

shared an apartment for a while. Roger and I got the impression they did almost everything together, including having sex with girls. It must have been mayhem.

Despite the pain I had caused by my disloyalty to Doug, it became clear that with Keith Moon in the band and a new record deal we had a real chance at a career in music. I had already written a couple of decent songs, and was using an old tape recorder to write new ones in the style of Bob Dylan. Through a friend of Helmut Gorden we met Peter Meaden, a publicist who seemed to know all the teenybopper magazine editors. Peter was much impressed by the antics of Stones manager Andrew Loog Oldham, who had a tough henchman who acted as his protector and sometimes enforcer. So Meaden found one of his own in a chap we came to know as Phil the Greek, who was sharply dressed and good-looking, with a vicious streak. He and I became quite good friends.

What Peter Meaden did do for us was to enact a thesis Barney and I had already gleaned at art school: every new product, including every new band, needed an image if it was to succeed. That is, we needed an identifiable style: outfit, haircut, and if possible a new way of making music. Barney, his girlfriend Jan and I talked late into the night about how to capitalise on this extraordinary time; we were smart, and we had a band that might make good if we got things right. Barney and Jan seemed almost as excited as I was about the prospect of The Who breaking big.

Peter Meaden also emphasised the importance of the Mod movement for us. That was the style and image he wanted us to embrace. Meaden was one of the authors and architects of the new vocabulary used by Mods, and I was eager to learn the lingo – beyond the little I'd learned when I was dating Carol Daltrey. Musically I felt I was already on course. Barney and Jan had both constantly urged me to develop my sound

and guitar solos, and to utilise all the wildest, most pretentious ideas from our old Ealing art-school lectures.

John Entwistle, always uneasy with being merely a bass player, began to open up his sound as well. He already played louder than most other bass players, but now he began to play with more harmonics. When he later discovered wire-wound bass strings, his sound evolved into the one we recognise today, but even at this time his playing was expressive and creative, almost a second lead instrument. As I developed my sound, so did John, and it is now much clearer to the world what he did to advance the craft of electric bass guitar playing, especially in his development of special strings. We each occupied a specific part of the sonic spectrum, and although we occasionally attempted to dominate each other, the end result was that John's sound perfectly complemented my own.

Against John's loquacious bass lines and Keith's liquid drumming I fell back further into using powerful, slab chords. My solos were often simply howling feedback, or stabbing noises, but never quite loud enough to suit me. One day in 1964 Jim Marshall delivered me an amplifier system I was reasonably happy with, a 45-watt amp that had a crisp American sound, but when you turned it up it screamed like a Spitfire, that essential British war machine – sleek, simple, undefeatable. I bought two, and used one to drive each of my speaker stacks of eight 12-inch speakers.

Now not only was my sound unique, it was so loud it shook most of the small halls in which we performed. Jim had no idea his amplifier design would make him rich, and I had no idea it would make me strong.

Despite my interest in songwriting, Peter Meaden decided he was going to write the two songs we would record for our first experience in a studio, the Fontana session. He had already

persuaded us that The Who was a tacky, gimmicky name; it sounded uncool, so we were to record as The High Numbers. 'Numbers' was the term used for a Mod subgroup of lieutenants that rated below the fashion-leading 'Faces' (among whom Peter Meaden no doubt saw himself as a major player), but above the 'Tickets', the ordinary kids on the dance floor.

What was happening in the Mod movement was based on trendsetting fashion statements and dance moves by local Faces that were immediately copied by the rest of the kids in any particular locale. Meaden wanted to help that transmission along with coded messages in our songs. His idea fit so neatly into what I'd been taught at art college that I readily agreed to allow him to go ahead. We went to the home of Guy Stevens, a Face and the leading DJ at the exclusive Soho Scene Club, the most fashionable Mod stronghold in London. Guy lent Peter a couple of then rare R&B records that we all liked, and Peter borrowed liberally from them, replacing the lyrics with his own.

At the time we were getting most of our inspiration from growling R&B songs by Bo Diddley and Howlin' Wolf. Peter's two songs were cool enough, but had very little of that driving R&B beat with its hard-edged guitar sound. Guitar feedback, a staple of our live shows, was entirely absent from the two sides Peter had written. On 'Zoot Suit', which was based on 'Misery' by The Dynamics, I play weedy jazz guitar, demonstrating that my solo work was undeveloped. The record didn't break out, despite Peter Meaden's assault on the pop magazines of the day. I think it sold about 400 copies. The problem was the sound, which was unoriginal. With Peter's help we had developed an image, but the musical puzzle was still incomplete.

Looking back it seems astonishing to think that Peter Meaden, the principal articulator of the lifestyle that lay behind the emergent British Mod movement, missed out on

the fact that we were breaking new ground with our sound. But he did. He hated all that feedback from my guitar, Keith battering away like a lunatic, Roger growling like an old black prisoner and John clanging at his bass sounding like Duane Eddy. It must have felt uncool to him. But when we played our first few shows in real Mod strongholds, like the Aquarium at Brighton, or The Scene Club, where pep pills and beautifully dressed young rent-boys were openly for sale, our Mod garb combined with that aggressive noise allied us to a very powerful new idea in pop culture: the elegant, disciplined, well-to-do, sharply dressed, dangerously androgynous yobbo.

What was I looking for in this drive to create a successful band? I was only eighteen and was motivated by artistic visions as well as the usual pop-star dreams: money, fame, a big car and a gorgeous girlfriend. We had just made our first record for a major label, and I had had sex for the first time not long before. To me the sexual conquests of Roger, John and Keith were as fantastical and unapproachable as my theories of auto-destruction were to them. Barney and Jan sometimes emerged from Barney's bedroom to join me for our ritual brainstorm chats after they'd conducted a long and sweaty sex session I could only imagine. How could it all last over an hour?

Of course I was dealing with psychological issues that my closest friends and bandmates didn't share. I suffered from a deep sexual shame over my dealings with Denny, although I'd managed to push the details out of memory's reach. Why should a victim of childhood abuse feel sexual shame at all? I still have no answer to this question, but its roots may lie in our tendency as children to take the blame. Perhaps it's a way of pretending we have some degree of control over our lives, when to acknowledge the alternative might drive us insane.

At the time I didn't realise how many other people were working through similar feelings. So many children had lived through terrible trauma in the immediate postwar years in Britain that it was quite common to come across deeply confused young people. Shame led to secrecy; secrecy led to alienation. For me these feelings coalesced in a conviction that the collateral damage done to all of us who had grown up amid the aftermath of war had to be confronted and expressed in all popular art – not just literature, poetry or Picasso's *Guernica*. Music too. All good art cannot help but confront denial on its way to the truth.

With The Who I felt I had a chance to make music that would become a part of people's lives. Even more than the way we dressed, our music would give voice to what we all needed to express – as a group, as a gang, as a fellowship, as a secret society, as subversives. I saw pop artists as mirrors of their audience, developing ways to reflect and speak truth without fear.

Still, I was more certain then of the medium than the message. Surely, God help us all, we weren't just going to write songs about falling in love, or hopeless longing? What was it, then, that needed to be said?

I had found a new sound. Now I needed the words.

In a remarkable act of synchronicity, two young men, Kit Lambert and Chris Stamp, had been searching London in order to make a film about some wonderful new, as yet undiscovered band that came from the street. Kit saw us perform that first time at the Railway Hotel in July when I smashed my guitar and described us as satanic. He persuaded Chris to come and see us, and they quickly decided to make us the subject of their film.

The two friends (later dubbed by the media 'the fifth and sixth members of The Who') came from very different

backgrounds. Chris, from the East End of London, was the son of a Thames waterman; Kit was the son of Constant Lambert, the musical director of the Royal Ballet at Covent Garden. Chris was drop-dead handsome, even better looking than his famous film-star brother, Terence. Kit had a look of Brian Epstein about him; we all thought he was gay. Most importantly, the two of them knew how to get things done.

Kit and Chris made their film. (That film still exists; Roger now owns the only remaining copy.) Then they decided to go one better, and offered to manage us. But Peter Meaden and Helmut Gorden didn't want to give us up. At some point in the negotiations Meaden brought the manager of the Stones, Andrew Oldham, to see us play at a rehearsal hall in Shepherd's Bush. He liked us, but when Kit's name was mentioned it quickly became clear that Oldham already knew Kit (they were neighbours), and Oldham wasn't going to get embroiled in Peter Meaden's failing power struggle.

Kit and Chris later confronted Meaden at a band rehearsal – an occasion on which Phil the Greek, Meaden's henchman, flashed a knife and menaced Kit. But Peter Meaden eventually stood aside for the then princely sum of £200, and Kit and Chris took over the management of the band. They quickly gave us back our proper name – The Who.

We had begun to play on regular summer Sunday concert bills with established major artists, all of whom had chart hits at the time. We supported The Beatles, The Kinks, Dusty Springfield, the extraordinary Dave Berry and Lulu. The Beatles' audience was almost entirely young girls who seemed lost in their own fantasy world while the music played. (The theatre really *did* smell of urine after the show.) Unlike the Stones, The Beatles seemed almost like royalty, distant and caught up in their own extraordinary potency. After they had been whisked away after their show, we hung around, and Kit

was mobbed by girls who thought he was The Beatles' manager Brian Epstein.

Lulu was just fifteen when we played with her in Glasgow, after which we attended her sixteenth birthday party. She had an enormous, soulful voice, and while the accordion played I nearly got off with her best friend. Dave Berry's hit was 'The Crying Game', and his act was the antithesis of the others. He moved slowly, with measured, controlled movements, almost like a mime artist, but he too drove the girls wild.

Away from the big-city Mod strongholds, these shows were like mini-festivals of bands with recent or current hits. We were all young, but there was solidarity between us reminiscent of the show business of Dad's generation. We learned from everyone we performed with, secure in the knowledge that none of them would borrow too much from us: our whining guitars and auto-destruction were our own inviolate territory.

At last we seemed to be achieving something, but it was proving a much slower, harder grind than promised in the heady days when Peter Meaden was telling us we'd be huge overnight. We passed one BBC radio audition but failed another, and also failed an audition for a recording contract with EMI. Our heavy-handed style confused a lot of older people, including record executives, and we mainly played covers of R&B material. The record labels wanted bands that wrote their own songs.

The Who kept working, trying and failing to get a guitar-smashing moment into the national newspapers. The Decca Records audition was our most encouraging. Kit's friend Russ Conway, the popular boogie-woogie TV pianist and principal investor in Kit and Chris's management company, arranged the audition and persuaded A&R man John Burgess to take us seriously. Kit and Chris later confided that we would have passed the audition had we played original compositions.

Knowing I could write songs, they encouraged me to come up with some new material that might suit the band.

This was the most critical challenge I had ever faced. I isolated myself in the kitchen of the flat in Ealing where I kept my tape machine, listening to a few records over and over again: Bob Dylan's *Freewheelin'*; Charlie Mingus's 'Better Get It in Your Soul' from *Mingus Ah Um* (I loved Mingus and was obsessed with Charlie Parker and Bebop); John Lee Hooker's 'Devil's Jump'; and 'Green Onions' (although my record was nearly worn out). I tried to divine what it was I was actually feeling as a result of this musical immersion. One notion kept coming into my head: I can't explain. I can't explain. This would be the title of my second song, and I was already doing something I would often do in the future: writing songs about music.

> *Got a feeling inside, I can't explain*
> *A certain kind, I can't explain*
> *Feel hot and cold, I can't explain*
> *Down in my soul, I can't explain*

At the time I was still using a clunky old domestic tape recorder to record my songs, which I used to put down a simple demo. Barney listened to it when he got home from college and liked it. I remember him describing it as Bob Dylan with a hint of Mose Allison.

Kit and Chris, through a friend of their glamorous personal assistant, Anya Butler, met with the producer of The Kinks' recent chart hits, Shel Talmy, who had his own label deal with Decca in the USA. He agreed to hear us.

I ran back to my tape machine and listened to The Kinks' 'You Really Got Me' – not that I really needed to, it was on the radio all the time. I tightened up 'I Can't Explain' and changed the lyrics so they were about love, not music. I tried

to make it sound as much like The Kinks as I could so that Shel would like it. I already had the title for the song that would follow it: 'Anyway, Anyhow, Anywhere', words I had scribbled on a piece of paper while listening to Charlie Parker.

We played Shel Talmy the revised 'I Can't Explain' and he booked us a session at Pye studios to record it. Shel also brought in some additional musicians, which Kit had warned me he might do. Keith jovially told the session drummer who appeared to 'scarper', and he did. Because Shel wasn't sure I could play a solo, he had asked his favorite session guitarist, Jimmy Page, to sit in. And because our band had rehearsed the song with backing vocals in Beach Boys style, but not very skilfully, Shel arranged for three male session singers, The Ivy League, to chirp away in our place.

Shel Talmy got a good sound, tight and commercial, and although there was no guitar feedback I was willing to compromise to get a hit. We wouldn't know if the gamble would pay off until after the New Year.

In November, Kit and Chris secured us a residency on Tuesday nights at the Marquee Club, a jazz and blues venue in Soho, and mounted an inspired campaign to make sure our first evening didn't fail. In one of my art notebooks Kit and Chris found some doodling they liked for a Who logo, incorporating the Mars symbol I'd used in my design for The Detours van years before. We had already done a number of photo sessions for various magazines, but Kit and Chris organised their own, and the photographer took a solo picture of me swinging my arm.

A graphic designer friend from Ealing made the 'Maximum R&B' poster now legendary in collectable Who paraphernalia, and Kit and Chris had it plastered all over central London. They went further: along with a general card for hand-out, they printed up 150 special invitations to join 'The 100 Faces', an elite hand-picked group of Mods, with free entry to the first

few weeks of our residency. Again, for some reason, only my face was featured, not one of our prettier boys.

Kit hired Chris's school friend Mike Shaw to act as our production manager. He became the only person ever to pass through The Who camp that no one will ever say a bad word about. He was a joy. He ran around all our gigs finding the coolest-looking Mod boys and handing them cards. Our attendance was about 90 per cent male, but a few girls were in the front row at the Marquee in the early days. Attendance started slowly, but built up very quickly to a packed house.

That winter playing our regular gig at the Marquee became an event I looked forward to. I remember wearing a chamois jacket, carrying a Rickenbacker guitar, coming up from the bowels of the earth at Piccadilly Circus train station feeling as though there was nothing else I'd rather be doing. I was an R&B musician with a date to play. It was a great adventure, and I was full of ideas. In my notebooks I was designing Pop Art T-shirts, using medals and chevrons and the Union Flag to decorate jackets I intended to wear. At the Marquee I felt, like many in our audience, that Mod had become more than a look. It had become a voice, and The Who was its main outlet.

A magazine photographer visiting our flat one day for a shoot had to climb up a stepladder to get his equipment out of the knee-deep rubbish that filled the room, trash now invisible to Barney and me. After the photo was taken Kit quietly took me aside and explained that he and Chris had obtained a very smart residence and office in Eaton Place in Belgravia, and felt I should move there. I worried a little that I might appear to be moving in to sleep with Kit, but the next morning I said goodbye to a stunned Barney and moved into the exquisitely tidy bedroom – adjacent through glass doors to Kit's – in a high-ceiling first-floor flat in a Georgian building in what is still the poshest street in London. I taped up some nifty Pop

Art images cut from magazines, set up a record player and lived like a prince.

Chris, it emerged, didn't have a bedroom in the flat, and Kit never attempted to seduce me, to my disappointment, although I probably wouldn't have responded. Happily, though, Anya did seduce me. I was 19, she was 30, and the sex was gloriously educational. While sending me into ecstasy with her long, sharp fingernails, she told me she had spurned the advances of all three other members of the band.

Kit and Chris asked their friend Jane, wife of Kit's old army friend Robert Fearnley-Whittingstall, to run a fan club for us. She became known as 'Jane Who', collected letters for us and kept a mailing list. Jane gave mail addressed to me unopened, and thinking that one day I might write this book I decided to leave one of those letters sealed until the day I finished it.*

For a time I lived under Kit's nose quite blissfully. I felt completely safe, protected, adored, cherished and valued, although I was still smoking a lot of grass, which I think Kit disapproved of. One evening I decided to conduct an experiment. Instead of my usual ritual of listening to music stoned, I began to listen to some of my choicest records while drinking good Scotch whisky. As I listened and drank, I wrote down what was going on in my head:

> I begin to feel afraid. Childhood self-pity arises. Music is inside me. Am not afraid to let it in. Finding new perceptive levels. I'm underwater, not going too deep. Going to write with eyes closed. Swimming with the fish. Unexplainable emotion now. Death.

My demons were still with me, but I was learning how to use them to fuel my creative process.

* See Appendix, p. 505.

7

I CAN'T EXPLAIN

Roger considered 'I Can't Explain' to be 'soft, commercial pop' and said he wouldn't record anything so anodyne again. He wanted our studio work to reflect the power of our R&B set list. Although I felt a little aggrieved by Roger's vehemence, I agreed with him. Our stage act was getting tougher and tougher, and that's what we needed to get down on vinyl.

The film Kit and Chris had made at the Railway Hotel screened to a full audience, and The Who played on *Beat Room*, a BBC show, and, best of all, *Ready, Steady, Go!* This was special because Kit had befriended the producer, Vicky Wickham, who allowed a number of our Marquee boy fans – the so-called '100 Faces' – to make up the audience. They went wild when we came on, waving colourful college scarves, the Mod fashion of the week.

When we sang 'I Can't Explain' on *Top of the Pops*, it immediately climbed into the Top 10. All the pirate radio stations picked up the track, and it was an incredible buzz to drive through my own neighbourhood hearing the first song I'd written for The Who, imagining the airwaves emanating from ships anchored at sea. Driving along, hearing myself on the radio, my art-school ideas started to seem overcooked. When the band started I had taken solace in the notion that we wouldn't last long, and I could claim that in our downfall I had demonstrated my auto-destructive plan. Now I was being tested. Did I really need to be so po-faced and serious?

Maybe it wasn't so bad to just be a successful pop star. Maybe I didn't really need to blow everything to smithereens in the name of art. Anyway, wasn't what I was doing truly creative? Denying denial didn't seem quite such an urgent matter any more.

On Friday 12 March The Who triumphantly returned to the Goldhawk, our musical home away from home. For Roger and me it had special resonance because we had both been pre-teen members of the Sulgrave Boys Club just down the road. Many of the club's old members – now teenagers – came to the Goldhawk to show off their new Mod threads, drink beer, take pep pills, fight and pull girls. We played 'I Can't Explain' over and over. The crowd went berserk.

Afterwards a delegation asked if they could come backstage and speak to me. Led by a gangly Irish boy called Jack Lyons, they paraded in and told me they really liked the song. I thanked them, asking them what they particularly liked about it. Jack stuttered that he couldn't really explain. I tried to help: the song's about being unable to find the words.

'That's it!' Jack shouted; the others all nodded.

Without my art-school training I doubt that this moment would have touched me the way it did. But it changed my life. I had been set up at college, especially in my last days doing graphics, to look for a patron, to obtain a brief, to find some-one to pay for my artistic excesses and experiments. My new patrons stood before me.

Their brief was simple: we need you to explain that we can't explain; we need you to say what we are unable to say. It would be wrong to say that I floated home on a cloud that night, but I felt vindicated. I was still hooked on sudden fame and notoriety, being on the TV and radio, having written a hit song. But now I knew The Who had a greater mission than just being rich and famous.

And – pretentious as it might still seem, even today – I knew, with absolute certainty, that after all what we were doing was going to be Art.

Anya and I had sex again once or twice when Kit was out and I wasn't working. I adored her; she was witty and sharp – the first person I ever heard use the term 'slag' towards a man. But we never talked very seriously, or went out for dinner; if we had I might have felt less like her toy boy. Kit eventually intervened in what he saw as Anya's sexual vampirism, and as penance he tasked her with finding me a flat close enough to his own so he could make sure I kept it tidy. In April she found the top flat in a Georgian house at Chesham Place, in Belgravia. The rent was £12 a week, well within my means.

This was the first place I ever lived on my own: I had it carpeted, simply furnished, kept it clean and tidy, and devoted one of the rooms to a recording studio. This was one of the busiest periods of my life. When I felt isolated among the diplomats and aristocrats of Belgravia, that loneliness became the engine of my creative drive. I worked mainly at night, when I could play records loudly through two partly rebuilt four-by-twelve speaker cabinets, casualties of my destructive stage act. The other apartments in the building were still vacant, and the building on the other side of my studio wall was being developed as a new embassy building for the Lesotho High Commission. I felt entirely free to make music for the first time in my life.

Kit often came to my flat to listen to the demos I was recording, and became a real mentor in my songwriting. His system was always the same. He would smoke several Senior Service cigarettes and pace around, listening and blowing smoke in the air. If I'd written several songs he would listen to them all before making any comment, then pick his favourite. He was incisive, and astutely never said anything I did was bad, or

could be better, or would be better when it was finished. When he didn't like something, he found something about it to praise.

It turned out that Kit was an expert at keeping the artist in me properly stroked. He was essentially kind, but I also took pleasure in the sense of his investment in me, expressed in a creative partnership. He treated me like a serious composer. If he laughed, it would always be a joke he knew I could share.

Roger sold our van and purchased a lorry to carry our gear. He always wanted to drive one. It was like a furniture hauling van, with no windows or seats in the back, except for a bench that wasn't bolted down. It was far too big and our equipment crashed around us as Keith, John, Mike and I tried to avoid vomiting. It was also very slow, managing only 55 mph on the motorway, so it took ten hours to drive to Blackpool. Roger had installed his girlfriend in the front seat so we were confined to the rear, travelling in the dark. He wanted to keep the rest of us out of his hair when driving long distances. He was a nervous passenger, and rarely allowed himself to be driven anywhere.

On 30 July we played at the Fender Club in Kenton. Karen Astley, a college friend from Ealing, came to the gig, and even handsome Chris commented on how cool she looked, calling her a 'dolly bird', a great compliment at the time. She had brought her best friend, who was keen on John Entwistle. It was fun to speak to someone from the old gang, and we all went out drinking together. Outside the hall after the show, as we waited for a taxi, Karen suddenly threw her arms around my neck and kissed me.

The essence of the song 'My Generation' had probably been contained in the first, abandoned lyric for 'I Can't Explain', which only Barney ever heard. That first version was a kind of talking blues. The title came from *Generations*, the collected

plays of David Mercer, a dramatist who had impressed me at Ealing. Mercer was a socialist, like Arnold Wesker, verging on Marxist, and his rallying on behalf of his plays' working-class anti-heroes later offered me a way to connect with the West London fans of the band.

At that time Kit Lambert had loaned me a record that changed my life as a composer. It was what I had played during my Scotch-fuelled listening experiment – a Czech recording called *Masters of the Baroque* including the principal movements of Purcell's *Gordian Knot Untied*, a baroque chamber suite, the most powerful part of which was the Chaconne. The performance is passionate, tragic and deeply moving. I was struck by Purcell's unique, luxurious use of suspensions, a staple part of baroque decoration at the harpsichord, but in Purcell's hands the suspensions were elongated into heartrending, tortuous musical modes, especially in the minor keys. I began to experiment, and the first time I used suspensions successfully, in 'The Kids Are Alright', it was mostly to suggest a baroque mood.

Belgravia, a rich neighbourhood where women in fur coats shoved me out of line as if I didn't exist, only made more starkly apparent the generational divide I was trying to describe. I worked on 'My Generation' all through the summer of 1965, while touring in Holland and Scandinavia (we caused a street riot in Denmark). I produced several sets of lyrics and three very different demos. The feeling that began to settle in me was not so much resentment towards those Establishment types all around my flat in Belgravia as fear that their disease might be contagious.

What was their disease? It was actually more a matter of class than of age. Most of the young people around me in this affluent area of London were working on transforming themselves into the ruling class, the Establishment of the future. I

felt that the trappings of their aged customs and assumptions were like a death, whereas I felt alive, not solely because I was young, but really alive, unencumbered by tradition, property and responsibility.

The Who played a string of summer shows, some at seaside towns, which brought back happy childhood memories of Dad's band. We were invited to play in Sweden, where Chris thought we could perform without our usual equipment, but this proved an insane notion. Borrowing gear from our support bands, some who could hardly speak English, and trying to explain to them that we were expected by the audience to smash their gear to pieces just didn't work. It was a frustrating tour. The Swedish press seemed to be really looking forward to some smashed guitars and were vocal in their disappointment.

We returned to Sweden again for three shows in October, and in an unfortunate recurrence of bad luck our gear got misrouted and we repeated lacklustre shows with borrowed gear. Keith, John and I took a lot of pep pills on this trip, prompting constant, mindless chattering, and in Denmark, worn down by our hyperactivity, Roger finally complained. When Keith challenged him, Roger lashed out with his fists, bloodying Keith's nose, turning what would have been a minor spat into a melodrama.

One significant thing about this outburst was Keith's response. Instead of responding with humiliation, he seemed to sober up. It was clear he was about to establish a boundary that Roger could never cross again.

Keith and John said they didn't want to work with Roger any more, but after a long period of uncertainty Chris met with Roger and asked him to never use his fighting skills to win an argument again. Roger agreed, so Keith and John decided to put the matter behind them.

* * *

Home from Sweden we recorded the final version of 'My Generation'. Kit had heard my first demo, a version that was very much inspired by Mose Allison's 'Young Man Blues', a song we later introduced into our stage repertoire. The vocal on my demo was laid back in imitation of Mose, casual and confident. Kit hadn't really seen the promise in the song, but Chris persuaded me to try a second demo with a heavier guitar riff. Then Kit chimed in, observing that the music was rather repetitive and needed several modulations – changes of key – to bring it to life.

This worried me a little, partly because I saw Ray Davies as a master of the art of modulation and I didn't want to be accused of copying him. Chris picked up on a stutter on my vocal on the second demo, so I played him John Lee Hooker's 'Stuttering Blues'. Roger had been experimenting with stuttering on stage ever since Sonny Boy Williamson Jr had joined us on harmonica at our first Marquee dates; Sonny Boy used a stutter rhythmically when he sang. Before I completed the third demo we experimented until the stutter became exaggerated and obvious. On this final demo we also created space for an Entwistle bass solo. John was becoming the outstanding bass revolutionary of the day, and I wanted to provide him with a vehicle for his incredible playing.

I was listening to a lot of new music. London was full of specialist record shops, and I visited them all. A high point that summer was the UK release of Miles Davis's live concert from Carnegie Hall, 1964, featuring his wonderful rendering of 'My Funny Valentine'. This led me to Miles's *Sketches of Spain*. I also found Stockhausen's *Gesang der Jünglinge*, and listened to some Wagner operas for the first time. Best of all, I found two great albums by the Everly Brothers. One was called *Rock and Soul*, the other *Rhythm and Blues*. Noting the shift to R&B and soul music among groups in the British

invasion of the USA, the Everly Brothers, whose superb stream of hit singles I'd grown up with in the late Fifties and early Sixties, had gone into the studio with their own incredible session musicians from Los Angeles and Nashville to show us how it could best be done.

The Everly Brothers played a number of R&B classics, but it was their original material – or the very obscure material they introduced as covers – that I thought exceptional. 'Love Is Strange' is an eerie bluegrass song that the Everlys transformed into a driving showcase for jangling electric guitars and nasal vocals. The Everlys' composition 'Man with Money' is also a magnificent song. Their interpretation of Roy Orbison's 'Love Hurts' was excellent too. Roger, John and Keith loved the new tracks as much as I did, so we incorporated all three of these songs into our repertoire. There were few artists that all four of us respected and enjoyed, and the Everly Brothers were among them.

I lost contact with Barney. I missed him and my other art school friends, but I assumed my separation from them would be brief. I still imagined the band would have a short career and then implode, at which time I could go back to my studies, installations and future life as an artist. Suddenly, putting things into perspective for us all, our beloved production manager Mike Shaw fell asleep at the wheel of a minivan while delivering stage lights to one of Kit and Chris's other bands up north. The accident broke his neck and he was paralysed from the shoulders down.

I went with Chris's personal assistant, Patricia Locke, to see Mike at Stoke Mandeville Hospital. Despite having no feeling below the neck Mike insisted that he needed to feel Patricia's breasts, which she bravely tried to facilitate, and Mike bravely tried to follow through. His sense of humour and appreciation of the absurd would sustain Mike through many difficult years

of adjustment. But the effect of his disablement on The Who, and on Kit and Chris, was terrible. He was truly adored by all of us, and none of us had encountered such difficulty until then.

On 2 November, at a celebratory return gig at the Marquee, we played the three Everly songs, along with the final version of 'My Generation', live for the first time, just after its release.

I was twenty. Many of my old friends were married; some even had children. But I still lacked the courage to pursue girls and risk rejection.

Keith, John and I bought a 1936 Packard V12 hearse for £30, drove it home from Swindon and parked it outside my flat. At some point it disappeared. I feared it had been stolen, but when I reported this the police told me it had been towed away. Someone important had complained about it.

Out of nowhere I received a call from a man who wanted to buy the Packard. It emerged it had been impounded at the request of the Queen Mother. She had to pass it every day, and complained that it reminded her of her late husband's funeral. The bill to recover the car was over £200, an absurdly large sum of money, but the buyer offered to pay the fee in return for ownership. I agreed, and resentfully dedicated 'My Generation' to the Queen Mother.

I purchased a 1956 Lincoln Continental Mark II. I knew nothing about the car, but I loved it – black and low-slung, a two-door coupé that looked like an overgrown Thunderbird. I had no idea that both Elvis and Sinatra had owned and loved the same car. Shortly after I bought it the front end collapsed, but my affection for the car was undiminished.

The Who played 'My Generation' on *Top of the Pops* on 11 November. Two days later we flew to Paris, performing to a glittering crowd at La Locomotive, buoyed by glamorous

French film stars. The single was at No. 4 in the charts when, on 27 November, Karen Astley, my Ealing Art College friend who had kissed me goodnight, rang me. We had a long, funny, magical conversation and decided to start seeing each other. I liked feeling like an artist again.

With a hit single and all that TV exposure, The Who were in high demand. I remember Kit bringing Mick Jagger to Chesham Place and playing him 'Magic Bus', which I was working on at the time. Although Mick was a friend, I was concerned by the thought that Kit might be collaborating with our most serious competition. I was also suspicious he was having a sexual dalliance with Mick, and felt a little jealous.

Mick is the only man I've ever seriously wanted to fuck. He was wearing loose pyjama-style pants without underwear; as he leaned back I couldn't help noticing the lines of his cock laying against the inside of his leg, long and plump. Mick was clearly very well-endowed. It reminded me of a photograph I'd seen of Rudy Valentino similarly displaying his equipment. In the band we all started to arrange our parts in such a way, especially on stage or in photographs.

A legal dispute was brewing between Kit and Chris and Shel Talmy. It turned out that Shel's deal with Decca Records was itself a sub-licensing deal, so the royalty he paid through to us was paltry. The row seemed to threaten our entire career and I became quite fidgety, not knowing what was going on.

On top of this anxiety, I'd lost track of who I was meant to be paying rent to in Belgravia, so I'd stopped sending in my cheques. Having also lost my keys, I had connected a thin, almost invisible, paired wire to the downstairs door buzzer. By touching the wires together I could buzz the front door and gain entry. My comings and goings always took place at night so no one worked out how I was doing it. When they changed the lock on the flat door I simply assumed someone had

latched it, so I climbed up the scaffolding on the adjacent embassy building and got into my flat through a roof hatch.

In the end I was caught inside the flat. The chairman of the Catenian Association which owned and mananged the house was a decent fellow, and allowed Kit to pay the back rent so I could retrieve my possessions, including guitars and demo tapes for 'Magic Bus'.

Despite having a hit record, I sank into a depression. To make matters worse, the *Observer* magazine decided to put The Who on the cover, and sent a photographer to Manchester where we were playing at the Jigsaw Club. At the time I wore the Union Jack coat I had commissioned for John, and at the Manchester hotel where the photo session was staged Chris placed me in the front of the group. From my photography classes I knew what an extreme wide-angle lens looked like, and the effect it had when thrust close to the face of a subject: the nose appears to protrude. As the camera moved closer and closer to me, I realised what the photographers intended; my nose, not small in any lens, would look enormous. I tried to muster the courage to ask them to back off, but I was too proud. Unfortunately, this photo remains one of the most enduring images of The Who from this period.

By early 1966 my first Rickenbacker 12-string and 6-string guitars were gone, leaving me with the remains of two more Rickenbacker 6-strings, two Danelectros and a Harmony. Despite my bravado, I was worried about the growing pile of broken parts, and decided to try to salvage them. I was also putting together a portable music system, a kind of precursor to the Walkman.

I listed in my notebook records or artists I wanted to hear: 'Marvin Gaye, 1-2-3, Mingus Revisited, Stevie Wonder, Jimmy Smith Organ Grinder's Swing, In Crowd, Nina in Concert [Nina Simone], Charlie Christian, Billie Holiday, Ella, Ray

Charles, Thelonious Monk Around Midnight and Brilliant Corners.' I drew designs for revolving speakers, which I hoped to use in my stage rig, as well as designs for a complex surround-sound speaker system for my home hi-fi system. And this:

I think I will write a book. It will take a year to write. It will be about the year I am 21, which will be this year in May. I will tell the truth. I have a wish to record what I'm doing because it's very important, and I don't have a very close friend at the moment to whom I can reveal my worries.

8

SUBSTITOOT

By spring 1966, when the *Observer* magazine cover story on The Who was published, I had become disaffected towards the press. Depressed and paranoid, I had carelessly admitted taking drugs on national television, although no one seemed to mind. The *Observer* story itself was a puff for Kit and Chris, but the rest of us were represented as braggarts, spendthrifts, dandies and scumbags. For at least a week after the publication I lost interest in the success of The Who. This may seem childish, but the polarities of my ego – the artistic grandiosity and the desperately low self-regard – were both powerfully triggered when I held the *Observer* story in my hands for the first time.

I arranged a new flat for myself in Old Church Street, Chelsea, in the penthouse of a building next door to Sound Techniques recording studio, thinking the studio's late-night rumblings would provide excellent cover for my own recording activities at home. The Thames was 100 yards away, and I regularly wandered down to contemplate the grey, swirling river. I often drove alone to the Scotch of St James nightclub, where I would sit with a Scotch and coke at a table surrounded by the likes of Brian Jones and the Walker Brothers. It wasn't like me at all, but I was pleased to be out with people I knew. Brian and I saw one of Stevie Wonder's first London shows there. Transported by the music, our adulation and his own adrenaline, Stevie got so excited he fell off the stage.

One night I drove a band of revellers back to Chelsea and, showing off, driving too fast in the rain, slid into a graceful skid at Hyde Park Corner, breaking an axle of my Lincoln. The party continued by taxi to my flat, where I played the National Anthem at five in the morning, and eviction loomed again.

'Substitute' began as a homage to Smokey Robinson by way of The Rolling Stones' '19th Nervous Breakdown'. ('Substitoot' had become a sublime buzzword since Smokey had used it in his masterpiece 'Tracks of My Tears'.) I set up my two tape machines, now stereo, in my new flat, and wrote. I heard in my own voice the tumult of a young man playing a role, uneasily, repackaging black R&B music from America, relying on gimmicky outfits, and pretending to be wild and free when in reality he needed to be looked after by his mother.

Keith and John had forged a drug-fuelled alliance with a wizened, charismatic Parisian chemist-cum-dealer. At several shows in March they had turned up red-eyed and glowing, excluding Roger and me from their decadent orbit. We also found ourselves on the outside of a conspiracy. It turned out that Keith and John were flirting with the idea of leaving The Who and writing their own songs, playing more surf-inspired music and having more fun. Being in The Who in 1966 was uncomfortable, unfulfilling and – with record-company lawsuits hitting Kit and Chris – the money was getting bad for the other three Who members. (To some extent I was protected by songwriting royalties starting to flow in; The Performing Right Society paid royalties only to songwriters.)

With my first pay cheque in April I exchanged my 1956 Lincoln Mark II for the more recent 1963 Lincoln Continental Convertible, and bought a 28-foot motorboat, which I moored on the Thames at Chiswick, close to the place where I had first

heard celestial music as a child. On one of the boat's first voyages we took wheelchair-bound Mike Shaw for a river trip.

Even before the Talmy case came to court Kit and Chris moved their offices into a space provided by Robert Stigwood ('Stiggy'), one of Britain's first independent record producers; there they created their own production company, New Ikon, as a step towards a record label of their own. I felt part of this new venture, and spent a lot of time designing a zippy logo for it.

'Substitute' was The Who's first single not to be produced by Shel Talmy, and I was elected to produce it. Kit and Chris used Stigwood's Reaction label to release it on 4 March. The record charted quickly. Shel responded by bringing legal action against Stigwood's distributor, Polydor, and provided a legal affidavit claiming that he deserved the lion's share of the royalties because he had contributed significant musical guidance. I had worked from my own demo, as had Shel, and in my own affidavit claimed that if the court compared my demos with Shel's they would see that all the creative work had been done by me before Shel even heard the songs.

On one of The Who's many trips away I began imagining that my fabulous new girlfriend Karen was deceiving me. Keith had been through something even more powerful in his early relationship with his wife Kim, who as a professional photographer's model had once been pursued all the way to her home in Bournemouth by Rod Stewart. It was this kind of paranoid, unhinged thinking that spurred me to write 'I Can See for Miles', one of my best songs from this period. The first lyric was scribbled on the back of my affidavit in the case between Talmy and Polydor. Perhaps that's why the song, about the viciously jealous intuitions of a cuckolded partner, adopts the tone of a legal inquisition.

* * *

The Talmy case came to court, and Kit and Chris lost. My demos were disallowed as evidence, and Shel was informed that his contract stood. This meant that we were still tied to Shel and the feeble royalty he paid us. I turned for guidance to Andrew Oldham, who took me for a ride down Park Lane in his stately chauffeur-driven Rolls-Royce. He told me he thought his friend Allen Klein might be able to exert leverage to break Shel's grip, but to do that we might have to break with Kit and Chris. Klein wasn't yet involved with The Beatles, but he was the Stones' US publisher and managed the great Sam Cooke.

Allen Klein sent me a first-class ticket to New York, and in June I flew there in secret to meet him. Klein came to pick me up in his Lincoln Continental, exactly like the one I'd just bought, down to the colour. He made it clear that the only way I could escape Talmy's grip was to repudiate my contract with Kit and Chris. If I gave him the word he would start proceedings, then he and Andrew Oldham – still at that time the Stones' manager – would take over management of The Who. I flew back home and slept badly on the plane. I must admit I was seriously considering recommending to the band that we sack our managers. Friendship aside, I felt that the deal they'd committed us to with Talmy was criminal.

Guy Stevens, the DJ at the Soho Scene Club who'd helped Peter Meaden launch the singles he'd written for us, was now a record producer. He'd heard a rumour that The Who were getting involved with Allen Klein, so he came over one afternoon with his boss, Chris Blackwell, to plead with me to let them guide The Who. They seemed genuinely worried. Klein had a reputation as someone who took absolute control over any publishing he could lay his hands on – in other words, he was a music publisher like any other – so I wasn't sure what the drama was about.

As they started to explain why I should avoid any involvement with Klein my doorbell rang. It was Kit, distraught, also having heard about my trip to New York. Guy and his boss hid in my study for half an hour while Kit anguished over the problems we all faced, and asked me to give him a chance to sort everything out. To crown this series of unsettling events I was evicted from my lovely Chelsea penthouse flat for making too much noise. Furious with myself, I went to stay with my parents until I found a new home.

An estate agent charged with finding me somewhere with no living neighbours got me a top-floor film-editing suite at the corner of Wardour Street and Brewer Street in Soho. It was a beautiful, light room with half-moon windows. A carpenter knocked me up a bed and some shelves for my tape machines and disk-jockey rig, and the flat became my recording studio and personal nightclub, though I rarely slept there.

For a while Karen shared a flat in Pimlico with a friend, then her father bought her a basement flat in Eccleston Square, close to Belgravia. I spent a lot of time there, going to Soho to work or when Karen and I had arguments. At night Soho was violent and sleazy, but if you lived there you found a way of moving about unnoticed.

Next door to my flat was Isows, a posh kosher restaurant whose owner would allow me breakfast sometimes at four in the afternoon, even on a Sunday. Once or twice I tried to fit into the gang at the Colony Club where the hard-nosed arty-alkies drank, and where I could see the painter-genius Francis Bacon and *Daily Mirror* diarist Daniel Farson in Wardour Street, deep in conversation. They were both very cool, but the brassy woman behind the bar tried to take the piss out of me, assuming I was a rent-boy because of my tight Mod trousers and pink shirt.

Once a group of us were in my flat smoking grass and listening to records at deafening volume when we looked up

to find a policeman standing there. I thought we'd been busted, but he was just looking for a burglar who'd climbed over my roof. The rule of law barely held sway in Soho, but I loved it.

The studio was big enough so I could play the drums, and I learned how to play keyboards on a clunky Hohner Cymbelet electric piano I had bought from Jim Marshall. I tried hard to write orchestral pieces and recorded an instrumental I called 'M'. Based on a 12-string guitar part that I made up as I went along, it ran for seven minutes, with rising and falling dynamics reinforced with basic drum overdubs and an additional guitar. I was immensely proud of this recording, which stands as one of the finest expressions of my free-form ability as a guitar-composer.

Roger, meanwhile, was cracking under the strain of Mike Shaw's accident and rows over Keith's drug use. He missed a number of gigs, where I had to stand in for him. Around May it appeared that he'd made up his mind to leave The Who entirely. My diary is venomous about him and the rest of the band, even about Kit and Chris. I'm also very hard on myself, challenging myself to deepen my study of Charlie Parker, Coltrane and Purcell, and to develop my guitar style. On the page I sound determined and unhappy.

The schism in The Who, that had first opened up when Roger punched Keith in Sweden, widened. One night Keith and John, with Jimmy Page, did a recording session with Jeff Beck ('Beck's Bolero') and word spread that they planned to start a new group, christened Led Zeppelin. The Who's first show after this was a modest gig in Newbury. Keith and John arrived very late – and very drunk. Roger and I had been holding the fort by playing without them, which was the pattern at the time. An argument broke out on stage, and – at my wits' end – I threw my guitar at Keith. He tried to throw one of his

larger drums at me and fell into his kit, gashing his leg. We were all utterly sick of each other.

A few days later, argument forgotten, I was driving down the M1 motorway in the early hours when I ran into an accident that had happened ten minutes earlier. Warning lights weren't set up and for a critical few moments I ignored a man waving a torch, thinking he was trying to get a lift. When I hit the brakes they locked and the car went into a time-freezing drift. At the very last moment of my skid, I smashed tail-first into a Jaguar that had rolled over, and still contained two trapped elderly people waiting for an ambulance. They already had multiple injuries so that bump caused them considerable pain. I felt terrible for them, and shame for the habit I'd fallen into of driving too fast when the road was empty. I was convicted of careless driving and heavily fined, although I didn't lose my licence.

The legal battle with Talmy had been lost, but only in the UK. Allen Klein wanted another meeting with me, so on 27 June 1966 I went back to New York once more, this time with our lawyer, Edward Oldman. This meeting took place on a chartered motor yacht that sailed around Manhattan as we listened to Barry Mann's 'Mandy', and other songs Klein controlled. This was my first time on a luxury yacht, and I was surprised to find superb sleeping cabins on the lower deck. The New York night sky was alive and sparkling, and though I was suspicious of Allen I was captivated by the whole affair.

Another uneasy overnight flight home, and the build-up of frustration and exhaustion started to eat into me. As soon as I landed I drove to a Who gig in Sheffield, forgetting how far it was; when I arrived at about 10 p.m. the rest of the band had given up on me and gone home. I turned around and headed home myself. Not having eaten or slept for hours I fell asleep at the wheel, waking up upside-down in a ditch with

petrol dripping on my face, and a police officer asking me if I was OK. I gave the breakdown man my Rickenbacker 12-string as a reward for pulling me out of the ditch.

My New York trip and Allen Klein's obvious interest made it clear that some smart business people believed we'd soon break into America. Ted Oldman had reported to Kit and Chris that Klein was trying to take over the band, and they quickly brokered an out-of-court settlement with Talmy. He would no longer produce The Who and we'd be free to make a new deal with any record company we chose. This would improve things for all concerned. The Who would get a bigger share, and Shel would get a commission on all future recordings as well as participate in all recordings made during the period of his original contract, without having to work, or fund our sessions.

Through this deal Kit and Chris kept control of the band, but at the time we knew nothing of the punitive settlement Kit had to make with Shel. The summer dragged on, the band's antics on stage becoming a parody of auto-destruction complete with smoke and flashes. During the finale at the Windsor Jazz and Blues Festival, Keith ran to the front of stage with a whip and a blonde actress in a leather outfit.

In August we recorded 'I'm a Boy' and 'Disguises' with Kit finally in the producer's chair. Our new record deal was with Track Records, founded by Kit and Chris with the promise that we would own shares as well as receive royalties. Kit was a joy to work with; he made recording fun, and seemed to be recording a more musical sound, although Roger and I still felt tied to the bluff, tough sound we had developed in The Who live gigs.

Meanwhile I was becoming obsessed with a bigger idea: could I write a real opera?

* * *

While 'I'm a Boy' was being prepared for release as the band's new single, Karen and I took a holiday to Caesarea in Israel. Her miniskirts were a novelty that attracted a lot of interest, especially from the Arabs, several of whom I had to literally fight off. On one occasion I turned to help from Jewish passers-by, dressed in Western clothing, who interceded before chiding me: 'What is a young Jewish boy doing allowing such an attractive girl to dress so provocatively?'

When I got home I began to ask people what was going on in Israel. One of my legal advisors, who was interested in international affairs, described the growing tension between Israel and Egypt, as well as the emergent communist threat from China, a country with a population growing so fast, he said, that it would soon dominate the entire planet. This sparked the idea for my first opera, later entitled *Rael*, whose plot deals with Israel being overrun by Red China. Over the next year I developed the story, and planned to complete it as a major full-length operatic composition outside my work for The Who. I hired a Bechstein upright piano from Harrods and installed it in Karen's bedroom in her flat in Pimlico. I wrote the first orchestrations there for *Rael* using a book called *Orchestration* by Walter Piston that I still refer to today.

After a summer of professional lunacy that included The Who's first appearance in the beloved Palace Ballroom of my childhood, in the Isle of Man, I completed and assembled demos for a number of tracks intended for The Who's still untitled second album. I bought a cello and played it on 'Happy Jack', a nonsense song I wrote about a village idiot from the Isle of Man. This is Paul McCartney's favourite Who song – tellingly, because it was partly inspired by 'Eleanor Rigby', which I thought was a small masterpiece.

Happy Jack wasn't old but he was a man
He lived in the sand at the Isle of Man
The kids all would sing he would take the wrong key
So they rode on his head on their furry donkey
But they never stopped Jack, nor the waters' lapping
And they couldn't distract him from the seagulls'
* flapping*

These are the original words, slightly altered on The Who's version; the atmosphere of the lyric is meant to be Kafkaesque.

Kit and Chris drummed up a deal to get publishing advances for New Action, their own new music publishing house. They told me the advance was contingent on John, Keith and Roger contributing at least two original songs each to the album. I went along with the scheme, since my songwriter earnings on The Who's hits had protected me thus far and I was happy to help. I'm pretty sure the band members never got the money – it was swallowed up in the enormous debts we all had by this time.

I explained my working method of making demos to John Entwistle, who bought himself a kit like mine and wrote and recorded his first song, 'Whiskey Man', in the tiny bedroom at his parents' house in Acton that he still used as a base. I was the first person in the band he played it to. A week later John added 'Boris the Spider' to his list. I loved both songs. I helped Roger demo 'See My Way' in my Soho studio; a Buddy Holly–style piece, it was easy to work with. But this time Roger didn't get any further than that one song, although he later wrote one more for The Who and went on to write quite a few in his solo career.

Keith got John to help him scrape together a lyric for Keith's song 'I Need You', inspired by seeing The Beatles at the Ad Lib club in London, and I recorded the demo with him in Soho. It was a nightmare trying to work out the melody, as Keith's

singing was so tuneless. His second song, a rip-off from a film score banging around in his head, he merely whistled at us. We all knew we'd heard it somewhere before, but couldn't place it at the time (it turned out to be 'Eastern Journey' by Tony Crombie). This became 'Cobwebs and Strange', a bizarre marching-band tune that was great fun to record because we actually marched around the studio while it was taped. John played trumpet, I played banjo, Keith a big bass drum and Roger the trombone – quite brilliantly, I thought. We overlaid the band over the marching track. I added penny whistles, and with Keith's cymbals it ended up sounding like the accompaniment for a circus act.

I had been discouraged from submitting any additional material to The Who's second album in order not to upset the necessary balance for the New Action publishing deal, so none of our recent hit singles appeared on the album. In a mad rush to fill the gaps left by this default, we added 'Heatwave', a Tamla song we always played on stage, but there was still a ten-minute hole. Kit came to see me at my Soho studio and I played him a few works in progress, songs about rabbits, fat people and 'Gratis Amatis', the opera dedicated to Kit and our beloved mutual friend the composer Lionel Bart. Kit asked whether I could put together a more serious pop-opera piece with several distinct strands, perhaps based around 'Happy Jack'. If I could, this would fill the entire hole in one fell swoop, and the record could be released quickly.

Quick, quick, quick. 'A Quick One' became our new watchword and the title of the new album when it was finally released. I scribbled out some words and came up with 'A Quick One, While He's Away'. This became known as the 'mini-opera', and is full of dark reflections of my childhood time with Denny.

Since so much of this music bubbled up urgently from my subconscious mind, I'm left to interpret it much like anyone

else. The music begins with a fanfare: 'dang, dang, dang, dang'. Someone has been 'gone for nearly a year'. This could be ascribed to the dereliction of both my parents, neither of whom saw much of me while I lived with Denny. As a result, 'your crying is a well-known sound'. That crying was mine as a five- and six-year-old, night after night, for my parents, for my friends from Acton and my freedom from Denny.

A remedy is next promised: we'll bring your lost lover to you, 'we'll give him eagle's wings, and he can fly to you'. At this point in my own story Rosie Bradley observed my suffering and quietly promised me she'd phone Dad and explain how crazily Denny was behaving, and he would surely come and rescue me. Suddenly the lyrics darken: 'Little girl, why don't you stop your crying? I'm gonna make you feel all right.' This is chilling to me even today: the implicit threat of abuse unless the child cooperates with the abuser. But 'little girl'? In my mind I was never alone when I lived with Denny – my imaginary constant friend was a twin girl who suffered every privation I suffered.

Ivor the engine driver may well represent my abuser: 'we'll sort it out back at my place maybe', and 'better be nice to an old engine driver'. Denny took in men from the bus garage and the railway station opposite her flat all the time, and I still have nightmares in which my bedroom door opens in the middle of the night and a shadowy man and woman stand watching me, the perfume of eroticism in the air.

Finally the grand orchestra takes over: 'cello, cello, cello, cello'; a great celebration. The rescuer has arrived. In fact my reluctant rescuer was Mum, with her lover and Jimpy in tow as peacemaker. Dad was waiting at home to see whether Mum would relent, dump her lover and take him back, or fight him for custody of me. As cellos soar, the subject of the opera proclaims: 'Do my eyes deceive me, am I back in your arms?' I know I felt as though I had been rescued from Hell itself.

Then, there is an elucidation: 'I missed you, and I must admit, I kissed a few ...' (Perhaps this refers to Mum's affair.)

Most disturbing of all is the line, '[I] once did sit on Ivor the engine driver's lap, and later with him had a nap.' Then suddenly, everyone is 'forgiven', not once but a thousand times, over and over – as though there's not enough forgiveness in a single line. When I sang this part live on stage, I would often become furious, thrashing at my guitar until I could thrash no more, frantically forgiving my mother, her lover, my grandmother, her lovers, and most of all myself.

During one of the October *Quick One* sessions I met Jimi Hendrix for the first time. He was dressed in a scruffy military jacket with brass buttons and red epaulettes. Chas Chandler, his manager, asked me to help the shy young man find suitable amplifiers. I suggested either Marshall or Hiwatt (then called 'Sound City') and I explained the not-so-subtle differences. Jimi bought both, and later I chided myself for having recommended such powerful weapons. I had no idea when I first met him what talent he had, nor any notion of his charisma on stage. Now, of course, I'm proud to have played a small part in Jimi's story. Kit and Chris snapped him up for Track Records – their first new signing.

Apart from 'A Quick One While He's Away' I wrote one song for the *Quick One* album, 'Join My Gang', which I didn't even submit, having overfilled my quota. Instead I gave it to Paul Nicholas, a singer on Reaction who was at that time going under the pseudonym of 'Oscar' and who was managed by Robert Stigwood ('Stiggy'). It's a witty song, and I was sad it wasn't a hit. David Bowie, then unknown, stopped me in the street in Victoria and told me he liked it, and that was before it was even released – he'd heard my demo at our music publisher's office.

In October and November The Who toured Europe: Britain, Sweden, Denmark, France and Germany. I remember Berlin as

war-scarred and still uneasy; it was at the Hilton there that Keith's hotel-room wrecking began in earnest. He so missed Kim and suffered so much from paranoid jealousy that every night after a show he had to get out of his brain just to sleep, and seemed always at the last gasp to be full of the most dangerous anger.

In Amsterdam, after a television show there, we were walking straight from the TV studio stage towards the car taking us to our hotel when a tough-looking young man saw me passing and asked if I'd go for a drink with him. I agreed on the spot, and – while even Keith looked on shocked and concerned, shouting at me not to go – went off with the man. I had no money, no details of the show we were playing next day in The Hague and no idea who the man was, or what his intentions were.

His first question was, 'Do you like jazz?' As we sat together and listened to his impressive jazz collection, I quickly got drunk. After a while the evening turned into a blur. He showed me to a small bedroom alongside the room we'd been sitting in, and I fell asleep. I woke up next morning with a policeman standing over me, asking me who I was. The owner of the flat, a woman, had no idea who my host had been. After being allowed to leave, I found the railway station and boarded a train by jumping a fence. The train was full of young soldiers who took no notice of me. I could have been invisible, even dressed, as I was, in bright white clothes and a face full of stage make-up and mascara, hung over and a little scared.

9

ACID IN THE AIR

We had heard rumours throughout 1966 of a new drug called LSD that promised the most amazing experiences. It sounded scary but exciting. I got hold of some Sandoz capsules, and Karen and I and two friends from art school took a capsule each and waited to see what would happen.

When the drug kicked in, after about an hour, I felt an initial panic. Then the hump of the high took over, in which I lost all self-control and suffered hallucinations, which lasted another hour. After that I settled into something far more enjoyable. I felt like a child again, and I spent the next four or five hours rediscovering everything I took for granted: stars, moon, trees, colours, London buses. I remember being amazed at how pretty my girlfriend was. Eventually I began to put myself back together, piece by piece.

Karen and I only took one or two more acid trips together, and I only ever took four in total. The second trip began in Notting Hill. We walked from there all the way to the Roundhouse on New Year's Eve 1966, waiting for the drug to take hold. By the time we arrived – The Who were due to perform at about three in the morning – I was coming down. My performance that night is reputed to have been destructive and angry, but I felt quite loved up, so I'm sure I was just going through my usual motions.

On 6 January 1967 I missed one of the only Who shows of my career through drug abuse, when I took my third acid

trip and realised I couldn't possibly drive 300 miles to Morecambe where we had a show. Instead I went to see the Pink Floyd play for the first time at the UFO Club. Syd Barrett was wonderful, and so were the rest of them. I fell in love with the band and the club itself, especially John Hopkins ('Hoppy' as he was known), who ran the club and worked the door.

I went again the following night. This time I didn't use acid and took Eric Clapton to see Syd, who walked on stage (off *his* head on acid), played a single chord, and made it last about an hour using an electronic echo machine called a Binson. When he did start to play again he was truly inspiring. Roger Waters had the most incredible presence, was strikingly handsome and clearly fancied Karen. I found him a little scary. It was evident that he was going to be the principal driving force behind Pink Floyd. What no one could have known, as the band hadn't yet made any recordings, was how glorious so much of their music would become once Syd's more experimental influence waned.

One night a group of Mods exposed themselves to Karen and her friends as they danced, oblivious, in an acid haze. I was wearing a long psychedelic robe, and one of the Mods told me I'd let the side down. I retorted that Mod was finished; I was rather sad when, rather than argue with me, he and his mates just zipped up their flies and left.

In 1967 a mild spring brought premature blossoms to the trees in the huge private communal garden of Eccleston Square. Karen's family had a house on the Thames's upper reaches, and we spent Sundays there, just enjoying the passage of time, the tranquillity of the river and countryside, long walks and conversation about all manner of subjects.

The new swinging Sixties ethos – free love, girls on the pill, and everyone in our new London crowd behaving as though

they were suddenly beautiful – played directly into my intense fear of being abandoned by Karen. One day I returned late after a gig to find a man talking to Karen in her bedroom. There was an air of intimacy between them, and she looked especially pretty and flushed. After I shooed him out I felt jealous and old-fashioned: everyone else was sharing their partner with whomever they fancied.

One night I listened again to the demo of 'I Can See for Miles'. There wasn't much more I could do to improve on it. I was ashamed of the jealousy that had inspired it, but I regarded the song as a secret weapon; when it was recorded properly and released as a Who single I believed we would flatten all opposition. Knowing we would be recording a third album fairly soon, I began to think about what kind of songs I wanted to gather.

During the winter of 1966–7 I listened to jazz saxophonist Charles Lloyd's *Forest Flower*, a live album of his extraordinary performance at the Monterey Jazz Festival in September 1966. *Forest Flower*, like the Beach Boys' stereo masterpiece *Pet Sounds*, seemed to fit the times perfectly. Keith Jarrett was Lloyd's pianist, and at some point on the record he starts banging the piano and picking and stroking the strings. Here, I felt, was a musician after my own heart, who played every instrument in unintended ways.

Keith Jarrett was born in the same month as me and his playing often reduces me to the kind of tears reserved for drunken solitude. I would sell my soul to play like him – and I don't make that statement lightly. While listening to this genius I was struggling at the upright piano I'd shoehorned into Karen's bedroom, and slowly, tortuously, beginning to find some path to self-expression on the eighty-eight black and white keys (a quantity I had often felt as a child was insufficient).

My friendship with Eric Clapton had deepened through our joint outings to pay homage to Jimi Hendrix, who was doing his first sensational gigs around London that spring. Jimi Hendrix was testing some of his first lyrical ideas at his shows. Eric's friend, the painter and designer Martin Sharp, was helping him write songs, and Martin's lyrics were very ambitious and poetic. Caught between two great new emerging songwriting talents, I felt challenged to evolve.

Seeing Jimi play for the first few times was also challenging for me as a guitarist. Jimi had the nimble, practised fingers of the concert violinist; he was a real virtuoso. I was reminded of Dad and his tireless practising, how much time he spent getting to a level when he could play so fast that the notes turned into a blur. But with Jimi there was something else: he married the blues with the transcendent joy of psychedelia. It was as though he had discovered a new instrument in a new world of musical impressionism. He went further on stage, and appeared to be powerful and manly without any aggression.

He was a mesmerising performer, and I hesitate to describe how fantastic he was to actually see play live, because I really don't want to make his legions of younger fans feel they've missed out. We all miss out on something. I missed out on Parker, Ellington and Armstrong. And if you missed Jimi playing live, you missed something very, very special. Seeing him in the flesh it became clear he was more than a great musician. He was a shaman, and it looked as if glittering coloured light emanated from the ends of his long, elegant fingers as he played. When I went to see Jimi play I didn't do acid, smoke grass or drink, so I can accurately report that he worked miracles with the right-handed Fender Stratocaster that he played upside down (Jimi was left-handed).

After seeing Jimi live, I rarely enjoyed his recordings, which paled by comparison. The exceptions were 'All Along the Watchtower' and 'Voodoo Chile', both tracks from a later

session in 1968. Eddie Kramer had engineered all of Jimi's records, but the sessions for *Electric Ladyland* were the first in New York, and it was there that Jimi and Eddie began to connect in that indefinable audio ether, where Jimi's shamanic powers would finally be allowed to express themselves on vinyl.

While I felt a bit stranded by Jimi's psychedelic genius, I felt equally out of the loop when drugs became a political issue for those of us in the music business – Paul McCartney had gone on TV saying marijuana should be legalised, for example. It might appear that I felt threatened by talented people, or those brave enough to live a wilder life, and there's some truth in that, but mostly I felt out of synch, a few steps behind. This feeling had been instilled in me as a young teenager when I was usually surrounded by older, more experienced young men. However, my awe of my elders was tested when Mick Jagger and Keith Richards were busted for drugs.

At that time it really did appear as though the Establishment was looking to make an example of Keith Richards by sending him to prison, and in what was possibly Keith Moon's only act of political solidarity he and his girlfriend Kim stood outside the court with banners appealing for some balance. All this impressed me. Psychedelia, drugs, politics and spiritual stuff were getting knitted together all of a sudden, and I did my best to keep up.

By the time Jimi Hendrix was doing his first London shows in January and February 1967, the couple of acid trips I'd done had definitely changed the way I perceived things. Trees bare of their leaves in winter, for example, began to look like those medical student mock-ups of the vein and artery network inside the human lung; in effect I suddenly saw trees for what they really are: planetary breathing machines. I wasn't a tripped-out freak, but the way I looked at things was evolving.

Around this time, Karen and I went to see some new friends, the illustrator Mike McInnerney and his wife Katie, whom I'd met at a Pink Floyd show. Their flat was on Shaftesbury Avenue. At the time Mike was painting the banner for The Flying Dragon, a clothes shop intended to rival Granny Takes a Trip. I waffled on to Mike about some of my revelations at the feet of Ron and Ralph of the Blues Magoos, who had introduced me to George Adamski's extraterrestrial conspiracy theories. Mike tossed me a book called *The God Man*, written by an eminent British journalist of the Thirties called Charles Purdom.

I opened the book and saw a photograph of a strange-looking, charismatic fellow with a large, rather flattened nose, flowing dark hair and a generous moustache. He was an Indian teacher, Meher Baba, which means 'Compassionate Father'. I read a few lines, and found that everything Meher Baba said fitted perfectly with my view of the cosmos. He was still alive at that time, and Mike told me that a group of his friends hoped to go to India soon to meet him.

On Karen's bedroom wall were three Victorian black-and-white postcard photographs of scantily dressed actresses. One was the infamous Lily Langtry, mistress of Prince Edward, later King Edward VII, and one sunny afternoon while Karen was at work I scribbled out a lyric inspired by the images and made a demo of 'Pictures of Lily'. My song was intended to be an ironic comment on the sexual shallows of show business, especially pop, a world of postcard images for boys and girls to fantasise over. 'Pictures of Lily' ended up, famously, being about a boy saved from burgeoning adolescent sexual frustration when his father presented him with dirty postcards over which he could masturbate.

'Pictures of Lily' was ready to go, but I didn't have much else completed. Kit had heard the demo of 'Glittering Girl',

and felt it might make a single. I also had a clutch of lyrics about frustrated romance. I have always said I never wrote love songs, but the truth is I rarely wrote good ones.

While I was working on the demo, a jazz critic for *Playboy* called to ask if he could bring Keith Jarrett over to use my piano for a few hours. I refused. Strange to think I turned down the chance of one of the greatest private concerts in my life, but I was fairly sure I had a hit in hand and didn't want the distraction. Keith Jarrett then got on the phone and asked me a few questions about my demo recording method. I told him I was playing all the parts myself, and he seemed inspired to do something similar. On *Restoration Ruin*, the album he produced the following year, which I eagerly sought out, he sang, played guitar, harmonica, sax, piano, organ, flute, bass, drums and percussion with great facility. Of course it's Keith Jarrett's freewheeling piano play that has made him so beloved; like Jimi, Keith is clearly transported by what flows from his fingers.

Jimi Hendrix's appearance in my world sharpened my musical need to establish some rightful territory. In some ways Jimi's performances did borrow from mine – the feedback, the distortion, the guitar theatrics – but his artistic genius lay in how he created a sound all his own: Psychedelic Soul, or what I'll call 'Blues Impressionism'. Eric was doing a similar thing with Cream and, in 1967, Stevie Winwood's band Traffic would release *Mr Fantasy*, posing another staggering challenge. The musicians around me were truly lifting off in a colourful, ascendant spacecraft, fuelled by Jimi, Eric and Stevie's new musical creations – and yet Jimi, Eric and Stevie's psychedelic songs were still deeply rooted in their blues and R&B upbringing.

For six years on our pub and club circuit we had first supported, and later played alongside, some extraordinarily

talented bands. Cliff Bennett and the Rebel Rousers were so authentic an R&B band that it was hard to believe they weren't American. The Hollies, Searchers, Kinks and Pirates changed the face of British pop, not to mention The Beatles or Stones. The 1964 Searchers' hit 'Needles and Pins' created the jangling guitar sound later picked up by The Byrds. The Kinks had brought Eastern sounds to British pop as early as 1965 with the hypnotically beautiful 'See My Friend'. And there were dozens of other transformative influences all around us.

Like many songwriters I also listened to jazz for inspiration and ideas. A short Cannonball Adderley track called 'Tengo Tango' drove me wild, it was so tight, so rocking; Herbie Mann's version of 'Right Now' was a classic of soft jazz; and flautist Yusef Lateef's *Eastern Sounds*, featuring the hypnotic track 'Plum Blossom', played on an ocarina flute, was very important to me.*

What had happened to The Who's blues roots? Had we ever really had any? Did John and Keith feel a strong connection to blues and jazz? Was Roger only interested in the kind of hard R&B that provided a foil for his own masculine angst? Though we enjoyed our recording sessions, The Who seemed to be turning to solipsism for inspiration. My songs were pop curios about subjects as wide-ranging as soft pornography and masturbation, gender-identity crises, the way we misunderstood the isolating factors of mental illness, and – by now well-established – teenage-identity crises and low self-esteem issues.

* This was used as the basis for 'I Love My Dog', released in autumn 1966 by Cat Stevens, and an immediate hit. Cat (born Steven Georgiou, later renamed Yusef Islam) now pays back-royalties to Lateef. I remember him fondly – I spoke to him once in Brewer Street when he was a teenager. His family owned a restaurant around the corner from my Wardour Street flat. He was three years younger than me, but that would have been quite a gap between such young men. He had caught me in my big, blue Lincoln, seemed to know of me and where I lived, and fired a number of questions at me about songwriting and guitars.

I couldn't see how to write about LSD, purple skies and free love. Despite my admiration of extemporised jazz I had no idea how to bring it into The Who's music. I couldn't see how The Who would ever become a band admired for their musicianship and ideology as well as their clothes, ideas, gimmicks, Pop Art transferences and aggression.

Why did that even matter? Wasn't it enough that I had helped discover guitar feedback? I had certainly invented the power chord. With Ray Davies I had introduced the suspended chord into UK pop. But none of this felt like enough. Something dangerous and new was happening in music, and I wanted to be part of it.

While Jimi Hendrix conquered London, The Who's first performance in the USA was almost an accidental event. Frank Barsalona ran Premier Talent, an agency in New York. He heard about The Who through someone in Brian Epstein's camp, and was persuaded to put us on the bill of an annual New York package with the famous Murray the K, the first American DJ to get really close to The Beatles. Murray had also been tipped off about Eric's new band Cream. The shows were planned to take place over a two-week period, during which we were expected to perform six shows a day, so we anticipated an intense period of work.

Flying into New York was a first for my bandmates. Having made two trips there on my own in connection with what became the Allen Klein takeover bid, I felt fairly at ease in the city. Keith and John were so excited they could barely contain themselves, and immediately started living in high style at the Drake Hotel, Keith ordering vintage champagne and John a trolley of several brands each of Scotch, brandy and vodka. The bill was astronomical, and the waiter chided Keith for giving him only a $20 tip. We ate our first real 'chopped sirloin' steak there, a big $15 hamburger. I think that's all I lived on during my stay.

The shows in New York in spring 1967 were a smash for both The Who and Cream. Contrary to the drudgery I'd expected, this was one of the most wonderful two weeks of my life, and certainly the time when I fell in love with New York, a passion that has withstood the test of time.

At the RKO 58th Street Theatre, where the shows would be taking place, we convened for a sound-check and pep talk from Murray the K. By now he had rather lost his 'Fifth Beatle' glow; his toupee was dusty and he sweated a lot. He insisted on having a gold-plated microphone, which no one else was allowed to touch, as well as the largest dressing room, which didn't meet his standards until a star was hung on the door. His address to the bands brought out the worst in me; I hated what I saw as his inflated absurdity, even though I knew Murray the K had been a vital part of breaking British music on American radio. He seemed to have delusions of being a great showman. And perhaps he was.

Murray the K may not have been in his prime, but he did put together an amazing group of musicians. On the regular bill was Wilson Pickett, who took great delight in using Murray's personal gold microphone whenever he could lay his hands on it. One day Simon and Garfunkel headlined; another The Young Rascals. It was basically a pop-music festival. A real sense of camaraderie developed that, in the end, extended all the way to Murray himself.

What is more difficult to describe is what happened in the audience during that series of shows, simply because we weren't out there on the folding seats. Legend has it that, because one ticket purchased allowed you to stay all day if you wanted to, a large number of young people attended every single show, partly to find out when The Who would run out of equipment to smash.

While I laboured backstage with soldering iron and glue, rebuilding smashed Fender Stratocasters, The Who's New

York fan base was being built from human kindness and affection never equalled anywhere else on earth. If I set up a mattress on Fifth Avenue today, I could live for the rest of my life on the beneficence and loyalty of our New York fans. I still know at least twenty of those RKO kids by name. I know at least a hundred faces. I know the names of some of their parents. Several kids have come to work for me at various times over the years, and some have written books or made movies about us. Some simply watched, grew up and did everything they went on to do with the same dedicated, compulsive lunacy they saw in us as we performed. We advanced a new concept: destruction is art when set to music. We set a standard: we fall down; we get back up again. New Yorkers loved that, and New York fans carried that standard along with us for many years, until we ourselves were no longer able to measure up.

On our return to England I drove Eric Clapton and Gustav Metzger, the auto-destructive artist whose ideas first inspired me, down to Brighton Pavilion where we were playing with Cream; Gustav was doing the lightshow. Compared with Jimi's shows I found Cream a little dry when they played a longer set. I wanted to see Eric do something more than just long, rambling guitar solos, just as I wanted something more from myself than silly pop songs and stage destruction.

It was the first time Gustav had seen my version of auto-destruction in process, and though he was pleased to have been such a powerful influence he tried to explain that according to his thesis I faced a dilemma; I was supposed to boycott the new commercial pop form itself, attack the very process that allowed me such creative expression, not contribute to it. I agreed. The gimmicks had overtaken me.

* * *

I remember going to a lunch gathering with Barry and Sue Miles. Barry was a founder of the Indica Bookshop, a radical establishment selling books and magazines relating to everything psychedelic and revolutionary. I met Paul McCartney properly there, with his girlfriend, actress Jane Asher. Paul had helped fund Indica, and he seemed much more politically savvy than any other musician I'd come across. He was clear-thinking and smart, as well as charming and essentially kind. Jane was well-bred, polite and astonishingly pretty; behind the demure exterior simmered a strong personality, making her the equal of her famous beau.

George Harrison arrived a little later with his girlfriend, Pattie Boyd. Pattie was immediately open and friendly. She had the kind of face you could only see in dreams, animated by a transparent eagerness to be liked. Karen was with me, and for the first time I felt part of the new London pop-music elite. Karen, strangely, seemed more comfortable than I was.

I saw Paul again at the Bag O'Nails in Soho, where Jimi Hendrix was making a celebratory return. Mick Jagger came for a while and then left, unwisely leaving Marianne Faithfull, his girlfriend at the time, behind. Jimi sidled up to her after his mind-bending performance, and it became clear as the two of them danced together that Marianne had the shaman's stars in her eyes. When Mick returned to take Marianne out to a car he'd arranged, he must have wondered what the sniggering was about. In the end, Jimi himself broke the tension by taking Marianne's hand, kissing it, and excusing himself to walk over to Paul and me. Mal Evans, The Beatles' lovable roadie-cum-aide-de-camp, turned to me and breathed a big, ironic Liverpudlian sigh. 'That's called exchanging business cards, Pete.'

* * *

The Who had several roadies from Liverpool at this time, who seemed to operate on the assumption that there was a moral gulf between London and their home city. One of them took five or six of my broken Rickenbacker guitars home for his father to repair, and I never saw them again. The other developed a compulsion for stealing hotel furniture, emptying an entire room once while the band was still on stage around the corner. He even took the wardrobes and the bed, all of which were added to our hotel bill. When these thefts were brought to their attention they made us feel as if we were making a fuss over nothing.

By contrast, Neville Chester, our first official road manager, was excellent and hard working. We were difficult to please in the best of circumstances, and the equipment smashing meant that a lot of his free time was being spent chasing up repairs. When he became associated with Robert Stigwood and began to appear wearing rather posh suits, we feared Stiggy had made him an offer he couldn't refuse. In any event, we lost him as road manager.

We then found the amazing Bob Pridden, who is still our chief sound engineer today. Bob's first important show should have been at Monterey, but for some reason Kit and Chris felt we should take Neville instead, for one last job with us. I haven't seen him since, but he played a vital part in our early career, and should receive a massive royalty share for everything he did.

That should flush him out.

The Who headed back to the States in June, flying out on the 13th, the day after Karen's birthday, to play at Ann Arbor, Michigan, our first show outside New York. We then moved on to play four shows in two days at Bill Graham's Fillmore in San Francisco. Cannonball Adderley was on the bill with his brother Nat, and I couldn't wait to tell them how much I loved 'Tengo Tango'.

Bill Graham told us firmly we had to play two one-hour sets with no repeats. We had rarely played more than fifty minutes, and most of that was filled by me, making my guitar howl. Suddenly I started to see the sense of Eric Clapton's extended soloing. We rehearsed and brought in new material, and the attentiveness of the Fillmore audience and excellence of the PA system more than made up for the extra work. It made us feel for the first time that we were playing real music.

The atmosphere in Haight-Ashbury was peace and love, the streets full of young people tripping. The ones to watch out for were the many Vietnam veterans, attracted by the promise of easy sex. They were often badly damaged by their wartime experiences, and despite the mellowing drugs they took they could be pretty hostile. One man grabbed Karen's arm as he passed and wouldn't release it, gazing at her like he'd found his Holy Mother. I caught his attention by knocking his arm away; for a second his face hardened, then he broke into a grin and walked away.

It was at the Monterey Pop Festival, on 18 June 1967, that Jimi and I met our battleground. Essentially it was a debate about who was on first, but not quite for the reason one would assume. When Derek Taylor, The Beatles' former publicist who was acting for the festival, told me we were to appear immediately after Jimi, two thoughts ran through my head. The first was that it seemed wrong that we should appear higher on the bill. Musically speaking, Jimi had quickly surpassed The Who; even then he was far more significant artistically than I felt we would ever be.

I also worried that if Jimi went on before us he might smash his guitar, or set it on fire, or pull off some other stunt that would leave our band looking pathetic. We didn't even have our Sound City and Marshall stacks because our managers

had persuaded us to travel light and cheap. Jimi had imported his, and I knew his sound would be superior.

Derek Taylor suggested I speak to Jimi. I tried, but he was already high. He wouldn't take the question of who would perform first seriously, flamming around on his guitar instead. Although I don't remember being angry, and I'm certain I wouldn't have been disrespectful, I knew I had to press Jimi to engage me. At this point John Phillips of The Mamas and Papas intervened, thinking we weren't being 'peace and love' enough. He suggested tossing a coin, and whoever lost the toss would go on last. Jimi lost.

After being introduced by Eric Burdon, The Who blasted through a clumsy set, ending by smashing our gear. The sound technicians tried to intervene as we went into our finale, which only added to the sense of disarray. The crowd cheered, but many seemed a bit bewildered. Ravi Shankar was apparently very upset to see me break my guitar. I towelled myself off and ran out front to catch Jimi's set.

It was strange seeing Jimi in a big music festival setting after only having seen him in small London clubs. Many of Jimi's stage moves were hard to read from where I was sitting. In the huge space Jimi's sound wasn't so great after all, and I started to think maybe The Who wouldn't compare too badly. Then he turned up his guitar and really started to let loose: Jimi the magician had made his appearance. What was so great about him was that no matter how much gear he smashed, Jimi never looked angry; he always smiled beatifically, which made everything he did seem OK.

The crowd, softened up by The Who's antics, responded heartily this time. When Jimi set his guitar on fire, Mama Cass, who was sitting next to me, turned and said, 'Hey, destroying guitars is your thing!'

I shouted back over the cheering, 'It used to be. It belongs to Jimi now.' And I meant every word.

When Karen, Keith Altham (our publicist) and I all gath-
ered at San Francisco airport to fly home, it turned out that
Keith had also been working with Jimi, who was allegedly
also paying his fees. I made it clear to Keith that I felt he had
been duplicitous by not telling us he would be acting for both
The Who and Jimi at Monterey. He denied any wrongdoing,
and defends himself to this day.

Jimi got wind of our little spat in the airport lobby and
started giving me the evil eye. I walked over to him and
explained that there was no personal issue involved. He just
rolled his head around – he seemed pretty high. Wanting to
keep the peace, I said I had watched his performance and
loved it, and when we got home would he let me have a piece
of the guitar he had broken? He leaned back and looked at me
sarcastically: 'What? And do you want me to autograph it for
you?'

Karen pulled me away, fearing I would blow up, but the
truth is I was just taken aback. Contrary to what I'd been told,
Jimi must have been as ruffled as I was by the reverse jockey-
ing for position before the concert.

As Karen and I boarded the plane in San Francisco, Keith,
John and Roger seemed unfazed by what had passed between
Jimi and me. We settled into our TWA first-class seats, which
in those days faced each other over a table. Keith and John
produced large purple pills we'd all been given by Owsley
Stanley, the first underground chemist to mass-produce LSD,
and Keith popped one. These pills, known as 'Purple Owsleys',
had been widely used at the festival.

As the plane took off, Karen and I split half a pill. John
wisely demurred. Within an hour my life had been turned
upside down.

10

GOD CHECKS IN TO A HOLIDAY INN

The Owsley LSD trip on the aeroplane was the most disturbing experience I had ever had. The drug worked very quickly, and although Karen and I only took half as much as Keith, the effect was frightening. Seasoned trippers have teased me since about how stupid we were, but Karen and I felt that Keith couldn't be allowed to trip alone, and that we'd all be able to help each other. In fact Keith seemed to operate in total defiance of the drug's effects, only occasionally asking how much we had taken to check if he was getting it worse – or bigger and better – than we were.

At one point I tried to console Karen, who was terrified, telling her I loved her. 'Ah!' Keith sneered, and John cynically joined in. Roger, sitting across the aisle, may have found the whole thing amusing, but I was reassured by his smile. After thirty minutes the air hostess, whose turned-up nose had made her look a little porcine, transmogrified into a real pig, scurrying up and down the aisle, snorting. The air was full of faint music, and I wondered if I was experiencing my childhood musical visitations again, but I finally traced the sound to the armrest of my seat. After putting on a headset I felt I could hear every outlet on the plane at the same time: rock, jazz, classical, comedy, Broadway tunes and C&W competed for dominance over my brain.

I was on the verge of really losing my mind when I floated up to the ceiling, staying inside the airframe, and watched as

everything changed in scale. Karen and Pete sat below me, clutching onto each other; she was slapping his face gently, figuring he had fallen asleep. From my new vantage point the LSD trip was over. Everything was quiet and peaceful. I could see clearly now, my eyes focused, my senses realigned, yet I was completely disembodied.

I looked down at Keith picking his teeth, characteristically preoccupied, and at John reading a magazine. As I took this in I heard a female voice gently saying, *You have to go back. You cannot stay here.*

But I'm terrified. If I go back, I feel as if I'll die.

You won't die. You cannot stay here.

As I drifted back down towards my body, I began to feel the effects of the LSD kicking back in. The worst seemed to be over; as I settled in the experience, though extreme, felt more like my few trips of old: everything saturated by wonderful colour and sound. Karen looked like an angel.

John Entwistle married his school sweetheart, Allison, on 23 June, while the band spent a fortnight in London before returning to America for a ten-week tour supporting Herman's Hermits, on what was to be their swan song. During this interlude Karen and I decided to look for a flat together, and found a perfect place in Ebury Street, closer to Belgravia. The flat comprised the top three floors of a pretty, though conventional, white Georgian house. The lease was short, and a great bargain, but the flat wouldn't be available until autumn, which seemed a hundred years away.

Karen didn't join me on the road – Herman's managers wouldn't allow that – but she did go to New York, staying with her friends Zazel and Val; when the band got close to the city I would try to hook up with her. I got a sense at one point that someone had actively and persistently pursued Karen while I was on the road. I heard a rumour that a musician or

artist friend of Zazel's boyfriend had been joining them on dates. At first I was insanely jealous, but I soon realised that this was the way things were. If one of us got swept away, then so be it.

The Who left London in early July 1967 and didn't return until mid-September. This was our indoctrination into the real America. We touched down in almost every important town or city, and in quite a few places we'd never see again. On this tour we listened to *Sgt. Pepper's Lonely Hearts Club Band* and not much else. The shockwave it caused challenged all comers; no one believed The Beatles would ever top it, or would even bother to try. For me *Sgt. Pepper* and the Beach Boys' *Pet Sounds* redefined music in the twentieth century: atmosphere, essence, shadow and romance were combined in ways that could be discovered again and again. Neither album made any deep political or social comment, but ideas were not what mattered. Listening to music had become a drug in itself. Keith Moon had become convinced he was 'Mr K' in The Beatles' song 'For the Benefit of Mr Kite' from *Sgt. Pepper*. He played it constantly, and his ego began to get out of control. It could just as easily have been about Murray the K.

San Francisco was full of pharmaceutical gurus and New York was arguably the capital of the world, but some places in between felt reactionary in the extreme. In the South we were banned from swimming pools without bathing caps because our hair was too long, and nearly beaten up by men who took offence at what they saw as our obvious homosexuality. Even women, especially older ones, were open in their derision. We hadn't been prepared for Middle America's prejudices.

Yet at a Florida motel Herman (Peter Noone) had sex with a pretty young fan and her pretty young mother at the same time. When the two females emerged from his room together,

we gazed in stupefaction. At one swimming pool a blonde girl in a bikini fluttered nervously around me. I was starting to chat her up when Roger took me aside and whispered: 'Jail bait!' In her bikini she looked like a woman to me.

Occasionally, on our rare days off, we got really drunk. One day Keith and I were walking along the second-floor balcony of a Holiday Inn when Keith suddenly climbed over the railing and leapt into the pool below. I followed, but miscalculated – I was falling not into the pool but towards its edge. I wriggled as I fell, managing to just scrape into the pool, badly grazing my back and one arm. I might have broken my neck, or my back. I should have known better than to emulate Moon's antics, drunk or not.

Roger and his American girlfriend Heather, who had dated Jimi Hendrix and Jeff Beck among others, established an aristocratic rock relationship, and Roger began to appear more certain of himself, and more comfortable as a singer. The tensions of the past were receding. On this road trip I felt no responsibility to act as principal architect of The Who. I just played my guitar during our twelve-minute warm-up for Herman's Hermits. The concerts made for a strange culture clash: we smashed our guitars and screamed about our disaffected generation, whereas Herman sang about someone who had a lovely daughter, and the fact that he was Henry the Eighth, he was.

On this tour we had less to do than we would have liked. I read Heinlein and Borges and tried to stay settled. Although today this sounds to me the perfect life, it didn't feel that way at the time. For the first half of the tour I carried no tape machine; instead I drew diagrams of my studio back home, and began to consider various new approaches to recording. Later I would find that many of the ideas I was scribbling down were already becoming industry secrets, thanks to the

efforts of engineers working with Brian Wilson and George Martin, The Beatles' producer.

One idea involved laying off a guitar solo on a separate piece of two-track tape, replacing all the spaces in the solo with blank tape, inverting the tape and playing a new solo matching the old but backwards. Another involved tape loop chord machines operated by foot pedals; tape sampling had been invented in the Mellotron, a kind of organ used by The Beatles that used loops of tape triggered by a conventional piano keyboard. I also suggested recording loops of white noise and tuning them to make it musical. I described techniques for creating extreme reverb effects using tape delays combined with echo chambers, reverb through revolving organ speakers and through guitar amplifiers with the vibrato unit turned on; all these effects became part of my home studio creative arsenal.

I commissioned a small low-power radio transmitter that would simulate a true radio sound to check how my tracks would sound if they were ever broadcast. I was already experimenting with stereo 'flanging', taking two identical tracks and bringing them in and out of phase with each other to create a psychedelic effect. I built a speaker in a small box, attached a tube and put the tube in my mouth, allowing me to 'speak' music. When Frank Zappa leaned over to me conspiratorially at the Speakeasy Club in London and described this new invention to me, I was polite enough not to tell him I'd already come up with it.

In New York, The Who did a show on Long Island, then we went to the Village Theater to support Al Kooper's Blues Project. On the same bill was Richie Havens, an intense, engaging man and an effervescent, unique performer. His acoustic guitar was usually tuned to a particular chord, and he sang his full-throated songs so powerfully that he sounded like

a band in himself. My old buddy Tom Wright said that when you shook hands with Richie you had to be the one to break the shake first, otherwise you could be there, gazing at his beaming smile, for all eternity.

When the Hermits' tour hit Baton Rouge, the tour manager warned us that there had been recent race riots: we were to be on our best behaviour, and vigilant for trouble. There was a possibility our show there would be cancelled. We were all hyped up, but there was no obvious sense of tension, no visible problem. We were aware that the race issue had caught fire in the South, but at the time we didn't feel part of the battle.

In August we passed back through New York to do some recording: 'Mary Anne with the Shaky Hands', some more overdubs on 'I Can See for Miles' and a version of 'Summertime Blues'. During this process I began to question some of Kit's technical decisions for the first time; he was trying to keep me out of the recording process, but by this time I knew a lot about it, and had a lot to offer. I considered some of his technical decisions amateurish, and he seemed to be pressing engineers to lower their standards to get more level on a master, causing distortion by having all the needles in the red. As a result many of our recordings from this time don't sound as clean as they should have.

We had no illusions of making any money on this tour. We just weren't very well known yet, and we were primarily playing in a support role. Many of the shows were less than half full; some were cancelled. I'm sure we collected a few fans on the way, and the word probably spread that we were a colourful, eccentric English outfit. But ten minutes on stage, a smoke bomb and smashed equipment says very little about what The Who hoped to become.

What *did* we hope to become? Was my mission to embellish the acid trips of an audience that no longer cared when a song began or ended? Had the song itself become a mere frivolity?

Look at the pretty colours. I loved smoking a little grass and listening to my two favourite albums, *Sgt. Pepper* and *Pet Sounds*, and every time I listened I heard something new, but I wish I could say I heard something important. These two great albums indicated the future, but passed on no tools, codes or obvious processes that would lead to a door. I ached for more than just a signpost pointing to the future, which is what these albums were to me.

Brian Wilson went on to attempt a masterwork he called *Smile*, but lost it to mental disorder and over-ambition. The Beatles went on to work on the prematurely curtailed *Magical Mystery Tour*, which we supposed was meant to be the film version of *Sgt. Pepper*. Both were wonderful, but both made clear that these pop alchemists had failed to produce anything but gold: they hadn't produced the love or passion of Broadway, nor inspired the humour or hope of Beat poetry, Bebop or Pete Seeger's Hudson River Peace Boat.

As the Sixties dripped by I felt like the messenger from Mars in Robert Heinlein's *Stranger in a Strange Land*, who promises that the secret of all existence is simply to learn to wait.

My wait came to an end in a most unlikely place. In a room of a Holiday Inn in an Illinois town called Rolling Meadows – with a vibrating bed far too big, a TV with a fuzzy screen, sheets and towels that smelled slightly of something warm but not quite alive, a terrace that looked out onto a car dealer's lot, grasshoppers buzzing in the scrub grass, a distant freight-train sounding its horn, the hiss of tyres from a passing Buick on the road nearby, a car door slamming and someone shouting 'Goodbye y'all!' – I heard the voice of God.

In an instant, in a very ordinary place at an unexceptional time, I yearned for some connection with a higher power. This was a singular, momentous epiphany – a call to the heart.

Why did God favour this particular place in America? Because it was so new? Because it was so sunny? Suddenly it became clear that I longed for a transcendent connection with the universe itself, and with its maker. This was the moment I had longed for. My mind was being set alight by the psychedelic times, but revelation came to me in the quietude and seductive order of Middle America.

I was drawn equally to both extremes, longing simultaneously for the traditional pastoral life I had left behind in England, a gentle life as an earnest, hard-working art student, which had been interrupted almost before it had begun by a brutally sequestered, constrained, testing life on the road, away from friends and loved ones.

While I made progress with my search for meaning, Keith was causing havoc with a birthday cake, a car, a swimming pool, a lamp and a young fan's bloody head.

How amusing it has been to spend my life pretending it was amusing. In truth, this day was unpleasant for me, though it has been turned into something of an apocryphal joke by everyone involved.

Keith was determined to have a great birthday party, egged on by the Holiday Inn banner outside the hotel: 'Happy Twenty-First Keith Moon'. He was actually only twenty. By the time I reached the party room the cake was all over the floor, the walls and Keith's face. In the swimming pool a Lincoln Continental balanced precariously, half in and half out. Later I heard Keith had released its brake and it had rolled in. I was trying to get Keith back to his room (he was raging by this time) when a young man approached, asking for his autograph; Keith threw a lamp at him, hitting him on the head. Keith then managed to knock out his own teeth, and it was only because he was hidden away at the dentist that he wasn't arrested.

The Who were banned from Holiday Inns for life.

We stopped in Las Vegas on the way home. It was Herman's nineteenth birthday. While trapped there in the searing heat I wrote a few lyrics and recorded three demos on a little Wollensack tape rig. These were 'Tattoo', 'Boats Are Coming In' and 'Touring Inside US' (directly quoting an early Beach Boys song, 'Surfing USA'); 'Tattoo' was inspired by recent events on the road: were we men, or were we something else?

In Gold Star studios we finished 'I Can See for Miles', which we then played, along with 'My Generation', on *The Smothers Brothers' Comedy Hour*. For televisual effect, Keith set off an oversized theatrical charge of gunpowder, blowing up the entire band in front of a panic-stricken Bette Davis and a sweetly concerned Mickey Rooney. My hair caught fire and my hearing was never the same. Keith was such a twat sometimes, even if he did make this TV show a significant moment in pop history.

I was looking forward to returning home to Karen, a new flat and a new studio back in London. But because the entire summer had been used up so profligately, we had to catch up, which meant The Who planned to go straight back into the studio. And because these sessions needed to be paid for, we'd have to play lots of British shows at the same time. We committed to a package tour with a bunch of current British pop groups with UK chart hits, as though we'd learned nothing at all touring with Herman's Hermits. We topped a bill of artists who all believed they should be topping the bill: Traffic, The Herd, Marmalade and The Tremeloes, all of whom would have legions of female fans screaming for them outside in the street every night.

Would anyone scream for The Who?

How the blazes would I know? I was still deaf.

* * *

The day we got back in September, Chris Stamp asked me to meet him at the Track Records offices in Old Compton Street, where he presented me with the proposed track-list for the new album. I was taken aback. We had 'I Can See for Miles', 'Rael', 'Mary Anne with the Shaky Hands', 'Our Love Was', 'I Can't Reach You', 'Glittering Girl', 'Relax' and a song by John called 'Someone's Coming'; 'Summertime Blues' could be put on the list as we had recorded it on tour. But there was little else of consequence, and only 'I Can See for Miles' seemed a potential chart song.

I had written very little on tour, having come to depend so much on writing in my home studio. I told Chris I didn't feel we were ready to release; we needed more songs, and I needed more time away from Keith and Holiday Inns to write them. Chris was unusually adamant: this was what we would be releasing. Suddenly I saw that he was now running a record label with a schedule to fill, as well as managing a band. He had, in some sense, gone over to the other side.

I took a little time to consider our dilemma. I'd written a couple of songs that weren't on Chris's track-list. I'd demoed 'Tattoo' in my hotel room in Las Vegas during our three-day vacation, and a song called 'Odorono', named after a deodorant stick. 'Odorono' led us to the most perfect pop idea of all time: we would make our next record a vehicle for advertising. When we called Kit to explain, he was as excited as we were. I suggested we link the gaps between songs with jingles like those on commercial pirate radio.

John and Keith leapt on the idea, and, inspired by 'Odorono', began making up advertising jingles for all kinds of things, like Medac spot cream, Premier Drums and Heinz Baked Beans. But when the album was ready to be put together we were still short of tracks. John's track didn't feel right either, so he quickly produced a demo for another song called 'Silas

Stingy', which, to be honest, was equally eccentric. But this was obviously going to be a very eccentric record.

Roger produced a demo for a good song called 'Early Morning Cold Taxi'. He said he'd written it with our roadie Cy Langston. We recorded it and it was a real contender until Cy could restrain himself no longer and revealed that he had written it. When I heard this I took Roger aside, asking him to let it go. Looking back on it, I'm not sure why. There was no territory at stake. I was desperate for songs from anywhere at all. It was still not unusual, nor regarded as in any way unethical, to take writing or publishing credit because you were part of the process of helping a writer get a song placed and recorded. But I was concerned Roger would look bad if it came out that he had contributed little or nothing to the track, and Cy was famously loose-tongued.

I found it hard to see why Roger couldn't write more songs. When I'd worked with him at my home studio on 'See My Way' for *A Quick One* he'd generated ideas quite freely. It may have been that he found studio technology too fussy. If Roger and I had managed to become closer, and had worked together in the demo studio, The Who's run might have extended a little longer. But I also believe Roger has mostly enjoyed being an interpreter, a voice, an instrument. The skills required to be a Sinatra or Jack Nicholson are very different to those of a Cole Porter or Orson Welles. When Roger chooses the right script, he is a giant. That has to be enough for any man who wants to be acknowledged as a force in show business.

At the time, though, Roger was concerned about the direction the band was taking. This album worried us all.

* * *

When recording restarted we added 'Armenia', a song by my aide-de-camp Speedy Keen. This was the first time an outsider had contributed an original song to a Who album, and it never happened again. Kit persuaded me to rejig 'Sunrise', a jazzy ballad I'd written for Mum years before; when I first played it to her she said nothing at all – complimentary or dismissive. That's Mum.

I ended up singing more than usual on this record. Keith and John were generating delightful studio chaos attempting to re-create *The Goon Show* with their jingles. At one point they came up with one for a car dealer they used in the hope they'd get a free Bentley out of him. He gave them some dirty photos instead; fearing they were dealing with the wrong kind of dealer, they dropped the jingle and stopped taking his phone calls.

Chris had taken the album concept to some advertising hotshots, David King and Roger Law (who later co-created *Spitting Image*). They came up with the inspired title *The Who Sell Out*, with an idea for the sleeve that we didn't hear much about until we showed up at David Montgomery's studio in Fulham for the photoshoot, but King, Law and Montgomery loved it, and were operating in that confident, serene way art directors do when they're on to a surefire hit.

The sleeve was to be divided into four panels, each band member advertising a product. I had to take my shirt off for 'Odorono', and was worried I'd look skinny. Roger had to sit in a tin bathtub of almost frozen baked beans generously donated by Heinz. Keith dabbed on Medac; for once the spot he treated was a phoney (he was prone to massive break-outs on his face). John got the best gig, posing with a half-naked blonde model for a Charles Atlas bodybuilding course. Having flown in genuine station identifications and jingles for Radio London, Kit cobbled together a sense of integrity for the record. After the final assembly and mix, we threw

ourselves into radio and TV publicity in anticipation of a release.

Concert reviews of this period depict me in perpetually foul mood, often breaking guitars, of course, but also throwing spats of anger. Roger too seemed unhappy on stage. This may have happened because we'd become used to playing so quietly on the Hermits' tour and were now back to our much louder British rigs, or because John had bought himself louder amplifiers. In any event I was happy to be back with Karen.

Years later I would discover that I really was struggling with some psychological anger that had always needed management, perhaps treatment. But the anger also seemed connected to something important: I often felt that as a performing artist I was undervalued, that my performances, angry though they appeared, were being misread. I wanted to be serious about what I did, and wanted my work – including smashing guitars in concert – to be regarded as part of a passionate commitment to an evolving stagecraft.

Perhaps I was taking myself and The Who far too seriously, but what was I to do? Turn everything into a joke, simply because the rest of the world regarded pop music and auto-destructive art as tosh? It's possible that our audiences didn't understand the significance of auto-destruction, but they certainly seemed to experience emotional release when we broke up our gear at the end of the show. Of course this did nothing to silence our detractors, critics with loud voices who looked no further than the end of their noses before decrying us as yobbos and hooligans.

'I Can See for Miles' wasn't shooting up the charts as a single, which was a shock to me; I really had expected my masterwork to sweep us to eternal glory. A few weeks after its release Kit's godfather, the English composer Sir William Walton,

wrote me a note congratulating me on the ambitious harmonies. Kit had done a wonderful job of recording this time; the test we brought back from Gold Star studios in California sounded spectacular on the mono single release.

Yet it was being received in the UK with a lukewarm response, and climbing the charts slowly. I worried that Track weren't pushing it properly; if that was the case, to whom could we complain? We all saw Track as our own record label at the time. The single did better in the US, but was still rather slow. The financial picture was bleak. As I'd guessed, the Hermits tour had actually cost us money, a common occurrence since the late Seventies for a developing artist but unheard of back then. And now we were spending money on recording.

At this stage in our development as a band, The Who were being described as the 'loudest band on earth', so much so that it had become part of our identity. Then we started hearing that Vanilla Fudge had eclipsed us: they had found a way of amplifying a Hammond organ up to rock guitar sound decibels; when they played, plaster fell from the ceilings of older buildings they performed in.

We were actually upset by this. I went into a silly little tizzy. We had a show lined up at Brian Epstein's Saville Theatre with Vanilla Fudge in October, so I started making statements in the press that we had some special stunt up our sleeve. I can see now that I was afraid of another head-to-head-with-Jimi-Hendrix-Experience experience. In the event, The Who did behave like schoolchildren and Vanilla Fudge did indeed bring the ceiling down; the building was condemned soon after. Although they were great live, and I don't think their organ volume on stage has since been surpassed, Vanilla Fudge were not Jimi Hendrix.

Poor Jimi. Someone must have told his managers that The Who had reached a huge audience by touring with Herman's

Hermits (wrong!), so they sent him out to support The Monkees. It's easy to forget how huge they were by this time. Their album had been number one all summer, and their TV series – which even music business's most serious intellectuals seemed to enjoy – was a massive success. Still, it's not an easy combination to imagine.

The Who were also realising that we too needed something very special if we were ever to succeed in a major way. Personally, I was at a loss as to what that something could be, and no one else in our creative group seemed to have an answer either.

'After wasting a lot of precious time,' I wrote on 4 October 1967, soon after *The Who Sell Out* photo session, 'I think it's time for a real shake-up.'

We returned to the States for a brief tour to celebrate 'I Can See for Miles' reaching No. 9 in the charts, and in hopes of sending it higher. It had probably been our appearance on the Smothers Brothers' show that had done the most good, but Monterey hadn't hurt either. Maybe the Hermits' tour had helped a little too – who knows. For a few shows we supported Eric Burdon and The Animals, and The Association. They had more pull at the gate, but once again I felt we were supporting artists who were inferior to us.

In New York I hung out one night with my friend Danny Fields at his flat. I was deeply tired but couldn't sleep, so Danny gave me a pill, probably a Mandrax, a sedative-hypnotic drug. I woke in the night, still in a trance, with Danny's hands all over my body, but I didn't fight him off. I enjoyed what he did, though I didn't let him actually fuck me.

When I left in the morning, walking down the streets full of workers – one of whom tipped his hat at me as I passed – I realised I'd made a mistake. I wanted to be someone who felt at ease with an unconventional sexual life, and I realised I was

probably bisexual; there was nothing to be ashamed of in this
– John Lennon had reputedly spoken to mutual friends of his
own experiments – but I still felt uncomfortable and hypocriti-
cal: I wasn't gay enough to feel at ease with my homoerotic
feelings.

The record company had to wait until December to get clear-
ances for the commercial brands mentioned on *The Who Sell
Out*. Despite its ambition, some poor material – songs that
lacked teeth – was included in the half-cooked package. Like
The Beatles' *Magical Mystery Tour* our album seemed poten-
tially brilliant but ultimately inconclusive. When it was finally
released it was The Who's slowest-selling record in the UK so
far. We fretted that we had neglected our British fans.

Interestingly, we played a few university shows around this
time – a new kind of gig that was going to change things for
The Who in the near future. But as Christmas approached I felt
distinctly gloomy. Chris got briefly excited when it seemed for
a moment as though he might have arranged a black-comedy
American movie featuring the band, but it fizzled. There was
even talk of a Who comic book. Our ad-agency-style brain-
storming was obviously still at work up at Track Records, but
it was difficult for me to take much comfort in that.

Karen and I were settling in at Ebury Street, but there too
I'd had a hiccup. We'd been struggling to find a cleaning lady
– they all insisted on seeing a marriage certificate before
committing to work for trendy young couples – so when I first
met our very friendly neighbours and enlisted their help I'd
told them we were married. I took Karen to one of our favour-
ite local restaurants, where I confessed what I'd said. Did we
need to get married to survive as members of polite society?

We sat across the table from each other, ate good food,
drank a bottle of good wine and decided to be content – for
the time being – to pretend.

11

AMAZING JOURNEY

A subtle shift in the way Karen and I were relating to one another made me take stock quite seriously. If I was ever going to be a husband and father, not just play at it, I needed to ensure that The Who survived the changes buffeting the pop industry. I might have to be less serious about art, and more pragmatic about how to sell records in millions. I also felt an acute sense of responsibility and duty to my band members and our crew, who unlike me didn't have a songwriting income to fall back on. My job was to come up with the hits, and recently I had failed to produce them.

Still, I believed that everything I had done to this point – every smashed guitar, every silly outfit, every ambitious arty notion set aside or hijacked, every beautiful girl I had refused to respond to for muddled reasons of pride, low self-worth, morality or loyalty to Karen, every crazy experiment undertaken for sexual pleasure or amusement – had conspired to position me for a major offensive on the pop industry. I also believed The Who's audience would enjoy longer works, although I knew this meant I'd have to battle with record companies, PR people, press, promoters and our managers, all of whom would try to persuade me to continue to keep things simple and cost-effective.

The Who had worked ceaselessly for almost four years. We had enjoyed a number of hit singles. I had delved deeply into my personal history and produced a new kind of song that

seemed like shallow pop on the surface, but below could be full of dark psychosis or ironic menace. I had become adept at connecting pop songs together in strings. Still, The Who needed a large collection of such songs if we were to rise in the music business at a time when the audience was expanding its collective consciousness, and the album was taking over from the pop single.

I have tended to reinforce the view that I started to write what eventually became *Tommy* out of pure desperation. That's only partly true. I did know that aiming to serve the young men in our audience wasn't going to work any more, which worried me. But having been in California recently, I also knew that pop audiences would begin spiritual searching, as I had. I could write stories and clearly see theatrical dramas in my imagination. Whether I could realise them was still to be tested. But I began thinking about a project that I wouldn't allow anyone to divert.

Karen and I had become good friends with bass player Ronnie Lane and his girlfriend Susie. Ronnie's chief sidekick was his colleague in The Small Faces, Steve Marriott. Ronnie liked the same music as I did; he liked to drink, and smoke a little grass; he was funny, sincere, artistic, creative, gifted and down-to-earth. In some respects he was a typical London East Ender, just as I was a typical West Londoner. We got on well, argued a lot, laughed a lot, could even cry together sometimes; it was a modern male relationship. He was also the first friend who listened to my interest in Meher Baba without sniggering.

I was reticent about diving into the Meher Baba community too deeply at first, and Karen seemed to stand back too. She was still part of the London hippy scene, in light of which the Meher Baba network seemed rather small and odd. Even our little gatherings for Meher Baba were eccentric, with our host Mike McInnerney still at his desk painting under a single light

bulb while his wife Katie played Van Morrison records and cooked slushy nettle stew. There were cats everywhere and I sneezed my way through our long friendship with the McInnerneys. Still, I was powerfully struck by the feeling that everyone I met in connection with Meher Baba seemed to have been someone I knew from some other lifetime, from some mysterious other place directly connected with my own inner life.

Meher Baba was born in 1894 and was still alive, living in Ahmednagar in India, where one of my teenage heroes, Spike Milligan, had grown up. That coincidence seemed a good sign. Meher Baba was born of Persian parents. At 19 he met an old woman called Hazrat Babajan, reputed to be one of the five 'Perfect Masters'. Her kiss on his forehead unlocked the young man's destiny and he became God-realised. When I first heard this story I remember thinking that the much-imitated but inimitable English comedian Tommy Cooper would have said: 'God realised! Just like that!' I found the story hard to fathom.

In 1925 Meher Baba decided to stop speaking, although he continued to communicate using an alphabet board and sign language, as well as through essays, books and poetry. From 1931 onwards he made dozens of trips to the West, founding groups, projects and missions, especially in America, a country he claimed would be the spiritual melting pot of the future.

In the Thirties, on one of his first visits to England, Meher Baba had visited the mother of Delia DeLeon, a young actress and one of his first British disciples, at the Star and Garter Hotel in Richmond where she was resident. The hotel has an uninterrupted view of the entire flood plain between Ham and Isleworth, with Windsor Castle visible in the far distance. Meher Baba stood on a balcony looking at the view for a long time. When he came inside, Delia asked him what he had been looking at. He said he had been planning his spiritual work for the next 200 years.

Until 1967 Delia had been holding together a group of followers who called themselves lovers of the Master, with occasional gatherings at the Poetry Society, many of whose members were despairing of politics in the 1930s, and had begun to look to the East for alternatives to imperialism and its wars. When Michael McInnerney brought a delegation of enquiring young people to a meeting, Delia, at 66, suddenly knew why her master of thirty-five years had insisted she stay put in Britain and await his directions.

People who follow Meher Baba speak of recognising his face, or feeling some deep connection to him. For me the chemistry was with those who already followed him. They seemed to be unusually good people, politically and socially. Delia told me that Tom Hopkinson, editor of *Picture Post*, Britain's equivalent of *Life* magazine, followed the Master. This was important to me. I had grown up with *Picture Post*, and I knew Tom's integrity was solid. Finding rational, intelligent people open to spiritual ideas gave me the confidence to tackle head-on what The Who's audience might best respond to. And I could do so without feeling like a hippy. I put a copy of Charles Purdom's *The God Man* in my bag as I packed for the short Australia and New Zealand tour The Who and Small Faces had planned for January 1968.

When I was handed my ticket to Sydney at Heathrow I saw it was tourist class, and turned around to catch a taxi home. We had been promised first-class seats. John Wolff (known as Wiggy), our production manager, chased after me, persuading me that we'd all hang together and the flight would be a piece of cake. It was Wiggy's job to get us to the shows; not his fault, but the flight was shocking, with four long stops along the way. When we arrived, shattered after thirty-six hours of travel, we were surprised to meet an aggressive group of journalists who put us through an inquisition. Roger had taken to

wearing a large crucifix at the time, and one of the reporters, clearly drunk, thought this was religious hypocrisy. I was challenged for looking unkempt. 'Couldn't you even brush your hair to meet your young fans?' There were no young fans anywhere in sight, just these arsehole hacks, fresh from a long stint at the bar.

It was a shock for which we could have been prepared: artists far more conventional than we had suffered a similar fate. The shows proved to be as difficult as our shoddy, half-baked trips to Sweden. We had our big amplifiers and guitars this time, but not the big PA system we used in Britain to get Roger's vocals across. The sound wasn't good. When we began to smash equipment the technicians at each venue seemed completely unprepared, and the newspapers began a ferocious campaign of ridicule.

We didn't really care. The halls were almost sold to capacity, and we were having fun. I was enjoying hanging out with Ronnie Lane. Steve Marriott found a ravishing girl called Rosie, and when I chatted with her she asked me what I was interested in at the time. When I told her I had decided to become a follower of an almost unknown Indian teacher called Meher Baba, she said, 'Oh, yes. I follow him, too.' She reached into a pocket and gave me a little button bearing his image.

I was stunned. I had no idea Meher Baba had made several visits to Australia – it turned out there were several well-established centres there. It seemed too extraordinary to be coincidence, and cemented two jetlagged ideas in my mind: that I had made the right choice in Meher Baba and the wrong choice in Karen, for here before me was a very sexy girl who shared my new spiritual enthusiasm precisely. Unsurprisingly, we ended up sleeping together. I was very affected by Rosie and wrote a song about her (that I never played for her) called 'Sensation'.

She overwhelms as she approaches
Makes your lungs hold breath inside
Lovers break caresses for her
Love enhanced when she's gone by

Who fans will recognise the lyric: I adapted it with a gender switch for use in *Tommy*.

On a flight from Sydney to Melbourne the flight attendant was uncomfortable dealing with us, and when the coffee trolley passed down the aisle she didn't serve any of the band. When English singer Paul Jones complained, she said she thought we had our own refreshments, pointing to the Australian musician sitting next to me happily drinking his own beer. When Jones wasn't mollified, she ran to complain to the pilot, who emerged looking angry and determined. Naturally he took her side, telling us that as soon as the plane landed we would be thrown off and arrested.

The truth didn't make a good enough rock 'n' roll story, so in the media retelling I became a leading figure in the events on the plane. In fact I first piped up when we were held by the police after landing; I challenged them to arrest us or let us go. They let us go. A few days later we were handed a telegram from the Australian Prime Minister himself, informing us that because of our misbehaviour he was withholding our tour receipts against damages. He also requested that we never again return to Australia.

The news of our 'misbehaviour' preceded us to New Zealand, where the hotel manager in Wellington warned us on arrival that he wouldn't stand any nonsense. Refused room service, or even a bowl, I ate the breakfast cereal I purchased from the corner shop out of the sink.

There were lighter moments. Steve Marriott had a birthday party and decided to do a Keith Moon and throw a TV set off

his balcony. It landed on the pavement just as a police car drove by. The police came directly to our room, and we opened the door thinking we were done for. To our astonishment they were very cheery, didn't even mention the TV set, wished Steve a happy birthday and left us a case of beer so we 'wouldn't think the Kiwis were as inhospitable as them miserable Ozzies'.

When we prepared to leave New Zealand for Hawaii, Rosie broke down. 'Everyone leaves me behind when they go home.' I was unhappy too, although distracted by her use of the word 'everyone'. When I got home I decided that in keeping with our new agreement – we had pledged to be absolutely honest at the very least – I must tell Karen what had happened. On some level I probably hoped it would send her a message that I wouldn't make a good husband, and that maybe we should both make other plans.

When I asked Karen if I could speak to her about something very important, she arranged herself in the Soo Choo Mandarin Throne, a grand wicker throne from Liberty's, one of the very first bits of furniture we had purchased together for our new home. She sat with legs crossed, looking very regal indeed, not to mention formidable. As I began to mumble, she picked something up from her lap. It was a letter. I knew immediately it was from Rosie. In an instant Karen had trumped my intended admission with her own forgiveness. There was no great moratorium, no dramatic declarations or intimidation. Implicit in the tense exchange that followed was the expectation that we'd now stop pretending and get married.

It may appear that I agreed to marry Karen out of guilt, but in fact it was important for me to ground myself in the reality of my life in London. Australia was a long way away. I had been a fool. My future wife was beautiful and smart, and we had a good life together. This didn't diminish the pleasure of my dalliance with an exotic girl on the other side of the world,

but I was home now, looking at Karen, and I felt damned lucky to have her.

I felt certain that radio stations in the States would adore *The Who Sell Out* – it was, after all, a tribute to their power and influence. But Joe Bogart, director of WMCA, New York's biggest radio station, called our album 'disgusting' and said he had 'grave doubts anyone would play it'. It seemed I'd got it wrong once again.

Burying myself in work, I brought my brothers Paul and Simon to my studio – they were both anxious to be musicians – and recorded them. I also recorded a little gem of a song in the style of Brian Wilson in *Smiley Smile* called 'Going Fishing', suggesting that even a bream can impart useful wisdom if only we would listen. I was going a bit soft. I went greyhound racing with Chris Morphet, taking me back to my childhood with Dad at White City. In the warm glow of domesticity I wrote two songs, 'Dogs' and 'Welcome', the latter about the value of friends. When I played the demo to Richard Stanley, who was lodging with us for a few weeks, he thought I was using the song to invite him to partake in a *ménage à trois*.

The Who were in and out of studio sessions in the first months of 1968, Kit pushing as usual to cobble something together out of thin air. I went along with it, but I was secretly planning to sweep all this nonsense aside – and soon.

We toured America again at the end of February, by bus. In my notebook I wrote my first plan for what would become *Tommy*. Our first shows were in California and I went a few days early to meet Rick Chapman, who ran Meher Baba Information out of Berkeley; he drove me to our first show in San Jose in his massive old 1959 Lincoln Continental. En route he explained that Meher Baba had counted marijuana

among those drugs he wished sincere followers to stop abusing, so I began to wean myself off it.

Rick smoked little Indian cigarettes called beedies, which I used for many years as a substitute for pot. They were foul-smelling and tasted almost as bad, but the nicotine hit was enormous. The Who stayed in North America until April, hitting Canada for the first time, meeting real Mods on scooters in Edmonton and finding authentic English beer in Toronto.

I was already bored with bus-tour life despite someone in the band bringing on an extremely good-looking, effervescently crazy girl. Keith stripped her naked, tied her to a seat with loose ribbons and pretended to rape her. When I worriedly intervened, she was the one who told me to 'fuck off'.

After she'd romped around the bus naked for seven hours between Toronto and Edmonton, I was feeling pretty stirred up, and when we arrived at our hotel, and she knocked on my room door, my vanity got the better of me. In fact, Keith and John, who thought I was stuck up around groupies, had paid her $100 if she would share her gonorrhea with me.

She was gorgeous. We had great sex. I caught the clap, and took the injection. I couldn't afford to be angry – this was rock 'n' roll 'hi-jinks' and in a way I was pleased to be included.

Karen Astley and I got married on 20 May, the day after my birthday. The party was held at Karen's parents' country house, where Richard Stanley jumped in the pool with his clothes on, but Keith Moon was well behaved. Mum wore a perfect hat. Linda and Lesley, two young Mod fans, were the only gatecrashers.

The chauffeur of the old Rolls I hired for the wedding turned out to be Great Uncle Pat Dennis, Granddad Maurice's youngest brother. I had never met him before until we got under way, when he turned and shouted an introduction

through the glass. He got extremely drunk at the party, and at the end of the night I drove him home in the Rolls.

I cut down my drinking, and had stopped smoking grass. I was certainly changing. Kit was terribly sniffy about my Meher Baba interest, and began to make jokes about Karen and me setting up home together in our new Georgian house in Twickenham, calling us Lord and Lady Townshend. He claimed he'd been standing in the rain one day trying to hail a taxi, and we'd sailed right past him in my Lincoln Continental as he waved his arms to catch our attention.

In June, on Karen's birthday, I bought her a spaniel puppy called Towser. We all know what the acquisition of a puppy signifies for a young couple – and sure enough, shortly afterwards she became pregnant. A life with children was not Kit's idea of a well-laid plan. He thought it would spell the end of my career with The Who. In retrospect, I should at least have expected the chaos that was to ensue.

One of the important documents I referred to while writing *Tommy* was a diagram I had sketched of the beginning and end of seven journeys involving rebirth. I was attempting two ambitious stunts at once: to describe the disciple/master relationship and, in a Hermann Hesse-style saga of reincarnation, to connect the last seven lives of that disciple in an operatic drama that ended in spiritual perfection. In 'Deaf, Dumb and Blind Boy' I borrowed from Meher Baba's teachings to underpin ideas I'd been playing with during the previous year of psychedelia.[*]

Each time the child/disciple Tommy is reborn, he returns with new inner wisdom, but still his life is full of struggle. Since the boy's ignorance of his spiritual growth is a kind of disability, I decided my deaf, dumb and blind hero could be

[*] More details on *Tommy*'s genesis are available at www.TheWho.com.

autistic. This way, when I wanted to demonstrate the glorious moment of his God-realisation, I could simply restore to my hero the use of his senses. It was a good plan; the boy's sensory deprivation would work as a symbol of our own everyday spiritual isolation.

At the very moment I began to gather what I needed to make sense of my story, The Who set off on a gruelling tour of the States, and in the process I lost valuable time. I had talked about rock opera to everyone who would listen, and, though I'm sure that, as with guitar feedback, many others had the same idea around the same time, I hoped we'd be the first rock band with a major thematic work. But as we began the tour I knew that wouldn't happen.

Some photos of the tour show me jumping up four feet in the air holding a Les Paul guitar and wearing high-top Doc Marten work boots. I was astonishingly fit, and it was a good thing, too, for in the years to come my cast-iron constitution and athletic body, honed purely on the stage with The Who, would be my only protection from the rigours of alcohol abuse and extreme overwork. Keith, equally fit from stage work, had moved into using complex cocktails of drugs and alcohol. However, one of the great consolations of being on a boring tour was that he was so funny most of the time, as was Wiggy, our production manager who had been promoted from John and Keith's chauffeur.

Poor Wiggy. His worst moment was pulling us off a plane from Calgary to Saskatoon in Canada because the baggage handlers couldn't get our stage equipment into the hold. We then spent the entire day without food or drink waiting for an old cargo charter plane to take us to the show with our gear. When we got there the audience, kept waiting for four hours by a promoter unwilling to return their ticket money, watched us troop gloomily onto the stage to rush off a thirty-minute show that, ironically, we played with someone else's gear. For

years after that, Wiggy could make us laugh simply by comparing a venue with Saskatoon – a bit unfairly, really, given how patient and forgiving the audience had been.

'Magic Bus' was released in late July in the States. It didn't do very well at first, but would later become the most requested song at our live shows, along with John's 'Boris the Spider'. In Detroit I met up again with my old art-school buddy Tom Wright, who now managed the Grande Ballroom there. He lived in the old skating rink, washed his grey sweatshirts in the toilet sink, ate tuna out of the can and lent us roller skates so we could zoom around the ballroom floor.

We played several shows with The Troggs, whose hit single 'Wild Thing' had been borrowed by Jimi Hendrix. A show with The Doors marked the first time I'd met Jim Morrison, who was respectful, but very drunk. During The Doors' show a girl ran on stage and tried to touch Jim's face. He was startled and turned suddenly; two bouncers misinterpreted his action and threw the girl into the barrier, cutting her face quite badly. Jim hauled her back out again and she was brought backstage, where I was among those who comforted her. The incident became the inspiration for my song for *Tommy* called 'Sally Simpson'.

In California I met a whole group of Meher Baba lovers from the Bay area through my friend Rick Chapman. I was stunned at how many there were. They weren't brainwashed, nor obviously religious in any way. They'd lived hard, done drugs, had lots of sex and decided to hunker down to follow Meher Baba. They were a mixed bunch, often eccentric (which I regarded as a positive), and also very real. The more of his adherents I met, and the more I learned about Meher Baba, the more convinced I became that I'd found a genuine master.

In San Francisco I hung out with Jann Wenner one evening at the home of Jack Casady from Jefferson Airplane. Jack and

his friends were doing cocaine, while Jann was there with his friend Boz Scaggs. I shared my thoughts about *Tommy*, using the opportunity to work it through in my own mind.

'It's a story about a kid that's born deaf, dumb and blind, and what happens to him throughout his life. The boy is played by The Who. He's represented musically by a theme that we play, which starts off the opera itself, followed by a song describing the boy. But what it's really all about is the fact that the boy exists in a world of vibrations. This allows the listener to become profoundly aware of the boy and what he is all about, because he's being created by the vibrations of The Who's music as we play.*

'It's a very complex thing,' I said, 'and I don't know if I'm getting it across.'

Jann assured me I was. We talked long into the night. Jann recorded what I said and published it a month later, spread over two issues of *Rolling Stone*, San Francisco's newest magazine.

By September 1968 Karen and I were ensconced in our new Twickenham home. For the first months we lived there we fell in love with it over and over again. The house had been built around 1745. The layout was delightful and traditional. Above a narrow kitchen extension a small anteroom had been turned into my new studio. The house was small, and I kept all my clutter in the cellar. I had to get used to working in my studio in cramped conditions with limited resources, but Karen and I were happy.

In winter 1968 we experienced our first serious flood. Heavy rain had swollen the Thames, and when it reached the tiny windows to the cellar it started to rush in. In the street,

* The full transcript of the Jann Wenner interview is available at www.TheWho .com.

cars were being submerged, some being carried off down the river. People were panicking, trying to save their cars or rescue what was inside them, in some shocking instances their kids or pets. I was home at the time, and had been partly prepared for the deluge, but it got dark during the worst of the flooding and water kept pouring in.

The situation made it impossible to keep up my normal studio work, or to even store my instruments where I needed them. This generated an almost apocalyptic mood in me for a number of weeks – more high tides were predicted and one did fill the basement again, this time harmlessly because we'd emptied it of valuables. The rather upbeat tone of my first sketches of *Tommy*, with its hero seeking to find a way through the spiritual planes, and gathering affectionate followers around him as he went, was replaced with a rather less benign view that was harder, closer to Hesse's hero Siddhartha's tough lessons at the feet of the ferryman.

It was asking a lot of this small house to expect it to provide a home as well as a working recording studio. My recording kit was now squeezed into one end of the tiny anteroom I had made my control room. At the opposite end my Bechstein upright piano – rented from Harrods – barely fit across the back wall. I had the same sound system at home as I did on the road: Sound Dimension speaker cabinets originally intended to be used with organs, capable of adding glorious reverb effects, as well as a mysterious quality to acoustic guitar. Sometimes the entire house would vibrate with sound when I was recording. My neighbours opposite were destined to spend the next four years listening to my demos and experimental recordings, but they were paragons, and never once complained.

* * *

ABOVE: Dad (left) queuing at mess in the RAF in Germany, 1945.

TOP RIGHT: Me, aged 2, August 1947.

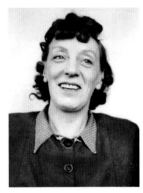

RIGHT: My grandmother Denny (left) with her only son, my Uncle Maurice, and his wife Joyce in the early 1950s.

LEFT: My Aunt Trilby in 1947. Tril was the first to encourage me musically.

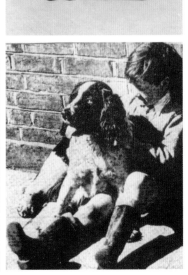

BELOW: The Squadronaires, with Dad playing sax (third from left).

BOTTOM RIGHT: Me and my dog Bruce in the *Acton Gazette*.

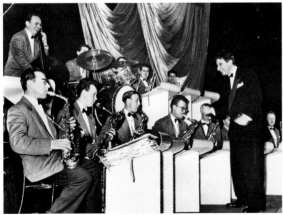

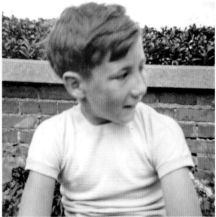

ABOVE: My parents and paternal grandparents, 1954. From left: Betty, Cliff, Horry and Dot.

TOP RIGHT: In my back garden in Acton.

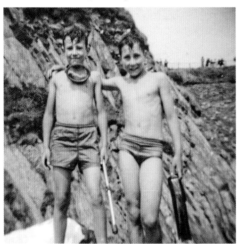

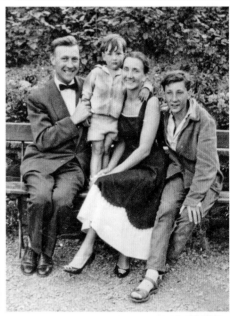

ABOVE: Jimpy and me, snorkelling.

CENTRE RIGHT: From left: Dad, my brother Paul, Mum, me, 1959. Paul's arrival had made us feel like a real family.

RIGHT: Playing the banjo, c. 1958. I look like a little boy. John Entwistle, already nearly six foot tall, has his back to the camera and is wearing a trilby hat.

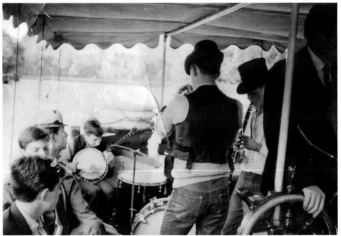

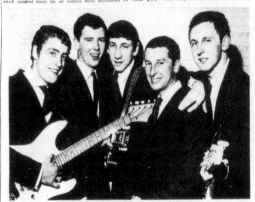

LEFT: Playing Shadows songs with Mick Brown and Peter Wilson, 1961.

RIGHT: After supporting the Ron Cavendish Orchestra at Acton Town Hall on 1 September 1962, we were billed in the newspaper as The Detours Jazz Group.

GAZETTE AND POST, THURSDAY, SEPTEMBER 6, 1962

Two band impact!

TOWN HALL DANCE GALA SWINGS WITH NEW LOOK

SOFT lights, hot music, and big names brought about a "spectacular increase in attendance from the usual figure of a hundred-plus to more than 317" at the Gala Ball at the Town Hall on Saturday.

Glad to see so many stepping out on the first night of the new season was Mr. George Scott, Town Hall Entertainments Manager.

He put the success down to the two bands — the Ron Cavendish Orchestra and the "Detours" Jazz Group — which supplied music for all

ages, the display by Peter Eggleton and Brenda Winslade, this year's international professional dancing champions, and the redecoration of the hall.

Licence

Six revolving lights, adding glamour to the scene in six colours, floral decorations for

the stage, foyer and tables, and a licence, extending until 11.30, have all been added to ensure the success of the Council's Entertainment Committee's weekly dances and special Christmas and New Year Balls. Attractions like Saturday's demonstration pair, who danced an encore, and the additional group which supplied

the gist of the twist, are hoped to be included as often as possible.

The buffet, run by the Council Catering Committee, and the novelty and prize spots will be maintained.

The Chris Stone, Fred Hedley and Phill Spurr orchestras are among the attractions this side of Christmas.

Acton jazz and jive group, the "Detours", at last found their way to a local booking on Saturday when they were the second band at Saturday's Gala Ball at the Town Hall. Left to right: Roger Daltrey (18), Colin Dawson (19), Peter Townsend (17), Doug Sandon (18), and John Johns (17).

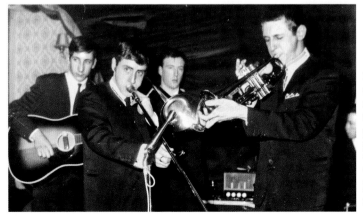

LEFT: The Detours, c. 1961. Roger let me join the band in ten seconds: 'Can you play E? Can you play B? Can you play "Man of Mystery" by The Shadows? "Hava Nagila"? OK, see you there.'

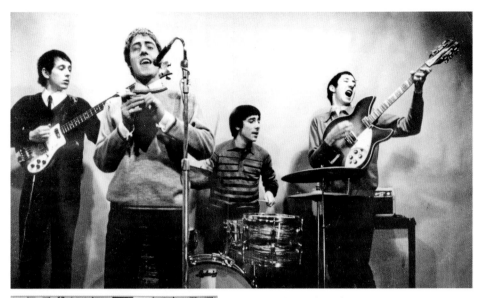

ABOVE: A photo shoot for *Seventeen* magazine at Blaise's Club in London, late 1964.

LEFT: In my Mod parka, 1964.

BELOW: The High Numbers, 1964. Pete Meaden persuaded us to record under that name. 'Numbers' was a Mod subgroup of lieutenants below the fashion-leading 'Faces'.

BOTTOM RIGHT: Karen Astley, Richard Barnes (Barney) and Liz Reid in Sid's café, 1964.

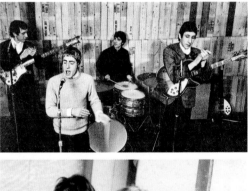

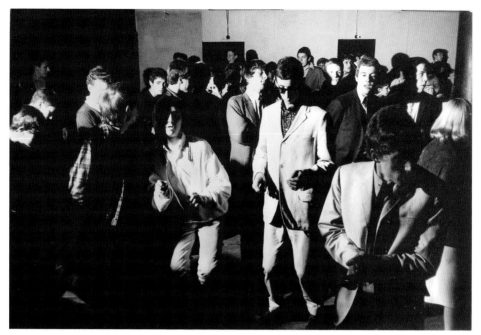

ABOVE: Dancing at The Scene Club, London, in 1964 with my friend Barney to the left. John is in the check jacket, Keith is on the left and Roger is in the foreground. Between me and Roger is Pete Meaden, still our manager in 1964.

BELOW: The Who in London on a magazine shoot with Tony Frank, 1965. That year we played in Holland and Scandinavia, causing a street riot in Denmark.

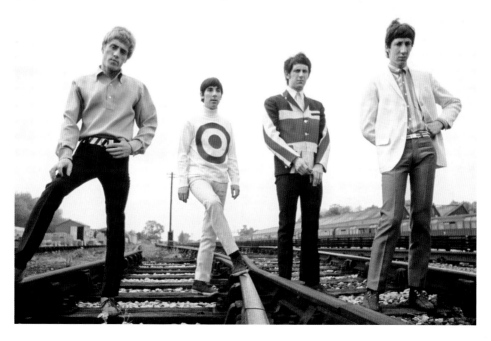

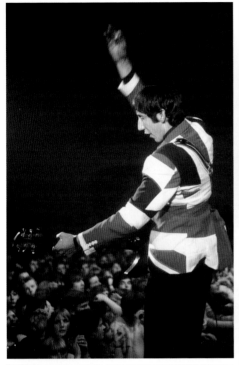

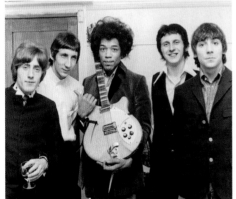

TOP LEFT: Windmilling at The Pavilion in Bath, 10 October 1966.

TOP RIGHT: Karen and me backstage after a show, November 1965.

ABOVE: The Who's managers, Chris Stamp and Kit Lambert. They were from different backgrounds. Chris, from the East End of London, the son of a Thames waterman; Kit, the son of Constant Lambert, the musical director of the Royal Ballet at Covent Garden.

CENTRE LEFT: The Who and Jimi Hendrix at the Saville Theatre, 29 January 1967.

LEFT: With Mick Jagger, before our fourth appearance on *Top of the Pops*, 10 June 1965.

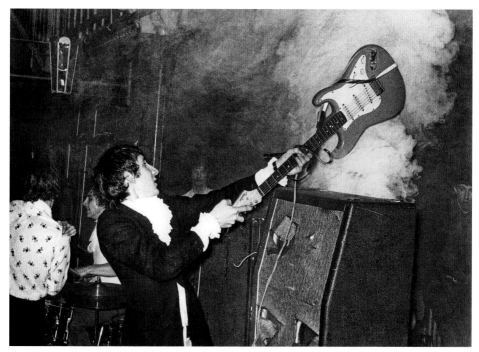

ABOVE: Auto-destruction at the Granby Halls in Leicester, spring 1967.

BELOW: The Who performing 'Happy Jack' on TV, 1967. After the recording, John and I went off to see Jimi Hendrix play at the Bag O'Nails.

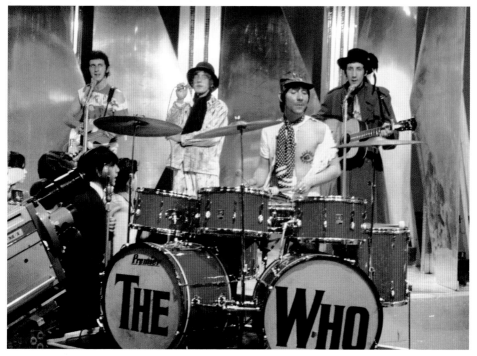

ABOVE: With Keith Moon, 1967.

BELOW: Rock and Roll Circus, December 1968. We drank brandy to keep interested. We were at it until four in the morning; even Marianne, smoking heavily, was looking the worse for wear by the end of the shoot. From left: John, Keith, me, John Lennon, Yoko, Keith Richards, Mick Jagger, Brian Jones, Bill Wyman, Eric Clapton, Marianne Faithfull.

A year had passed since I had come up with the idea of writing a cohesive, self-contained song-cycle with a spiritual theme. Even though I was working quickly and effectively producing songs in my new studio, I felt bullied by Kit. As soon as a recording session was set up, we had a sound and we'd gained some momentum, we had to go back out on the road.

By this time we should no longer have been broke. Our managers often claimed they were paying for our equipment wrecking. They weren't. In any case, a guitar smashed every few days would merely add a few hundred pounds to the bill. Not only was the financial cost of our stage finale greatly exaggerated, but I paid for my own guitars out of my own money, and Keith got most of his drums almost free from the manufacturer, an English company called Premier.

Our managers also blamed Keith for high overheads; he did draw large amounts of cash whenever he could, but he always had to ask permission. Kit was equally profligate and impulsive. The financial chaos around The Who suited everyone working around us and behind us. It just wasn't great for the members of the band.

Kit and Chris had arranged a Bahamian account for our offshore earnings. My father-in-law, the composer Edwin Astley, was a partner in one of the first offshore tax shelters called Constellation. It was this arrangement that had allowed Edwin Astley to pick and choose what television work he took on, and to live in such great comfort when taxes in Britain were the highest in the world. Our own scheme was an update of Constellation, making us employees of a service company that booked us out on tours. The profit after a foreign tour could be disbursed so we could get the best tax rate at home. Unfortunately, at this time there was never any profit left to tax.

If there had been, our aim was not to cheat the government. We only wanted any windfall earnings from our labours

abroad to be taxed as income over time. As I say, this had all
been academic, but as we started recording *Tommy* – and it
quickly took such promising shape – I began to get a feeling
that one day soon I would be needing all the financial advice
I could get.

Many music celebrities simply chose to leave Britain, and it
wasn't all about tax: America was the main global market for
music, and, after all, the country where rock 'n' roll began. I
had considered moving to America myself, but I didn't want
to leave home. Everything I am and have done for myself, all
my artistic work, was rooted in the British way of life, the two
world wars and the hidden damage they had done to four
generations. I knew I'd never leave Britain. My roots were too
deep.

Ronnie Lane and I visited Mick Jagger while he was recording
at Olympic Studios, to develop an idea we had talked about.
I wanted to embark on a grand rock tour with all my friends.
This was the fantasy I had illustrated as a child: tour-buses
with cinemas, swimming pools and recreation rooms. Ronnie
dreamed of something more military: tents, mud and rough-
house camaraderie. Mick had always dreamed of travelling in
a circus, with animals, trapeze artists and massive spectacle.
After an hour of brainstorming it became obvious that what
we were talking about would only be possible with an extraor-
dinary amount of gear and the most incredible organisation.
It just might not be feasible.

When The Who later played the Shrine in LA in June, we
had a fairly long break before our tour kicked off again in the
second week of July. Mick was there with Chip Monck, who
was designing a big stage rig for the Stones' next tour, and the
three of us met to discuss the idea further. Mick had told Chip
what he wanted, and Chip mentioned that several major
American circuses were in the process of going bust, and all

their equipment was for sale. There were hospitals, school-rooms, cinemas, kitchens, jacuzzis, cages for tigers – all in luxurious railway carriages, my childhood fantasy made real. Chip's trump card was that several film companies were incredibly excited by the idea of filming such a tour, and would be prepared to invest. Mick and I were inspired.

A few weeks later Chip brought us down to earth. Due to the poor condition of railway track all over the USA, our trains would only be able to travel an average of 4 mph. A grand tour would take us several years at that rate. Not to mention that the idea of being trapped on a slow-moving train for several months with Keith Moon blowing up its one and only toilet and throwing things out of windows and Keith Richards scoring smack from passing Hell's Angels didn't appeal to either Mick or me. The thought of all of that mayhem being filmed was an added disincentive.

'I think maybe we should drop this idea,' said Mick.

'Maybe we could do, like, a gig or something?' I was groping.

'A TV show,' said Mick. 'That's what we'll do.'

On 9 December, the day before the TV shoot,* we met at the Londonderry House Hotel to talk about the show. Mick was still driving everything; Keith Richards was looking green but cool, having recently started using heroin every day; Bill Wyman and Charlie Watts were sanguine as ever. Brian Jones was absent. The director was to be our friend Michael Lindsay Hogg. The sound was to be recorded by Glyn Johns.

On the bill were Eric Clapton, John and Yoko, Jethro Tull and – most exciting to me – Taj Mahal, whose first album I had been listening to constantly on the last tour. An

* This TV film was called *The Rolling Stones Rock and Roll Circus* but was not released until 1996.

unexpected pleasure was that Marianne Faithfull was going to sing a song. The only drawback – and a very sad one – was the arrival of Brian Jones. I hadn't seen him for a year or more. His eyes were bloodshot and he was in tears, wilting under the effect of an elaborate cocktail of uppers and downers.

During the first day of filming on 10 December Yoko was brilliant, screaming with John in the Dirty Mac Band, her role as an artistic irritant not unlike my own auto-destructive work with The Who. However, to sceptics we would both appear quite daft for a number of years more. The Who's performance of 'A Quick One, While He's Away' was very sprightly; we went on mid-afternoon. But the Stones had to work hard to bring their set to life. They started very late, by which time their fans had been shipped home. By now Brian was a heap of misery and futility. I'd heard Mick and Keith saying that they were worried about him, and Brian himself told me about some muddled plans for retiring from the band; he was thinking of going to Tangier to record musicians there.

As the Stones struggled I enlisted our road crew as a stand-in audience, all of us drinking brandy to keep interested. We were at it until four in the morning; even Marianne looked worse for wear by the end of the shoot. Everyone did – except Mick. He had just spent several months filming *Performance*, the dark, forbidding London fairy tale, with lighting camera-man Nic Roeg and director Donald Cammell. Making that film had had a profound effect on everyone involved, and Mick had clearly grown in some indefinable way. He looked devilish, his hair dyed black, and he was entirely focused on the cameras, looking deeply through the lens to those he knew would one day watch him. His performance is still extraordinary to see; he never loses concentration for a second.

Allen Klein wandered the studio. He was still deeply immersed in the Stones' affairs and had produced the event.

When he came over and asked whether I was making any money yet, I felt a flicker of rage. Yes, I had once turned to him for help, but still his question crossed a line. He said he was always ready to help. Annoyed, I told him that although I wasn't making money I would never turn to him. He had The Beatles and the Stones, but he would never get The Who.

12

TOMMY: THE MYTHS, THE MUSIC, THE MUD

Myths have grown up around the recording of *Tommy*. One is that we spent a lot of time in the studio discussing my ideas, trying to help me solve problems. This happened occasionally, but not often. Roger remembers it this way, but perhaps that's because as a singer he was often waiting for long periods for us to complete tracks on which he could sing. Keith said we all pulled together as a group to make *Tommy* happen. As a band that's true, but there were plenty of times when I tried to explain the more personal shades of the Tommy story to my mates, and they simply weren't interested.

Another myth is that Kit completed and guided the story around *Tommy*. He typed out what we settled on together, but only several days after the album was completed and the tracks sequenced. He did this in part to protect the dramatic copyright.* He also did it to create a film treatment, something I wasn't aware of at first. Still, there's no doubt that Kit did make many valuable suggestions – that I should write a conventional overture quoting the important musical themes in the opera (the very last piece I would write), and that the story should cover two wars rather than one, a structure Kit and I imposed on the collection of songs after the album was complete. Kit also recognised the underlying framework of

* In the US, the Library of Congress Grand Right is a copyright that aggregates three creative strands – music, lyrics and story. No such right exists in the UK but the form is respected as a rule.

Tommy as tightly biographical. 'A Quick One, While He's Away', for example, is my own story retold as a fairy tale. Being aware of this biographical aspect, Kit shrewdly brought it to my attention whenever my creative process began to meander.

The *Tommy* tracks were well engineered, with conservative, tight drum and bass sounds, and great acoustic, keyboard and vocal sounds, but the electric rhythm guitars sounded poor. I felt I had two great strengths as a studio musician. I was a good acoustic guitar player and electric rhythm guitar player. But IBC Recording Studios had no isolation booth, so when making backing tracks I couldn't really play acoustic guitar along with Keith and John; they were too loud. Kit had persuaded me to cover any proposed acoustic part with a thin, low-volume electric guitar, which I planned to replace with a killer combination of full-bodied acoustic guitar and driving electric rhythm guitar. Unfortunately, this never happened.

Kit also had a powerful agenda involving arrangements for a symphony orchestra. Whenever he mentioned it I took him aside and challenged him; this was my creative work and I believed we should try to play every instrument ourselves. Still, I could see that in a number of songs Kit simply hadn't left enough tracks empty for me to properly replace and implement my guitar work. We were running out of time. It was anathema to me that Kit should fill the space he had forced me to leave with an orchestra, but Chris said that Kit may have been grasping at an opportunity to impress, or snipe at, his father's friends with an ambitious orchestral rock parody of opera.

We were strong, good-tempered most of the time and strangely optimistic in most things. The band were supportive of my ambitious plans for a rock opera and Kit was too, but he clearly believed I wasn't going to create anything cohesive

without a masterstroke he himself injected into the proceedings. It was initially Kit's intention, one I went along with, that I perform the role of Tommy's 'inner' voice, for which the *leitmotif*, 'See me, feel me, touch me, heal me', was the main refrain. To confuse things I also took the role of Narrator, and was supposed to sing, 'Captain Walker didn't come home' from the 'Overture' as well as the role of the nurse who delivers baby Tommy and sings the entirety of 'Amazing Journey' and 'Acid Queen'. (The Acid Queen is a prostitute, drug-pusher and gypsy.) I enjoyed singing this song and carried the role in all live performances with the band for years. As Tommy's father I also sang 'Christmas'.

Roger's role in these initial recordings was Tommy as a young man. In these early assemblies his first appearance was 'I'm Free', the moment of realisation. As recording progressed he worked hard to achieve a soft, falsetto voice in which to sing Tommy's main refrain, 'See me, feel me', so he could sing it instead of me, making things less confusing. (There are several versions in the *Tommy* archives of songs for which I sang the lead before Roger replaced me.) One day he pulled it off, which meant he could now sing all Tommy's lines from childhood on, which was a crucial breakthrough.

One notion I had proposed was incorporating or adapting songs I'd first heard performed by Mose Allison: 'Country Shack' and 'Eyesight to the Blind' both include the words 'deaf, dumb and blind'. 'Young Man Blues' was simply a song I'd always wished to honour as the fulcrum of my first few songs about teenage angst. Only my adaptation of 'Eyesight to the Blind' got on the finished album (the working title was 'The Hawker'), but it would make Sonny Boy Williamson's family some useful pocket money over the next thirty years.

I wanted to show the hero of *Tommy* abused by his family, by school friends and by drug-pushers. There was no moral

message intended; I simply wanted to demonstrate that my hero was, by my own measure, a normal post-war child. After many frustrated attempts at dealing directly with the issue of sexual molestation, I had to give up. I kept coming back to my time as a toddler with Denny, and the creepy 'uncle' with the Hitler moustache, but having exposed such darkness inadvertently in 'A Quick One, While He's Away', a piece meant to be light-hearted, I wasn't sure enough of myself to tackle it.

I turned to John. Could he compose a song about an 'uncle' Ernie abusing a boy? There didn't need to be any actual touching, just onanistic voyeurism. He said he would try, and came up with 'Fiddle About'. I liked it very much: it was disturbing, relentless and powerful, although I was sad that it also seemed to turn into a dark joke something I myself had found so disturbing as a child. Still, it did the job nicely, and I was relieved not to have to battle with the subject myself.

John also took on the job of writing a song for Ernie's son Kevin, who bullies Tommy. My take on bullying was different to that on sexual abuse, but the topic was nearly as difficult for me; in various young gangs I had taken part in bullying, and found it painful to think about. Again John made 'Cousin Kevin' brutally comedic, but this time the music was canonic, poignant, moving and frightening.

In the last few days before assembly two more vital changes were made. One came about because I felt that my song 'Welcome' lacked edge. Were Tommy's followers merely being lulled into a meditative, soothing state? Was Tommy's welcoming house like a quiet church, or a happy, vital place that young people would truly enjoy inhabiting?

It was Keith who came up with the necessary masterstroke: Tommy's house wouldn't be just a house, it would be a holiday camp, a Butlins-style retreat like those I had spent many happy years in as a small child. I quickly knocked off a throwaway fragment about a holiday camp and gave Keith the

well-deserved writing credit. To further confuse the roles sung
by each group member, Kit used my demo on the finished
album, so I briefly took the role of Uncle Ernie.

I was working in my home studio on 1 February 1969 when I
got a call from Delia DeLeon to tell me that Meher Baba had
'dropped his body', and would I be attending a special meet-
ing that evening at the Soho centre? The meeting was to
discuss how his sudden death would affect plans for a planned
mass *darshan* (public gathering) scheduled in Meher Baba's
home town, Ahmednagar, in March, which he had promised
after a long period of seclusion. I explained that I would be
driving to Newcastle the following day, a journey of about five
hours, and couldn't attend.

Baba had been ill so his death wasn't unexpected, but it
was still a terrible shock. I had been planning to go to India
with the McInnerneys and Ronnie and Susie Lane. Karen, in
her final month of pregnancy, planned to stay behind. We
hadn't been able to meet Meher Baba, but had followed him
since 1967, and I was upset that now we'd missed our chance.
I asked Delia what she planned to do; she said she would of
course go. What about Mike and me? I wondered. Should we
accompany her? Fiercely independent as ever, she scoffed:
What would be the point? She may have also been thinking
that Meher Baba would not actually be there to meet us,
without taking into account the view of his Indian family
who felt that he would still be present, even if not in his
body.

Under the deadline hammer on *Tommy* we cancelled our
tickets to India that morning with mixed feelings of disap-
pointment and relief. The next day, when The Who played in
Redcar, I was still numb from the Meher Baba news. Three of
the road crew joined me in the Volvo for the drive back to
London; it was a long journey and there was an eerie silence

throughout. The following day I rang some of my friends and discovered that the planned *darshan* would go ahead. This had been Meher Baba's express wish all along. For Mike and me it was already too late to reschedule. Meher Baba's tomb, however, would be opened for visitors in March, through April and beyond.

The Who had spent six weeks over the past four months in and out of IBC studios recording *Tommy*. Kit brought Nik Cohn, the young record critic from the *Guardian*, to IBC to listen on 4 February. Nik and I had become good friends (he was part of Kit and Chris's social circle), and we'd taken to hanging out in games arcades near the Track offices in Old Compton Street playing pinball.

He was writing a pop novel called *Arfur: Teenage Pinball Queen*. One day Nik brought Arfur – the real girl who was his inspiration – to meet me. She was short, with short dark hair, pretty and rough-cut in a tight-fitting denim jacket. We would play pinball furiously and competitively and she slayed me on a machine with six sets of flippers. After our games Nik and I usually popped over to Wheeler's oyster bar for lunch. We were terribly Sixties pop about this – pinball, oysters and house Chablis.

At the review session Nik listened to *Tommy* and said he thought the opera was pretty good, but the story was a bit po-faced and humourless.

Kit's face tightened as he heard Nik confirm his worst fears. Why did Tommy have to be a guru? It was so old hat. I tried to explain that Tommy was actually a kind of divine musician, that he felt vibrations as music and made music in the hearts of his followers. Nik's expression made it clear I was making things worse.

'So you won't give it a good review?' I teased Nik.

'Probably not five stars.'

'What if Tommy was a pinball champion, and that's the reason he gathers so many disciples?'

'Well, in that case of course it would get five stars – and an extra ball.'

I wrote 'Pinball Wizard' the next day, then cut a basic demo in my home studio in a great hurry; it had acoustic guitar and vocal on one track, and an electric overdub and backing vocal on the other. The terms 'pinball wizard' and 'mean pinball' had been used by Nik whenever we played. In the next three or four weeks it was relatively simple to interpolate 'pinball' into a couple of other places in the sequence of *Tommy* songs, and to redo the necessary vocal lines.

I made a huge leap into the absurd when I decided that the hero would play pinball while still deaf, dumb and blind. It was daft, flawed and muddled, but also insolent, liberated and adventurous. I had no doubt whatsoever that if I had failed to deliver The Who an operatic masterpiece that would change people's lives, with 'Pinball Wizard' I was giving them something almost as good: a hit.

I decided Mike McInnerney would be the first person to hear it. Mike and I had spent lots of time brainstorming about the music for *Tommy* and the way Mike's illustrations would complement it. Meher Baba taught that life as we knew it was 'an illusion within an illusion', an angle Mike was developing for the album sleeve. The front cover and one of the inside panels showed a kind of latticed grid through which listeners had to pass in order to reach the music inside.

Tommy hadn't been intended as a pop album. My new definition of what I did was 'rock', and musicians and journalists were starting to use the word to describe a youth movement and an attitude as well as the favoured popular music of the day. Jann Wenner and his writers at *Rolling Stone* were already using the word to describe more than a style of music, and

when *Creem* magazine emerged a little later they coined the term 'Punk rock' to define the entire scene that produced such disparate individuals as John Sinclair and Abbie Hoffman on the one hand, and Iggy Pop on the other.

Meher Baba had spoken about 'God playing marbles with the Universe', and the newly introduced pinball element echoed that in *Tommy*. Mike was thinking about a new painting for the record sleeve to depict the way that illusion deceived us into believing that what we saw was real, but he was running out of time. His illustration work in gouache was meticulous and time-consuming. He decided to create a photograph instead, and enlisted someone he knew to set it up.

The problem for us both was to work out what the function of *Tommy* would be now that Meher Baba was gone. I had never intended for *Tommy* to be a proselytising vehicle for Meher Baba, but it was certainly intended to reflect spiritual yearnings during these post-psychedelic times. Youth movements were dividing and polarising into two camps – political activists and spiritual seekers, and I saw myself in the latter. We discussed whether Baba's name should be credited on the sleeve and agreed that it should, but merely as 'Avatar'.

By the beginning of March we had finished. The last track we worked on was 'The Overture', demoed by me in a haze of exhaustion after everything else was completed.

When 'Pinball Wizard' was first pre-released to radio, I wasn't prepared for the critical onslaught for daring to write a song about a deaf, dumb and blind child. Several BBC DJs refused to play the track, with one or two making strongly worded statements, calling me 'sick'. Many softened their position when the album was released and they could hear the track in proper context. But music press approbation has dogged *Tommy* ever since.

I'm often described as 'pretentious' for attempting to write a composed song-cycle that tells a story (which itself has been torn to pieces a thousand times because it doesn't fit established rules of operatic written drama). It was even called my 'brain fart' by some critic that I have since relegated to the sludge-pile of memory. 'Rock opera' had already happened with The Pretty Things' *SF Sorrow* and Keith West's *Excerpt from a Teenage Opera*; The Kinks released their own *Arthur* the same year as *Tommy*, and we were certainly both using the term 'rock opera', albeit tongue-in-cheek. We knew that what we were doing owed more to British music hall than to grand opera.

My songs for *Tommy* still had the function of pop singles: to reflect and release, prefigure and inspire, entertain and engage. But that vein – of promoting singles apart from a whole album – had been thoroughly mined by the time we released *Tommy*. Change was necessary for us, which of course meant taking a lot of criticism on the chin. If the naïve, workmanlike songs I wrote immediately before *Tommy* had been hits I might never have felt the need to try something else. I might have kept my operatic ambitions private. There's nothing I admire more than a collection of straightforward songs, linked in mood and theme only by a common, unspecific artistic thesis.

But the 'pretentiousness' of *Tommy* was necessary. Without its audacity and cheek to attract both attention and opprobrium, I believe The Who would have eventually disappeared or become irrelevant. In any case, I enjoyed writing songs serving a brief. It's how I had begun, it seemed to work for me, and the result was songs that might otherwise not have been written. After *Tommy* every collection of songs I submitted for a Who album was inspired by an idea, a story or concept that had some kind of dramatic shape and form, not always evident, but always there.

* * *

I experienced something very peculiar when my daughter Emma was born on 28 March. First the doctor arrived at the hospital, and after explaining how the inducement procedure would unfold he broke Karen's water to begin the contractions. When I went into Karen's room to comfort her, the room was filled with angels. I didn't say anything, worried I was going mad and that I might frighten her. But as I sat holding Karen's hands and we smiled at each other, the room buzzed with magical energy. I wondered if I was having an LSD flashback. A little later, when Emma was born and first placed in my arms, I was awestruck by seeing this beautiful little thing for the first time. She seemed to look straight through my eyes and into my soul.

At that moment I was overwhelmed by a completely unexpected feeling. I felt an urge to pass the new baby back to her mother, rush out into the world and earn money. It was as though I had a caveman's primitive drive to hunt and kill to provide food for his family. A few days later, driving my newborn daughter home, I pulled my head above the parapet: I would do whatever I had to do in order to succeed.

Kit had left the first mix and assembly of *Tommy* to our IBC studios engineer Damon Lyon Shaw. When I first heard the double album I was a little taken aback. Kit had remixed the entire album so that the band was very low behind the vocals, and some tracks seemed to lack the punch I knew they had delivered in the studio. But the collection hung together better, and after a few listens I decided Kit had taken the correct approach. The story behind *Tommy* was fairly easy to follow, and the sleeve would contain the words as well as sensational pictures; practically every lyric line could be clearly heard in the mix, and this – after all – was the whole point. Mike McInnerney's sleeve design was a triumph. It added mystery and coherence, a seemingly impossible combination. Printed

up and held in hand it was an object of beauty as well as elucidation.

On 31 March we went into rehearsal in a hall in West Ealing. It took just four days for us to realise that *Tommy* was going to be a wonderful piece to play live. After the last rehearsal Keith took me for a drink, looked me in the eye and said, 'Pete, you've done it. This is gonna work.' Our rehearsals were a revelation: the music of *Tommy*, when played live, even in an empty hall, generated an extraordinary, building energy, and seemed to possess an inexplicable power that none of us had expected or planned.

As critics gathered like a pack of baying, snarling dogs, we prepared to face them. The only way to stem the attacks would be to play the first live show of *Tommy* in London exclusively to the enemy, to the cynical British press and radio media. On May Day we took the stage at Ronnie Scott's Jazz Club to première *Tommy* live to a bunch of music journalists half-drunk on booze we'd provided. As we walked on, one or two shouted out: 'Townshend, you sick cunt, smash yer guitar.' The audience murmur began to build; the situation didn't look good, so we drowned out the objectors by turning our amplifiers up far too loud for the small club, and began to play.

By the time we had finished everyone was on their feet. We had triumphed. The music worked.

Historically, The Who's stage act had revolved around a kind of childish look-at-me competitiveness that had worked well from 1964 to 1968, as the four of us, boys still, tried to get the attention of the audience in our own eccentric way. I jumped around, posed like a Mod fop, squiggled sideways, swung my arm and battled my Marshall stack. Roger swung his long golden hair and twirled the tassels on his shawl or his chamois leather jacket, as he sang and produced white noise or explosions by pushing his microphone against Keith's cymbals.

Keith played too many notes and made too many faces, throwing too many sticks and falling off his stool too often, but never lost the beat. John got attention simply because he stood so still, his fingers flying like a stenographer's, the notes a machine-gun chatter.

But when we performed *Tommy* in 1969 this competitiveness began to fade; we worked much more as a unit, supporting each other in making the journey of performing and listening to *Tommy* effective. We might begin our shows with a lot of noisy hard rock, and maybe end that way too, with amplifiers toppling over and drumkits falling into a heap, but while we played *Tommy* we became real musicians. This made being on stage with The Who a better place to be, although offstage we often still coalesced into our separate factions.

John seemed to ally himself to Keith without question, and was thus ensnared in many of Keith's most disastrous escapades. Roger was often preoccupied by a stunning girl, which meant he was no trouble, but neither was he much fun. I survived on my own, supported by my studio work, Karen and Emma, and a few good friends, as well as by spending time with journalists who took me seriously. These were mainly Americans – John Mendelsohn, Danny Fields, Jann Wenner, Dave Marsh and Greil Marcus come to mind. But even back in Britain rock writers were becoming less tabloid in their approach. Music magazine editors were realising that their readers took the bands and singers they liked seriously.

Pop music was evolving, becoming the barometer for a lot of social change. As journalists began to feel less embarrassed about speaking seriously about music I felt as though I was returning to familiar ground, where it was acceptable to speak of Bach, Charlie Parker and Brian Wilson as geniuses without fear of looking nerdy. In radio too there were great innovators who made me feel valued, and I passed a lot of time with them, perpetuating The Who myths and deepening the

realities, as well as listening to music and ideas they felt were important.

On tour, however, I couldn't get past the unshakeable feeling that there was a party going on somewhere to which I wouldn't be invited because I didn't take drugs and didn't feel at ease with groupies. My take on groupies had nothing to do with morality; I just didn't understand what they really wanted, or what they felt they were doing. If you got to spend a few nights with Daltrey or Clapton, what did you *go on to do* that would make it mean something? Tell your friends? Put notches on your high heels? One woman, who often slept with Eric, was never anything but beautiful, elegant and impressively intelligent. What made her follow bands around and hang around backstage, waiting for crumbs? Or are we all really star-fuckers wanting some buzz by association, or kudos by reputation and secrets?

Keith often allied himself with well-known groupies (groupie débutantes) whom he treated like princesses, speaking in a posh English voice like a lord as he served them Dom Perignon; he was so much fun I could understand why they enjoyed being with him. John often adopted one girl for an entire tour, who would become very familiar to all of us before disappearing for ever once the tour was over. I watched men in hotel bars, travelling salesmen or those attending conferences, speaking to girls they had just met, unbothered that they might be ladies of the night or just single women out for a good time. I could see what they needed, and why. But somehow I couldn't understand it in my bandmates.

Some musicians in pop and rock, even those on the sidelines, have numbered their sexual conquests in figures that defy the imagination. My priority was being faithful to Karen, but that left me feeling somehow left out. And of course everyone who dealt with me, the outsiders, believed they knew how I lived and what I did; the legendary rock 'n' roll life wasn't

easy to disown. Nor was there mileage in trying to explain that despite being in a rock band and smashing guitars I didn't take drugs and was trying to be a good husband.

I knew I had to go back to work, but I left my flight to the US to the last minute. Our first three shows were at the Grande Ballroom, Detroit, where we had played the previous July. Joe Cocker and the Grease Band were supporting us, and I loved watching them play. It was also a chance to catch up once again with my art-school buddy and mentor Tom Wright, who was still managing the Grande.

Every night our soundman Bob Pridden and I hung out with Tom Wright, who had heard *Tommy* and gave me his unexpurgated critique. 'Pete!' he giggled, waving a bottle of J&B at me. 'An opera. Man! A fucking opera. What were you thinking?' A few minutes later looked at me earnestly, his eyes boring into mine. 'Acid Queen ... man! Who was she? Where is she?'

The Who moved on to Boston, to Don Law's Boston Tea Party venue, which offered an eclectic mix of rock and jazz artists. Roland Kirk was the support act for three nights. (The following year he would add 'Rahsaan' to his name, after hearing it in a dream.) I was a huge fan, and a year earlier, wanting to share my passion, I had taken Karen and a couple of friends to see him play in London at Ronnie Scott's Jazz Club. We sat at a great table to the left of the stage, near the front, while Roland Kirk stormed his way through the most extraordinary feats of musicianship, dazzling jazz and showmanship. His gimmick was to play two or three instruments at once. We were astounded by him.

After forty-five minutes Kirk seemed to get bored and told his band, which included bassist Malcolm Cecil, who had lectured so brilliantly at Ealing, to go get a drink while he made his way to the piano. Roland's noodling was wonderful

– he had a two-fingered, two-fisted approach reminiscent of Duke Ellington in a playful mood. At one point I whispered into Karen's ear, 'I love this, but I'll be glad when he picks up his horn again.' He turned and glared in my direction. He'd heard me! I don't really know how; being blind his hearing must have been highly acute, but I really was whispering.

'Sorry, *Roland*,' I shouted, saying his first name in the arch-cockney manner we all used at Ronnie's to speak about him. He scoffed, then got up from the piano and walked back to the middle of the stage where he stuffed six different instruments into his mouth and played while singing at the same time. He looked over at me a few times, as if to make sure I was getting enough horn.

After we had performed *Tommy*, I stood exhausted in the dressing room as Roland Kirk pushed his way in shouting, 'Where's that little white motherfucking dude that wrote the thing about the deaf, dumb and blind kid?' I stayed quiet, but he heard me breathing, came over to me and gave me a hug.

'You don't know what it's like man, but you gave us blind folk our own opera thing at last! But I ain't dumb, and I ain't deaf.'

'Sorry, *Roland*,' I said, in arch-cockney.

'Damn!' Roland turned on me again, scowling in mock-anger. 'You're that white motherfucker who wanted me to stop playing the piano at Ronnie's last year!' I got another hug, this one more of a crush, but he sat backstage to listen to *Tommy* all three nights we played it that week.

Roland Kirk taught me that when musicians pay respects they don't always do it with claps and hugs or fan letters. Sometimes they merely listen. If they happen to be blind, they listen with acuity.

* * *

Bringing *Tommy* to New York, our spiritual home in the USA, was an emotional leap for us, but by this time I was starting to feel confident, if not a little cocky. In early 1969 I approached performing as I always did: a hard-working professional musician with a mission: get to the stage, do my job, go home. No encore.

I had become frustrated with the generally disorganised, experimental nature of pop shows in the late Sixties. Many promoters were straight out of college and had learned their craft in the cocoon of the student union. Behind the psychedelic posters and hippy atmosphere, the way these new young people operated created chaos – except where money was concerned. They were the emergent hippy businessmen of the future, like Richard Branson and Harvey Goldsmith. Despite my irritation I never felt violently angry, at least not with those who ran this new business I was in.

Tommy, for all its spiritual roots, is full of violence. It begins with bombs dropping, a young RAF pilot lost in battle (possibly captured as a prisoner of war), a domestic murder, bullying, sexual abuse, extreme drug use by a back-street quack, the incompetent medical treatment of a disabled child, and finally rioting by an aggrieved populace that has been promised nirvana but delivered boring day-job medication instead. When performing *Tommy* I often seemed to lose consciousness at some level. I wasn't high, at least not on drugs. I kept very focused. I was buzzed on my own endogenous chemicals – endorphins, dopamine, serotonin and epinephrine flooded through my body.

For New York we had three shows planned at Fillmore East. On the opening night I was more excited than usual, and we were bullish that we'd have a good show. In the middle of a storming set a man appeared centre stage, tore the mike from Roger's hands and started speaking to the audience. He didn't ask us to stop performing. In fact he didn't address us

at all. One minute we were at work, and the next minute he was there, speaking to the audience – my audience.

Roger tried to get his microphone back, but the man pushed him away. In the middle of a heavy guitar solo, I ran over to boot his arse with a flying double-kick but as I approached he turned to face me and my Doc Martens connected with his balls. He doubled up, and a couple of Bill Graham's men ran on stage and walked him off. We continued to play. Only later did I discover I had kicked an off-duty officer in the Tactical Police Force, who was trying to clear the theatre calmly because a fire had broken out in the store next door.

I went to stay at my friends Steve and Nancy Baron's apartment that night. While I was discussing plans for Steve to come to London to record with me at my home studio, Nancy came in and said that a warrant was out for my arrest, and for Roger's too. I decided to wait until the morning to turn myself in.

At the police station I was put in a cage. The TPF were a special unit with a lot of pride; the Commander, a tall man in his fifties with a scar on his face, dropped in to make his presence felt. I was bailed and arraigned for court on 27 May, in ten days' time. I regretted the incident, and was upset by the police and press reaction; it seemed I might be deported and refused a visa in the future.

When interviewed by the police officer I had hurt I apologised sincerely, but the affair had become a matter of pride by then, and he wouldn't look me in the eye. In the street, under normal circumstances, if I had kicked a man with his training he would have dropped me in a heartbeat – or may even have shot me, and been quite within his rights to do so. What I couldn't find a way to explain was that my adrenaline had been running so high on stage that I hardly remembered the incident, nor did I have any sense of the power of my kick.

I called Karen back in London and explained what had happened.

'Pete, please be careful,' she said. 'I miss you.'

Hearing her voice, and the fear in it, I just wanted to give up the rock 'n' roll life and go home.

We did two more shows at the Fillmore, and somehow I managed to do good work. Then it was my birthday, and I decided again, as I often did at stressful times, to throw fate to the wind and revert to my aggressive stage persona. I was 24. I was a man. I would survive.

Tommy was released in the USA on 17 May and in the UK six days later. On 25 May The Who performed alongside Led Zeppelin for the first time. Three weeks later Roger and I went to a preliminary court appearance in New York, where our lawyer informed us that the issue was less politically charged now, and the charges would probably be dropped; still, we would have to return to New York for the court date itself. Relieved for the time being, we went on to play a series of shows that I still think of as the defining moments of our career. Our performances, always energetic and tiring, were now additionally taxed by the extra focus and concentration required to give *Tommy* its due on stage.

After our outdoor show with Led Zeppelin in Columbia we went on to the Kinetic Playground in Chicago. The Buddy Rich Orchestra supported us and Keith got to speak to his idol after the first show. Rich's drum solo at these two shows made every drummer in rock look like a chimpanzee. Joe Cocker was also on the bill, and I had one of the best times of my life listening and playing with him.

In San Francisco The Who argued with Bill Graham about having to perform twice for our first show – with *Tommy* it wouldn't work – but he was intractable. We made our first set very short as a challenge to his so-called 'authority', so he had a disgruntled audience on his side too.

Bill Graham was used to telling musicians what to do, what to play and for how long, and what to wear. In return he provided clean dressing rooms and great PA systems, and paid good money. Bill didn't know what to make of The Who. He was a really tough guy, but for some reason he adored me, and let it slide when I challenged him. In the end he agreed to let us combine the proposed two-show evenings into single-show evenings. We performed *Tommy* on both nights and from that day forward hardly ever performed two shows a night again, under any circumstances.

Back in New York, our court appearance was harrowing. Charges were dropped against Roger, but I was charged with a misdemeanour, the most minor legal infraction in the USA, similar to a 'caution' in the UK, and paid a $75 penalty. Relieved in spite of secretly hoping I'd never get another US visa again so I could be with my growing family, I told friends that I never wanted to go back to the States.

Before flying home on 23 June, I sat down with Frank Barsalona, our agent in New York, in his apartment, along with John Morris, a promoter, who pitched me on what came to be known as Woodstock. It sounded monumental, courageous and exciting, but it was only a few months away – too soon for me. I refused. I was a new father, and Karen had just spent two months on her own with a new baby in a new house. I had terrified her with my arrest, and I needed to give her and the baby some support.

Frank got quite animated, telling me I'd be a fool to turn this down – it was going to be the rock event of the decade, if not the century. I said I wouldn't consider performing under any circumstances; my mind was made up. I had faced down Bill Graham, so Frank didn't intimidate me. Frank went to his front door and locked a security lock, then went to the window and threw his keys to the apartment down into the street. He

told me that I couldn't leave until I agreed to perform. I sat out this absurd situation for two or three hours while John Morris tried to mediate. After missing my flight to London, I finally pretended to agree just to escape.

But Frank had a contract for me to sign before I did so. I scribbled my signature, knowing I could only sign for myself, without binding The Who. But a few days later, unbeknownst to me, Chris Stamp signed the final contract for the rest of the band.

Once I got home Karen was extremely tired, unsurprisingly. I did my best to help out with Emma, but I didn't feel like I made much of a difference, frankly. Delia DeLeon wanted me to meet her sister Aminta, a Stradivarius-owning cellist who had been in the first contingent of young Western women gathered around Meher Baba in the early Thirties. At Delia's insistence Aminta hosted a small garden party for Baba lovers, and Karen and I went with Emma in a carry-cot. Walking into Aminta's drawing room, I saw the magnificent Stradivarius. It seemed to be glowing. Then I did a double-take, like a cartoon character. There was another glow in the room. Next to the cello sat the girl from Australia for whom I'd written 'Sensation' (now incorporated into *Tommy*).

I introduced my wife and baby to her; she said nothing, but continued to glow. I felt that life was conspiring to teach me a lesson. Karen intercepting the letter from the girl from Australia had made me really face what I wanted from my life, and who I wanted to spend it with. I had no doubt the girl was uneasy in this moment, and I sympathised, but the heartless artist in me rejoiced that from our liaison I had produced a good song.

* * *

For me, getting a hit single after *Tommy* was something I thought might never happen again. But with 'Something in the Air', written by my friend and drummer/singer Speedy Keen, I had drawn on all my skills to hone a song that was as radio-friendly as possible. I produced it for Thunderclap Newman, a band formed behind Speedy, recorded the song at IBC studios after the *Tommy* sessions, and it went almost directly to No. 1 in the UK charts.

I went with Thunderclap Newman to the set of *Top of the Pops* to celebrate their first appearance on the show. I was backstage, feeling strange that I didn't need to appear on TV to earn my pay but kind of liking the idea, when an old friend took me aside and told me of the rumour that Brian Jones had been found dead. The details surrounding his death would take time to emerge, and the truth would always be hard to establish. I just sat there in stunned silence. I couldn't believe Brian was dead. I hadn't seen him since the *Rock and Roll Circus* filming, when he had been so unwell and upset. I knew he'd recently left the Stones, which must have been terribly painful for the man who had been the band's original leader.

Two days later, on 5 July 1969, The Who performed at the Royal Albert Hall at the first Pop Proms. We were on the bill with Chuck Berry. There had been some friction from Chuck about who should top the bill, so we agreed that he would close the 5.30 show, and we would do so at 8.30 p.m. I took my eight-year-old brother Simon, and left him in David Bowie's care. Across the road, in Hyde Park, the Stones had played their first show without Brian Jones, with Mick Taylor on guitar. They played in the afternoon, so afterwards quite a few of their audience walked over to attend our late show as well, all slightly worse for wear.

As the rockers started to get unruly, throwing things on the stage, Roger picked up a coin and came over to me.

'It's been sharpened, Pete,' he said. 'It's like a razor.' We managed to complete our show, dodging flying pennies without any harm, but were banned by the Royal Albert Hall for a long time. They must have thought we'd somehow incited the rockers, even though the mayhem took place before we'd started wrecking our equipment.

After the show I retrieved Simon from Bowie's care. They both said the same thing: 'I am going to do this.' David meant he would create conceptual albums based on imaginary characters. Simon meant he was going to be a rock musician. As I took Simon down a flight of stairs I came across the 'Sensation' girl from Australia, who had been looking for me. We had a short, embarrassing conversation on a landing as road crew bustled past. I asked her if she was OK.

'I was looking forward to seeing you again,' she said. 'Then, at Aminta's Stradivarius party, it was wife, baby.'

The wife and baby had stayed home today. Suddenly, I couldn't wait to see them. The glowing girl from Australia was to be the last girl I slept with before my marriage, and I intended, sincerely, never to cheat on Karen again.

I had to break the news to Karen about The Who's imminent return to the States. We agreed that we'd been spending too much time apart and would go together, taking Emma with us. We flew to New York and drove up to Woodstock.

The Who were to play on day two of the festival, the last show on Saturday night, following Sly and the Family Stone and Janis Joplin. Someone suggested that, because of problems on the local roads, we should leave early for our set. Karen and I made a quick decision that the baby needed peace and quiet, so I would go to the festival site alone. I slipped into my Doc Martens and my white boiler-suit, and we climbed into a limo. Our driver said the helicopters had stopped flying when the charter company realised they weren't going to get

paid. Wiggy's ears pricked up. He was responsible for collect-
ing our fee.

It took ninety minutes to drive two miles along a road so
muddy that occasionally we needed to be pushed by passers-
by. The road was littered with abandoned motorcycles and
cars, some still containing tents and other belongings. It
looked like a wartime flight. John and Keith were behaving
strangely in the car. We'd only been in the hotel for fifteen
minutes and they'd managed to score dope.

The scene greeting us at the backstage area of the festival
was horrific. The entire parking area was a slurry of thick,
gelatinous mud. The backstage crew were covered in it, and
their travels back and forth to the stage were traipsing mud
everywhere. As I got out of the car I slipped and sank up to
my knees.

There were no dressing rooms available so we went to a
tent with a hot-water machine, tea-bags, instant coffee and a
coffee dispenser. I helped myself, and within minutes realised
the water had been spiked with acid. It was fairly dilute, but
as the low-level trip kicked in about twenty minutes later I
noticed a photo of Meher Baba posted high on a telegraph
pole. It was a wonderful moment. The image was ubiquitous
at the time: Meher Baba as a young man, handsome, long-
haired, Christ-like. It felt like a sign to me that everything
would be OK.

Then tragedy struck. As I gazed at the photo a young man,
barefoot and shirtless, clearly out of his head, leaped up on the
roof of an ambulance parked under a telegraph pole and
gracefully shinned up some thirty feet. As he touched the
photo he screamed and fell backwards, landing on top of the
ambulance. The telegraph pole was in fact a power line. The
paramedics ran out to attend to the unconscious man. When
I went into the first-aid tent to investigate I thought I had
walked onto the set of *M*A*S*H*. There were cots of patients

everywhere, mainly young people on bad trips, some injured, but mostly kids suffering from bouts of terror.

Back outside the tent I saw the faces of John and Keith peeping out from the back window of a station wagon. They waved and grinned; later I learned that each of them had a girl's mouth around his cock.

I walked alone on the edge of the main field where most of the audience gathered. Rumour had it that over a million people had come to Woodstock, and it looked like half that number were scattered on the hill. The light was fading fast as I entered an eerie woodland scene: naked fairies dancing between the trees, dealers carrying trays of readymade joints, tabs of acid, hash, grass and rolling papers.

As I broke through the woods I came across the open area where most of the campers were strewn about. Thousands sat listening to the music pulsating up the hill from the stage, as though in a natural amphitheatre. The sound system wasn't bad, but neither was it designed to cover such a massive area. Occasionally someone would try to engage me, sometimes a loved-up soul on a trip, smiling and kind, sometimes another over-stoked boy like the one on the pole, demanding money or drugs, threatening violence, then laughing and running away at lightning speed like a woodland sprite.

The highlight that night had been Sly and the Family Stone, who had whipped the crowd into a muddy lather with 'I Want to Take You Higher'. Instead of acid they must have been doing cocaine: the music was urgent, dark and powerful. By now, in the early morning hours, Janis Joplin was finishing her encore, 'Ball and Chain', which would cap the last set before ours. She had been amazing at Monterey, but tonight she wasn't at her best, due, probably, to the long delay, and probably, too, to the amount of booze and heroin she'd consumed while she waited. But even Janis on an off-night was incredible.

As our turn on stage approached, I worried about losing the effect of the stage lights. I asked someone what time the sun was going to rise. As we set up our gear and began to play, some of the people in sleeping bags started rubbing their eyes and sitting up. As usual, I was pounding around like a frothing pony, fighting to keep my Gibson SG in tune, constantly fiddling with my amplifiers.

Whoever was doing the lights had chosen white lamps for Roger, so his long, curly hair looked like golden fire. He was mostly singing with his eyes firmly closed. Suddenly someone appeared at Roger's feet holding a big film camera. Roger nearly tripped over him, so I pushed the invader back down into the press-pit in front of the stage. It turned out to be Michael Wadleigh, filming the documentary that would make Woodstock legendary.

Vulnerable now, Roger moved in ways that seemed to mean something deeper. His whirling microphone and mythical poses suggested frustration and pain, his sweat an angelic sheen that evoked an Old Master painting. By contrast, John and Keith were laid back. They had dropped acid and consorted with a couple of friendly fans, and it showed. Skilled musicians that they were, however, they were still able to follow my lead.

As we started to play 'Acid Queen' I put myself in character, imagining myself as the black-hearted gypsy who had promised to bring Tommy out of his autistic condition but was actually a sexual monster, using drugs to break him. As I walked to the mike stand, someone stepped in front of me, trying to stop the music. It was Abbie Hoffman. 'This is a crock of shit,' he shouted into the mike, waving his arms at the audience. 'My friend [the Detroit poet] John Sinclair is in jail for one lousy joint and ...' He got no further.

Still playing the 'Acid Queen' intro, and still feeling malevolent, I knocked Abbie aside using the headstock of my guitar.

A sharp end of one of my strings must have pierced his skin because he reacted as though stung, retreating to sit cross-legged at the side of the stage. He glowered at me, his neck bleeding.

I finished the song and looked over at him. 'Sorry about that,' I mouthed.

'Fuck you,' he mouthed back, and left the stage.

I was always absurdly territorial about our performance space. This may have been instilled in me as a little boy with my father's band, the Squadronaires, but, for whatever reason, the stage was sacrosanct.

By the time we hit 'I'm Free' most of the audience was on its feet. Before I knew it, Roger was singing 'See me, feel me, touch me, heal me' to waves of young people who suddenly realised that *Tommy* was music unwittingly designed for precisely this kind of festival, for this particular moment, for *them*. At one point Keith shouted, 'For Christ's sake, Pete. No more!' I went into a long, feedback-rich guitar solo as the sky behind the hillside began to pale with the first signs of dawn. Ebullient but weary, I struck my guitar on the floor a few times, tossed it into the audience and The Who went home to London.

It would be some time before we realised that our Woodstock performance, which might easily have never happened, would elevate us into American rock aristocracy, where we would remain year after year, even into the twenty-first century. It wasn't just The Who; everyone who performed at Woodstock enjoyed mythic status once the film was released. Anyone who had been there on the field enjoyed their own special celebrity. Many who hadn't been there genuinely felt they had. Woodstock – a crock of shit in the estimation of at least two grouchy folk who had taken the stage: Abbie Hoffman and me – came to represent a revolution for musicians and music

lovers. Today there are over 450 music festivals every year in Britain alone. Woodstock became a model for what music gatherings could be. And it was Mike Wadleigh's beautifully edited film that locked its legacy firmly into place. He even made the mud look good.

As the Sixties came to a close, the band members of The Who had worked out their respective modes of survival, on stage and backstage. We were happy, and rightly so. The usually acerbic Albert Goldman, music critic for the *New York Times*, wrote on 30 November 1969 of our shows at the Fillmore in New York that The Who were 'standing now on the rock world's stage, haloed in fame, glory and gold'.

After Woodstock, especially after the release of the movie, much was expected of our live performances. The film had turned Roger into a star. On stage a smashed guitar was always expected, although out of sheer recalcitrance I would sometimes put my guitar down quietly at the end of a show, enjoying the groans of disappointment. There was still a sense that The Who were rather a gimmicky band – Union Jack jackets and Pop Art T-shirts replaced by long hair and guitar smashing – and many musicians didn't consider The Who anything close to a serious blues-inspired band like Cream.

There was a creative lull from me after *Tommy*, caused by the tumultuous flood of shows after its initial release, then Woodstock, and the mounting wave of enthusiasm triggered by the Woodstock movie. There was no time for me to form ideas for songs, and I had little energy left after our sets to sit around and play guitar. However, towards the end of every Who show I would play a few phrases finger-style, often down on one knee, with the audience silent, waiting for the explosion to come. On a single hearing, Keith and John chimed in powerfully, playing as though we'd been rehearsing the improvisation for a month. We were tight, coordinated and

riffing in such a way that all Roger had to do was throw in a few moans and screams, pose gorgeously, and we were full on.

Anything worth repeating I used in subsequent shows; then, over a week or so, Roger or I would come up with proper lines to sing. In this way we were developing new songs on the stage – and also inventing a new form of rock, though we didn't really understand this at the time. Led Zeppelin later used a similar formula; I don't know if they were as freestyle as we were, but the effect was similar.

Our record company was demanding our cooperation in controlling bootleg recordings of our show. What they didn't understand was that unlicensed recordings were being made by promoters as well as fans. Bill Graham recorded almost all of them, often using an on-site studio. Bob Pridden, our soundman, sometimes found pins inserted into stage cables leading off to makeshift recording bays. One such studio, in a box at Fillmore East in New York, hadn't been sanctioned by Bill Graham, who was the promoter, so he hurled the bootleggers and their expensive recording gear down the fire escape. I don't think any of us in the band knew, or cared, what might happen to all this music fifty years on. Graham knew it was important, though; he even discreetly filmed certain concerts.

I found out from a fan that Who bootlegs were being passed around widely: six songs performed at Monterey in 1967; the second night of our two-day stint in April 1968 at the Fillmore East (the night we got thrown out of our favourite hotel in New York, when Keith set off cherry-bombs in the elevator that contained the manager's wife); a set in New York supporting The Doors; another in Central Park; ten shows of varying quality and interest from 1969, including our set at the Fillmore, when I kicked the off-duty policeman off stage; and Woodstock, where I did the same to Abbie Hoffman and Michael Wadleigh.

* * *

The *Tommy* demos had been partly recorded at my top-floor home studio in Ebury Street, in London, and completed at my new, cramped home studio in Twickenham. My home recordings may have been starting to sound as good as what we produced in the multi-track professional studio, but generally the equipment was still expensive, cumbersome and – worse – delicate. Two of the band's stereo Vortexion tape recorders – good workhorse British machines, with military-grade components – were rugged enough so that I suggested to Bob Pridden that we carry one to record every show on the US tour. We would only have a stereo mix, but it could be refined throughout the tour, and we might get one really great show we could give to Decca, to beat the bootleggers to the punch.

Back in September 1968, before we had released *Tommy*, following rumours I had started myself that we planned to release a live album before starting a new studio album after *Tommy*, Decca had rushed out a strange collection of tracks called *Magic Bus: The Who on Tour*. It was a catch-all, intended to capitalise on the rumours, and contained not a single live track, merely a collection of singles, B-sides and a few random album tracks.

This time, in autumn 1969, I was convinced we'd have the album we wanted. Bob would record thirty shows in all. I couldn't really fathom how he might get a good sound using a single tape machine, the PA mix and one or two additional microphones, but he did. The band was playing really well, and Bob's recordings were superb. I listened to a few of Bob's tracks myself in his hotel room. Together, with planning and enthusiasm, we had cracked it, technically speaking.

Shortly after Christmas 1969, with the intimidating prospect of a number of *Tommy* shows at the very posh opera houses of Europe hanging over us, I met up with Bob. He had been

holed up in a studio listening studiously to each of the thirty performances he had recorded.

'So what have we got?'

'There's definitely an album here,' he said.

'So which show do you rate as the best?'

'They're all amazing, Pete.'

'But which one stands out?'

'They all sort of stand out. They're all fantastic.'

'So we should just pick one at random?' I was being my usual acerbic self. 'Let's have a look at your notes.'

Bob's worried expression revealed the dilemma: he hadn't taken any notes. After all, compiling albums wasn't what he did for a living. I had asked him to listen and tell me what he thought, and that's what he had done. Still, I was angry; there wasn't enough time for us to wade through thirty shows again. Plus we now had an additional eight that Bob had recorded in England – including the most recent show at the London Coliseum. For me to listen to thirty-eight shows would take five days in a studio. Even with notes I would lose track. This live album was never going to happen if we didn't do something, and fast.

'After the opera houses, have we got any shows we could record here in the UK using a professional mobile rig?'

'Leeds and Hull – Valentine's Day weekend,' replied Bob.

'Hire an eight-track rig, record the two shows, I'll mix them both at home on my new eight-track machine, and the best of the two nights will have to do.' I had just further upgraded my home studio with a pro multi-track tape machine and new mixing desk.

Bob was looking anxious again. 'What shall I do with the live tapes from the tour?'

Still irritated, I made one of the stupidest decisions of my life.

'Destroy them,' I snapped, and before leaving the room I uttered a warning. 'And if I ever hear a bootleg of any of those tapes I will know where it came from.'

This was terribly unfair to Bob, the most loyal of all Who employees and friends. It was also a dumb decision commercially and historically. I have long been chief protector of The Who archive, and those 1969 summer concerts in the US would have made a fabulous set of collectable shows – especially online as a complete cycle. They included the seven shows recorded in our *Tommy* week at the Fillmore in New York, and two wonderful performances at the Boston Tea Party, as well as other great nights.

Bob faithfully destroyed them in a bonfire in his garden. During the process he phoned me to ask if he could preserve just one tape for posterity. Foolish and sarcastic to the end, I taunted him.

'Ah! But which one are you going to preserve, Bob?'

When I arrived at Leeds University Refectory on Valentine's Day, 1970, where the first of the two new live recordings was to be made, I was surprised not to see a mobile vehicle of some kind. I had hoped we'd be using the recently built Rolling Stones Mobile. Instead, a junior engineer from Pye studios had showed up in a van with a bunch of bits and pieces in military-grade boxes, and was wiring them together in a room backstage. It hardly seemed an improvement on the basic rig Bob and I had dreamed up for the US tour, and I hoped there wouldn't be any problems.

The refectory (an eating place) wasn't particularly large, and the packed crowd made the atmosphere intense and hothouse. University crowds were often irreverent and noisy, but at Leeds they respected the fact that we were recording, and behaved very well. The sound in the hall was good too. I played more carefully than usual and tried to avoid the

careless bum notes that often occurred because I was trying to play and jump around at the same time. The next day we played a similar set in City Hall in Hull. This was another venue with a good acoustic for loud rock, but it felt less intense than the previous night.

I had a few weeks free from engagements to mix and edit the two new live tapes, but it only took me two days. The first reel I put up, from Hull, had no bass guitar track. If I had listened to the subsequent reels I would have discovered that this was only an intermittent problem, that more and more of John's playing had been safely recorded as the show went on. But it seemed such a tricky problem to fix that I moved quickly on to Leeds. Here the problem was that the backing vocals hadn't been correctly recorded. I arranged a session at Pye studios, played the show back, and John and I simply sang along. We covered the backing vocals in one take, preserving the immediacy of the live concert.

I didn't discuss with anyone what we would put on the record. I'm not sure why I decided not to include any of *Tommy*. I fixed a few blips here and there before realising that the entire recording was blighted by loud clicks. Each one needed to be cut from the master reel, and there were about fifty such razor-blade edits. Many more minor clicks, and noises during quiet passages of music, I simply couldn't fix. Chris added a note on the record label implying they had been left in deliberately. One questionable decision I made was not to try to pump up the audience's applause. There had been no audience track recorded, so I just left it as it was, a flawed but accurate artefact.

None of us in the band was ready for the overwhelmingly positive response to *Live at Leeds*. We'd thought of it as an interim record, as padding designed to quiet Decca and appease our fans. But this album vaulted us to yet another

level. There is little doubt that the heavy guitar-driven energy on the record (the mainly hard-rock songs I chose to include), combined with John, Roger and Keith's thunderous bravura musicianship, inspired the heavy-metal revolution that soon followed. The improvised blitz-riffing featured towards the end of the record and in the soloing on 'Young Man Blues' launched a thousand electric guitar bands in which crude force would be the main component of the music.

Apart from 'Amazing Journey' there were no other songs from *Tommy* on the album, and the softer, more musical side of what we were doing at the time was set aside. Led Zeppelin were also working with a powerfully driving stage sound, but Jimmy Page was following the tradition of Eric Clapton and Jimi Hendrix. By comparison, *Live at Leeds* is more direct and spontaneous. Our intention was simply to blow you away.

Nik Cohn, whose conversation with me had helped make *Tommy* accessible and less po-faced, wrote in the *New York Times*: '*Tommy* is rock's first formal masterpiece. *Live at Leeds* is the definitive hard-rock holocaust. It is the best live rock album ever made.' This was a glorious review, but after the critical success of *Tommy* it set another sky-high mountain of a benchmark that I'd need to transcend with whatever The Who recorded next.

Could I do it? And if I could, what else would I then have to prove? Where else could my life go?

ACT TWO
A REALLY DESPERATE MAN

Focusing on nowhere
Investigating miles
I'm a seeker
I'm a really desperate man.
'The Seeker' (1970)

Inside outside. Leave me alone.
Inside outside. Nowhere is home.
'5:15' (1973)

13

LIFEHOUSE AND LONELINESS

We were rock stars. All of us – Keith, John, Roger and I – had reasons to be happy, yet each of us was soon to suffer some kind of difficulty dealing with our new-found celebrity. What had happened? We were successful, hugely so. That success changed everything for us, for the band and for Kit and Chris.

At the end of 1969 The Rolling Stones had suffered an awful, stigmatising tragedy when a fight broke out at their Altamont show near San Francisco, and a member of the Hell's Angels, hired as security enforcers, was filmed stabbing a man to death. It seemed as though 'Sympathy for the Devil' was coming back to haunt them. At the beginning of 1970 The Beatles split up. In contrast, The Who seemed to have the gods on our side.

Looking back to 1965, when I believed The Who would only last a few years, I was amazed at our change in fortune. For the first five years of our career The Who had been struggling to compete with bands like The Move, The Kinks, The Pretty Things, Cream, Jimi Hendrix, Free and The Small Faces, and we weren't in the same league as the Stones or Beatles.

Now, suddenly, we were on our own. This isn't to say we were on top of any pile; but rather, we were out in open water when many of our equally serious peers seemed to be struggling to stay afloat in a sea of pop lightweights like Dave Dee, Dozy, Beaky, Mick and Tich, or The Herd. These bands were perfectly good, but they had no ambition to do anything adventurous. They just wanted hit singles. But by 1968 having

a hit single seemed almost irrelevant – at best a dubious achievement – and before long some of the bigger rock bands would turn their backs on the singles charts completely.

Yet by spring 1970, in the wake of *Tommy* and *Live at Leeds*, without any other musical project for the time being, no immediate ideas for a new large-scale work, I was emotionally and spiritually unsettled. This had probably been the most intense, vigorous and successful period of The Who's career, and now that everything was slowing down a bit all eyes were turning back to me, the composer.

The attention was challenging, and felt like an honour, and of course I was excited by the thought of creating some new, exciting project, but it was also disquieting and scary. From this point forward, my life was often fraught with the paradox of success and creativity. When I was brainstorming every day, searching deeply into myself – and the world around me, the past, the future, the band, its fans and music itself – for some kind of kick-start for inspiration, my actions sometimes seemed deranged and absurd.

This wasn't clinical schizophrenia, though in some ways it produced big mood-swings and compulsive behaviour in me. I was still a young man, learning a new trade as I went along, and I didn't really understand the pressures on me, or the damage and confusion I might cause to those around me, especially to Karen.

My spiritual longings, and continuing attachment to Meher Baba, were constantly under siege by all-too-worldly ambitions, undermined by residual scepticism and ambivalence, and challenged by my sexual yearnings. I didn't know then that Meher Baba would have worried less about the sexual stuff than I did, as long as I was sincere about loving him and accepting him as my master.

Even the addictions that would plague me for years seemed to have no internal consistency, regularity or logic. I could be

sober and responsible for days, weeks, months, even years. I could behave with dignity, and take on a range of ambitious commitments that would lead me into new, exalted circles, not only musically but intellectually. I could strive to achieve – and even pioneer – radical acts on behalf of social change. And I could also behave, frankly, like a complete arsehole.

In retrospect I can see that the desperate, chaotic and increasingly fragmentary nature of my life over the next twenty years was chillingly foretold in the lyrics of a song I was soon to write.

As spring 1970 wore on I neglected my dentist, rarely cut my hair and never saw my doctor. I was trying to keep the band recording, and at one point invited them to my home studio for a week of work. But we all had small ideas compared to *Tommy*. My best efforts were 'The Seeker' and 'Naked Eye'.

I was writing songs purely for fun – we were all trying to have fun together too, as a band. Maybe that's why it didn't occur to me just how much the words of 'The Seeker' – a song about a man I could see in my mind's eye as I wrote it, that wild-eyed Vietnam vet who grabbed Karen when we did our first tourist walk of Haight-Ashbury – reflected the impasse I was facing.

> *People tend to hate me*
> *'Cause I never smile*
> *As I ransack their homes*
> *They want to shake my hand*
>
> *Focusing on nowhere*
> *Investigating miles*
> *I'm a seeker*
> *I'm a really desperate man*

I learned how to raise my voice in anger
Yeah, but look at my face, ain't this a smile?
I'm happy when life's good
And when it's bad I cry
I've got values but I don't know how or why

I'm looking for me
You're looking for you
We're looking in at each other
And we don't know what to do

My characteristic stance on stage – the leaping, windmilling and wrecking of guitars – was by now a purely physical display of macho swagger, yet at a psychic level the Angry Yobbo, or hooligan, had seared himself into my soul, and I was still no wiser about where all that energy came from.

That Angry Yobbo had also somehow penetrated the soul of The Who as a band, but here the effects were largely positive. *Live at Leeds* had made us realise just how potent we were as live musicians and performers. The Who were a unit, a machine, a force of nature. As a composer I was just beginning to understand how to harness the power of our stage sound, and balance it with light and shade when making an album. Ironically enough, the idea of variance of mood and tone on an album would soon be tossed away. Hugely successful bands like AC/DC would make album after album using precisely the same degree of intensity.

As the number of big rock groups multiplied, each claimed a stratum of the available sound-field for themselves and guarded it jealously. Any artist straying into the territory of another would appear guilty of a lack of conviction. There were now two expectations of The Who that I could readily identify in our audience but had no idea how to reconcile. One was that for our next album we would produce some

audacious new idea, a new *Tommy*. The other was that the album would rock the way *Live at Leeds* had rocked.

If the band was playing as a unit, its internal machinery and its management seemed more at loggerheads than ever. If Roger and I (as well as Who fans) felt released by some of the raw power of *Live at Leeds*, Kit was still chasing the whale, as it were, of pop gimmicks. He was always egging Keith on to wilder publicity stunts, and me on to more arrogant statements to the press.

In June 1970 Bill Graham persuaded the director of the Metropolitan Opera to host *Tommy*. Our shows there weren't much to my taste, although I was proud to be there and confident we belonged. At Fillmore East during our week of *Tommy* shows in 1969 a smiling, elegant Leonard Bernstein had held me by the shoulders, looked into my eyes and asked me if I understood the importance of what I'd achieved. That same week Bob Dylan came to watch us. He'd said very little, but he was there, which said enough.

At the Metropolitan Opera House we did our usual high-energy show, but we did it twice in one night. We also performed a short encore after the first set, which was quite unusual for us. After our even better second set we ended with a final burst of energy, like marathon runners crossing the finishing line. We had given it our all; we were physically, emotionally and creatively wrung out. But many people in the crowd had purchased tickets for both performances (the faces in the front ten rows hardly changed that night), and having enjoyed an encore in the first set they expected one in the second. They carried on shouting while we got out of our damp clothes and planned to unwind in our hotel.

But Bill Graham had other ideas. He decided after fifteen minutes of cheering and stamping that we should go back on stage. I asked him to tell the audience to go home; he refused, so I did it myself. When the crowd realised what I was saying

they started to jeer. I threw my mike stand into the pit and stalked off. I knew we'd done a good day's work. Passing Bill in the hallway I looked him in the eye. 'It's easy to bring us on, Bill,' I said. 'It's much harder to get us off.' I still had a chip on my shoulder about the fact that the Fillmore East staff had failed to let us know about the backstage fire back in 1969, when I had ended up in court for kicking that cop.

Bill Graham took a step towards me with steel in his eyes, but then he relaxed, shrugged and allowed me to win. It was good of him, because he was a very powerful man – and a pugilist who usually won his fights.

We were soon back in the bear pit, and it was a big one, as we went from the pre-eminent US opera house to a baseball stadium outside LA. The Beatles had played New York's Shea Stadium in 1965, but this was still a rarity among rock bands. John Sebastian opened for us, and was perfect for the 'bring blankets and sit on the grass' atmosphere of the event. He was gregarious and talented, a fantastic harmonica player as well as a gifted songwriter.

Kit's advice in our first year together had been to run onto the stage as though it was the place we most wanted to be in the world. He advised us to wear stage clothes, and to use exaggerated movements that would allow our energy on stage to be read by audience members at the very back of a large venue. I always favoured white or light blue, and often wore white trousers. Keith did the same for many years. Roger made himself seem bigger by wearing a lot of fringe that rhymed with his long flowing hair. John wore eccentric tailored outfits, suits made from the Union Jack flag and later a leather one with a white skeleton painted to scale.

But what really made us work at long distance, apart from how loud we were and the epic nature of some songs, was the athleticism displayed by Roger, Keith and myself: Keith

throwing sticks high in the air and standing at the kit; Roger swinging his microphone and bashing it into cymbals; me leaping, jump-kicking and swinging my arm in a windmill. And through it all, as if to anchor the experience, John stood like an oak tree in the middle of a tornado.

Our next two shows were at the intimate Berkeley Community Theater, small, modern, with light wood-panelled walls and a sparkling acoustic. These shows were also produced by Bill Graham, who seemed determined to heal any rift between us. He not only laid on the most delicious steak and cheese fondue for us, but he solicitously cooked a selection for me himself.

On the first night, when Roger sang 'See me, feel me, touch me, heal me', the lights went down and a single, very tight spot illuminated his face. Then, as we launched into the slow-build finale, a curtain behind us went up and three massive Klieg lights, the kind used on Hollywood Boulevard for a film première, roamed the audience with their white-hot glare. For a moment the crowd didn't know what to make of it, but one by one they stood up, acknowledging that the music belonged as much to them as it did to us, until every single soul was standing. It was a brilliant piece of lighting design.

The real surprise was yet to come. On the second night, after another successful show, Bill took me aside and told me that if we had space in our truck the lamps were ours. We hired a special truck to carry them away. Bill Graham had redeemed himself.

In LA we stayed at a motel with rooms arranged around a pool. John Sebastian, whom I had wrongly taken for a New Yorker (he was born there), showed up for a visit with his new girlfriend. Catherine was a stunning blonde with penetrating eyes and an amazing mouth, always smiling. She seemed too young for him, probably 18 or 19, but otherwise a perfect foil

for the charismatic Sebastian. It turned out that they had bought a little house in Tarzana; their shared obsession was tie-dye. John, egged on by Catherine, asked me for one of my white boiler-suits so they could tie-dye it for me.

John also wanted to play me his latest song, a work-in-progress. He picked up a guitar and shuffled his chair near to me, so that he was, I felt, as an Englishman, rather too close. Look at the photos of John and the young Dylan playing together in Doug Gilbert's sublime photo book *Forever Young*. They each hold the other's gaze, merely inches apart. They share a level of intimacy I yearned for but was unable to cope with in reality. John looked into my eyes, held my gaze and began.

'Welcome back,' he sang. The song was lovely, but it put me in excruciating discomfort, seeming to be aimed at me in particular. I thought back to my friend Richard Stanley, and how he had misinterpreted my playing him 'Welcome' from *Tommy*. Now it was my turn.

Catherine lay back on the bed looking like Monroe reborn. I would have happily gazed at her, but John's earnest eyes held me in a vice. When the song was finished, he asked what I thought of it; did I have anything to contribute? I was almost ready to scream. For whatever reason, this level of intimacy between musicians and fellow songwriters has never been possible for me. Suffocated by feelings, I was unable to say a word. Catherine got up, they said their affectionate goodbyes, grabbed my white boiler-suit and left.

Alone in my room I drank too much that night, and tried to work out why it was that after half a bottle of cognac I felt such regret at not being able to manage co-writing. The truth is that, drunk or sober, it's out of my emotional range. I'm a loner, and never more so than when I'm in creative mode. I fell into a stupor and dreamt about John Sebastian's girlfriend.

The next morning I rolled over to face the sunshine streaming through thin motel curtains. My heart pounded: there was a shadow at the window. Someone was there. No. A body. Someone, some insane fool, had actually hanged themselves right outside my room. I could picture the rope tied to the canopy frame above my door, the lolling head, the torso, legs, feet. I watched tensely and saw no movement through the curtains except for a flickering shadow – the gentle, almost imperceptible sway of a body in the breeze. This, I thought, is what happens when you fuck with basic morality, even in your dreams. I leapt from the bed, grabbed the phone and dialled the front desk. 'Something terrible, terrible', was all I could say.

When I heard the motel manager's footsteps approaching my door, I nervously opened it and peeked out across to the window.

Keith? Kit?

It was my freshly tie-dyed boiler-suit stuffed with newspaper, complete with a large grinning Halloween pumpkin head and a pair of orange work boots.

Benefits from our new fame didn't follow us everywhere. In Memphis we were thrown off a plane and threatened with arrest. The pilot had emerged from his cockpit red-faced to demand who had used the 'b— word'. I put up my hand – I'd told Pete Rudge that *Live at Leeds* was going down a bomb, and the young flight attendant had overheard me and misunderstood the British meaning of the word. She was in tears.

A few days later we were in Cleveland with our friends Joe Walsh and the James Gang, who supported us for five shows in June and July. My old friend Tom Wright, from art-school days, travelled from Detroit for the Cincinnati shows. I have a cassette recording of the entire evening, with Joe Walsh and me playing acoustic guitars together, exchanging songs and getting very drunk.

In Columbia, Maryland, I arranged to buy a sleek-looking Dodge Travco 28-foot motorhome, and ship it back to Britain. I called Karen and told her about it, promising we could afford it, and that I'd find somewhere to park it in our narrow suburban street. She loved the idea.

After the Columbia show one of John's groupie frolickers attached herself to me; in a boozy haze I didn't tell her to scram. In fact my heart revved with anticipation and ambivalence. We talked for a while in my room and it became clear she was well read and smart. I could have asked her – gently and kindly, of course – to leave, but I didn't. After she took off her clothes and I took her in my arms, I quietly called her the devil. What could she have thought I meant by that?

A week later I was back home. I had demanded a two-week break from touring, and Karen had found a holiday cottage for rent on an island called Osea, in the Blackwater Estuary of Essex. All the properties on the island, including ours, were sadly run-down, and the weather was vile. Towser, our spaniel, ran into the sea and grabbed a heavy piece of driftwood that was far too big for him; unwilling to let go, he began drowning, so I had to dive in and save him. In the process I swallowed a small jellyfish; the water was full of them.

The cottage had no TV or radio; it was so cold that we huddled together, making love passionately but with chattering teeth, like Russian peasants in a Tolstoy novel; Karen said our second daughter Minta was conceived there, probably helped along by jellyfish protein.

Although this time was supposed to be a break, I had given myself a creative mission during the holiday to set Meher Baba's Universal Prayer to music. I succeeded, and it felt like a cosmic sign. One other job I had brought with me on holiday was journalistic. Ray Coleman, *Melody Maker*'s editor, had commissioned me to write fortnightly articles about music

and anything else that interested me. I had enjoyed reviewing a few records in 1969, praising the début albums of Mott the Hoople and King Crimson. I had also taken to writing letters to the music papers whenever something niggled me. 'Pete! You've been writing letters again!' Ronnie Lane would say; Keith Richards sent a handwritten scrawl asking if we could be pen pals.

My first *Melody Maker* article, written during the Osea holiday, was published shortly after. 'I'm beginning my first page of this bulky journal in particularly strange surroundings ... far away from the sounds of London's traffic and Keith Moon, on an island in the Blackwater estuary called Osea.' I went on with an unabashed plug for my buddy Joe Walsh, and the James Gang.

Why was I doing this at all? I had a day job in a band, and my free time was almost entirely packed. I was supporting the Meher Baba Association and attending meetings; developing Trackplan, a company I formed with record producer John Alcock to build home studios for my pop-star buddies; I was recording an album with Thunderclap Newman; and involved in a film cooperative called Tattooist, writing their film music and even delivering a lecture for one of them at an art college. But when The Who were between engagements I was incapable of slowing down and spending time at home. I was a workaholic, running away from the present, and probably the past, because something about my life made me uneasy – I was myself a really desperate man.

At a time when I could have been supremely happy I was feeling ashamed about being an adulterer, and oddly guilty about my professional success.

Writing for *Melody Maker* I was at least being honest about one of my principal defects: I loved the sound of my own prattling. But it was more than just that. In his manifesto for the

Ealing Art College Ground Course, Roy Ascott had used the word 'feedback' in a creative context. Feedback, he said, could be seen as the way an artist might evolve and deepen a creative project by observing the reactions of those who viewed your work or took part in it. With *Tommy* the feedback system began with Kit, and included Richard Stanley and Mike McInnerney. Even before my bandmates had fixed on the real picture behind *Tommy* and helped to make it happen, I had brainstormed with two smart, open-minded journalists, *Rolling Stone* magazine's Jann Wenner and John Mendelsohn.

Through my 1970 *Melody Maker* articles I hoped to do this again, but with clearer focus. The feedback I had enjoyed with Jann and John would be replaced by feedback from Who fans who would read my brainstorms and get involved. I would reproduce their responses in the *Melody Maker* articles, and a fertile creative loop would establish itself that would feed The Who its next big breakfast.

In all of this I overlooked one important fact. If I couldn't share my ideas too soon with the guys in the band, because they were so resistant to grappling with my awkward, often intensely secretive creative process, how did I expect our fans to help me? The journalists I'd worked with were used to brainstorming and creative risk-taking. They had closed the circle when The Who went on to do so many spectacular live performances of *Tommy*, underscoring my original aims, giving me a feeling that I had known where I was heading all along with *Tommy*, when in fact it had been a leap into the unknown. I could reach Who fans through *Melody Maker*, but how would they reach me back?

I conceived the idea of *Lifehouse* in August 1970 in my big new camper bus, in which I stayed for a few days after playing the third Isle of Wight Festival. Although the complete story didn't come together for another year, it was essentially one of

a dystopia, a nightmare global scenario, a modern retelling of Aldous Huxley's *Brave New World*. My hero in *Lifehouse* would be a good man, an advanced soul who would make a bad mistake and suffer the karmic repercussions. In the dark future I visualised in *Lifehouse*, humanity would survive inevitable ecological disaster by living in air-filtered seclusion in pod-like suits, kept amused and distracted by sophisticated programming delivered to them by the government. As with *Tommy*, people's isolation would, in my story, prove the medium for their ultimate transcendence.

In my draft, I touched on some of the major anxieties of the times. When the Earth's ecosystem collapsed, its inhabitants would have to drastically reduce their demands on the resources of the world. Only through submission to a police state would we survive. The allied governments of the world would join forces to demand that ordinary folk accept a long enough period of hibernation in the care of computers, in order to allow the planet to recover.

What would make forced hibernation, plugged into a mainframe called the Grid,* bearable? Only virtual experience, piped in through digital technology. What would free people from this forced hibernation? Live music and the Lifehouse. Rock music would be quickly identified by the controllers of the Grid as problematical. Because of its potential to awaken the dormant masses, rock music would be strictly banned.

A group of renegades and nerds would set up a rock concert, experimenting with complex feedback systems between the audience and the musicians, and hack into the Grid. People from everywhere would be drawn to the Lifehouse, where each person would sing their own unique song to produce the music of the spheres, a sublime harmony that would become

* It is now known as the internet or the World Wide Web.

what I called 'the one perfect note'. When the authorities stormed the Lifehouse, everyone would have disappeared into a kind of musical nirvana.

The Mysticism of Sound, a book written in the 1920s by Inayat Khan, a musician who became a Sufi spiritual teacher, was my inspiration for the story's musical solution. The core of my idea was that we could all hear this music – and compose it – if only we would truly listen.

The idea of dystopian bleakness that could only be redeemed by creative fantasy* resonated with me at a deep, personal, psychological level. I knew there was a manic-depressive element to my personality, a seasonal swing in my psyche between periods of emotional bleakness (forced hibernation) and the dynamic creative activity (the Lifehouse) that served to pull me out of the void. I had always relied on my imagination and creativity to see me through the lowest points, the darkest days of my childhood, and later at school, art college and the early days with The Who. I had come to rely on this mechanism to fly me out of danger and depression, like the air-sea rescue of a drowning man.

Before I could complete the story The Who were back on the road, playing a ten-day tour of Europe. The first show was in Munich, where during the improvisational part of 'My Generation' I started experimenting with completely new guitar work. I wanted to take the band into deeper musical terrain, and all three of my bandmates struggled to find a way into what I was doing. During the rest of the shows on this tour, and a set that followed in the UK, I continued to push hard to create mesmeric arpeggio effects on my guitar, leading into uplifting heavy riffs. Bob Pridden became like a third hand for me. He set up a series of complex fluttering echo

* For a complete exposition on the concept and history of *Lifehouse*, and its various incarnations, see www.TheWho.com.

effects, and by listening very carefully to what I played he introduced these at perfectly chosen moments.

The sound I heard on stage was wonderful, soaring, stratospheric, intoxicating. One otherwise appreciative reviewer remarked that my freeform work went off at too many tangents, but musical tangents were precisely what I was trying to explore.

In my second *Melody Maker* piece, published a few weeks after the Isle of Wight festival, I began my creative feedback experiment.

> Here's the idea, there's a note, a musical note that forms the
> basis of existence somehow. Mystics would say it is OM, but
> I am talking about a MUSICAL note. [...] Do you hear it? I
> think you must, particularly the allegedly musical lot who
> read *Melody Maker*. Probably all musicians or music lovers,
> i.e.: people with trained ears waggle waggle. They all hear it.
> Musicians have to learn to listen before they can begin to
> learn to play. I think it's the hardest part, the listening part.
> Probably why so many people involved in music are attracted
> to pot smoking, it helps one to listen.*

Earlier that year I had given a lecture at Winchester Art College about the use of tape machines by non-musicians. In the audience was Brian Eno, the experimental musician, who cites the lecture as the moment he realised he could make music even though he wasn't a musician. I wanted to go further. Encouraging our audience to become part of what I did as a composer and songwriter, and to contribute to the sound we produced on stage, was an important part of the second phase of my idea. I believed synthesisers would make

* *Melody Maker*, 19 September 1970.

it possible for non-musicians to express their creativity, but first I needed to be completely hands-on about them myself, as a layman.

I commissioned one of the first small synthesisers from a British company called EMS. Before the machine (the 'Putney') was delivered, I was given its manual, which became a vitally important resource. It opened with a simple description of how sound is made, how it travels through the air and how it is reproduced electronically. Clear diagrams made the basic physics behind musical sound easier for me to grasp. In my notes I envisaged the practical integration of synthesisers into the regular rock-band format.

I imagined The Who playing along with rhythmic synthe-siser sounds, or pre-prepared backing tracks on tape. By now musicians knew how to overdub in a recording studio, that is, play along with pre-recorded music, but in the live arena drummers were used to defining the tempo and pace of any particular song. In my home studio I played Keith a few synthesiser-chopped rhythmic demo backing tracks. It was a revelation how well and comfortably Keith was able to play along, and I realised this was how he had always played drums with The Who, following, rather than leading, the tempo set by John and myself.

As The Who dragged around Europe, trying to amuse ourselves with absurd displays of rock-star mischief, I was becoming increasingly determined to create something truly spectacular for the band's next project. It took me three days to write *Lifehouse*, from 28 to 30 September 1970. I scratched out a summary that would guide me and sent a copy to Chris;* I

* OVERTURE: The farmers – Life – Beauty – Celebration,
LIFEHOUSE: The City – Rock – Youth against finance – Individuals working for the whole,
GLORIFICATION: They disappear – they triumph, leaving everyone behind.

needed to explain the general idea behind *Lifehouse*, especially to Chris, so I also produced a comprehensive breakdown of what I felt we needed to bring the story to life. I described the sound systems we'd need, how we would record work in progress, the musical instruments required, how to collect the data needed to reflect each audience member musically and how filming might be handled.

As it happened, we were about to go into technical rehearsal that week to try a new lighting rig and stage design. I used these rehearsals to pitch *Lifehouse* to the band, but it quickly became clear that I'd blundered at first base. In referring to the sound of the entire universe as a single note and suggesting that when we gathered at a rock show we were taking the first steps towards re-creating that note, I muddled them.

Even today, pundits wishing to detract from the possibility that the *Lifehouse* project could ever have worked speak disparagingly about 'the one note' idea on which I rested my thesis in the early *Melody Maker* piece, relating it to the hippy notion of a universal chord, something I hadn't mentioned at all. The Moody Blues had dabbled in this kind of mystical writing, and I very much liked their sweeping melodic music at the time, but I was trying to evoke the style of Inayat Khan in my first verses and brainstorms about *Lifehouse*.

The song 'Pure and Easy' was the fulcrum song for *Lifehouse*, just as 'Amazing Journey' had been for *Tommy*. But behind the poesy lay a much more challenging ideal, and the possibility of a darker reality. The song refers to the one note, but also to the death of civilisation through the decay of our planet.

> *There once was a note*
> *Pure and easy*
> *Playing so free*
> *Like a breath, rippling by*

The note is eternal
I hear it, it sees me
Forever we blend
As forever we die

Confused by my presentation, the guys in the band didn't get it. 'It's like trying to explain atomic energy to a group of cavemen,' I told Karen when I got home. She tried to reassure me. 'I'm not sure I understand either, but I've got faith in you, Pete – and I think they do too. What you can't do is take on such a huge experiment and expect no difficulties.'

Karen always took my side when I ranted about my problems with the band. But she also offered her own opinions, and helped me see that although my role was often difficult, it was a valuable one. She often seemed to me to play the same supportive role as that of a miner's wife, her husband home from a day in the pits, who just needs empathy. She also tried to bring me back into the present, to the everyday pleasures of bathing children, walking the dog, cooking a simple meal, having a glass of wine and making love at bedtime, but my urge would be to go to my studio, to try to find some new way to get my ideas across – and all too often that's what I did instead.

I am clearer today about how my songwriting process had evolved by this time, but I had been writing songs professionally for just six years, and was still getting used to the enormous technical jump I'd made during the summer by incorporating a multi-track tape machine into my home studio. Access to my first music synthesiser was important too. What I knew was that once I had a good musical idea I could work much more quickly and efficiently than ever before, and my songwriting could be more ambitious.

That said, I needed more time, and I wasn't getting it. This was partly because of the pressure of constant touring; as

proud as I was of having created *Tommy* we were collectively getting tired of having to perform it again and again, but audiences internationally still seemed to have an insatiable demand for it. Over and above this, Karen became pregnant again in autumn 1970; she was 23, already a mother of a one-year-old girl, putting up with a compulsive rock musician living and working in her home. I was 25 – a young man still beset by anxieties and insecurities, who had no idea how to reconcile a growing family with the new pressures presented by The Who. As a result I found myself living in a bubble of denial: I would tell the band they came first, and I'd tell my family the same thing. I didn't accept that if I served one well I would probably fail the other.

In that bubble, incredibly, I continued to take on more and more work.

14

THE LAND BETWEEN

In the autumn and winter of 1970 I began experiencing regular manic-depressive episodes. To calm myself down I drank. One such episode took place after a concert up north when, instead of returning to the dressing room after a powerful experimental show, I wandered into the audience. I intended to mingle, to find some connection with the audience in keeping with the high-flown congregational notions I had espoused in my second *Melody Maker* article. Instead I got into a fight and drove home at dangerously high speed. I got lost, lost consciousness and didn't get home to my family until the early hours. At the time we were doing one show every three days on average, and whenever we had some down time I quickly found something else to do. I was probably just suffering from exhaustion.

Pete Kameron, a strange little gnome of a man whom Chris and Kit had hired as their own manager, came from New York to have me explain my *Lifehouse* idea. Chris and Pete Kameron both suggested that my complex ideas for *Lifehouse* really needed a theatrical structure, and that workshopping these ideas at the Young Vic Theatre might be helpful.

The next day I had my first meeting at the newly inaugurated Young Vic. Frank Dunlop, a friend of Kit's, was its artistic director, and we got on very well. My mental state was still unbalanced, though, and with a head literally bursting with new ideas – mostly unformed – I attempted to enjoy a

Christmas and New Year celebration with my family. I don't think I was able to contribute much.

I was nearly ready with *Lifehouse* by the end of 1970. I had overworked, was paranoid, short of ready money and despite my family's support I felt lonely. Even so, I was excited about *Lifehouse*, and driven to finish it. My excitement was greatest when I was exploring the terrain between the spiritual magic of music and the march of physics. Unfortunately I wasn't having much success communicating in the language I was using – one part science fiction, one part mystical waffle, one part visionary glimpses of the role computers could play in the future of electronic music.

The *Lifehouse* demos were mostly recorded in January and early February 1971. I played all the parts on every song, working particularly hard to get a good drum sound. A few days before workshops were due to begin at the Young Vic I published my seventh *Melody Maker* article.

> The music we play has to be tomorrow's, the things we say have to be today, and the reason for bothering is yesterday. The idea is to make the first real superstar. The first real star who can really stand and say that he deserves the name. The star would be us all.
>
> The Young Vic becomes the 'Lifehouse', the Who become musicians and the audience become part of a fantasy. We have invented the fantasy in our minds, the ideal, and now we want to make it happen for real. We want to hear the music we have dreamed about, see the harmony we have experienced temporarily in Rock become permanent, and feel the things we are doing CHANGE the face of Rock and then maybe even people.

On the first day at the Young Vic, Kit walked through and admired four huge paintings I had commissioned from my

eccentric artist friend John Davis. Each represented a member
of the band, their families and the way they lived their lives.
While Bob and I struggled to get the quadrophonic PA system
working, Kit disappeared, and I didn't see him again for the
duration of the Young Vic workshops. By contrast, Hoppy
(John Hopkins), from my UFO Club days, was smiling
mischievously as he ran around with his team and their video
cameras. 'This is radical, Pete!'

Hoppy was a lone voice. Roger, John and Keith looked
completely nonplussed. Frank Dunlop, the Young Vic's artistic
director, stood with Chris and looked as though he'd bought
a dud ticket for a lottery. He'd set aside a full week for work-
shops, and within a few hours it was clear that nothing was
going to take place that would prove anything to anyone.

The second day was as fruitless as the first. We did manage
to perform some songs to a pre-recorded backing track, but no
new music was produced; the assembled audience wasn't given
access to electronic instruments, or even tambourines to bang.
Any idea of trying to make music that mirrored the audience
– who numbered less than thirty* – had to be set aside.

We needed more money and time to make this work the
way I had envisaged. We ended up in the local pub, where
Chris explained that Kit had needed to get back to New York,
where he was halfway through making an album. I enquired
about some promised *Lifehouse* funding from Universal, and
Chris was evasive. As Judy Collins's 'Amazing Grace' started
to play on the pub juke box, Keith pushed the skip switch.
'We're not listening to that rubbish!' he announced. A hard
nut at the bar turned his head and quietly told Keith to put it
back on or take the consequences. Keith complied. It seemed

* The first workshop was held during the day, so attended only by truants. Also,
frightened we would be overrun, we made no announcements at all. So in fact no
one knew what we were doing. I felt the workshops would be best allowed to
grow exponentially.

as if we weren't going to be making any significant musical changes to the audience around us after all.

The crash I experienced after the second day at the Young Vic was immense, my fantastical imaginings having collided with reality. The high-flown writing, my grandiose theories in the *Melody Maker*, the scripts, technology, meetings pitching for money from Universal, the songs, the torturous struggle to do decent creative work while doing far too many live shows: it was all for nought. The Who made one more weekend appearance at the Young Vic, playing a load of old hits. I could see I had to give up on the *Lifehouse* project, or start all over again.

I worried about my family's privacy in our tiny house, especially now that Karen was seven months pregnant. Fans had started knocking on the door. Sometimes I managed to be courteous, but if interrupted when writing I was short-tempered, which could turn into fierce, dangerous arguments on the doorstep. Fans often felt entitled to my time simply because they'd managed to track me down and come long distances to visit. Karen and I had also experienced challenges to our privacy from hippies on the nearby Eel Pie Island commune, who sometimes looked on me as a resource. I wasn't around enough to provide my family with security, and I didn't like the idea of hiring out the job.

Karen struggled to give me support, but I had been working in a veritable bubble since the end of the previous summer. I couldn't explain to anyone what I felt. I was still experiencing manic-depressive anxiety attacks, hearing voices and music, seeing visions. The only medication that helped was alcohol. Most discouraging of all was the fact that when I listened to my demos I couldn't imagine how I could ever write better music, however hard I tried. During the day I walked the dog relentlessly, up and down the Thames footpath. I tried to do a

few interviews, but instead of inspiring me they only made things worse. It was an unusual stand-off between music writers and myself: I wanted their support, and they were only willing to give it if I would explain what I was doing in simple language.

The failure of *Lifehouse* to inspire the band in the way it inspired me was especially surprising because I'd used the same techniques I'd employed to make *Tommy*. But they didn't work a second time. One important difference was that Kit was no longer in my orbit. In some ways he had come to serve the role that Jimpy had for me in my childhood – as fellow adventurer and creative catalyst. But Kit had passed me off to Pete Kameron, and without Kit's support and enthusiasm I lost conviction in the sustainability of *Lifehouse*, just as my world had turned grey when Jimpy moved away.

Chris tried to hold the fort in London, but unbeknownst to me narcotics had breached The Who from top to bottom. Everyone in our management team was anaesthetised or high; it was the stereotypical story of rock decadence and ego-driven grandiosity, and every stratum of our operation was tainted.

Kit told the people at Universal that I was going mad. On that score he wasn't far wrong. But he also told them something way off the mark: that *Lifehouse* was the working title for music workshops that were really aimed towards the production of a forthcoming film of *Tommy*. One more nail in the *Lifehouse* coffin.

Now I had almost no contact with the other three members of the band. I wasn't even cheered by the arrival of my large new ARP studio synthesiser from Boston. It was delivered by the musician and programmer Roger Powell, who completely understood *Lifehouse* and offered many wonderful ideas for it, but I was too far gone. I fiddled with the big synthesiser for a little, but I'd lost my appetite for it.

* * *

In the same week, out of the blue, I had a friendly phone call from Kit. Still in New York, his enthusiasm sparked all the way down the line. He had discovered an exciting new recording studio called the Record Plant, designed by the brilliant acoustician Tom Hidley. He knew I'd love it, and suggested I arrange a quick band rehearsal of the songs I had ready to go, and then fly over to record with him.

A prayer I'd never made had been answered. I was so manic with delight that while taking the dog for a walk I wept and laughed my way around the local park in relief. Kit, dear Kit, had come to my rescue. New York. The spring. What could be better medicine?

The Record Plant was everything Kit had said it would be. Its large control room had an impressive desk. Tom Hidley had designed his own speakers with wooden tweeters; they were loud but sounded really good. The studio had two isolation booths – unusual at the time – allowing backing tracks with live acoustic guitar and a lead vocal to be recorded at the same time as the rhythm section.

The songs I had ready for recording had already been played once or twice by The Who during the chaotic Young Vic workshops, so it was a cinch to get them up to speed in a normal rehearsal room. They all sounded great played live: 'Won't Get Fooled Again', 'Behind Blue Eyes', 'Baba O'Riley', 'Love Ain't for Keeping', 'Let's See Action' and 'Getting in Tune'. A couple of test acetates were circulating (later bootlegged) containing songs I hadn't found time to rehearse back in the UK, but the band had been listening to them, including 'Bargain', 'Pure and Easy', 'Going Mobile', 'Greyhound Girl', 'The Song is Over', 'Teenage Wasteland' (an alternative version of 'Baba O'Riley'), 'Mary', 'Too Much' and 'Time is Passing'.

Jack Adams was Kit's new engineer. He was an old friend – we had worked together at a small studio in New York on some songs with my friend Steve Baron. Jack had always said

he hated heavy rock – he preferred R&B – so I was surprised to see him behind the board. I remember him demanding the snare drum be made to sound like a 'stiff cock', but he got a great sound.

After the session I tried to bring myself down with a drink, as always. Roger had hooked up with one of his contacts, and Keith and John had simply melted into the New York night-club scene. I spent the next morning in my hotel room, look-ing over lyrics, trying to work out how I might persuade Kit to salvage the movie component of *Lifehouse*.

For the first two days at the studio Kit himself didn't show his face. I knew he was staying in the same hotel we were – one of our favourites, the Navarro, facing Central Park. On the third day Kit arrived at the studio with his personal assistant, Anya Butler. I was surprised to see her, unaware that they were still working together. Kit was smartly dressed but food-spattered, as usual, perennial cigarette in hand, smiling his lopsided grin and ready for action. Jack already had a sound for the band, and we began with 'Behind Blue Eyes', which sounded very good indeed.

In the evening Andre Lewis, a keyboard player who had worked with Patti LaBelle, came to provide the organ for 'Getting in Tune'. The first sign of Kit's drug-addled condition came when, as the band was grooving delightfully over the extended coda, he came out carrying a piece of paper on which was scrawled some kind of command. He ran around the studio, crouching as if that made him invisible, and showed his instruction to each musician in turn. When he got to me I struggled to read what he had written. He brought it closer and closer to my face, and when I was finally able to read it I collapsed, partly in laughter, partly with exasperation, as the music shuddered to a halt. The note said: 'This is GREAT! Keep playing.'

Keith seemed the most disturbed by Kit's clumsy intervention. We had finally got into a groove, and being stopped at that point was like coitus interruptus. Kit and Jack then disappeared for about thirty minutes while an assistant played back the three or four takes of the coda; I was hoping to be able to edit an ending from a previous take, but the tempos were all slightly different.

When Kit and Jack returned, there was the usual energy from Jack, but Kit had visibly transmogrified. His colour had gone, his face had fallen. He slumped into a chair, lit a cigarette and closed his eyes. After all the musicians had trooped back to the studio, I looked over and saw Kit had disappeared again. I gave up and went back to the hotel.

I had very mixed emotions. I was grateful to Kit for arranging the sessions in New York. He had done it to revive the passions of the band, and to support me in my rambling ambitions, but his heroin addiction was still in its early days, and he didn't seem to know how to manage it. I slept badly that night, my vivid dreams populated by ghosts. As much as it revived ailing spirits in daylight, the fizzy energy of New York seemed to feed on human frailty at night.

I woke early to a beautiful spring morning, determined to see Kit and speak to him. Anya arranged a meeting for midday. I ordered coffee and gathered my sheafs of notes. If Kit was in trouble, the state of my papers revealed my own. Scribbles, reviews, updates, edits, scratch lyrics and confused brainstorms about *Lifehouse* were all lumped together. My new plan was to let go of the film once and for all, but to ask Kit to help me create some cohesive sequence for the songs that might suggest an underlying storyline – as he had done with *Tommy*.

Impatiently, I ran up the fire escape to Kit's room, a few floors above mine. I was an hour ahead of schedule. Anya and

Kit had neighbouring rooms, and their respective doors were open to catch the breeze that blew into the hallway. As I approached I heard Kit's animated public-school voice.

'If Townshend thinks he can swan over here to my new world and just take over he's wrong.' He was extremely angry. I could tell he was striding up and down the room.

'Kit,' Anya argued. 'The music is great. Pete is just –' As I entered the room, Kit saw me and, not knowing whether or not I'd heard his rant, attempted a smile and turned away.

'Kit is calling me "Townshend" now?' I murmured to Anya. I had never heard Kit call me by my surname. I loved him, and felt terribly betrayed. Anya had opened both sash windows to their limit and the park stretched like a green lake into the distance. Music filled my head, and the air around me danced with flitting lights as I walked to the window and looked out. I had a sense of weightlessness, and at that moment whether I lived or died seemed of no consequence. As I started to fall forward between heaven and hell Anya was suddenly by my side, grabbing my sleeve. She whirled me around.

'Pete,' she barked. 'What the hell are you doing?' Coming to my senses, I ran from the room.

Later I spoke to Roger and told him I was abandoning the recording sessions. I called and arranged a flight home. Throughout the afternoon my head continued to swirl. I wasn't drinking, I wasn't taking drugs, but at one point I imagined the room was full of agents and powerbrokers from Universal and Decca records. I heard them grumble that I had humiliated them, that I was a failure and that I would pay. As the ghosts in my dreams came to life I was being beaten by two Mafia-style thugs ... then there was a knock at the door. I slipped into the bathroom, and my nose was indeed bleeding. I cleaned myself up quickly and opened the door.

It was Devon, a friend of Roger and Heather. I had seen her once or twice with Roger, usually backstage at the Fillmore. She was a great beauty, a statuesque girl with an astonishing figure, her face slightly Ethiopian. She said she had come to offer me help and came towards me with a tissue to wipe the trickle of blood from my nose. I must have presented a pathetic picture.

'I'm sorry, Devon, you can't help me,' I said. 'I'm really fucked up here.'

As I said this she was reaching her arms out to me. In my wildest dreams I might have been able to handle such a woman, but in reality she frightened me. I was also suspicious.

'Did Roger send you?'

'Roger? I heard from Anya, who said you tried to jump out a window.'

I was still confusing dreams and reality. 'Universal have a contract out on me,' I whispered. 'I've been threatened by the Mafia. Kit is behind it all.'

Devon was still trying to hold me as I babbled on, but I pushed her away.

She was understandably furious. 'I supported one of the greatest musicians in the fucking world all the way through a nervous breakdown.' She started to say that she had been Miles Davis's girlfriend – and I knew this to be true – but I was beyond conversation.

'Thank you. Thank you very much, Devon, but you have to go.'

She didn't say another word, but drew herself up to her proud, full height and stalked out, while I continued to mumble my thanks.

* * *

The next day I was back in London. The Who still had a record to make. This wasn't just a contractual issue; more than two years between albums was too long. I attempted to enlist first-rate engineer Glyn Johns (our old producer and former lead singer of The Presidents) to work with Kit in London to complete what we'd started in New York, but Glyn wouldn't countenance working with Kit. Glyn was my model of what a good producer should be – someone who guides the music and creates the right sound – and there was great mutual respect and fondness between us. We were both impatient in the studio, perfectionists who worked quickly. It was his work as an engineer on the early Who sessions with Shel Talmy that had made them sound so great.

Glyn listened to the tapes from the Record Plant and agreed they were good, but he made no bones about the fact that he could do better. He also felt that a completely fresh start would re-energise the entire band. I agreed. Some tricky politics flared up over the Atlantic with Kit over production control and credits, but Chris smoothed it over. I was still hanging on to the frail hope that I could sequence the *Lifehouse* songs to reveal the meaning of the story behind them. I had enough songs for a double album, and quite a few lyrics that I knew had great promise, if only I could grab some time to complete more demos. I imagined a gatefold sleeve in which, at the very least, I could publish my manifesto for the *Lifehouse* idea.

The recording with Glyn at Olympic studios immediately demonstrated that his approach was superior to Kit's. After a couple of weeks we had enough tracks ready to start thinking about the shape of the album. I presented Glyn with my ideas for sequencing. It was then that I came up against his intransigence. Sequencing the album to serve a story would undermine one of Glyn's greatest strengths, which was to sequence an album to best serve the music. Glyn invited me to coffee at a nearby café so I could explain *Lifehouse* to him.

I did my best, but *Lifehouse* wasn't an easy idea to pitch in a few minutes. I did a poor job of explaining it, and Glyn – who had been concentrating very hard – responded in typically direct fashion. 'Pete, I haven't understood a single word you've said.' His befuddlement was yet another nail in the coffin. Incredibly, my exhaustion and disappointment gave way to an enormous sense of relief.

Soon after we started recording with Glyn in April, The Who had one more weekend engagement at the Young Vic – a fundraiser that coincided with the birth of my second daughter, Minta. I smoked a cigar on stage and announced her arrival – just as that motorcycle messenger had announced my own birth to Dad in Germany: 'It's a girl!' We played 'Won't Get Fooled Again' for the first time in public with the backing tape, and the impact was profound. The rest was a bit of a mess, and we treated the several shows that followed as tests, almost rehearsals for the two elements of the *Lifehouse* project that I refused to let go of – synthesisers and backing tapes. The shows were carefully spaced, two or three days apart, and paced to allow us to do good studio and rehearsal work.

In rehearsal it became obvious that using analogue synthesisers on stage wasn't going to work. I needed a preset synthesiser for each song (there was no way to retrieve patches on the first synthesisers). But the backing tapes had proven themselves at the Young Vic, and Keith could play to a pre-recorded tempo exceptionally well, something that every good drummer can do today, but was unheard of in 1971. As we got on top of the recording with Glyn we slowly increased the frequency of live shows, all in the UK. Roger says that working on songs in live shows before recording them is his favourite method, and Glyn often got good studio performances from us in one or two takes.

In July, at a happy party at Keith's wonderfully eccentric house in Chertsey, we launched the new album. *Lifehouse* became the pathetically titled *Who's Next*. The album cover was, in my opinion, a joke in bad taste. On the front we stood next to an obelisk against which we had been pissing. On the back we were all pissed in a dressing room after a show. The sleeve almost stank of urine. I was utterly confounded when so many fans and friends I respected loved the title and the sleeve design.

I fell into a petulant mood, but recovered as I realised that by some miracle Glyn was putting together a single album from the rubble of *Lifehouse* that would be the first Who material in a long time to be properly recorded.

Joseph Strick, the American film producer, writer and director, came to visit me in London a number of times. His film *Ulysses* had been highly regarded, and he wanted to make a movie of *Tommy*. His ideas were dark and interesting, and he was keen to dig into the project, but I had very little time to give him. The Who had a US tour booked starting on 29 July, and on the 16th my family would be travelling to New York on the *Queen Elizabeth 2* ocean liner.

My friend the artist Johanna Freudenberg had arranged a house for us to use during the summer in Bayshore, on Long Island. Her family had a holiday home nearby, so we would be near the beach. A series of shows had been arranged that were all within easy reach of New York. Emma was now two years old; Minta was still in a carry-cot. In July, determined to try to combine family and touring, Karen and I arrived in New York and moved into the house.

The Who's first show was on Long Island itself, at Forest Hills, a short drive from Bayshore. On stage I felt a release of explosive claustrophobia, rage, frustration and depression as The Who's music – and my physical workout – converted

emotion into adrenaline-fuelled passion and exhilaration. I drank neat Rémy Martin on stage that night, and insisted on having a bottle near my amplifier.

I ended this show by smashing two guitars, hurling one into the air and, in homage to the venue's famous tennis tournament, I used the other as a racket. After I walked off the stage and my adrenaline started to dip I decided I didn't want to go back to Bayshore. Wiggy had booked the road crew into a nearby hotel since we had another show at the same venue in two days' time. I planned to have a couple of drinks with Wiggy and Bob Pridden, listen to some music and let the adrenaline settle before going back to my wife and babies. I lay on Wiggy's bed to rest.

On the radio news we heard that a security guard had been stabbed to death by a fan outside the stadium after being told there were no tickets. The blame was attributed to the violence of our show. I was deeply shaken. Until that moment I'd been comfortably tipsy. As I began thinking about getting home, the girl from Maryland whom I'd called the devil appeared at the door looking more like an angel. She was wearing a flowery summer dress, her breasts firm and proud under the thin fabric.

Within seconds our re-acquaintance had become a sexual reunion. Where I had resisted Devon and paid the price of comfort that might have helped me, this time I decided not to resist, and paid an entirely different price. I knew that living a lie would eat away at me, and it did. Many people around me felt I made too much of this kind of thing, and looking back I agree with them. I was a young rock star after all. But my standards weren't high, they were just muddled.

My capacity for booze while on stage was enormous, especially if I stuck to cognac, but I still refrained from using the drugs my friends were using; cocaine was everywhere backstage, and both Keith and John combined it with Mandrax,

which couldn't have done their hearts much good. Roger smoked a little grass, and occasionally drank alcohol, but he didn't necessarily need a fix – girls always wanted to have sex with him. The next day I went to Manny's famous music shop in New York and bought $30,000 worth of guitars, a symbolic act of shameless self-indulgence I could ill afford.

On stage in Chicago Roger tried to get me to take control of my sound. I took no notice but started to spin on the spot like a dervish. He became angry and kicked over my amplifiers, knocking down a crew member who was standing behind them. Later that night, unbeknownst to me, he put his hand through a glass window in frustration.

Bit by bit, chunks of *Tommy* had sneaked their way back into our set list, which was usually put together by Roger a few minutes before each show. By the end of the tour we were playing a kind of *Tommy* medley along with the heavy rockers we'd made famous with *Live at Leeds*. New songs from *Who's Next* were slow to become familiar and established, but it was some consolation that we arrived home in time to see *Who's Next* go to No. 1 in the UK.

The Who now lived in splendour befitting our status as rock stars. Keith had Tara House, his modern pile in Chertsey. Roger bought a beautiful sixteenth-century house in Sussex, and lavished money on developing it. John bought silly cars, dozens of basses and brass instruments, custom-made luggage and a fairly modest new house in West London. Karen and I wanted to build a house with an architect, and were looking for land; we wanted to be close to Karen's family and their country home on the upper Thames. We also intended to keep our house in Twickenham. Even though it was too small, we loved it.

After some false starts we found 'The Temple', a delightful riverside plot in Cleeve on the Thames, five miles downriver

from my in-laws' house. We retained the cottage and outbuildings, but tore down the house (intending to replace it with something more exciting). With three weirs near the cottage, the place was stimulating. Our gardener pointed us to a book about the area that described ley lines running between Stonehenge, Glastonbury and Goring-on-Thames, 'where a temple was formerly sited near the river crossing of several prehistoric tracks'. I had serendipitously happened upon a promising site for my new studio – a creative, stimulating environment complete with ancient energies.

After the failure of *Lifehouse* Chris Stamp was determined to find a film treatment that would serve the band, reunite us, pull Kit back into the fray and trigger some new giant leap. He went back to Nik Cohn, the *wunderkind* critic who had inspired the pinball *leitmotif* of *Tommy* and anointed *Live at Leeds* in the *New York Times*. Chris commissioned him to advise us, and possibly write a script.

In the late summer and autumn of 1971 we had a number of meetings with Nik. I dropped small bombs into our conversations, and took photos with my new Nikon camera. One is of Chris and Nik at the Track offices in Wardour Street; they are young and smiling. Chris is his usual handsome self, hair a little long in front, swept in a long fringe to one side. Nik has his mop of unfashionable curly blond hair and glasses, his face like Mr Punch.

Chris and Nik were buzzing on cocaine in the middle of the day, punting ideas in front of a classroom blackboard where they had chalked a lyric fragment by Stephen Stills. I never felt a part of the discussions.

The producer Lou Reizner wanted to record an orchestral version of *Tommy*. I met him in November and, as I had completely forgotten Kit's own ambitions for its orchestral

implementation, gave Lou my blessing. When Kit heard I had approved the project he was deeply hurt, and yet another obstacle was placed between us. *Tommy* was chiefly my work so I had no need to feel guilty, but Kit had played a major part in it.

Before the band was packed off to the USA, we performed at the Oval cricket ground with our friends in The Faces. Rod Stewart kicked footballs into the crowd and the party atmosphere continued hours after the event, while Kit chased after the promoter who had run off with the money, allocated for a charity. I was drunk by the time I drove through the exit gates with less than an inch to spare on either side of my big American camper bus.

The US tour started in Charlotte, North Carolina. I took the opportunity to visit Meher Baba's American home in nearby Myrtle Beach. One of the verses of the song 'Who Are You' refers to my experience walking through the forest there for the first time.

> *I know there's a place you walked*
> *Where love falls from the trees*
> *My heart is like a broken cup*
> *I only feel right on my knees*
> *I spill out like a sewer hole*
> *Yet still receive your kiss*
> *How can I measure up to anyone now*
> *After such a love as this*

I was overcome. I tried to sleep in one of the simple guest cabins arranged around the secluded lake at the heart of the estate. The next morning, before joining the band in Charlotte, I was shown round Meher Baba's modest house. My mind was racing ahead to the show I had to do that night, when suddenly my guide opened a door and showed me in. 'This,' she said

dramatically, 'is where beloved Baba slept. You will want to be alone here for a while.' She left the room and closed the door behind her.

I had no idea how to behave, what to do, how to pray. My friends who had visited Meher Baba's tomb in India had felt deeply moved when they had placed their heads on the marble capping of his headstone. So I knelt and lay my head on the edge of the bed. Nothing happened. I waited a little longer, hoping for … I didn't know what. And then I had a vision: Meher Baba as the superb young man he had been in his youth, lying face down on the bed, naked, and I was his lover. The vision felt less like a specific memory and more like a familiar feeling, somehow connected with my childhood. I pulled myself up off the bed, shocked and a little ashamed.

Alcohol helped. In Miami, slightly hung over in a rented convertible Pontiac, I stood up to feel the hot, rushing air. It felt sublime: my hair blowing in the wind, Moby Grape on the radio, Wiggy doing his racetrack weaving through traffic. After our first show a wealthy friend of the promoter invited us to a party at his house in the Keys, which was dominated by a huge indoor swimming pool. I was drunk enough to swim naked for the first time in my life in the company of fifteen or twenty other young people. I repaired to the sauna – and there she was again, the 'devil' girl from Columbia. I wondered if I was being stalked. This time, though, instead of turning to me she began to caress the girl I had followed into the steam.

I ran back to the pool and swam the width underwater, my eyes firmly closed, only to emerge between the legs of yet another voluptuous, smiling blonde. I really didn't know how to manage this rock 'n' roll infidelity thing at all.

I had only been away from my family for a week. I did my job, packed and unpacked my suitcase, and hoped for a good

night's sleep uninterrupted by Keith wrecking his room. Drinking was now necessary every day there was a show, but I knew when I got back to my family I could knuckle down and behave.

We had two shows arranged in New Orleans, our first time there. When we arrived I was greeted by Chris Stamp, who had brought Nik so we might continue brainstorming a new idea for a film that would involve the band. I pitched a working title: 'Rock is Dead, Long Live Rock'. I also had a few written notes for a dual album about rock 'n' roll decadence in conflict with its youthful, idealistic roots. I had engaged my brain no further than the end of my nose, but Nik and Chris were content to have something to work with. Nik started right in interviewing the other three members of the band, taking notes.

Backstage in Los Angeles it was clear that the band had reached a new level of cool. Glamorous Hollywood actresses walked in and out of our dressing room, and Mick and Bianca Jagger watched our show from the side of the stage. I wore a crown I had found at a theatrical outfitter and asked Mick what he thought.

'It's hard to take you seriously, Pete,' he said fondly. 'You look like a cunt.'

We had two shows in San Francisco where I further developed the idea for the *Rock Is Dead* project. Instead of confining myself to a 'before and after' double album, each member of The Who would write (or curate) one side of a double vinyl album each. This harkened back to 1966, and Kit and Chris's plan for each band member to write a quarter of the songs. Meanwhile, Nik and Chris worked in secret on a movie treatment called *Rock Is Dead (Rock Lives)*.

The brief of the movie's narrative turned out this way: to present The Who in a simple, accessible way, in vivid, brilliant

cameos. Nik had worked hard on it, seeing that a stylised documentary about the band would not only be entertaining, but could also go some way to explain why rock had happened at all. I needed help, and Nik had offered it. After my theoretical tsunamis with *Lifehouse*, Nik's introductory notes were a lesson in brevity.

> The Who have now worked together longer and harder than any other major group; have played to more people on more nights in more places under more pressures than anyone, until they have come to encapsulate almost all of Rock, past, present and future, within themselves. So if one catches their development, that isn't simply a story about four kids growing up and getting rich. Partly, yes, but it also becomes a metaphor for Rock in general – their public, and their context, and their time. That, in the simplest terms, is what *Rock Is Dead* aims for: to catch The Who and, by doing so, catch the essence of Rock itself.

I couldn't have hoped for a more affirming beginning from Nik. Indeed, with time much of what he envisaged for The Who came to pass.

Interviews Nik had conducted on our recent tour informed the cameos he created for each member of the band. For me they made sobering reading, and I decided not to share the treatment with my fellow band members, afraid of the hurt that it might cause. In hindsight this may not have been the best decision, but at the time it seemed right. Of course anyone looking at The Who in this period would have seen a lot of comedy, absurdity, hypocrisy, grandiosity, infidelity and pathos, mixed with stadiums full of powerful rock shows, available women and massive dollar grosses. Nik's treatment, after its smart and incisive introduction, churned all of that up.

The Who were really quite ridiculous. As the band's principal architect I had known it all along. I put the treatment away in a file and never referred to it again.

15

CARRIERS

I drank, then I didn't drink, then I drank, then I didn't. It was black and white, on and off, at home or on tour. I tended to drink heavily but rarely got helplessly drunk. The options it gave me, to be up, down or merely numb, got me through some difficult years.

As 1972 began, Emma was two and a half, Minta six months. At last we had a nanny to help, Trisha, who was also my part-time secretary. Trisha was sparky, resilient and unimpressed by me. She was a Bowie fan, and irritated me with her rapturous descriptions of his brilliant make-up as Ziggy Stardust. I probably irritated her by claiming that *Tommy* had been his inspiration.

While I planned my visit to India and ruminated over the rise of Ziggy Stardust, we started weekending at The Temple at Cleeve. It had never been intended as a permanent home – in any event we wanted to stay in our small Georgian house in suburban Twickenham. The cottage was draughty, cold, unpleasant and shoddy. I hated it. But it was a few feet from the river flowing past, faced the southern meadows and rolling hills of Streatley on the opposite bank, and when the sun came out it was a pleasant enough. The river close by was the redeeming factor, much as it was at Twickenham, where even though Karen had knocked down some walls we were still packed in like sardines.

Living modestly as we did, I could pretty much say what I wanted about anything that offended me about the rich – whoever they might be. Few of our friends had ostentatious homes. None of the band was wealthy. Roger bought his beautiful Tudor house with a surprisingly small amount of cash and did a lot of the restoration with his own hands. Keith's Tara House was splendid and mad, but mortgaged to the hilt. John had yet to splash out on a big house, content to live in Ealing in a semi-detached, but made up for it with the Cadillacs in the garage and whatever pharmaceuticals he kept in their gloveboxes. Our cars – silly, flash or boring – were all purchased on credit. We had worked hard. We had enjoyed success. But we were, effectively, still broke.

My two brothers still lived at Woodgrange Avenue with my parents, in the flat upstairs where Barney and I had lived for a while. Mum had taken in an untold number of musicians and given my Nanny Dot a home for her last years. Uncle Jack, too. There were always people around, and lots of conviviality. Woodgrange Avenue was a cul-de-sac, and my parents knew everyone in the street, and everyone knew them. My notoriety was something all the neighbours enjoyed. They could all talk about what a snotty little git I'd been as a boy.

If any Who fans appeared on the doorstep, my parents would entertain them. They kept an open house, really. Dad played less and less music, more and more snooker and golf, slowly allowing himself to retire. Mum was harder driving, and rarely stopped. A raconteur, she managed to laugh a lot and was well loved by her friends, but could still explode in aimless anger. I learned a lot by watching my parents. Together, they seemed to show me the Middle Way, the Buddhist path to inner liberation.

During Dad's birthday celebration on 28 January he coaxed me to have a whisky. I had managed to stay off the

booze for a month, but Dad was persuasive – and a biblical drinker.

The next day, slightly hung over, I set off on my pilgrimage to India.

I had been summoned by Sarosh Irani, the member of Meher Baba's family who had organised the celebrations of the Master's passing. When I arrived, the Meher Baba people suggested I perform a few songs. On this first trip I played 'O Parvardigar,', my version of 'The Master's Prayer,', and 'Drowned', which would appear on *Quadrophenia*. While I performed in front of the Tomb where Meher Baba's body lay, I glimpsed him for a moment, sitting in an armchair, waving one hand from side to side like a metronome. On the recording I made, you can hear me skip a beat at the sight.

My spiritual submission to Meher Baba at the Tomb was fraught with the same trouble I'd had by his bed at his house at Myrtle Beach: all I could think was lewd thoughts. I still have no idea where they sprang from, but they certainly made it impossible for me to be subsumed like the other pilgrims. Even so, I was enchanted, not only by Meher Baba's disciples and close followers, but also by India itself.

I stayed at Sarosh's villa in comparative luxury, and his wife Viloo looked after me kindly. But it felt like a whirlwind trip. I had felt a more profound sense of Meher Baba's presence at Myrtle Beach, and although meeting many of his Indian disciples meant a lot to me, what I enjoyed most about this trip was that it felt so normal, natural, gentle, real and homey.

Back in London, Lou Reizner began recording his *Tommy* orchestral album in April. I had been uneasy about Lou's desire to cast Roger as Tommy; I felt we were losing the opportunity to bring in a new, different voice. But as soon as I heard Roger's first tests I changed my view. Roger had grown

enormously as a singer, and hearing him in the context of an orchestra was proof positive that he was the perfect choice.

Lou lined up a great array of celebrities to perform alongside us. I did no work at all with the arrangers, and attended only the first and last of the sessions at Olympic studio. I found the first session horrifying. As David Meesham began conducting the London Symphony Orchestra with the legendary Keith Grant engineering, a rock drummer and bass player with a large amplifier kicked in. The orchestral detail was lost in their thunder; the effect was dreadful.

Keith Grant did his best, but it wasn't good. The recording was made in a few takes, but I could find nothing helpful to say about it. Lou Reizner sacked the musical arranger for his inclusion of live drums and electric bass and gave the job to Will Malone. Sublime by contrast, his pieces also sounded more like real rock 'n' roll. Even so, I didn't go back to the studio until the last session.

The first public performances of this orchestral *Tommy* were to come later in the year.

Once Karen, the girls and I were properly set up in the Cleeve cottage in June 1972, I wanted to get the studio equipped. I had the Neve mixing desk ready to go and fancied doing the installation myself, as I had in all my previous home studios. The acoustic work was tedious, though, and the wiring complicated. Instead of eight channels I was dealing with sixteen, and with a larger mixing console and its many additional connections the sheer amount of cabling was beyond me. Trisha suggested I might like to meet a friend of hers, Rod Houison, a musician and sound engineer who could take on the installation of my studio and also act as chauffeur and minder for me.

I liked Rod immediately. To facilitate the journey from Twickenham to the studio, I bought a Mercedes Grand 600

limousine. This extraordinary car, with its six doors, black windows and TV, became Rod's daily runabout. He worked a six-day week, driving to and from Cleeve every day, averaging 1,000 miles a week.

With Rod driving, I could also safely go out with friends and get drunk. I sat in the back like a twat, drinking cognac, dictating replies to fan mail and playing music loudly. Sometimes, to make it clear a yobbo rock star was in the car, not a financial potentate, dictator or pope, I lowered the window and stuck out my Doc Marten boot.

I had another epiphany that June, less theoretical than the one that had spawned *Lifehouse*, but personally just as risky. If I was to serve The Who with new material, I had to take complete control. I knew it would be hard work, but I had recovered sufficiently from *Lifehouse* to attempt a new album. I would try to avoid film. Music and story: I'd keep it succinct, simple and effective.

I also realised that there was something important about Nik's *Rock Is Dead* treatment that I had missed. The four members of the band were very different, and by this time, even as relatively young men, extremely eccentric. This offered contrasting doorways into the music for our fans. Nik's treatment helped me recognise that The Who were *carriers* for our fans. Live shows gave us a sense of being filled and refuelled; we carried that energy from our fans and used it to power our performance. Without live shows we lost our entire sense of function.

In band meetings I found myself experiencing a strange duality. I could see myself as the band's guitarist. I did my job, rarely did a bad show, and caught my share of praise. Seeing myself as an equal member of the band was good for my humility. There were a dozen guitar players far better than me. But when I did press interviews I suddenly took on the role of

primary driver of The Who's musical direction. A new voice started to talk, and like a man possessed I was often surprised by what it said. This, for instance, in a *Rolling Stone* interview two years earlier in May 1970:

> I believe rock can do anything, it's the ultimate vehicle for everything. It's the ultimate vehicle for saying anything, for putting down anything, for building up anything, for killing and creating. It's the absolute ultimate vehicle for self-destruction, which is the most incredible thing, because there's nothing as effective as that, not in terms of art, anyway, or what we call art. You just can't be as effectively self-destructive if you're a writer, for example, or a painter, you just can't make sure that you're never going to fucking raise your head again; whereas if you're a rock star you really can.

The duality continued when I closed my studio door and started writing and recording new songs; then The Who became a kind of client. It was in that mindset that I turned to *Rock Is Dead*. The glimpse I had been given by Nik of the four extreme characters in The Who was all I had. How could I write something new and grand for The Who and simultane-ously make each band member feel they were truly a part of the process?

My idea was to take the band back to our roots. We'd been different then; we'd been subsumed in the Mod gang, and we needed to do that again. At least I did. I had grown up in a gang when I was a four-year-old street kid running wild in Acton. When you're part of a gang you soon find the parts of you that don't fit. These apparent defects can become assets; they're the things about you that make you interesting and useful.

So what did this mean for me? All the piss-taking I got from the band about following Meher Baba made it clear that what couldn't be accommodated in The Who gang was my spiritual

longing, my increasing concern that I lacked purpose. That summer I wrote the following reflection:

> The river makes me think of old times. Somehow, those days on the water were the best, with a first love, full of potential. Things should have turned out better. These feelings lead to more desperation. Not mental, not problems of the heart, not physical, not frustration. Rather, a deep, nauseating spiritual desperation. Nauseating because there can be no answer.
> Why should I care, if I have to cut my hair?

This was to be the first line of the song 'Cut My Hair', which arose out of the cognitive dissonance between my worldly concerns and my spiritual desperation. I also referred to *Tommy*, making it plain that this time I wanted to try to stay *inside* my hero for the entire opera. I went on: 'Trace the late teens of a kid to the point he experiences a lot of things that fuck him around. I will take a four-angled approach. The kid is – sort of – *quadzrophenic.*'

This is the first mention of what would become the working title for *Quadrophenia* (with the 'z' dropped). In this first sketch there is no elaboration of the setting that became so fundamental later on, but already I saw my new hero as a Mod.

> He goes through a series of temptations. He realises what the four facets of his character bring out in him. The good, the bad, the romantic and the insane come together. His triumph is strange, he feels ecstatic to find all his parts combined. He is also sad to be nostalgic again, looking back. Something makes him want to get back into life.

My hero was someone I was still holding close.

* * *

After our vacation débâcles on Osea Island and Bayshore, Karen and I decided we needed a real family holiday. We would use the American camper and take with us all the food our children required. We wanted sun, so we decided to go to the South of France, and booked a place for the bus near Marseille. I built a permanent cot for Minta in the back, gathered up Emma's trike and my guitar, and we set off. The drive took us through the heart of France, and every stop-off was a new adventure.

Sometimes I drove through the night while my family slept; it was uplifting to come upon small villages, where after midnight entire families still sat outside their homes, the lights welcoming, drinking wine, playing *boules* and enjoying the cool air. When we shopped, Karen and I bought huge flagon-baskets of cheap local wine – tasting better than claret – and made love when the girls were asleep. It was a happy time.

In France I generally tried to keep my new idea out of my mind, but on long drives I allowed it to surface. *Quadrophenia*. I wanted to do an album that would mark The Who's tenth anniversary. I wanted a replacement for *Tommy* in our stage act. I was also looking for a way to stroke four eccentric egos, generate a sense of optimism and rally us. I believed I had one last chance to do something that might hold us together. My bandmates had almost stopped listening to me.

On 2 August Bob Pridden called, in some distress, about Eric Clapton. Bob's partner and future wife, Mia, was a good friend to Alice Ormsby-Gore, Eric's then girlfriend, and was desperately worried that the couple had succumbed to long-term heroin use. Alice, the youngest daughter of Lord Harlech, had begun seeing Eric when she was still sixteen. Bob asked if I would go with him and Mia to assess the situation.

We met that evening at a pub near Bob's home in Ripley. It was pouring rain, so we didn't get out of the pub and on our

way to Eric's exquisite Arts and Crafts country home nearby until after closing time. Slightly drunk and proudly touting my Porsche's perfect road-holding in all conditions, I lost control of the car on a wet country lane and nearly killed us all. We ended up between two trees, but had miraculously missed both. We arrived at Eric's house at 11.30. I didn't see the irony in a drunk showing up to offer assistance to a junkie.

We arrived at the same moment as Alice, who had driven to and from London to score more heroin. Eric was listening to Bill Withers and J.J. Cale, laid back and mellow. The house was a quintessential Surrey mansion; Eric still lives there and I think it's one of England's great houses. He was his usual funny, courteous, gentle self. Two fine Weimaraner dogs loped in and out as he put logs on the fire.

Alice nodded off almost immediately. Bob, Mia and I didn't know how to deal with heavy heroin users. All I knew was that Eric had stopped performing and found it hard to make recordings. Eric showed me the small studio in his garage, which had a Helios desk and an eight-track tape machine. It was the real deal. I offered to work with him on some tracks he had started. No one mentioned heroin or spoke of why we were there, but under the surface we all knew. And, when Bob and I left at 5 o'clock in the morning, I had two reels of tape tucked under my arm and thought perhaps we could reach Eric through music.

Towards the end of The Who's summer tour of Europe I persuaded Eric and Alice to come over and join us in Paris, thinking it might animate Eric and get him interested in playing before big crowds again. The Who were booked at a massive daytime event, the Fête de l'Humanité, sponsored by a Communist newspaper of the same name to raise funds for the party. I didn't realise this until I found myself on stage and saw all the red banners.

Eric and Alice, beautifully dressed, stood on the side of the stage. Even when they were high they were elegant and well-behaved, but at one point – probably because of my leaping and running around in my boiler-suit throwing imaginary hand-grenades – Eric started to laugh helplessly.

'*You* should try to keep this fucking band moving along,' I shouted to him over the racket.

In a single month in 1972 a number of incidents occurred that should have told me I needed to slow down. One night, when my driver Rod had become ill with gastroenteritis and had to go home, I drove the Mercedes much too fast and was chased by the local police and arrested. I spent the night in a cell, and a court case would follow. Finally, when my court case for speeding in the Mercedes came up, I lost my driving licence.

At a family dinner with friends, someone made a remark to the effect that men were all the same. I responded by swiping all Karen's coveted china from the kitchen. I was trying to be ironic of course, but it was the behaviour of a complete jerk.

After dinner with Karen's family in Moulsford, I became angry with our artist friend Johanna Freudenberg for nagging her partner Chris Morphet about his driving on the short drive home to Cleeve. So as soon as we got back I jumped into my Porsche and drove it into a tree on the driveway. Quite how that taught Johanna a lesson escaped even me at the time.

After a family row I called Dad a coward for being subservient to Mum. And one evening in Cleeve, when my parents had come for the weekend as guests, I railed at Mum for over an hour, until Dad interceded and they went up to bed. I sat with my brandy bottle, in tears. The next morning Johanna commented that she hadn't known I was capable of such 'Latin emotion'. She was being kind – I'd been an arsehole.

There had been time enough in the first part of 1972 for me to recover from the intense overwork and pressure of the first

five years of The Who's career. It didn't happen. When I started on *Quadrophenia* in earnest I was already exhausted. The première of Lou Reizner's orchestral *Tommy* at the Rainbow in December, which should have been a wonderful evening, became an excuse to celebrate, and to drink, and thus to fuck things up.

I had written out the interminable lyrics to 'Sally Simpson' in a small book to jog my memory, and, at some point in the evening, someone – mischievously or kleptomaniacally – had torn out half the pages. Or so I thought. Instead of going back to the start of the song as I performed it for the partygoers, I simply pretended to wipe my ass with the book and tossed it from the stage into the audience. As I threw the book the pages flipped in the air, and I realised I had simply stopped too soon. The words I wanted were a little farther into the book.

Much of this darkness infected my work. Our country cottage didn't help. After sunset it became squalid and depressing. The river no longer sparkled with light and droplets of water; at night it was all freezing spray, icy wind. No wonder Jimmy the Mod in *Quadrophenia*, emerging from the chrysalis during those autumn and winter months, was such a whining little git.

Quadrophenia isn't a straight narrative, but rather a kind of distorted dream-view. Nik's composite of the four members of The Who, called Tommy in *Rock Is Dead*, became Jimmy in *Quadrophenia*, and all my hero needed was a few days in which to find a way to recover from being a Who fan. I wanted everyone who listened to the album to find themselves and their own story in it, including each member of the band. If my malaise, and Jimmy's, was spiritual, then the members of The Who were simply going to have to bite the spiritual bullet, because it seemed to me that our fans' malaise was probably spiritual as well.

Despite the setback of *Lifehouse*, I was still convinced that we would somehow draw creative energy from our fans. We would find ourselves in them.

16

A BEGGAR, A HYPOCRITE

In early 1973 I made several visits to Eric Clapton's house, but nothing had changed. Lord Harlech, Alice's father, joined me there one day. It was tense. While Alice was out of the room, Eric told Alice's father his fears that if he and Alice stopped using heroin their relationship might change, and he might not still feel in love with her. Harlech gently made it clear that he cared only for their lives at this point. Later he called me and proposed that to help Eric I should ask him to perform in January at a concert at the Rainbow for a charity Lord Harlech supported.

When Eric agreed in principle I began to put a band together. I turned first to Ronnie Wood, who provided positive, generous energy. We invited Jim Capaldi, Traffic's drummer, and Steve Winwood. Rick Grech from Family, whom I adored, played bass. He introduced me to amyl nitrate in liquid form, telling me it was harmless, not a real drug at all. I hadn't used any drugs since 1967, so my tolerance was low, and I was impressed by the simple power of having the blood supply to my brain quickened.

We started rehearsals at Ronnie Wood's house, The Wick (a house I had always loved, and dreamt of owning). Stevie Winwood didn't appear. Speedy Aquaye, Georgie Fame's conga player, played along with Jim Capaldi on drums. Ron Wood played in support of Eric, mainly slide guitar. I played electric rhythm, chugging along in my usual way. Eric had a

very clear idea of what he wanted to do, and we very quickly started to sound like a band. The room we rehearsed in was oval, opening through three sets of french doors to the garden and an open view of the Thames. Ronnie's wife Krissy sat on a stool smiling like an angel, wearing a flowery dress, her blonde hair framing her schoolgirl-pretty face, which belied both her stunning figure and her mischievous spirit. She made it like a rock 'n' roll affair that would have been perfectly appropriate in California.

With only a few days to spare before we moved to a proper theatre to do a soundcheck, there was still no sign of Stevie Winwood. I rang and threatened him with unspecified violence, and the next day he duly arrived with his Hammond organ. From then on the band took off into another level of stratus cloud. There had always been a deep connection between Eric and Stevie; they had, of course, played together in Blind Faith, and worked together intuitively.

The soundcheck was a breeze. On the night of the concert I rolled up to Ronnie Wood's house in my Mercedes 600 limo and we all piled in. It felt like an epic event. Ronnie Lane and his partner Katie came along for the ride. Stevie rolled a joint, and I took a small puff of my first marijuana in more than five years.

The concert, on 13 January 1973, passed flawlessly, and the atmosphere was quite glorious. Everyone who attended had good things to say about it. Ron Wood played an astounding solo exchange with Eric on 'Layla', and we extended the song for ten minutes (it was edited for the live album release). With no leaping around, I wasn't affected by the usual adrenaline rush I had with The Who, which allowed me to enjoy every note of the music played that evening. The stage seemed to elevate slightly as we ended.

I'd been part of the creation of a new band from the ground up. I'd known precisely how to play my part as a solid rhythm

guitarist, and my contribution had been valuable. I hadn't worked like this since the early days of The Who, and it felt very good indeed.

Once the concert was over I settled back into my boozy routine, wine at home with my family, cognac in my studio when I was composing. I returned to *Quadrophenia*, the story still incomplete, looking for a simple hook on which all the music could hang.

I began to experience a powerful comedown from the lack of amyl nitrate. I felt cold, depressed, tragic, lost and hopeless. On a dark, wet, winter weekend in the jerry-built cottage at Cleeve, with the river flooding part of the lawns, the wind howling through the badly made doors and windows, my memory pulled me back to a single night when I was 19 years old.

I had slept for a few hours under Brighton pier in 1964 with my art-school friend, the pretty, strawberry-blonde Liz Reid. We had been together for a riotous night at the Aquarium Ballroom after our gig on the night of a Mod–Rocker street battle on the seafront. Walking along the beach in the dark, under the pier, trying to stay out of the drizzling rain, we'd come across a group of Mod boys in their anoraks. They were giggling as the tide came in, getting their feet wet. We sat with them for a while. We were all coming down from taking purple hearts, the fashionable uppers of the period.

As I thought back to that night, a sense of falling and vertigo came flooding back with the flooding river outside – I felt that same sense of depression and hopelessness. But I also felt again the remembered romantic warmth of nodding off on the milk-train home in the early hours, with Liz by my side. For a short time we had both felt like Mods. There was something wonderful in all that. We also fell in love, and yet I didn't go on another date with Liz, never again. The moment with her was frozen, exalted and would always be special.

In the house at Cleeve, the river raging outside in the black-ness as I looked back, I realised I'd worked up – or down – to this moment of epiphany for quite a few months. I wasn't actually alone: I had a wife, kids and friends asleep upstairs in the cottage. I grabbed a notebook and, anxiously and quickly, while still in this sad, lonely mood, scribbled the story featured on the inside sleeve of the original vinyl album of *Quadrophenia*.

This was the story of Jimmy, a young Mod, hopeless, stranded on a rock in the rain, wondering if he might find redemption through the recounting of his pathetic life thus far by the four members of the band he felt had once reflected him, now loved and lost, just as he had loved and lost every-thing else important to him as a teenage Mod.

I wanted *Quadrophenia* to be released in quadrophonic sound, four channels representing the four facets of my hero Jimmy, each channel taking the form of one member of The Who. As the recording unfolded it became clear that, technically speak-ing, *Quadrophenia* was going to be a complicated, audacious project. I planned to emulate Walter Carlos's *Sonic Seasonings* album, with extraordinary soundscapes between tracks providing atmosphere for my simple story. I wanted to capture the raging sea in quadrophonic sound.

My Cleeve studio would make a terrific quadrophonic mixing suite, but it couldn't accommodate The Who for recording. I needed a large commercial studio whose control room included a quadrophonic speaker array I could trust. Nothing like this existed in London, so we would have to do what I'd done in Cleeve, and build it ourselves. I turned to Wiggy.

Wiggy, our dedicated, technically driven, seemingly insane production manager, had started life with the band as Keith and John's driver (a baptism by fire), had progressed to

looking after lighting, and then to dealing with promoters on the road, booking hotels, making travel plans and bailing us out of jail – when he wasn't conspiring with us in the business of getting arrested in the first place.

I explained to Wiggy that the studio at Cleeve would be fine for mixing, but that the recording room there was basically a tractor garage. He invited me to check out the road crew's storage facility and tape archive in Thessaly Road in Battersea, which turned out to be a very large church hall full of road gear.

'What a pity we don't have enough time to turn this building into a studio in time to record the tracks,' I said.

Wiggy screwed up his eyes. 'When do you want it?'

'Sort of ... now?' I replied apologetically.

'Now,' he repeated.

'That would be good.'

Six weeks later, through Wiggy's employment of a troop of thirty workers from an off-season circus, and with considerable help from John Alcock of Trackplan, we moved in. The large studio room was complete, massively soundproofed, lined in hardwoods, with two booths, one for grand piano, one for acoustic guitar, and another smaller corridor that doubled for guide vocal. The layout was perfect for us. I believe Ramport, as the studio was known, was the first studio in London to offer three isolation booths in this way. It meant we could record drums, bass, piano and acoustic guitar with a guide vocal simultaneously.

The sound was glorious. We hired Ronnie Lane's mobile, and used that to record the basic tracks until the work and acoustics in our own control room were sorted out.

For *Quadrophenia*'s album sleeve I felt we needed an approach that was photographic, truly authentic in detail. Glyn Johns, who had co-produced *Who's Next*, suggested his close friend Ethan Russell to shoot the sleeve photo for that

album in 1971. Although I hadn't personally liked that obelisk-pissing album cover, I loved Ethan and his work, and knew he was perfect for a serious photo-document about a young Mod.

Barney had come back into my life around the time Karen and I became interested in LSD and Meher Baba, back in 1967. He too became a follower of the Silent Master. From then on we saw each other often, and I regarded him as invaluable in all matters relating to The Who. On this occasion he helped put together some Mod consultants and a group of people to pose as models for the *Quadrophenia* shoot. My brother Paul and Janie – Simon's future wife – were also in the cast. It felt like a family affair.

Recording *Quadrophenia* with The Who was a joyful experience. Not having a driving licence, I travelled to and from Ramport studio in Battersea by speedboat on the Thames. Inside the studio the walls were hung with Who trophies – gold discs, awards and souvenirs, most of which I'd never seen before. A flight case containing a full bar was always sitting by the piano booth. I drank Rémy Martin by the pint from an old-fashioned, heavy, dimpled mug, borrowed from the local pub. Keith's drumkit faced the huge window between the studio and control room, John was set up to his right and me to his left – just as we appeared on stage. When Roger was present he occupied a vocal booth next to the control room.

The studio was filled with exotic instruments we rarely played: marimbas, glockenspiels, xylophones, vibraphones, gongs, drumkits and tympani. (Keith knocked them all over in the finale of the album.) There was also a Hammond organ, electric pianos, a beautiful Bösendorfer piano, guitars, amplifiers and all kinds of strange things. Wiggy had purchased them from Manny's Music Store in New York City, and charged them to a touring account.

The control room – completed in June, about a month after we began recording – was graced with brand new Studer tape machines, 16-track, 8-track and twin stereo machines. Every add-on gadget deemed necessary was present in triplicate. We had a gorgeous, eccentric, blue Helios desk, *de rigueur* in rock at that time. Instead of the usual two (or at the most four) large monitor speakers our control room had *twelve* JBL 4320s! Four pairs at the front, two pairs at the back. The sound level was monstrous.

There was a button on the desk that said 'Do Not Press'. The button had no purpose other than to create shock and was potentially the stuff of heart-attack. If pressed, a nuclear explosion shuddered the room at a reading of about 138db. The effect would send most normal folk to the floor in tears.

Ironically, because of the UK miners' strikes, triggered by mining disasters and poor working conditions, there were massive strikes while we were recording the *Quadrophenia* album in 1973, and we had to work with a government-imposed three-day working week meant to preserve energy.

After a couple of weeks' preparation the Ramport recording began in earnest on 22 June. Kit pretended to be the album's producer for the first several weeks. Showing up smashed, usually extremely late, he sometimes brought delicious but unwanted food from the trendy South Kensington restaurant AD8, in which he had shares. He scribbled his usual incomprehensible notes on tape boxes, and for a while prevented our engineer Ron Nevison doing his job properly.

By the end of the second week I had had enough. Kit had been distracting the recording process, erasing tapes while I was out of the room, and I just snapped. Close to punching Kit, I sacked him instead. For weeks afterwards we were visited by irritated heroin dealers trying to find him.

Ramport started to take on a new life. I loved working there. Wiggy and Keith always managed to hire gorgeous, sexy women to help run the studio. Three local girls sat at the desk behind the control-room window, watching us play, wide-eyed and impressed. There was no better audience.

When John started work on the brass parts, he gathered for the purpose at least twenty or thirty magnificent trumpets, horns and valve trombones. He could play all of them, writing out his parts on manuscript paper like an orthodox composer, and working through the recording meticulously until his lips started to go numb. He was wonderful to work with, disciplined, funny and inspired. What he arranged and played on a whole variety of exotic brass instruments fitted my own synthesiser and strings arrangements perfectly. The Who members still had that one all-important facility when we were making music: we listened to each other.

The rule we established during recording was that energetic musical rage would be used throughout. We didn't need throwaway tracks for light relief, we didn't need light and shade, irony or humour. An iconic Daltrey bellow could convey an extraordinary range of human emotion: withering sadness, self-pity, loneliness, abandonment, spiritual desperation, the loss of childhood, as well as the more obvious rage and frustration, joy and triumph.

The angst of those teenage years in which we all feel misunderstood is easy to make fun of, but it's real, and it brings my hero Jimmy to the brink of suicide. When, at the end of the album version of the *Quadrophenia* story, Jimmy steals a boat and takes it out to a rock in the middle of the sea, his anguished but jubilant cry, 'Love reign o'er me', suggests that he has finally been able to integrate his multiple selves. Even as author and composer I realised I had no right to decide whether or not Jimmy should end his own life. I let Jimmy decide for himself.

Studio recording was completed by 1 August. Mixing began at my studio in a barn two days later. I was excited by this move, and looked forward to creating the soundscapes I felt would transform the music we'd just recorded into a stunning sonic journey. When finished it would provide us with a rock-opera piece cohesive enough to replace – even improve on – *Tommy* as the backbone of our stage show.

I spent part of the summer recording sound effects: rain, storms, thunder, trains, traffic and of course the sea. I also commissioned a radio announcer to cover the Mods and Rockers battles on the beaches, and recorded myself walking along a beach singing the first few lines of 'Sea and Sand' to use as a prelude. Taping birds taking off on the river was a major coup, and I had a lucky moment as I approached a gaggle of geese in my punt. This kind of sound design is almost as fulfilling to me as composing music.

Mixing ran from 3 August to 12 September. There were a few short breaks for business, family (as it was the holiday season) and catching up on the quadrophonic technology I hoped would allow me to do a quad remix once we'd completed the stereo. This was the most intensely creative and demanding studio work I had ever done.

Thus far, by mid-September 1973, every part of my evolving plan for *Quadrophenia* had unfolded gloriously. Apart from Keith's occasional antics the band had supported me, given me creative space and done the most extraordinary work in the studio. All we needed was a month and we might have finished things properly. Instead, I was shocked to read in the press that the UK release date of the double album was less than a month away, on 13 October, with the first tour date a little more than two weeks later.

I still had to complete the quadrophonic mixes that I esti-mated would take about a month. And I'd figured that the rest

of the work we had to do – mastering the stereo album in Los Angeles, mastering a quadrophonic version, preparing quadrophonic backing tapes for our stage rehearsals, rehearsing and getting the show on the road – would take us through the winter. I'd imagined we would probably tour the album in spring 1974, but the idiots at Track couldn't bear to miss the lucrative Christmas selling period, and forced the premature release date.

I should say, in their defence, that the idiots at Track were as deeply in the red financially as The Who by this time, so their decision was probably necessary to keep the company afloat. Building Ramport studio had cost £330,000 at the time of opening (nearly ten times that at today's standards). Roger was on edge. He had been harbouring grave doubts about our manager's honesty.* The heavy spending – of his fellow band members, and Wiggy for the new studio – was driving Roger crazy.

Tension was building for me, too. When I rushed from Cleeve to Shepperton with stage tapes that had taken forty-eight hours to prepare, having had no sleep at all, and Roger announced he had waited long enough and was about to go home, I flipped. It wasn't Roger's fault, but I lashed out at him, trying to give him the Abbie Hoffman treatment with the neck of the guitar, while a film crew recorded for posterity every move we made. Roger responded by knocking me out.

Some observers claim I arrived drunk. Yes, Bob and I had celebrated finishing the stage tapes with a brandy in my limo, but on this occasion it would have been mainly exhaustion and frustration, not booze, that was ailing me.

* * *

* I may have sacked Kit as a record producer but he was still The Who's manager and we were still on Track records, the label owned by Kit and Chris.

Critical reaction to *Quadrophenia*'s October 1973 release was relatively muted compared with the raging success of *Tommy*, but over the years it has come to be seen as superior to *Tommy* both musically and conceptually, and as my 'redemption' after the collapse of *Lifehouse*.* The album sleeve note ends this way:

> So that's why I'm here, the bleeding boat drifted off and I'm stuck here in the pissing rain with my life flashing before me. Only it isn't flashing, it's crawling. Slowly. Now it's just the bare bones of what I am.
>
> A tough guy, a helpless dancer.
> A romantic: is it me for a moment?
> A bloody lunatic. I'll even carry your bags.
> A beggar, a hypocrite, love reign over me.
> Schizophrenic? I'm Bleeding Quadrophenic.

Roger was the helpless dancer; John, the romantic; Keith, the bloody lunatic; and I, needless to say, was the beggar/hypocrite. But the four aspects of Jimmy the Mod's multiple personality were, in a sense, *all* to be found in me, and I had always known it.

I had spent money creating a quadrophonic PA system similar to that used at the time by Pink Floyd. Again Roger was concerned about the cost, being particularly attuned to the financial chaos that surrounded us. We all had a longstanding gripe with Kit and Chris over the fact that seven years previously we had allowed our recording contract to be vested with

* Commercially it reached the highest position of any Who album in the States at No. 2 and in the long term has achieved the recognition I hoped for it. IGN, for instance, placed *Quadrophenia* at No. 1 in their list of the greatest classic rock albums of all time.

Track (instead of directly with Polydor). We had thought that we would be partners or shareholders: this never happened. Jimi Hendrix was their biggest signing by far, but I'd brought them two No. 1 artists in Arthur Brown and Thunderclap Newman, and had received no royalties.

I was also covering some of Keith's day-to-day expenses by lending him money that I clawed back in band meetings with accountants that he rarely attended. Kit and Chris didn't try to hide their troubles, or their addictions at the time. They had hired two managerial second-in-commands in Peter Rudge (who went on to manage the Stones' office in New York for a while) and Bill Curbishley, a childhood friend of Chris's.

Keith himself had massive personal problems at this time. We all knew he was crazy about his wife Kim, so it was hard to work out what he was doing, bringing girls in and out of the studio, behaving as though we were on the road. Meanwhile my best friend Barney had taken to spending a lot of time at Tara House, ostensibly to hang out with Keith, but Barney had fallen in love with Kim.

When Kim left the family home in October to file for divorce, Barney sought out my advice. He wanted my permission to pursue her – he was terribly torn between loyalty to the band and his new passion for Kim. I pleaded with him not to be a party to the break-up, as it would mean my having to choose between him and Keith. Barney gave himself some time to consider my plea, and missed his moment. Kim went to stay with Ian McLagan (Mac) from The Faces. A week later Kim and Mac were an item. They fled somewhere together, leaving Keith to make death threats while Barney went back to Jan.

Not for the first time it occurred to me that I had to look no farther than life right around me to find the makings of a rock opera – at least of a rock soap opera.

I listened to Keith on the finished *Quadrophenia* album. His playing was great, but I worried about him: he had lost his

first great love, and I was certain the impact on his self-esteem would be massive, and it was.

When we finally started touring in the UK we confronted the most complex technical difficulties. I had hoped we could use four screens on stage on which we could project the story in some form. Several experiments were undertaken, but there simply wasn't time to get them working properly.

Even the music was problematic. Keith, who had been so brilliant playing along with the backing tapes on *Who's Next*, couldn't seem to cope with the stage tapes we'd put together for *Quadrophenia*. Our quadrophonic sound system was tricky too. In almost all of the smaller UK halls it was difficult to find safe positions for the two rear speaker systems. They needed to be hung high up and it wasn't always possible to get them set up correctly before our time ran out.

What followed were some of the most shameful performances in our career on stage. I was utterly bereft that although we had made a great record it had not provided us with the new rock-opera performance piece we so badly needed. We were all disappointed, that most disastrous of emotions. My anger onstage with The Who had always been an act for the most part, but my frustration over the live performances of *Quadrophenia* boiled over. On *Top of the Pops* I lost my patience and smashed a cherished guitar (a gift from Joe Walsh), and in Newcastle I pushed over all of our sound equipment in a fit of rage.

Yet it was Keith who was the first to crack. In November at the Cow Palace in San Francisco he collapsed on stage after taking three elephant tranquilliser pellets. I had to drag him back to his drumkit when he came round; then he collapsed again. At first I thought he might be play-acting a little. When he was conscious he made jokes, and so on stage I treated the entire débâcle as funny. I didn't get really upset until later,

when it became clear he had taken a very powerful, and potentially fatal, substance.

It was the first show in our entire career that we had to give up on because one of us had openly goofed up in this way. The American tour to promote *Quadrophenia* continued after Keith's collapse at the Cow Palace, and both Roger and I felt the need to try to explain the story before each show, and sometimes even between songs on stage. Reviews were mixed, mainly good, but Robert Hilburn in Los Angeles, always effusive, was troubled by the 'impression that the group's momentum – and therefore, importance – is waning'.

In Montreal, Keith held a party in an elegant suite in the brand new Four Seasons hotel. Piles of room-service food lay all around us. At one point some ketchup, refusing as ever to come out of the bottle, ended up on the wall. I thought it looked aesthetically pleasing. 'Someone should frame it,' I said.

Keith, agreeing, looked around the room. He took down a framed print from the wall, punched out the picture it contained, and held it up to frame the ketchup. There was applause. Reminded of my first lesson at Ealing Art College, I grabbed a steak knife, stabbed my hand, and wiped the blood on the wall. 'That's a line!' There was more applause.

Bedlam followed. What had started as a joke ended with a sofa being thrown out of a window into the beautiful courtyard gardens. As it exploded through the tempered glass, revealing small ponds, ferns and miniature trees in the garden, we all stood quiet for a moment. Directly opposite us was the hotel reception area behind a glass wall. The hotel staff looked at us in shock; we stared back, equally horrified as we slowly came to our senses.

Three French-speaking policemen answered the call, and once in our room they went through my luggage and found

some girlie magazines that they waved around as though they'd discovered a cache of chopped-up body parts. I admitted I'd taken part in the destruction. (I may even have muttered something about art, as I was still a little drunk.)

'So,' said one, in English, looking at my passport. 'The cop-kicker.' He went on to elaborate in French, which I didn't much understand. It obviously wasn't complimentary. They took me down to a basement room in the hotel, but fortunately, as they menacingly closed in on me, the hotel general manager, who had been roused from his bed, passed the open door.

'What is going on here?' he said in French.

'It's an interview,' barked one of the cops.

'The room allocated to the police is upstairs,' said the manager, firmly. He gave them the room number, waited right there until the police moved, and locked the basement door behind me. He probably saved me from a serious beating.

Every single person in our party was arrested and put in jail, including Roger, who hadn't even attended the gathering. The police cells were packed, so I shared a cell with Keith's aide, Pete Butler. We took turns sleeping on the hard bench. Paraplegic Mike Shaw had been travelling with us, wheelchair-bound and unable to get in or out of bed without help. The police left him in the hotel, but took his nurse along with us.

Peter Rudge, who had joined in with the wrecking, managed to ring the promoter, who paid the hotel damages. Later, when I saw a photo of the room, I was shocked. Everything in it was destroyed.

As soon as we arrived back in Britain, Lou Reizner put on a second charity gala of his orchestral *Tommy*. I refused to participate, but happily attended. It was the first time I'd ever seen Roger from the vantage of the audience. He projected himself into the crowd, his eyes fixed right on the heart of the

audience, and yet he addressed each of us. His technique was that of an experienced stage actor.

'He's really very good, isn't he?' I exclaimed to Karen.

A short series of Who shows followed in London, taking us right up to Christmas. The reviews of our shows were beginning to get rather picky; some were just bad. Compared to other bands we were still good, but we were going off the boil.

It wasn't because we didn't put all our energy into it on stage, and we certainly were putting in long performances, sometimes playing as long as two and a half hours. But we all realised that, however hard we worked on stage, *Tommy* had to a great extent been the element of our stage act that, from 1969 through to 1972, had helped us garner such positive reviews.

Quadrophenia had failed to replace *Tommy* as the backbone of our live show.

17

BE CAREFUL WHAT YOU PRAY FOR

Tommy was destined to be a movie. Since 1969 a number of producers, writers and directors had expressed serious interest in coming up with a decent script – Joseph Strick was probably the most distinguished – but nothing had stuck. Kit hung on to his dream of directing, even though, in 1973, he was using heroin every day. He and Chris had fallen out.

We all still adored Kit. He kept managing to work his way back into our affections, making us laugh with grand stories of his own absurdity. I had forgiven him, despite some lingering discomfort between us. He was still funny, clever and kind, but if I was resentful that too much touring had compromised my creative projects, he was resentful that I had cast him aside in the recording studio.

One afternoon in June 1973 I was walking down Wardour Street, recording, hoping for a quintessential Soho Mod moment that could be included in the *Quadrophenia* soundscape: a shout, a snatched conversation between boys dealing drugs or their bodies, something romantic, a racing tip or news of a hip, upcoming event. I was wearing headphones, carrying a stereo tape machine and holding out a stereo microphone. I kept my head down, surreptitiously slipping the microphone into groups of people standing around talking. Suddenly in my earphones I heard a familiar voice. It was Chris. I hadn't seen him for a couple of months. He was talking about *Tommy*. I switched off the mike.

It turned out that Chris had just attended a meeting with Michael Carreras of Hammer Films; they had been trying to get hold of me to join them. Chris took me for a drink and told me Kit was opposing any deal that didn't recompense him for his film treatment, but despite his threats of litigation things looked promising. (The treatment was something Kit and I had cobbled together in an hour at my studio in Twickenham.)

A little later, Robert Stigwood stepped in as producer of the film, replacing Hammer Films. I considered this a positive move, not only because Stiggy and Kit were friends and he promised to deal with Kit kindly, but because of our long-standing relationship with Stiggy. I believe Carreras had suggested Ken Russell to direct; I was a fan of Ken's work, which ranged from serious Sixties *Omnibus* documentaries about composers to irreverent films about music and art in the late Sixties and early Seventies. I especially liked his films on Delius and Elgar, and the more recent *Savage Messiah*.

Ken Russell wouldn't have considered directing *Tommy* were it not for Lou Reizner's orchestral version, so when we first met at Ken's home in Ladbroke Grove that was what we listened to. Ken was keen to inspire me to use orchestra as well as rock for the soundtrack. As an example of how powerful and brutal orchestral music could be, he played me Carl Orff's *Carmina Burana*, which I hadn't heard before. I told him I could orchestrate my music using synthesisers, and after Ken made a number of visits to Ramport he finally seemed convinced.

As it happened Ken was present when we recorded *Quadrophenia*'s 'Drowned' and a stormy rain found a leak in the roof, filling the piano booth with water. 'Be careful what you pray for,' said Ken, as we cleaned up. 'You're dabbling in the composer's arts, Pete – both the dark and divine.'

* * *

One of the first changes Ken wanted to make was to nudge the story towards a kind of modern version of *Hamlet*, with the lover of Tommy's mother killing Tommy's father – rather than the other way round, as on the album. I was concerned about this at first, then I saw that the dead father would become a symbol for *Tommy* of the 'Master' he sees in his dreams.

There were a number of other changes: Ken needed to flesh out a lot of the story and introduce new scenes, which would require original or extended music. As mythic, absurd and exaggerated as the film may have been in some ways, the denouement remained true to the album and centred on the spiritual benefits of growing up in troubled circumstances. I was excited and intrigued by how this would unfold.

Once Ken had produced a basic script he felt he could use, I started on scratch lyrics for the additional scenes. As I completed them they were added to the script Ken had laid out in two columns: action to the left, lyrics to the right. No dialogue. Ramport was the obvious venue to record the music, and Ken wanted all the music in place before he shot a single frame. Ron Nevison, who had done such wonderful work on *Quadrophenia*, engineered. I gathered different groups of musicians for each music cue. Keith was spending time in LA, so I tried other drummers. We usually started work in the afternoon so Ken could attend, since he was doing a huge amount of pre-production work earlier in the day. We started recording in early January 1974.

Bill Curbishley effectively took over management of The Who early that same year. Roger adored him, and we all liked his straightforward approach, but it took me longer than the others to completely trust Bill. Bill had an unusual, and appealing, demeanour, like that of a cultivated but pugnacious boxing trainer. He quickly became a fan of the band, and came to understand its inner mechanics and mysteries, but was less

intimidated or awed by it than Pete Rudge. Where Chris and
Kit may have allowed gulfs to widen between Who members,
Bill attempted to create bridges, and in his letters often
addressed us together as a band, and circulated copies of any
important documents.

If The Who had lived in a tax haven, we'd have been
millionaires back in 1969. Bill Curbishley knew this, and his
priority was to see us financially secure as individuals. There
had been two ways to look at the financial vagaries around
the band. One was that we only worked as much and as hard
as we did because we needed the money; this pleased our
fans, and also kept the band together. The contrary view, my
own, was that the pressure of trying year after year to gener-
ate a big enough annual gross to live on would eventually
break us.

Bill realised he had to resolve this situation. He wasn't a
creative thinker like Lambert and Stamp, but he was widely
read, wrote poetry and regarded his managerial work as a
chess game. The overwhelmingly positive difference between
Bill and his predecessors was that he always made sure the
finances were properly arranged. From the moment Bill took
over Who management, my money worries were over.

Stiggy set about casting the film with Ken Russell, and I began
to interfere. I disagreed with them on the inclusion of veteran
actor Oliver Reed (playing Tommy's stepfather), as well as the
more Hollywood choices of Ann-Margret and Jack Nicholson.
Stiggy's explanation of the Hollywood star system was succinct
and persuasive: 'We-Have-To-Have-Them.'

I knew Oliver Reed couldn't sing, but as I knocked back
mugs of Rémy Martin while coaching him line-by-tortuous-
line, he did his thing in the studio and it worked extraordinar-
ily well. I had been told that Jack Nicholson wasn't a trained
singer either, but he sang beautifully. (He has never stopped

teasing me about how stunned I was when he began to croon like a world-class Fifties club singer.)

Ann-Margret I knew nothing about, and I thought her voice was too musical-theatre for *Tommy*. But she convinced me the moment we started to record. She displayed real passion, a sense of the absurd and an ability to make the songs her own; she sang in a drawling theatrical way – more Ethel Merman than Tina Turner – but it worked well. And of course she'd been in a movie with Elvis. The Who were small beer in comparison, yet she was respectful, and an amazingly hard worker in the studio.

Elton John, Tina Turner and Eric Clapton were of course easier for me to work with, being musicians, and each of them was magnificent. Tina had been having difficulties in her private life, but you would never have known it: as the Acid Queen, she was electrifying. Roger, a natural actor, created a new kind of Tommy character that was also utterly convincing.

The recording of the *Tommy* score continued at Ramport in March and April. Keith had a role acting (as a drummer) in Mike Appleton's *Stardust* movie, a follow-up to his *That'll Be the Day*, so I used a variety of other drummers: Kenney Jones (The Faces), Mike Kelley (from Spooky Tooth) and Tony Newman (Sounds Incorporated). Eric Clapton had spent a good part of the previous year getting himself into shape. Some of his treatment had been at the hands of Meg Patterson, the addiction therapist whose NeuroElectric Therapy (NET) reduced withdrawal symptoms. Eric claimed it did nothing of the sort, but he worked with Meg nevertheless.

Stiggy, Eric's manager, pressed him into taking a role in *Tommy*. Eric wasn't keen but did it partly for me, since I'd helped him put up the Rainbow concert. The song he would play was 'Eyesight to the Blind', and Eric wanted to create a new riff for the song to make it his own; he had the notion

that he would like his guitar doubled by clavinet, the electric keyboard used famously by Stevie Wonder. As it happened Stevie was in town, so Eric took me with him to Island Studios to try to persuade Stevie to work on the track.

As we drove to the studio together I reminded Eric that Stigwood had originally suggested Stevie take the role of Pinball Wizard. Ken and I had been nonplussed: a blind musician playing the role of a sighted pinball champion who is beaten by a deaf, dumb and blind boy? What we didn't know was that Stevie himself had been interested in the role, and was still considering it when he heard of my concern. He was told by his brother, who managed his affairs, that I had objected to him in the role because he was blind. Perfectly true; it didn't make sense, given the story line.

Given this history I wasn't surprised when we got to the studio that Stevie ignored me. He was sweet to Eric, but even so he refused to contribute in any way; we left feeling almost as rejected as Stevie had no doubt been made to feel by me. In the event, I tried to emulate his inimitable wah-wah clavinet style on the track, which certainly wasn't easy.

Elton John took the role of the Pinball Wizard, and asked to use his own band and producer Gus Dudgeon to record his track. Elton arrived at the Battersea studio in a Phantom 5 limousine, similar to that used by the Queen; I hadn't seen one in the rock world since Andrew Oldham's in 1967. It was a revelation to observe how quickly and efficiently Elton and his band worked, nailing a driving track with solos, lead and backing vocals in less than four hours.

Principal photography on *Tommy* began in late April. I found Ken Russell bombastic, energetic, funny, tireless and inspiring. He had an obsessive eye for detail and planning that I now realise every great film director needs, together with the ability to adapt to fluctuating circumstances.

I never had a bad moment with Ken. During the *Tommy* film he only ever slept about four hours a night, and in the first six weeks of shooting I did the same. We'd have a script meeting for the next day's shooting that lasted until two in the morning, and he'd be up again at six for a breakfast meeting. I survived on cognac. I have no idea how he did it.

Ken pushed his actors very hard indeed and wore a few people down, but during the filming I could stand aside and recuperate if I wished; and when we filmed our own sequences as The Who I simply behaved like the arrogant half-drunk rock star I was. Although Eric Clapton wasn't crazy about appearing in the film he pulled his weight. The scene Ken arranged for 'The Hawker', the song based on 'Eyesight to the Blind', was set in a church, with voodoo as the theme. Arthur Brown, John Entwistle and I joined Eric as his acolytes, all wearing loose-fitting gowns. We looked like complete idiots. I felt a little embarrassed for Eric. My old buddy Arthur Brown, whose song 'Fire' was a No. 1 hit in the UK, knew voodoo like a New Orleans shaman, and seemed to be in his element. Ken filled the church with real paraplegics and disabled folk in wheelchairs; it shouldn't have worked, but they all very much enjoyed their day of filming.

Eric came back into the studio to complete the recording. After we had finished he told me he was building up the courage to speak with Pattie, George Harrison's wife and the subject of 'Layla', and beg her to leave her husband. Would I go with him and maybe spend some time with George so Eric could be alone with Pattie?

This turned out not to be difficult. George was happy to talk to me about Indian mysticism and music, even his use of cocaine. I found it hard to follow his reasoning that in a world of illusion nothing mattered, not wealth or fame, drug abuse or heavy drinking, nothing but love for God. We sat in his

wonderful recording studio and talked for two hours. I fell in love with George that night. His sardonic, slow-speed, Liverpudlian humour was charming, and his spiritual commitment was absolute: yellow-robed young Hare Krishna followers living in the house wandered in and out as we chatted.

George lived a quiet life; his house was vast, rambling, and the reception hall was like a theatre it was so huge, with its ornate galleries. I think Pattie may have been more relieved to escape the house than she was to leave George. A superb gardener, his great love was Friar Park.

That night Eric tried to talk to Pattie about his feelings, and he said later that it was a crucial moment in their relationship. Pattie did eventually leave George for Eric, who celebrated that success by having as much fun as he could without drugs. Pattie seemed happy, and free. I hadn't seen her smile in quite the way she did with Eric since I had first met her.

At a Chelsea restaurant soon after filming Eric's scene in *Tommy*, Karen and I were invited to dinner with Bob and Mia Pridden and Eric and Pattie. The four of them arrived half an hour late, raging drunk, wearing gorilla masks. After so many years of being exposed to similar stunts by Keith, my response was studiedly nonchalant; without batting an eye I asked the four gorillas what they would like to drink. Eric thought at first I was angry, and became a little sheepish, but it was delightful to see how happy he was.

Post-production work on the *Tommy* movie music score was proving to be highly demanding. Towards the end of the last recording sessions at Ramport, which had been devoted mainly to backing vocal sessions and amplifying the crowd scenes, one of the girl singers told me about a charity event at the Roundhouse for which Tim Hardin, who'd agreed to headline, had cancelled. The goal had been to buy a bus for children in need, so I stepped in to do it solo. I decided to use backing

tapes for a few of the songs I wanted to perform, and got to work preparing them. In full harness in my studio, I moved quickly. Even so, it took several days to build enough material to make the concert interesting. I felt under pressure because, on news of my appearance, tickets had sold out completely.

This was the first-ever solo performance I did, and I stuck to songs I loved. 'No Face, No Name, No Number' from Traffic's *Mr Fantasy* album, Jimmy Reed's 'Big Boss Man' and Kiki Dee's 'Amoureuse' were included in a list of Who classics. My favourite moment was coming across the great English jazz eccentric George Melly backstage, and his telling me he was looking forward to my show.

The Roundhouse, then still unrestored, had the mood and smell of an old railway engine shed – which it was. The crowd stayed seated for the entire show, something I hadn't seen since the early Who performances in California. Unfortunately a drunk sitting fairly close to the front kept demanding that I play the 'Underture' from *Tommy*. He was persistent, and irritating. When he shouted his request once too often I leapt from the stage, got hold of him by the neck and was about to punch him. His friend, equally smashed but slightly more coherent, intervened.

'No need for that, man,' he slurred. 'We're just fans.'

I relented, returned to the stage and apologised (although the fellow I'd threatened continued to request 'Underture' for the entire remainder of the show). Otherwise it was a landmark event for me. I was surprised by how well I was able to hold the attention of the audience without heavy amplification, and pleased I sang well enough to get by. And the charity got its bus.

While the *Tommy* film was being made, Bill Curbishley had been dreaming of The Who performing in the UK's première football stadiums. He may have been encouraged by our

success in Anaheim in California, but no single British band had ever played in a UK football stadium before, not even The Beatles.

He secured a date at The Valley Charlton, where his brother Alan played (and later managed the team). The Charlton show was scheduled between the movie work I was still catching up on and a planned four-day stint in New York. It was also the day before my twenty-ninth birthday. I wasn't just drunk by the time of the concert – I was *smashed*. Fortunately, it went off OK.

We also held a free concert in Portsmouth for the cast of the movie. It was the first time Ann-Margret had seen us perform, and she was astonished by us. I was astonished too, if only by the fact that I managed to perform at all. I was half-drunk, but I knew the audience was in our pocket before we started, and I was happy to be entertaining the crew we had worked with for so long, many of whom had never seen us perform. The whole band played well, but Roger was especially good; during filming he had worked out consistently and was in great physical shape. As usual, he gave the show his all.

After the show, our lawyer Ted Oldman produced a document for us to sign, which he said would assure that the Grand Right in *Tommy* would remain with us. I refused to sign. Ted simply waited until I was drunk enough and placed a piece of blank paper over the foot of the contract. I signed, pulled the blank sheet away to reveal the subterfuge, carefully tore off my signature, and handed the contract back to him.*

From there, after a few rehearsals, we trooped to New York for four days at Madison Square Garden in June. Our usual

* There were many contracts to sign and I did not sign the assignment of copyright to Kit and The Who (I saw it as mine entirely). At a later date it *appeared* that I had signed this particular contract (in the presence of my PA Judi Waring) but my signature was stapled onto the bottom of the other signatures and Judi had not even been at the show. So we both agreed that it must have been literally chopped from a different contract.

hotel, the Navarro, was besieged by fans. A few critics review-ing the concert complained that we had introduced no new music since *Quadrophenia*, now nine months old. Some front-row fans found me insufficiently energetic, and started shout-ing at me, commanding me to jump. I was upset by this, feeling like a clown, but I kept my cool. Overall, however, the shows went well.

Filming continued on *Tommy* while we were away, although I managed to attend all the major shoots: 'Acid Queen' with Tina Turner, 'Go to the Mirror' with Jack Nicholson, and 'Champagne' and 'Smash the Mirror' with Ann-Margret. I returned with only a day in which to take in a massive backlog of musical issues and script changes.

The last period of filming was in August 1974. Already exhausted from the post-production musical arrangements I looked like a corpse and felt worse. During these shoots I began to see just how many long hours every single person on the crew put in. Meanwhile Keith and Oliver Reed were in a Portsmouth hotel, raising hell. I tried to raise a little myself, accepting a challenge to a drinking competition from one of the hard-looking lighting gaffers. The mission was to drink half a bucket of draught Guinness. My challenger managed two-thirds before he gave up. I managed about the same, then vomited what I had drunk thus far back into the bucket.

When I told Ken I had bought a boat he was scathing. 'Bloody things,' he scowled. 'My father had a yacht and all I can remember is polishing it.'

Every person who has ever owned a boat knows the phenomenon: you begin with a small boat that's easy to manage, then get one slightly bigger, then another slightly bigger, then bigger, until you hit unmanageability, sell and buy a boat as small as the one you started with. I was on boat

number two. I didn't sell my speedboat but gave it to Dad so he could get rid of the ageing *Liz-O*, our first boat together from 1967 that had sunk on its mooring on the Thames. I wanted a boat that would cross the English Channel, with two sleeping cabins. I found a 36-foot Grand Banks trawler boat whose owner was willing to take my Rolls Mulliner coupé in part exchange.

Oliver and Keith were up for sailing. The problem was they were still shooting the movie, so we settled on an evening cruise. A group of us – Ollie, Keith, Jason (my new driver) and his pretty girlfriend Carla, Barney and myself – ferried out to the Grand Banks at 8 p.m. With several bottles of Navy Rum we considered ourselves equipped for a sea voyage. Once aboard I gave Jason his instructions.

'Let's pop over to Cowes,' I said carelessly. There and back it was a distance of less than eight miles.

'I should get a weather forecast first.' I could see he was nervous.

'Are you sure you're an experienced sailor?'

'Oh yes,' he assured me. 'I just want to get in touch with the coastguard.'

It turned out he didn't really know how to work the radio. While he was frigging around, Keith set the dinghy adrift; it was carried quickly out sea by the falling tide.

'Sorry chaps!' He was extremely pleased with himself. 'We seem to be stranded.'

Ollie rolled a joint, which surprised us all. We had only seen him drink beer and eat curry thus far. It was left to me to consume the rum. I didn't know I liked it until I found myself stark naked toasting *Mafuta*, my new boat.

'Well done, Pete,' said Ollie, gazing at my package.

'At least someone has done something sensible at last,' I responded. I expected everyone else to follow suit, rather fancying Carla, I suppose.

Keith had a better idea. 'I'm going to swim ashore,' he exclaimed brightly, like some twit-spark from a P.G. Wodehouse story. Before any of us could stop him he left the saloon and dived in. Within seconds he was out of sight in the pitch black of the moorings.

The tide was ebbing at about 5 knots now, and I was worried for him. Ollie had the answer: he would go and rescue Keith. In a flash he was gone too.

My answer was the best of all. I went to bed.

When I woke up next morning only faithful Barney was still with me. I was still comfortably rum-drunk from the night before, and extremely jolly. Barney told me Keith had made it ashore, borrowed a dinghy, and had come and taken the others back. My dinghy had been rescued by someone from the yacht club, who had very kindly tied it back on the boat, so Barney and I rowed ashore.

We arrived back at the shoot in time to find Roger sitting on a rooftop, doing deaf signing to the assembly of acolytes who believed they had to pretend to be deaf, dumb and blind if they were to follow Tommy. It was a very moving scene, shot almost entirely in silence until the sound of an autoharp glistened in the morning sunshine.

'What beautiful music,' I said, forgetting that I'd written it.

The contrast between Roger and me was, by this time, dramatic. He looked beautiful, tanned, healthy, alive, alert and fit. I was shattered, bleary and hung over. And, to make things worse, I knew the toughest part of my work on the *Tommy* movie was ahead of me, at least technically speaking.

My workload, once post-production was rolling in earnest, was beyond imagination, but I was completely committed to restoring some musical sense to the new and extended scenes

of *Tommy* by adding orchestrations, guitar solos and additional vocal schemes. Someone suggested that the film be dubbed in surround-sound, and I got behind the idea very quickly. For quadrophonic dubbing work we needed a specialised quad desk, so I used my own large Neve from Cleeve. Nothing seemed to stop me turning over my home to whatever project I was working on.

Terry Rawlings, our music editor, introduced me to John Mosely, who ran Command, a recording studio near London's Piccadilly Circus. He met up with Ray Dolby, the famous creator of Dolby noise reduction, whom I knew through Trackplan and our Thames jaunts. Mosely was sometimes imperious and could be difficult, but he was technically brilliant and inspired, helping us create surround set-ups that worked. He understood how to move things around between speakers using phase cancellation between channels.

Ray Dolby found it tricky working with John Mosely, who wanted to tie the Dolby system to his own patent (Quintaphonic) for surround sound, and I'm certain Ray had his own ideas. When the two fell out we used the DBX noise-reduction system on our tracks instead, and in the première theatres it worked extremely well to deliver the rock dynamic.

Dubbing was completed in mid-December. For a while, apart from *Fantasia*, the first and only matrix-encoded five-channel surround film was *Tommy*. I learned more working on *Tommy* than I ever needed to know about film sound and editing. Taking on the technical aspects was challenging and exciting, but ultimately exhausting, and I promised myself I'd never work on another movie soundtrack. I certainly could never have done it without Terry Rawlings.

While I scrabbled on my own to write songs for The Who in early 1975, the other three members of the band were embarking on the most intense activities of their respective careers.

This extramural work had taken root while *Tommy* was being made. Roger agreed to take the lead in Ken Russell's next film, *Lisztomania*. John had no long-term role in the *Tommy* film, so while waiting for the rest of us to wrap it up he got serious about his solo career, compiling enough material for two records in quick succession. He also started to produce other bands.

Keith made his first solo album, too, and both of us joined Eric Clapton for a few days of his comeback tour. Keith introduced me to his new girlfriend Annette Walter-Lax, a Swedish model. He seemed very happy, and she clearly adored him. This was a good omen; it looked like Keith would get over losing Kim after all.

As a band and a business The Who had hit a speed bump. Kit was causing legal trouble, and had thoroughly confused our lawyers over who owned the copyright to *Tommy*. Keith was being disastrously irresponsible with money, and I thought he was wasting his time trying to be a movie star. John was, in my opinion, being impatient and overly ambitious to break out on his own; I felt he would have plenty on his plate when the band started up again. Roger had worked very hard on *Tommy* and had become a real actor, but I was irritated that he had accepted *Lisztomania*. Selfishly, it seemed to me The Who were suddenly playing second fiddle to the individual pursuits of the band's members.

Despite my gloom, I wrote songs for The Who in my few days off. These rough pieces would be developed in my home studio on sixteen-track tape, but only after being approved by Roger. I couldn't see the point in completing demos of songs he wasn't going to sing. Before *Tommy* premièred, I had thirty songs and instrumental pieces for Roger to listen to. I visited him one evening at Shepperton, where he was filming, and played him the songs. We had a drink together, and then I left him two cassettes so he could listen again on his own.

He called the next day, very positive about what he'd heard.
I had come up with a broad sweep of material, some upbeat,
some R&B influenced, some reggae, some very light in tone,
and some introspective or angry. I was surprised by the songs
he liked best – the angry, cynical, depressive ones. The music
was only partly complete, though; what I lacked on this collec-
tion, once again, was a defining context, a theme or concept.

The songs Roger selected may have been the ones he liked
best, but as a group they were later described as a kind of
'suicide note'[*] from me, and better suited to a solo album. I
wasn't feeling suicidal at all, but I was terribly tired.

During an interview with Roy Carr in *New Musical Express*[†]
I talked about the way I felt The Who had got stuck:

> I can tell you that when we were gigging in this country at
> the early part of last year I was thoroughly depressed. I
> honestly felt that The Who were going onstage every night
> and, for the sake of the die-hard fans, copying what The
> Who used to be.

Roger did an interview in retaliation, defending himself and
attacking me for ruining shows while drunk. I may have blown
a song or two, but never a complete show. Neither of us took
this kind of thing to heart in the long run, but when it came to
The Who we were both clearly confused and a little lost.

* http://en.wikipedia.org/wiki/The_Who_by_Numbers.

† Roy Carr, 'The Punk as Godfather', interview with Pete Townshend, *New Musical Express*, 31 May 1975.

18

THE UNDERTAKER

There was an aspect of *Tommy* that was worrying me. I was
angry with Ted Oldman, despite my fondness for him as a
friend, for trying (unsuccessfully) to get me to sign Kit's
Grand Right document when I was drunk. Ted acted for
Lambert and Stamp as well as the band. When Kit started
ranting in the newspapers that he owned the copyright to
Tommy, the penny dropped and I turned to Sam Sylvester, a
leading show-business lawyer, for help. We had been intro-
duced by The Who's accountant, David Rosten. Sam's advice
was to deal with issue of the Lambert and Stamp agreement
quickly.

Sam was passionate about music and the arts; he wasn't a
rock fan, but when he reached into my work for artistic
context and meaning, he seemed to find it. Sam was deeply
religious – not Orthodox, but the patriarch of a devoutly
observant Jewish family – with an incredibly sharp mind.
From the moment he became my legal advocate and friend, I
was guaranteed a long life.

I'm sure Bill Curbishley learned a lot from the way Sam
navigated the vagaries of our already over-complicated tax,
recording and publishing contracts. In the USA Ina Meibach
provided a similarly loving legal umbrella. The friendship that
grew between Ina and Sam over time worked in my favour
without alienating the other members of the band. As I
mourned the loss of Kit as my Svengali, and Chris as my

advisor in all things cool, Bill, Ina and Sam provided me with an entirely different style of life management.

It was Ronnie Lane who encouraged me to consider 'Squeeze Box' for the album. It was a rank outsider as a song, not even included in the songs I had first suggested to Roger. I had written it entirely for my own amusement, to show off my abilities on an accordion I bought at a local music shop. One evening I played Ronnie my demo, and he loved it. He said it sounded like a crazy Country & Western polka. He also thought it was time for me to give up on The Who.

Ronnie Lane knew me very well and respected me as a musician, not just as a rock polemicist. I knew I could articulate my ideas as an artist more clearly if unencumbered by the band, but I had hoped a movie of *Tommy* might address this need. Ken Russell had done a first-rate job, but during the final dubbing of the film I realised that Ken had missed a key point at the heart of my rock opera: that it spoke of the end of dictators and self-created messiahs. Somehow Russell, eighteen years older than we were, was operating on the far side of the generational divide. He knew the rigours of war first-hand: he had been bombed, blitzed, and had performed military service in both the Royal Air Force and the post-war merchant navy. But he had little sense of the next generation's post-war shame and anger, or the way our parents' denial of those feelings might need to be confronted by us, and cast aside.

The movie of *Tommy* premièred at the Ziegfeld Theater in New York on 18 March 1975. John Mosely and I were still fiddling with the sound system in the theatre when the time came for me to make my appearance on the red carpet.

Watching the movie I saw my life passing before me, but the rest of the audience response was, at first, quite strange. The first thirty minutes were set in a typical British post-war holiday camp, so the American viewers couldn't relate. The

breakthrough moment was Tina Turner's stunning rendition of 'Acid Queen'. The track I'd put together with Ronnie Wood had a Rolling Stones edge to it, and suddenly the sound system proved its worth. When the song finished the audience roared its approval. After that every song received applause, even the linking sections.

By the time the film ended I felt we had a hit of some kind. The real test would be when the film went on general release, but the first response was certainly encouraging. The sound-track went straight to No. 2 in the album charts.

We flew to LA the next day for the West Coast première at Grauman's Chinese Theatre, complete with Klieg lamps combing the sky, then the London première at Leicester Square. Reviews were mixed, but I didn't care. The film was grossing large amounts of money, and Stigwood's accounting to us was very fast. We had become used to waiting for performance income to drift in six to nine months after a tour, so it was a shock to see millions of pounds accruing in The Who group bank account just two months after the film was released. It was a nice problem to have, but we were all concerned that the income would be taxed into oblivion should any of us choose to take the profits personally. We had no current tax schemes, and – apart from Keith, who wanted to live in California – no desire to move to another country.

Roger was still involved in the last weeks of shooting *Lisztomania* with Ken Russell. When the band convened at Shepperton studios for recording, Roger arrived in a twin-engined Jet Ranger helicopter, and announced that he owned it. Thirty minutes later he flew out again. Roger's home was in West Sussex, so the helicopter was certainly useful, but we all found it strange. With the release of the movie Roger had become ostentatiously rich, a superstar teenybopper sex object, complete with helicopter.

Keith was clearly jealous – the two of them seemed to compete over such mine-is-bigger-than-yours displays. He gazed at Roger's helicopter dwindling in the distance, and I could tell he longed for something equally impressive.

Did I long for anything? I was longing for my hair to stop receding.

I tried to meditate. One summer night, unable to sleep, I got up with the sun at 5.30, went down to the drawing room, made tea and sat before an open window at the front of the house. The low morning sun played on the ceiling as flickering reflections from the surface of the river danced with the corner shadows.

I put a cushion down, sat cross-legged and tried to put everything out of my mind. After a few minutes I passed into a kind of white light state. The sun warmed my closed eyelids. After ten minutes of meditation I spoke.

'Dearest Baba! What should I do? I will accept your answer.'

Immediately I heard a voice say, 'Go back to The Who until further notice.'

This was not what I hoped to hear.

'How do I know this is what you want? Give me a sign.'

At that moment, in the window frame directly in front of me, a wildly dishevelled red-haired man without a shirt jumped up into view. His face was dirty, his eyes black, fiery and alive. He looked directly at me. 'I heard you,' he said.

I jumped up, ran to the door and caught a brief glimpse of a man scurrying away towards the river. I had seen him a few times, sleeping on newspapers and flattened boxes in our little front garden. I must have woken him with my prayers.

* * *

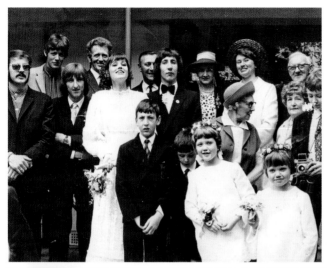

LEFT: Our wedding, 20 May 1968. My best man was Speedy Keen (left of Karen). My parents stood behind me, and my brothers Paul and Simon stood in front.

CENTRE LEFT: Standing at the record decks in my Wardour Street studio, where I was pretending to be Guy Stevens.

BELOW: The blessed Who, at a photoshoot for *Vogue* magazine, July 1969.

BOTTOM: The Who, Woodstock, August 1969.

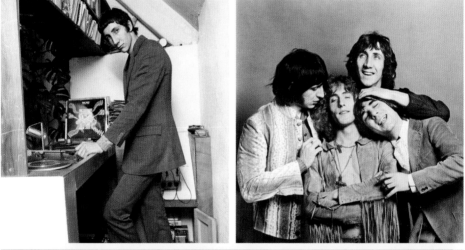

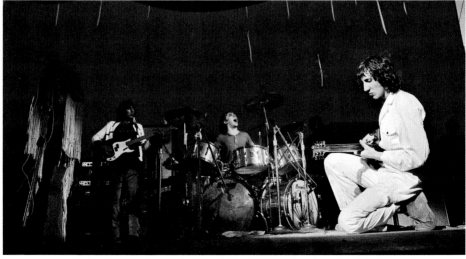

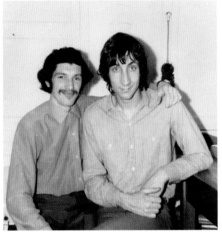

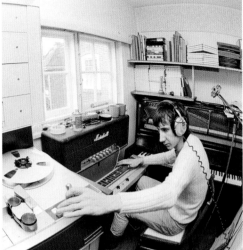

ABOVE: With Jack Lyons aka Irish Jack, early 1970s.

TOP RIGHT: In my home studio at The Embankment, Twickenham, 1969.

RIGHT: With Mum and my brothers Paul and Simon.

BELOW: At a party with Mike McInnerney in his back garden, 1970.

LEFT: On board *Babajan*, 1973. I have always loved boats and the sea, and my time sailing was like a meditation.

RIGHT: Rock 'n' roll excess. On 5 October 1972 Keith and I, with some help, launched The Who's sponsored car in the 1973 Rally of Great Britain.

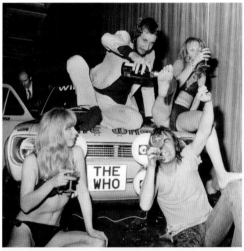

BELOW: Chris Morphet shoots Richard Stanley shooting Keith and me at Belle Vue in Manchester on the *Quadrophenia* tour, November 1973.

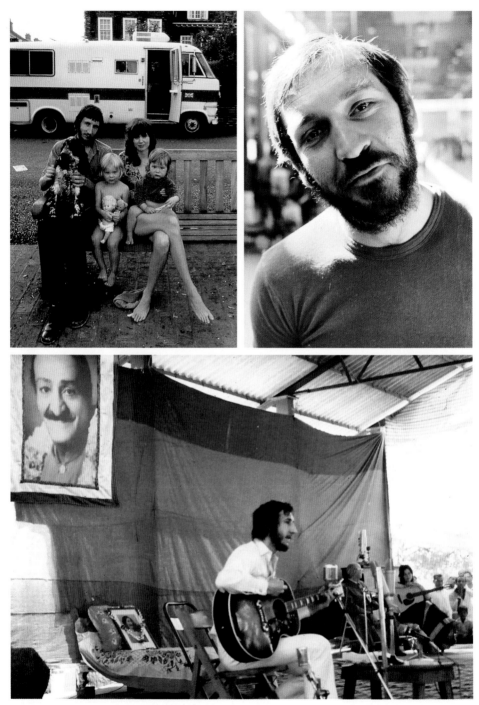

TOP LEFT: With Karen, Emma, Minta and Towser, outside our Twickenham house and motorhome, 1972.

TOP RIGHT: Bill Curbishley, The Who's manager, 1972.

ABOVE: On my whirlwind Indian trip, spring 1972, I played 'Drowned' for the first time in public.

OPPOSITE: Playing with the new Who, Madison Square Garden, September 1979.

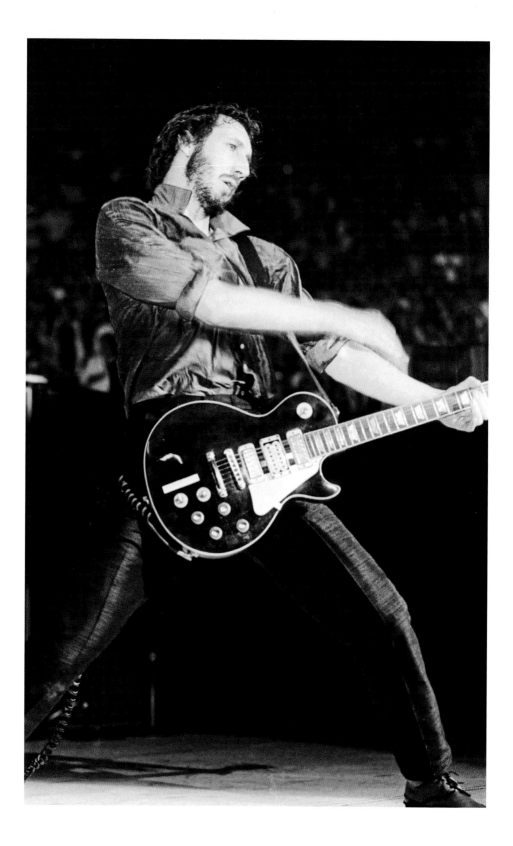

TOP LEFT: Minta and Emma at home in Twickenham, 1973.

ABOVE: With Karen, Emma and Minta in Goring, 1971.

LEFT: With my son Joseph, early 1990s.

LEFT: With Sexton the Bull. From left: me, Robert Fox, Ted Hughes, Matthew Evans, 1987.

ABOVE: Chris Stamp (left) and Nik Cohn brainstorming at Track's Wardour Street offices, September 1971.

TOP RIGHT: Lisa Marsh (right) with our mutual friend Heather Reilly, 1993.

ABOVE: I met the Scrabble hustler Louise Reay at the Embassy Club in 1981 and never won a game against her.

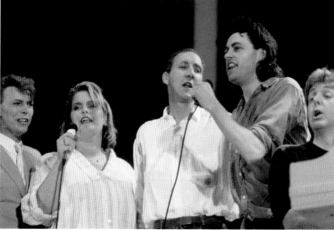

LEFT: The Live Aid finale, 13 July 1985. From left: David Bowie, Alison Moyet, me, Bob Geldof, Paul McCartney.

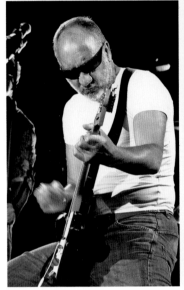

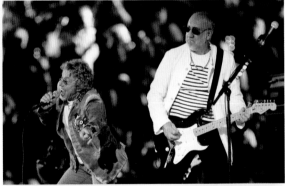

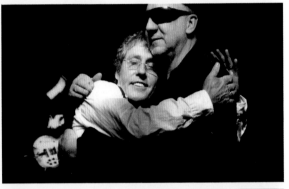

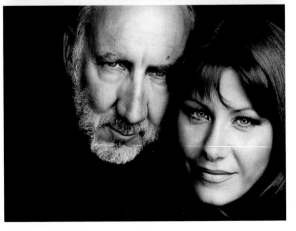

CLOCKWISE, STARTING FROM ABOVE:

In Osaka on our first Japanese tour, 2004.

Recording the cast album of *Tommy* with George Martin (sitting) and Des McAnuff (centre right), in 1993.

Mobbed by fans outside the Beacon Theatre in New York during the *Psychoderelict* US tour, 12 July 1993.

Brothers in arms: Roger and me at our intimate Indigo show, December 2008.

The Who were the final act of the Closing Ceremony of the London Olympics, 12 August 2012.

With Rachel, c. 2005. Met in 1996, still together in 2012.

The Who by Numbers was surprisingly well received. Roger
was angry with me, which I knew was a response to my inter-
views.* I hadn't intended for him to take them so personally,
but he did. It was our New York lawyer, Ina Meibach, who,
after listening to me speak about the void that had opened up
between Roger and me, advised me to try giving Roger more
control.

'Control?' I asked. 'Control of what? All he seems to want
to do at the moment is sue Kit and Chris.'

'I'm not talking about legal issues,' she said calmly. 'I'm
talking about the band.'

'None of us controls this band. It's uncontrollable.'

'Can I give you just one piece of advice to take away? Think
about it.'

'OK,' I replied.

'Let Roger win,' she said. 'For once, let him win.'

I'd been here once before, and by conceding a role to Roger
in the band's creative direction that time, we'd kept it together.
So I knew Ina was giving me good advice.

I wrote to Roger to apologise, offering to support him in
whatever he wanted to do. There was no hidden agenda to
this, it was just time to try something different. It was time to
align myself more fully with Roger rather than continue with
John and Keith in the long-established 'back-line' faction that
was failing. In the matter of our management it was time, too,
for me to align myself with Roger and his commitment to Bill
Curbishley, rather than continue to hope for Kit and Chris to
return on white horses. With a little help from Ina I suddenly
became willing to try new methods.

Without any effort whatsoever my drinking stopped. It just
stopped. Within a few days of writing to Roger my head began

* For example, Roy Carr, 'The Punk as Godfather', interview with Pete
Townshend, *New Musical Express*, 31 May 1975.

to clear. With it came the thought, *I need a holiday. A long one.* I flew with my family to Washington, DC, then chartered a Learjet to get us into the small airport near Myrtle Beach. At the Meher Baba Center we were given the Lantern Cabin, an exquisite cottage on the large lake at the heart of the land. Alligators basked on the banks; there were hummingbirds and snakes; the air itself conveyed a powerful sweetness that was almost cloying. As I walked down to the pristine beach I felt slightly heady. I had visited before, but never stayed.

We had a wonderful time. The four of us walked, sunbathed and swam. Emma and Minta met some friendly kids of their own age. On one occasion, while they were swimming, Karen and the girls got into difficulty with the powerful undertow, but I managed to guide them back to the shore. It was the one shock of reality in the midst of an otherwise dreamy experience. Minta spoke for years after about being sucked out to sea by the 'Under Toad'.

In the autumn 1975 tour The Who were the first stage act in the world to employ high-powered lasers for dramatic lighting effects. We had no idea what it would cost, but we didn't care when we imagined being on stage, bathed in mystical rays. The first night we used them before an audience, on 18 October in Granby Halls, Leicester, I was reminded of the way the three big Klieg lamps given to us by Bill Graham had lifted the finale of *Tommy*.

Wiggy used his rather modest single 4-watt laser, dispersed through a fast-moving microprocessor-controlled lens, to create a fan around Roger Daltrey's head as he sang 'See me, feel me'. As the fan widened it created a kind of moving ghostly ceiling above the heads of the audience. It was magical. For Roger there was a downside, however: to work best, the lasers were projected through a mist of light oil, which irritated his throat.

The day before the first Granby Halls show, Keith's anger came to the boil. He had been frustrated by seeing millions of pounds spent on resources that would keep our road-crew employed for the next ten years, but would earn him nothing personally. Stuck in fog at an airport in Scotland, he walked up to the British Airways desk and was so brutally rude to the ground staff that he was arrested.

Because no airline would carry us for a few months after this, the rest of the tour required a charter plane, which cost us the profit from the entire UK and European tour, a sum equal to around £2 million today. Keith's retort was a mocking laugh. 'No problem, dear boy,' he said. 'We can write it all off against tax.'

In the dressing room after a show at Belle Vue in Manchester, Roger and Keith were frolicking with some girls Keith had met when he worked at the same venue with teenybopper heartthrob David Essex on the movie *Stardust*. I became aware of a girl left over, sitting by my right side, gazing at me intently.

'You,' she said appraisingly, 'look like an undertaker.'

Until the British Punk-rock movement kicked off there were just two contenders for our crown: The Rolling Stones and the upstart Bruce Springsteen. Bruce had been celebrated in the *New York Times* in October 1975 with the headline: 'If There Hadn't Been a Bruce Springsteen the Critics Would Have Made Him Up.' I concurred: in my mind I had already made him up, and Johnny Rotten too. I saw them both guaranteeing my extinction, or at least forcing my early retirement, a thought that triggered mixed feelings.

Rock for me was about catching fire on stage, going the extra mile. The Stones caught fire because Mick Jagger never let up, never lost focus on stage and spent millions on stage sets. Springsteen caught fire because he believed passionately in the importance of the audience, and the story the audience

needed to be told. His sets were usually well over two hours long. He worked on stage the way I did: to complete exhaustion. He also honoured Roger's working-class approach to singing, from both the heart and the lungs at once.

In October 1975, while setting out plans for shows outside the USA, Bill Curbishley suggested we might try to break into Japan around the time the *Tommy* film premièred there. I couldn't see how we could possibly break any new territories without one of us dropping dead, and I was seriously worried it would be me. We couldn't keep up with the demand from the UK, Europe and the USA, and if we opened up new territories like Japan, Australia and South America we might never get any down time at all.

In the background, Bill was being told by Roger and John that Keith's life would be saved if only he could be kept on the road where we could keep an eye on him. I wasn't so sure. I thought this was an excuse; they just wanted to tour all the time. Keith had told me many times that he was in trouble, but I couldn't help but think we were probably all being played; Keith was a clever man.

After a show in Baton Rouge Keith ejected a difficult girl from his room. Around midnight I found her weeping in the lobby. She had finished telling Nik Cohn, who was travelling with us writing an article for a magazine, that 'he took my heart and threw it away like a broken toy'. She had bleached strawberry-blonde hair, bright red lips, pretty eyes, and was wearing fraying jean shorts and a low-cut red top. She looked like a Texas bar girl. Her eye make-up was smeared, and when I asked if she was OK she quickly pulled herself together and smiled at me.

'Hey,' she said, laughing. 'Don't worry about me. This ain't the first time I've been thrown out of a rock star's room for talking too much. But he didn't even fuck me first.' Her accent was singsong, slightly Southern, the kind of American accent

that to the indiscriminate English ear sounds cultured and sophisticated.

Something about her made me feel at ease. 'Do you need a cab?'

'Keith shipped me in from South Carolina, honey. That's a thousand miles away.'

I thought it might be a little nearer than that, but I didn't argue. As usual I felt lost in America, with no real idea of where I was unless I was by the sea.

'Can I get you a room here?'

Suddenly she stood up, shook her hair, appeared to recover her composure completely, smiled at me, took my hand and led me towards the lift.

'Better yet,' she said, 'I'll come and stay with you.'

So started a friendship that lasted for more than fifteen years. Donna Parker was, like me, a devoted Kinks fan and a Ray Davies disciple.

'Got anything to drink?' She was circling the room like a panther.

'I don't drink,' I replied. 'At least, not at the moment. I could get you something.'

She asked for J&B and coke. I found two bottles and added ice from a machine in the corridor. She was funny, sexy and smart, flicking through my copy of *The Old Man and the Sea* in the knowing manner of someone who is obviously well read.

She made a pass at me and I demurred, trying to prove I was above all that. If I had been drinking I would have succumbed. She smiled at me very sweetly, lay down on one of the room's twin beds and quickly fell asleep with her clothes on. I spent the entire night with a raging erection, willing myself not to reach out and touch her quite fabulous body. In the morning she spent a long time in the bathroom. I could hardly believe the transformation.

'Yes, honey,' she drawled, hand on hips like Marilyn Monroe and doing a breathless impression. 'I do scrub up well, don't I?'

She'd carried a short flowery dress in her little bag, nipped tightly at the waist. Her legs were spectacular.

'Give me your address,' I said. 'I want to see you again.' In the lobby I recklessly gave her my home address – and $150 for the flight home. The desk clerk made a face as though he smelled rotten eggs.

'It's not what you think,' I told him. 'We just talked.'

Donna looked at me askance.

'Talked?' She put her arm in mine and started to walk me out, then turned to the desk clerk and shouted, 'I fucked him five times until he cried for his momma!'

It made me feel like a rock star.

During our US tour Keith visibly darkened. He was often funny, but there was a new edge. And his cocktail of drugs had grown more complex. His minder, Pete Butler (nicknamed 'Dougal'), had no influence over him whatsoever.

One day in December 1975, somewhere in the Midwest, Keith let it be known he was throwing himself a dinner party. Dougal telephoned each of us ceremoniously, inviting us to Keith's birthday gathering. Keith's birthday was in August, and when I mentioned this I was told this was a special gathering for a good friend of his who had missed the day itself.

A room in the hotel had been set aside for the dinner, with a stunning display of mixed flowers at the centre of the table. One by one we arrived and took our seats. There was excellent wine and champagne already in buckets and a low buzz of anticipatory chit-chat. Suddenly Wiggy stood up.

'Here he is! Happy birthday, Keith.'

Keith was dressed in an absurdly grand outfit: a smoking jacket, black velvet slippers, a white shirt with large black

scarf. He was wearing several very expensive-looking rings and chains with gold medallions.

'What lovely flowers,' he said graciously. 'Thank you, Dougal.' He picked a single bloom from the display and ate it. He'd made a habit of this gag, but it was always very funny.

'Dearest fans!' He bowed as he addressed us, speaking in a very posh English accent. 'How lovely of you to gather like this. Come, darling ...' He ushered a very pretty blonde girl of about seventeen to an empty seat.

'My dearest friend Kathy, an actress hoping to make it big in Hollywood, has her birthday on nearly the same day as my own. So this is a joint celebration.'

At least you could tell when Keith was lying. I smiled at him, but he gazed back at me coolly. Keith turned back to Kathy, poured her wine, settled her chair, showed her the menu and whispered advice to her about what she might choose to eat. She behaved like a spoiled starlet in an old movie. The rest of us talked among ourselves. I relaxed a little after the excellent meal, took up my usual role as Keith's straight man and tapped my glass to propose a toast.

'I'd like to propose a toast,' I said loudly. The table had become noisy with much raucous laughter. 'To Keith! To Kathy! On their birthdays, many happy returns!'

The assembly eventually stood and repeated the salutation. Keith rose with mock modesty and gestured for everyone to be seated. He surveyed the expectant room, holding his glass, and said, 'I have a second announcement to make. I am leaving the band, leaving The Who.'

We all thought Keith was trying to be amusing, but he went on quite seriously. 'I have been offered a part in a new film by Marty Scorsese, and I have instructed my agent to accept.'

He sat down, turned to Kathy and whispered to her conspiratorially. She was giggling. I suddenly felt Keith was taking the joke too far.

'Keith, we're in the middle of a tour ...'

As soon as I said the words, I felt stupid.

Keith turned to me. 'I will fulfil my obligations to this tour,' he continued, 'and then it's over. I would ask you to raise your glasses to me, and wish me luck.'

Kathy, unaware of the gravity of the situation, merrily raised her glass and gazed up at Keith adoringly. She lowered it when she realised that no one else intended to join the toast. I was incensed.

'What next?' I demanded. 'You eat another flower?' My cynical emphasis was on the word 'flower', but I gestured to Kathy.

'No!' Keith was quite calm. '*You* eat a flower.' He gestured at the display.

I wasn't going to refuse this challenge. I took a bloom from the display, put it in my mouth and started to chew. Everyone watched me for a few moments, then lost interest. Keith stood judging me; he was an expert flower-eater after all.

My throat suddenly began to burn, then swell up, and my breathing became constricted before turning into a kind of noisy death-wheeze. I was allergic to whatever I had put in my mouth, and starting to suffocate. No one seemed to have taken it in but Keith. Suddenly he leapt across the table and looked straight into my face.

'What's happening?'

'I'm fucking choking,' I gasped.

'Stay calm,' he said. 'Just stay calm. Someone call an ambulance. He's in trouble.'

Everyone jumped to their feet, and some people scattered to get help, but before it arrived my throat began to open up a little.

'It's OK,' I wheezed. 'My throat swelled up, but it seems to be going down again. Fuck! That was scary.' I looked up at Keith. I could see the very real concern on his face.

'Thanks,' I said.

Keith settled on his haunches in front of me, watching me recover, making sure I was OK, tears in his eyes. It was suddenly obvious how much he adored me and was frightened for me. He looked thoughtful for a moment. Then he stood up and addressed the room.

'Champagne!' he shouted, with his usual panache. 'Dom Perignon. 1924.'

'Keith,' I spluttered. 'We don't want to celebrate you leaving The Who.'

'I was winding you up, mate. Trying to impress the lovely Kathy here. Actually, she didn't know who The Who are. Silly bint only knows about Hollywood.'

Kathy looked from face to face incredulously, as if to say: 'Are these people crazy?'

19

GROWING INTO MY SKIN

'I think I've fallen in love.'

I was talking with Murshida Duce, head of the Sufi movement in California. The girl I thought I'd fallen in love with was Donna Parker. I described what had happened, and Murshida said it was just an infatuation. I knew what she meant, but that wasn't how it felt. I was nuts about Donna, and we hadn't even had sex.

I had taken my alcohol problems to what I felt was a higher authority by going for help to the Meher Baba family in Myrtle Beach and California, and it had worked for me. I had cut down my drinking almost to nothing. Murshida Duce had introduced me to Dr Wong, a Chinese herbalist who prescribed me his special tea, tailor-made to my needs, brewed from herbs and plants he gathered in the mountains in China. The first day I drank a cup I felt like Superman. I will never know what was in it, but I drank that tea before every show for the next year, and whenever I got a fresh batch I performed with additional energy and drive. My stage work at the end of 1975 was, according to most reviews, exemplary, fuelled by Dr Wong tea rather than cognac. Keith's woes, however, continued.

During the second leg of our *Who by Numbers* US tour, in Boston on 9 March 1976, Keith collapsed after two songs. It was very worrying. Our fans reacted badly, and smashed part of the building and some subway trains. Our first New York

show at Madison Square Garden was scheduled for the next day, but Keith was still ill. This wasn't a long tour, but several additional last-minute difficulties on the road caused shows to be shuffled.

Bob Pridden had managed to hike up the level of the two sidefill speaker stacks on either side of the stage that helped fill in Roger's vocals and allow him to hear himself above John's thundering new bass rig. Suddenly, perhaps as Roger whirled the mike, the sidefills screamed for about five seconds, bringing me to my knees with pain. The accidental noise had taken me completely by surprise. My left ear had stopped functioning. After a few days it recovered some function, but, already damaged by Keith's explosion on the Smothers Brothers' show, it would never be the same.

In San Francisco for two days at Bill Graham's Winterland, a venue I adored, Dr Wong sent me a supply of his tea freshly brewed. On both nights I was like a jumping bean. Towards the end of the show, with me endlessly jamming and inventing new riffs with seemingly limitless energy, leaping and smiling, Keith pleaded for me to stop. He was exhausted. Keith was playing with flashes of the old genius, but something was seriously wrong.

Babajan, the 25-foot Skaggerak speedboat I'd used for *Quadrophenia* commuting, was now owned by Dad and still lived on a mooring opposite my house in Twickenham. The mooring was rented to me by Bill Sims, a man of the tides, patient and slow-moving. He owned licences to moorings all the way from Eel Pie Island down to Syon Reach, about three miles of river.

I asked Bill about a strange property I'd seen from my trips on the river. It looked as though it had been built in the Fifties, brick, with three double wooden doors opening to the river, obviously not in use.

'It's mine,' he replied. 'I built it on the site of the old family business, near the old Syon ferry crossing, and we had our racing boat company there once.'

'What do you plan to do with it?'

'Nothing.'

'What will happen to it?'

'Nothing.'

He didn't seem to want to be drawn out, but after a long pause he went on. 'I built it as a place for me and my wife to live. We've got our little place and she loves it here, but I wanted more light. So I built the boathouse, planning to build the skiffs downstairs. We were supposed to live on the top floor. One of the best spots on the river.'

'What happened?'

'She didn't wanna move.'

'Ah.'

Every time I saw Bill I'd bring it up, pretending to clean my rubber boat while he pretended to be preparing lengths of rope and chain.

'Bill,' I'd say, offhand. 'Do you think you'll ever sell the boathouse?'

'Nah.'

A while later I'd bring it up again.

'Bill, how much do you reckon the boathouse is worth?'

'Priceless, innit?' He'd take off his working-man's cap, crumple it, uncrumple it, put it back on his head, revolve it a few times. 'Unobstructed view of the Old Deer Park, fabulous view of the river down to Syon Reach. You can see up river to Richmond Hill, the old lock. Lovely.'

'Hmmm.'

Bill was skilfully whetting my appetite. I had no idea what I might do with such a building; I hadn't even looked inside it. Nor had I any cash to spare: my own building project in Cleeve was sucking me dry.

One day I asked him to show me around. The lower floor had been designed with quite a low ceiling for the construction of rowing sculls. The upper floor had no staircase, so we climbed a ladder. There were a few rooms laid out in logical fashion for a large apartment, and a huge oversize terrace area overlooking the river. It was breathtaking. But it was a shell – walls and concrete floors – no windows, electricity or plumbing.

'I'll give you £40,000 for it,' I said the next time we met.

'Nah, don't really wanna sell it.'

I increased my offer a number of times, but I never really expected Bill to sell it to me. Even so, he gave me permission to go and look inside any time I wanted, and told me where the access key was hidden. One week I went back to the building and stood outside. I took a coin bearing Meher Baba's face and tossed it in the air, covering it as it landed.

'Baba,' I said aloud. 'If you want this building for your work, I'll try to buy it.'

I looked at the coin. It was heads. I tossed it again, and again. It was heads every time. The next morning I walked over the Eel Pie Island footbridge.

'Bill,' I said briskly, 'I want to buy the boathouse. I'll give you £75,000 for it. If you don't accept it I'll never mention it again.'

'Yah,' he said, in exactly the same flat tone he'd been saying 'Nah' up until then. 'I'll sell it for that.'

My idea was to convert the boathouse into the Meher Baba Oceanic Centre, which would combine meeting facilities and overnight lodging for Baba followers with film dubbing and editing facilities, a cinema and a recording studio. Meher Baba's sister Mani was encouraging, but warned me that when Baba was finished with centres that opened in his name they crashed suddenly. Adi K. Irani, who had been Meher Baba's secretary for many years, had a mischievous sense of humour,

and seemed to have my measure. His catchphrase for me was apposite. 'Peter Townshend,' he would say whenever he saw me, arms outstretched. 'Where are you, what are you, who are you?'

As my comic hero Spike Milligan said, the hard questions first.

We received many small items, signed books and photographs, all intended to decorate and enhance the Oceanic Centre when it opened. I was going to concentrate on films for the centre, because Meher Baba had said they would be the main source of spiritual inspiration in the future. I began sending out invitations – to Barney, Ronnie Lane and Aunt Trilby, to whom I owed so much.

Shortly after the Oceanic opening Ronnie decided he couldn't work any longer with Rod Stewart in The Faces. He quit, immediately hit money troubles and came to ask me to produce an album for him. I suggested we do an album together, in parallel, with Glyn producing if he agreed. Glyn did agree, and Bill Curbishley put together a deal for us. The album wasn't intended to touch on our mutual commitment to Meher Baba; we just wanted to go into the studio and see what happened.

I knew the music wouldn't take long to record, and that I would enjoy it; Ronnie was my best friend at the time.

The whirlwind leg of the US tour kicked off in August 1976 in Maryland. I had fallen off the wagon during festivities in the opening week of Meher Baba Oceanic. By the time we played Miami I managed the show itself sober, but afterwards I knocked back a full beaker of Rémy Martin while chatting to journalist and drinking buddy Chris Charlesworth, who had come to congratulate me. I was in a philosophical mood. It was the first show we'd done for years that was badly

undersold, and I told Chris we had played for the people who weren't there.

Keith's tempos were sliding, and some of his most ambitious drum fills were falling short, but he managed to play OK. It was a shock to discover that after the show he had collapsed at his hotel, and would be hospitalised for eight days. He returned, drinking a bottle of Rémy a day on top of his medication.

Anxious about Keith, who had been so good to me in my hour of need, I asked Meg Patterson if she could help him the way she had Eric, and deal with the effects of withdrawal. After the tour Meg introduced Keith to her husband George, whose notion of counselling was to bring the recovering addict's attention to Jesus. Keith led George, a sincere, brilliant man in many ways, on a merry chase. He managed to convince George that he, Keith, was possessed by two demonic entities, Mr and Mrs Patel. I recognised the mischievous charade immediately: Keith grew up in Wembley, in a neighbourhood where almost every single Indian family was called Patel. George wasn't gullible, but Keith ran rings around him.

Roger was demanding a bigger say in what he sang. His recent successful solo work had given him a new level of confidence and expressiveness as an artist, and although he wasn't always co-writing with the songwriters on his solo albums he was always full of ideas, and they listened to him. He became far more discriminating and choosy about what he wanted to sing with The Who. There was no longer a Stamp or Lambert to cajole him and convince him to trust my process, which meant that where once I might have spent three months writing songs for a new album I now needed about a year, as I had with *Quadrophenia*.

* * *

During the September lull of our US tour, before the final leg in October, I commissioned the completion of *Ahmednagar Queen*, a partly built 47-foot motor boat from W. Bates & Son at Chertsey. It was wooden, low-profile, with a removable 'flying bridge' so it could go under low bridges all the way to the upper reaches of the Thames. I wanted it around my new house at Cleeve, as well as in Cornwall in the summer, and was hoping it would be ready in time for a Cornwall holiday with Karen and the family.

While I waited I bought a small sailing boat to learn in, and sailed it from Falmouth over the mouth of the River Fal to St Mawes in bad weather. A journey of about two miles, it felt to me at the time as if I had crossed the Atlantic. Mum and Dad joined us for a few days and I took Dad out sailing. He found it hard to move around the tiny boat as we tacked, and slipped a couple of times; for the first time I realised he was getting old. He was just sixty.

By contrast my father-in-law Ted Astley had done a bit of sailing in his time, so when we went out together we sailed out into the broadest part of the River Fal itself, and I was the uncomfortable passenger with Ted on the tiller. He was a determined 'beater', pinching into the wind whenever he could; a lot of my time in the boat with him I was wet and cold, but I learned to sail.

The *Who by Numbers* US tour had one final leg to complete. Joan Baez attended one show, and as a fan of hers from art college I wanted to know how she liked us. She had one comment: 'It was very loud.' I felt like telling her she sounded like a nun, but exercised better judgement. My buddy San Francisco photographer Jim Marshall told me that day that he was in love with her, and always had been. I could see how that could happen. When I first heard Joan Baez in 1962 it was alongside Howlin' Wolf and Muddy Waters, before

Dylan, and she held her own. She was a beautiful, tough, talented woman, with a message and a brain. And if she said so, then we were very loud.

Keith seemed fit again, and played brilliantly. The reviews were good, and the atmosphere was wonderful. Roger was looking Woodstockian, all fringe jacket and long hair. John was playing astoundingly well, coming up with a whole set of new finger tricks he'd obviously spent the summer practising. His usual minder Mick Bratby wasn't with him on this trip, and there was a rumour that Mick had conducted a secret affair with John's wife after spilling the beans about John's own dalliances on the road.

The last show of the tour, in October at the Maple Leaf Gardens, Toronto, was a triumph: we were astounded at how we had bounced back. John and I agreed that we had rarely played better. At a party after the show provided by our road-crew, I danced with a stunning girl and took her back to my hotel. The sex was purely carnal: delightful and basic. I was growing into my skin. I was a hard man, a rocker, strutting the next day through the airport in high-heeled Frye boots that elevated me to six foot three; my puffy blue Maple Leaf Gardens ice-hockey jacket gave me the chest of a football player. I had never felt so omnipotent.

Yet I was dreading going home. I couldn't face what I imagined would await me on my return – piles of charity requests, imploring letters from budding musicians, communications from Meher Baba followers, either complaining they hadn't been treated right at Oceanic or hoping I would fund their various projects. There was huge pressure to do interviews, and if I did I was afraid that what I said could disturb The Who's new equilibrium. And would Karen see the guilt in my eyes?

Of course I had set myself up for failure; I could never be the right kind of Meher Baba follower, not if I continued to

work in rock. Yet rock was where I was meant to be: it was the place where I had to take on board whatever spiritual lesson it was I had been put on the planet to learn.

The recording of *Rough Mix* with Ronnie is now a blur, but I remember some special moments. I played live guitar with a large string orchestra for the first time, my father-in-law Ted Astley arranging and conducting on 'Street in the City'. I was surprised at the respect given me by the orchestral musicians. Playing with Charlie Watts on 'My Baby Gives It Away' was also very cool, making me aware that his jazz-influenced style was essential to the Stones' success, the hi-hat always trailing the beat a little to create that vital swing.

Meeting John Bundrick (Rabbit) was also an important event in my life as a musician. He wandered into the *Rough Mix* studio one day looking for session work. Here was a Hammond player who had worked with Bob Marley, and could play as well as Billy Preston. Offstage he could be reckless and impulsive, drinking too much, asking for drugs and telling crazy stories, but musicians of his calibre didn't come around very often.

Critics seemed surprised that Ronnie Lane and I didn't collaborate as writers. As I had never co-written a song in my entire career up to that point I thought they must be a bit dim. Ronnie never said he expected me to co-write, although later he expressed disappointment that we hadn't even tried. In the last days of the sessions Ronnie and I bickered, I don't know why. I loved Ronnie but wasn't happy with myself, and no doubt it showed. In an effort to explain why I was so down I made the mistake of telling him I had cheated on Karen.

'Why?' he said angrily. 'Are you trying to destroy her?'

I was stunned. I had expected empathy.

'What do you mean?'

'Don't you see that you're trying to drive her away?'

Ronnie was often right in my case, ready to tell me the truth as he saw it, like my friend Barney, but the thought made me explode. I lashed out at him, pushing him hard squarely on both shoulders. Ronnie flew like a man made of paper and came very close to smashing his head on a concrete step at the foot of a stairway. I could have killed him. At first I thought I didn't know my own strength, but I later learned that Ronnie was exhibiting the first symptoms of multiple sclerosis.

Ronnie and I were interviewed about the *Rough Mix* album on BBC TV's *The Old Grey Whistle Test*. While I tried to set Ronnie up as my straight man and attempted to be funny, Ronnie wanted to be serious about the record. I appeared childish, and almost dismissive about what we'd achieved together, trying to bring up the future of The Who, even though at that time there was no future.

The time I had spent with Ronnie Lane working on *Rough Mix* showed me that even someone I regarded as a best friend could trigger me to fight. I fought if I was up, and I fought when I was down. When I lost my temper it was all I knew to do.

But as the autumn weather softly announced the end of the year, a time I always loved, I fell into a wistful mood. I was listening to *Ommadawn* by Mike Oldfield, and the song 'On Horseback' touched me deeply, reconnecting me to an England I had once known. I listened to the music over and over again. It had sparked something in me and I wrote Mike a note, to which he responded, offering a pint of Guinness if I ever visited the Cotswolds.

My wistful mood evaporated on 17 December 1976, with a telex from Keith's lawyer, Michael Rosenfeld. Keith was concerned that the band's tax affairs were being arranged to suit the other three members, who had elected to remain living

in the UK. It must have been frustrating for Keith to be earning money on the road with the band in the USA, and watch it return to the UK to be taxed into dust, but the way we'd set things up he was still an employee of Ramport.

Keith wanted to live in Malibu. There was nothing wrong with that, but suddenly I could see that what had troubled me for so long was now eating at Keith. A rock band with four young men of the same age appears to be a cooperative in which decisions are made at regular meetings with simple voting rules. But a band isn't a unified fellowship, it's an uneasy, sometimes competitive merger of young men with divergent ambitions who've agreed to play music together.

One exception to this was The Grateful Dead, with whom we played two shows in Oakland; I was told their long-term road crew received a share of concert royalties equal to the band members. We had been big-hearted with our own guys, but hadn't gone that far. When we talked about it we couldn't agree.

Queen, Springsteen, AC/DC – they all found ways to stifle the in-fighting and conflict that The Who struggled with too. I had even come to believe that our fans thrived on our arguments, and I tended to dramatise them in interviews. Roger always took the bait, and although there was no real war going on inside The Who we had our share of trouble: financially, because our companies only felt like they were a part of our life when we were on tour; socially, because Keith was constantly going back and forth to LA; and musically, because nothing new was happening – and neither Roger nor I had an easy answer for that.

Punk rock was a tsunami that threatened to drown us all in 1977. You could see it on the streets, hear it in the clubs and even smell it in the air. I welcomed its arrival as a regenerative force in music, while being well aware of its potential to turn

The Who and all our generation into rock dinosaurs. It certainly gave us a compelling reason to snap out of our complacency and come up with something new.

Punk was now established in London, and Keith would arrive at the 100 Club, or the Vortex, like Elizabeth Taylor stepping out from her Rolls-Royce. He'd hold court at the bar, buying drinks for kids who wore zigzag eye make-up and safety pins in their clothes. They were mostly middle-class brats pretending to be tough. They threatened Keith, and he laughed at them, inviting them to come out and ride around in his car. I wasn't so brave. I went with him one evening and met Billy Idol. I thought he was pretty scary, and he made me want to act tough myself.

But any pretensions I might have had to become a Born-Again Punk were quickly shattered when I was summoned to New York by Aaron Schecter, my New York accountant, who looked after Track Music, Inc, the US arm of my UK publishing company. There was a matter of great urgency I had to deal with. Without explaining to me what he was doing, or why, he walked me from my hotel to a large bank.

'Go in,' he said.

'Why?' I asked, confused.

'Just walk in.'

I walked in, and approached one of the tellers, a pretty one.

'Good morning, Mr Townshend,' she said.

Wow! I spluttered. A bank full of Who fans!

'Pardon me, Mr Townshend,' she corrected me. 'I am not a Who fan. Would you like information on your account?'

'I don't have an account.'

'Mr Townshend, we hold a number of accounts here with individuals the bank regards as important enough for us to remember their names and faces. You are one of those individuals.'

'Right then,' I said. 'Can I have details of my account? What's the balance?'

The girl fiddled about for a few moments.

'You have one million, three hundred thousand dollars on high-interest deposit on call, and a further fifty thousand dollars in your main account. Would you like to make a withdrawal?'

'No, thank you.' I had never seen a million of any currency, apart from Italian lire, in my entire life.

Aaron had joined me at the desk. 'Ask yourself, Pete,' he said 'why did you not know your money was here?'

He then slipped away. As I left the bank I bumped into Annie Leibovitz.

'Hi Annie,' I mumbled. 'Take my photograph. I'm rich.'

When I returned to London I went directly to see David Platz, my publishing partner in Fabulous Music, and its manager. I complained that my writing royalties were being held up in a bank in New York, in my name. The same bank was used by Kit Lambert and Chris Stamp for Track Records and New Ikon in the US, and I was worried there could be some intrigue. I held David Platz responsible. He told me he was aware of the problem and had already asked his friend Allen Klein to look into it.

I was stunned, but David assured me the money would come to me very soon. Shortly afterwards I was summoned to a meeting at David Platz's office with Chris Stamp and my attorney, Sam Sylvester, to meet with Allen Klein. 'This should be a simple affair,' I said, when I arrived for ten o'clock tea. 'Royalties owing to me have been found in a bank account in New York, and they merely need to be disbursed.'

David looked at me deadpan. *You charged me to sort this out*, his eyes said. *This isn't going to be simple.* Chris explained. 'On your behalf, David has alleged wrongdoing. Kit, Pete

Kameron and myself have been cited. In such circumstances Allen is able to freeze the money in question on your behalf, in lieu of a legal case, or an agreement.'

Klein added a numbing footnote. 'For an unlimited period of time.'

I asked for a private word with Sam. He confirmed all this.

'So what does Allen want?' I asked. 'A huge fee?'

'I doubt he will settle for a fee,' Sam replied soberly.

Klein, it emerged, would only clean up the mess if given a percentage of all my future publishing income, and of the money he was holding. Although he was legally within his rights to withold funds he had sequestered, I considered this demand for a cut rather than a fee to be blackmail, and I didn't want to give in.

We had more tea, coffee, sandwiches for lunch, more tea, more coffee. Klein was in and out of the room like the cuckoo on a Swiss clock, each time with a new set of computations. Sam was struggling to keep up with the figures. I was lost. Klein's trick was to develop percentages of percentages to add weight to any particular proposal. 'If you give me ten per cent, and David and Chris take a reduction of five per cent respectively, they only lose two per cent of their share of the net income and you gain by twenty in the gross.'

The meeting went on until the evening. I have never felt so stupid. The maths was beyond me, even at its most basic level. I became weary as the day wore on, but Klein by contrast became more and more alert. He thrived on this kind of encounter.

At eight o'clock that evening an agreement was reached. David and Chris, acting also for Kit in this meeting, would pay Klein the commission he demanded in order to release the money. They would also further reduce their share to give me an increase.

'Thanks for doing this, Chris. But what is Kit going to say about it?'

'He'll go nuts,' replied Chris. 'Let's go and get a drink.'

And so we did. We went to the Speakeasy that night where I met two of the Sex Pistols, and started to preach at them, raging about money. Until the very end, I thought Paul Cook, their drummer, was Johnny Rotten. I wasn't even that drunk, just angry about our submission to Klein. I should have gone home. When I did finally get into my big limo, Tom Jones and the comedian Jimmy Tarbuck pulled alongside in a Rolls.

'Any birds in there?' Their faces were full of hope.

'No,' I replied. 'Just a few dead bodies.'

'Who Are You' was written the next day, and reflected the fix I was in. Back in my studio I was writing songs about music, songs about songs and songs about touring: 'Music Must Change', 'New Song', 'No Road Romance' and 'Sister Disco'. But with a million pounds more to my name, I decided to stop touring with The Who and to sail around Cornwall on *Ahmednagar Queen* with my parents. I started a book-publishing company, Eel Pie Books, with Matthew Price, and, with Delia DeLeon, opened a bookshop in Richmond called Magic Bus, where we sold the book Barney and I had put together, *The Story of Tommy*. At Shepperton I formed an equipment-hire company for small gigs, filling a gap in the high end of the rock business.

After the wonder of the demos, recording the *Who Are You* album was no fun. I was really proud of my new songs, but Roger felt some were over-produced. He didn't fight me over this, but he did punch Glyn Johns on the nose, and my brother-in-law Jon Astley took over. Jon loved my work of the time, and was very encouraging. At one session Keith laboured over the jazzy 6/8 swing of 'Music Must Change', but when I offered to drop the song from the record Keith came alive. He stood up, his sticks in the air.

'I can do triplet jazz! I've wallowed in the gutter with Phil Seamen.' (Seamen, the legendary British jazz drummer, had died a few years earlier, addicted to heroin and booze.)

Keith was off on his grandiose Crown Prince Moon the Loon routine.

'I am the best ...'

He caught my eye. I looked at him sadly. Keith hesitated for a split second, before he carried on.

'I am the best ...' another pause for thought, 'Keith Moon-type drummer in the world!'

There was no arguing with that.

I took my family to our new house at Cleeve for Christmas 1977. The Astleys, Karen's parents, lived just up the Thames. Anyone sitting at the table at dinner would have noticed that Karen was uncomfortable with me. She spoke with enthusiasm about the teaching course she was on, but when I was asked about my work and my plans for the future, and I began to prattle about it, her face would clench. The expression said that she'd heard it all before.

Karen's brother Jon was working with me in the studio, and knew what was going on – that Keith was failing and that it was badly affecting the recording process. They all knew. My eyes moved from face to face around the table, trying to divine whether Karen's family could tell me anything that would help me feel I was doing the right things – by taking on the new house at Cleeve and Meher Baba Oceanic, and by trying to help Keith by refusing to tour until he'd stopped drinking for good.

Rabbit was also having drink problems: at an experimental Who rehearsal in March 1978, Rabbit, his musical brilliance clear to all, got so drunk that he threw himself from a moving taxi to avoid paying the fare. He broke his wrist, and some proposed test shows were abandoned. I was upset because the rehearsals had been very exciting.

Rabbit was true to his name, a fast keys player, in my book; he brought tricky new songs like 'Music Must Change' and 'Sister Disco' to life, and allowed us to avoid the use of stage tapes. His Hammond and piano solos were often mind-blowing. Yet, however badly Rabbit behaved, Keith was still my main concern. At these rehearsals, which we filmed, he was hilarious as ever, but I spent a lot of time attempting to get him in line.

One evening Keith invited Rabbit and me to a small gathering at Keith Richards's house in Chelsea. Mick was there with Carinthia West, an old friend of mine I'd met with Mike and Katie McInnerney. She was tall and beautiful, the only female there. While Mick and Keith were playing old R&B records and I was bantering with Eric Idle and Ahmet Ertegun (founder and chief of Atlantic Records), Rabbit decided he'd never be an important enough rock star to attract women like Carinthia, so he tried to drown himself in a bathtub full of water. Then he leapt from a second-floor window like a jinn, and ran off down the street with no shirt.

Jeff Stein was making a biographical film on The Who, *The Kids Are Alright*, mainly from clips of our concert performances and TV appearances. I'd heard stories that Keith had cooked up a film project with Jeff in Los Angeles. The comedian Steve Martin and Ringo had both been co-opted into partly scripted comedy scenes. Keith was still flying back and forth from Malibu. At one important Who accountancy meeting he arrived very late, bustling in like a whirlwind direct from the airport.

'I bring news from Hollywood!'

He had started wearing a huge fur coat, like the one Kit used to wear. He sat down, threw off his fur, swept his copies of the contracts onto the floor and put his fingers together as though in prayer. His eyes were dark and penetrating under his thick black eyebrows.

'I have spoken to Cubby Broccoli' – the executive producer of the James Bond movies – 'who has agreed to cast me as the next James Bond. It will be a comedy, of course.'

'Where did you meet Cubby Broccoli?' I gasped.

'The same restaurant in Beverly Hills where I met Mel Brooks,' he said proudly. He went on even more proudly, 'Mr Brooks gave me the theatrical rights to *Springtime for Hitler*.'

'You mean you got the rights to *The Producers*,' I corrected.

'No.' Keith looked at me as though I were an idiot child. '*Springtime for Hitler*, the play within the play, the story within the story.'

'Ah,' I muttered. 'And James Bond as a comedy?'

Keith went on to deliver a concept that was not unlike the one later made famous by Mike Myers with his Austin Powers series. It was convincing. It was funny. And it was all absurd, of course.

Still, it was clearly important for Keith, and for us as his friends, to feel he could build another life. Maybe he really could be useful setting up Hollywood contacts for Who Films Ltd, our new company. Musically his drumming was getting so uneven that recording was almost impossible, so much so that work on the *Who Are You* album had ground to a halt. Keith went public with the fact that the recording had been prematurely interrupted by his condition. We had just about enough tracks for a record, with very little additional material to spare. 'Music Must Change' was completed with footsteps replacing drums.

Jeff Stein's film on The Who was nearly completed and he wanted a current live Who show for *The Kids Are Alright*. He put me under relentless pressure. I was terrified Keith wouldn't be able to hide his deteriorating condition on stage, but agreed to it.

The show, a short one at Kilburn State Cinema, was appalling. We were all out of practice. Keith was hard to drive along and I became angry very quickly. It wasn't Keith's fault, he was half-dead from alcohol-related exhaustion and the sedatives he was taking. There was some affectionate heckling from the Punks in the audience, and I responded with a tirade.

'If any of you little gits wants to come and try to take my guitar away from me, you can give it a try!'

I was assuming the audience was full of Punks hoping we'd fall, and in my view of the day that's precisely what happened.

After our abysmal performance, Jeff Stein persuaded us to do a second shoot that would be better produced, more expensively shot, and we'd only be expected to play a few selected songs such as 'Baba O'Riley' and 'Won't Get Fooled Again' before an invited audience of Who fans. The shoot was set up on the largest stage at Shepperton. Keith was in a good mood but bloated and unfit, and he found the repeated takes wearying, whereas the rest of us had the adrenaline to keep going. Keith's earphones kept falling off, and he ended up with them taped to his head with thick black gaffer's tape.

I worked hard, jumping up and down and leaping from one side of the stage to the other. At the time I just wanted Jeff to go back to New York and leave me alone, but I look back on the day with affection. The gathering of our fans was something special. The film director Tony Richardson introduced me to Nic Roeg, who had directed Mick Jagger's extraordinary film *Performance*. We talked for some time about film, and the way existing pop and rock songs were now being used in films. The atmosphere that day was joyful and full of bonhomie.

My disenchantment with The Who at this time – mainly because of the difficulties with Keith – was growing, and like Keith I was trying to build another life. I piled up a dozen

major projects, and was allowing a number of other people to
haul me into theirs. Books, shops, studios, a record company,
equipment rental, the revival of *Lifehouse*, an exhibition at the
ICA, solo record deal, films and more.

By the end of the summer the *Who Are You* album and
single were selling well without any touring to support it, we
had signed a film deal for *Quadrophenia*, I had been commis-
sioned by Melvyn Bragg to develop a television play called
Fish Shop, and Cameron Mackintosh, who would later
produce *Cats*, took me to Hornchurch to see a production of
Tommy with a chorus of schoolkids on a gantry.

Keith came to London to attend the opening of the 'Who
Exhibition' at the Institute of Contemporary Arts in the Mall.
He was in extremely good form: he was sociable with our
fans, solicitous and kind, gracious and charming. He seemed
happier. I met my hero the pop artist Peter Blake for the first
time, and it was a relief to find that he too – in the company
of New Wave singer Ian Dury – was prone to taking a few
drinks too many.

In August I made a serious attempt to connect with Keith in
Malibu while playing piano on a recording session there with
Rick Danko and Eric Clapton, who were working with Bob
Dylan. Rick Danko, bass player and singer for The Band, took
it on himself to teach me how to play New Orleans-style
piano. This requires that the swing of the left hand, a rolling
bass line with a kind of internal flourish, syncopates against
an entirely different and more persistent swing in the right
hand. Play the two together, a feat that requires suspension of
belief as well as any normal rhythmic coordination, and you
sound like Dr John. Play them apart and you could end up like
the drunk pianist of my childhood whose left hand had a mind
of its own.

* * *

In Malibu Keith was drinking very hard, and I couldn't keep up. Instead of helping him, I got caught up in his great parade, and almost forgot why I'd gone over to see him in the first place. But something I'd said had touched him: we wanted him to come home, all of us. When I got back to London, Keith called to ask if I'd rent Harry Nilsson's flat opposite the Playboy Club for him; he wanted to come home, but had no money. I spoke to Harry, who agreed to it, but told me he was worried. The place was cursed. Mama Cass had died in the flat. I assured him lightning wouldn't strike the same place twice.

Bill Wyman had a place on the same block, and tried gamely to keep an eye on Keith. One evening Bill Wyman and Spyros Niarchos, son of the Greek shipping magnate Stavros Niarchos, arranged to meet Keith in his third-floor flat and have some drinks with him. Keith, in a rock tradition that he himself may have started, had hired his own minder, instructed him not to let him escape, then set about proving he couldn't be contained. In the middle of enjoying a quiet drink, Keith drifted to the window, opened it and – without seeming to give the slightest thought to anything at all – simply jumped out.

Bill and Spyros ran to the window to see Keith lying on his back on several mattresses he'd previously piled in a construction dumpster. He got up, brushed himself off and shouted up past the gasping onlookers, 'See you at the Playboy Club. Mine's an orange juice.'

At the time Keith was juggling doctors to create confusion and to get the most medication he could, especially to relieve the symptoms of alcohol withdrawal, but he seemed determined to stay sober, at least. He rang me almost every night, almost always around midnight, to say he loved me.

In September 1978 Roger called me at my studio. He was succinct.

'He's done it.'

*　*　*

Throughout my life I haven't been able to feel any great emotion when someone close to me dies. It's a terrible defect that makes me appear cold-hearted. I'm sure it's my own weird way of coping. In the case of Keith, my reaction was immediate and completely irrational, bordering on insane. Instead of letting The Who gently fade, and picking up the solo career I had started with *Rough Mix* with Ronnie Lane, I confounded everyone. I even surprised myself when I called a meeting with Roger and pressed him to join me in taking The Who on the road. John was still in shock, but fully prepared to join us.

This idea was madness. Among other things, I was seriously worried about my hearing. I was hearing birds singing all the time, night and day. It was the beginning of tinnitus. But the real absurdity of persuading Roger and John to join me on tour in a new Who with a new drummer was that I had already begun a new life in anticipation of never touring with any band ever again.

The incredibly charged emotions around Keith's death made me lose all logic. I was convinced that everything would be OK if we could only play, perform and tour. I now see that, although I had worried for a long time about Keith dying, I had never really believed it would happen. I was shaken to my foundations, and my mind flipped.

Without grief, in its usual manifestation, I had to find a different way to deal with my loss. You can say I was in denial. Keith had been a pain in the ass, but he had also been a constant joy. Once he'd gone, something irreplaceable was missing from the magnificent boardroom at Shepperton. The fur coat, the grand schemes, the Cubby Broccoli and Mel Brooks visions. There was something missing from Ramport Studios as well. All that was left was a sense of his ghost, playing the drums, laughing as he played 'Who Are You' with his earphones on fire.

The building is now a doctor's surgery. How very fitting.*

At Keith's funeral Roger was the one in the band who seemed most affected – perhaps that's why I took charge. It had been Charlie Watts whose eyes were full of tears as he remembered his old friend; my eyes were hard and dry.

Phil Collins called me and offered his services, and I knew he would make a great drummer for us. But he was building a solo career, and was still touring and recording with Genesis. How could it work? He assured me he could do it. But I wanted Kenney Jones. He was my friend, I had worked with him quite a bit, and I liked the idea of having a drummer who kept strict time so I didn't have to do it. I felt Kenney's work with The Small Faces had been inventive but restrained; 'cool' is the word.

In addition to putting together the new band I was swept up in other work. The *Quadrophenia* movie was going into production: Johnny Rotten and I had met, got drunk, become friends and talked about him playing the lead, but we both agreed he shouldn't try to play a tidy little Mod. My bookshop Magic Bus opened with great ceremony. The Hornchurch *Tommy* show was headed for the West End and I was funding it.

Ina was the person setting up potential solo deals for me in the US, reporting to Bill Curbishley. When she got wind of the fact that I was considering backing out of making a solo album now that The Who was back in harness, she flew to London and came to our house in Twickenham.

The evening began with Ina as a family friend. Karen knew her pretty well, and thought of her fondly. As the evening

* Keith's new doctor, Geoffrey Dymond, unaware of his history of prescription sedative abuse, gave him a full bottle of 100 sedative pills to alleviate his alcohol-withdrawal symptoms as he tried to dry out. Keith had taken 32 tablets.

passed, that fondness ebbed away. What Karen heard was yet another voice urging me to pursue my creative duty to myself, when I had promised her I wouldn't take on a solo deal until The Who were really finished. Ina knew for certain that my heart was no longer in the band. She felt I wasn't doing what I needed to do creatively. Therefore the problem I would face if I just careered on with The Who would become spiritual in nature, and very dangerous for me. A solo deal would give me the chance to express myself, to make records the way I wanted to make them.

Ina's advice a few years before, to let Roger win for once, had proved correct, and had led to an unexpected renaissance for the band. I was convincing myself that Ina was probably right this time as well, when Karen picked herself up and went to bed, having made it clear she was against the plan. I sat with Ina until late and got drunk, feeling deeply torn.

The next day Ina arranged for me to meet Walter Yetnikoff of CBS, who offered me an astounding deal, which included an additional life-changing non-recoupable sum as an inducement. A couple of days later I met Doug Morris from ATCO, part of the Atlantic group headed by Ahmet Ertegun. They offered me exactly half of what Walter had proposed, with no inducement, but I felt as soon as I met Doug that he was the guy for me. Then I met a few other record-company figures as well; delighted by the passion and commitment they were all showing, I began to get confused.

At one point I asked Ahmet for his advice, as a friend. I suppose I wanted the man who had worked with Ray Charles to say he wanted to work with me, but he made it clear this would be Doug Morris's signing, not his.

'Just decide, Pete,' was what he advised. 'Make a choice. Whatever you do, this is a great time for you.'

20

ROCK STAR FUCKUP

The new Who started rehearsing at Shepperton in April 1979 with Rabbit and Kenney, who we were still auditioning. I managed to persuade Roger and John to let me rehearse a four-piece brass section to bring our many unplayed *Quadrophenia* tracks to life. We spent an entire month working.

I felt that the old Who was dead and buried along with Keith, so for me the new band was a new opportunity, one I could never have taken had Keith lived on. I became suspect in this matter; some people felt that I had been happy, or at least opportunistic, about Keith's death. Sometimes I may have come close to admitting, in a clumsy expression of gratitude, that tragedy could lead to rebirth.

Roger, on the other hand, always regarded The Who as part of a personal continuum, a story that began in 1960 when he had formed his first band, and continued when he had invited first John, then me, to join him straight from school. He wanted the band to evolve, to replace Keith with someone as expressive and passionate; Roger admired Kenney's drumming, and liked him as a human being, but felt he wasn't the right drummer for the band.

I told Roger I'd carry on with The Who, but only on my terms. If he didn't feel comfortable with that, I could make solo records and do shows on my own. The future was very much still up in the air, and I have no idea what Bill Curbishley would have been advising Roger behind the scenes.

In May 1979 the new Who performed their inaugural show at the Rainbow in London. It went on a bit – I think that was my fault – but it felt good. I was happy, and it showed. The exhaustive rehearsals paid off. Kenney was great, and Rabbit inspired me at every turn. Roger played the hard man in a leather jacket, his hair cut short. He was fantastic that night, and so was John. The reviews were good, too.

A week later I took Karen and some friends to Cannes for the premières of both *Quadophenia* and *The Kids Are Alright*. I chartered an old classic yacht, *Moonmaiden*, where we slept. The Who played two concerts at Fréjus amphitheatre during the premières, so we didn't have much time to take part in the celebrations, but the press received us with great warmth and seriousness, and we felt honoured to be there with two movies.

There was no hiding the fact Karen was getting sick of me, my selfishness, my overwork, my drinking. Some close friends advised me *she married a rock star, what did she expect?* But that wasn't it; Karen had grown up, whereas I was having difficulty doing so, in or out of rock.

What most annoyed her, I think, was my failure to make a choice – to either choose music and let her build a life around what was left, or just tell the world to fuck off and become a reliable husband and father. I had complained to her about the spot I was in, and she had advised me, usually with deep empathy, but I didn't listen – even though she was the only person who knew the whole story. Instead, I followed my nose (never difficult in my case) from one day to the next.

Karen was working very hard on her teaching course, doing well, and would obviously get a good degree. Every morning she received a phone call from a young man called Ben, whom she arranged to pick up en route to college. Her face always lit up at the sound of Ben's voice. She made no secret of the fact that they had spent time together while working, and she dropped him off home every evening. At the end of May her

course involved a final week away somewhere, and I was left with the kids. When she came home she was glowing. I couldn't tell whether it was intuition or paranoia that made me feel that she and Ben had connected. I didn't ask. She may have thought I didn't give a shit, but in truth I was panic-stricken.

After Cannes The Who did two quick shows in Scotland, first in Glasgow, then in Edinburgh, where I got spectacularly drunk at a nightclub, and while idiot-dancing I tore my trousers. I wasn't wearing any underpants and my tackle was hanging out. It was only when I woke up after my first night back in London and took a shower that I saw in the mirror that I was covered in bruises, scratches, love-bites and teeth-marks. Even my neck. Karen couldn't have failed to notice, surely. I vaguely remembered a red-headed girl grabbing me, but I must have blacked out completely after that.

I played an acoustic set as a solo artist for Amnesty International's benefit show, *The Secret Policeman's Ball*. I didn't drink any more than during any other performance, but sitting on a chair 'unplugged' wasn't the way I usually worked, and without the adrenaline rush of jumping around I fell into a light stupor during the show, rather than afterwards. There was always someone around drunker than I was, or doing more drugs, so I always managed to feel I wasn't so bad. Actor, satirist and comedian Peter Cook was trying not to drink that night, hoping to save his liver, and suggested I give his method a try – he smoked huge joints instead. Graham Chapman from Monty Python was there with his young boyfriend; they were both smiling, remembering Keith fondly.

The next month I helped organise a Rock Against Racism benefit concert in which I performed. I was becoming an artist of conscience, which was important to me. Meanwhile Harvey Goldsmith arranged for The Who to perform at Wembley

Stadium with AC/DC in support, but it wasn't as intense as it should have been. The Greater London Council limited the sound level, and forbade us to use our lasers. We worked hard, playing to a huge audience of nearly 80,000 people, and fans sent letters praising the show, but it didn't feel right.

I was back into songwriting, often sitting alone in the middle of the night in the open-plan living room of our home with a bottle of Rémy, cassette machine and guitar. I was confused about being back in The Who again. I had made a promise to Karen that I'd settle down, and I was clearly not going to be able to keep it.

One evening, by some miracle, we were in bed at the same time. Before she dozed off I asked her a question. 'Do you still love me?'

'I don't think so.'

'Not even a little?'

'Maybe a little,' she replied. 'Now please go to sleep, or go down and work. I've got to be up early.'

Meher Baba's secretary Adi Irani made a visit to London around this time. I tried to get his advice.

'My wife doesn't love me any more,' I said. 'What should I do?'

'She doesn't love you at all?' He wobbled his head as he spoke.

'She said she loved me a little.'

'Ah!' Adi clapped his hands and smiled. 'A little! That's good. Love is universal. Limitless. So even a little is enough.'

I wrote a song called 'A Little Is Enough', and recorded it using the same system as I'd used on 'Let My Love Open the Door'. Although I'd always thought my love songs were terrible, I think this is one of the best songs I've ever written.

* * *

The Who crashed back for a short tour of the States. I loved playing with the new Who. I was able to stretch out a lot more, play more single-note solos and my playing quickly got better. I was drinking on stage, but as long as I kept moving I'd stay in good shape.

In New York I found myself in the peculiar position of being the only member of The Who travelling alone. Kenney had his wife with him, as did Roger, and John was holding court every night with the new group of acolytes he'd built up on his recent solo tours. At my parties at the Navarro there were lots of beautiful girls. I was often rejected, but not always, and even if I was rejected I didn't give a fuck. It was wonderful, I can't pretend otherwise.

Of course I wasn't separated from Karen, and we had never even broached the subject, but I was convinced that my marriage was over. Or maybe I was just trying to convince myself that her not loving me made it all right to behave like every other decadent rock star.

I began seeing myself as a party man, an honorary senior Punk-playboy-cum-elder-statesman. Chris Chappel, who worked for Bill Curbishley, escorted me to see U2, The Clash and Bruce Springsteen. Chris was a young, hip dude, a massive Clash fan, and his enthusiasm was infectious. I thought The Clash were spectacular. They were charming to me when we met, and Joe Strummer clearly had a heart of gold. His work for political causes, especially anti-racist ones, was inspiring.

Chris began to act as advisor to me in all things young and cool. I took to wearing baggy suits and brothel-creepers, piling my thinning hair on top of my head like a rocker. Always a pretty good dancer, I stopped idiot-dancing and danced like Mick Jones and Paul Simenon from The Clash. At 34 I was still just about young enough to pull it off.

* * *

After a riotous show at New Bingley Hall, Stafford, where the crowd went crazy and I danced like a fool, I found Rabbit at the hotel bar talking to Sue Vickers, the wife of Mike Vickers, an old friend from the Manfred Mann band. Rabbit lived in West Hampstead, close to the Vickers family, and they sometimes met up and socialised together.

'You were amazing!' She kissed me on both cheeks.

'Amazing,' another voice chimed in.

On a stool next to Sue sat a young girl. She had a pretty, slightly upturned nose. Her blonde hair was long, almost to her waist, and it swung behind her as she spoke. 'I'm her daughter,' she explained. I took a few steps back, blinded; there were rays emanating from around her head.

'Have you got kids?' The girl from outer space was addressing me.

'Yes,' I mumbled. 'Two daughters.'

'Do they like horses?'

Bloody hell, I thought. *She's a mind-reader.*

'Yes,' I replied. 'They ride, they really want horses, and they nag me a lot about it, but I've never felt brave enough to let them have their own.'

'You must buy them their own horses.'

The girl smoked, blowing swirls of blue cloud around her face. She spoke for fifteen minutes about how fantastic horses were, how they had made her life worth living when she was a teenager.

I suddenly felt I might fall over. 'Pete,' I breathed to my friend Peter Hogan, a Meher Baba follower who managed the Magic Bus bookshop. 'Get me back up to my room.'

He grabbed me, and I said my goodbyes.

'I'm on my way to bed too,' said the girl. 'I'll give you a hand.'

Up the stairs we went, one arm around my good buddy, the other around the fabulous girl. At the top I made a lot of

joyful noise and a mother trying to get her baby to sleep emerged from her room to shush me. I apologised profusely, telling her I knew what it was like.

The next morning I woke up to see a passport on my bedside table. It belonged to someone called Jacqueline Vickers. I looked at the photo but her face seemed like a stranger's. I called Sue Vickers's room and of course I found the girl. I started to apologise, I didn't know what for, but she interrupted me.

'I'll come and get my passport.'

When she got to my room she explained.

'You wanted to fuck me,' she said. *Bloody hell, who wouldn't!*

'Why the passport?' I asked. 'Surely I didn't ask to see it?'

'No, you berk.' She picked it up and flicked through the pages. 'It's my ID for being in a bar.'

'So I wanted to—'

'I told you you'd have to rape me, and you fell asleep.'

I started recording my solo album on 19 November 1979 with Chris Thomas, whom I'd met at Paul McCartney's Hammersmith Odeon concert, for which he'd produced the recording. Rabbit was present for every track, and his work was phenomenal. I used several drummers. Kenney Jones was an obvious pick. James Asher had worked with me at Oceanic. Simon Phillips came in on a few tracks too; I'd loved his work with Gordon Giltrap.

Chris had chosen Wessex recording studios where he'd recorded *Never Mind the Bollocks*, on the other side of London. 21 November was Rabbit's birthday, and after the session we went to Mike and Sue Vickers's family home for a drink. Their daughter Jackie was there with her boyfriend, musician Reg Meuross, and her younger sister Cathy. Mike and Sue were incredibly kind to me. Mike was my contemporary, and we

spoke about the difficulty of maintaining a marriage in our business. He revealed that he and Sue had been having problems.

I felt more at home in their house than for years. Mike, a big-band aficionado, could discuss the kind of music Dad played. Rabbit seemed more at ease than I'd seen him recently. Suddenly I had an idea. 'Why don't you all come to New York? Our first show is on 30 November, but we can go earlier and hang out. I'll get tickets on Concorde!'

Mike and Sue, I suggested, could get some quality time together. We could see shows, go to art galleries and go shopping on my credit cards.

When this fabulous idea didn't go down as well as I'd expected, I got Jackie alone in the kitchen. 'What's the problem?'

'Reg won't come,' she explained. 'He can't.'

'Oh.' I was disappointed. 'What about your sister?'

'She's at school, you dope.'

'What about you?'

She said yes.

The solo album recording moved to AIR studios in Oxford Street, and the tracks started to sound better and better as more was added. Chris Thomas helped find a new voice on tricky songs like 'Jools and Jim', 'Empty Glass' and 'Little Is Enough' and to build really solid backing vocals in thick layers on pure pop songs like 'Let My Love Open the Door'. Wherever my demos had good elements, Chris used them, like Glyn Johns before him.

Chris had just completed the first Pretenders album with Chrissie Hynde. Chrissie had an extraordinary and unusual voice with a huge dynamic range, and Chris worked with her intensely, doing quite a lot of 'comping' – recording a number of vocal tracks, and then choosing, isolating and combining

the best parts. By the time he worked with me he knew precisely how to get a virgin singer like me to find a real voice. There is no false modesty here: this was my first really serious solo album, and I had to learn to sing hard rock, high notes, low notes, and express passion and sexiness.

One night all the band members had dinner at the Hilton with Kenney and his wife, Jan. The mood in the room was extremely high. Winning the point over Roger, I had insisted Kenney be made an equal partner in The Who. He would get a 25 per cent share in the new Who record deal Bill Curbishley had brokered with Mo Ostin of Warner Brothers. The deal was for $10 million for four new albums and a 'Best of', hopefully to be delivered within seven years or less.

Doug Morris, head of ATCO records, came to see me in London with a deal for three solo albums over five years, also for very good money.

'Can you deal with both these contracts, Pete?' Doug was asking the obvious question. The fabulous money aside, I was committed to seven albums over seven years. To do that I needed to write more songs per year than I'd ever managed before.

'Yeah,' I told Doug carelessly. 'I can deal with it. I'm on a roll.'

My best friend Barney and his girlfriend Jan got thrown out of their flat in Richmond, so I allowed them to move into the top floor of my old office near my Twickenham home. Barney soon wanted to buy the entire house. I made Barney an offer I knew he couldn't refuse: if he accompanied me on the next batch of Who tours of the States I would let him have the house for nothing.

'What would I be doing?' he asked.

'I want you to be my friend, and tell me when I'm out of order.'

'I am your friend, and you're always out of order. I tell you, and you never listen.'

'I will listen,' I promised.

'Fucking liar.'

'I'm not a liar.'

'See,' said Barney triumphantly. 'You never listen.'

I was preparing to travel to New York with Barney, Mike and Sue, and Jackie. I also gave Rabbit a ticket to thank him for his amazing work on *Empty Glass*. Karen and the kids had simply faded into the background of my consciousness. It was the only way I could handle what I was doing. When I arrived at Heathrow Airport, slightly hung over, only Sue, Jackie and Rabbit were there waiting for me.

Sue handed me an envelope: 'Dear Pete, Thanks for the offer of a trip to New York, but I don't think things are going to work out for Sue and me. Please look after my family. Love, Mike.'

As Concorde took off, Jackie gripped my hand. When we were in the air she asked me to tell her some jokes to keep her distracted. I was in the middle of the one about the hippopotami in the swamp (my father's favourite) when she looked back to the rows of seats behind us. She suddenly gripped my arm.

'Oh my God!' She put her hand to her mouth, as though about to retch. 'Mum and Rabbit are snogging!'

I couldn't tell this story if not for the fact that from that day forward Sue and Rabbit remained together as a couple until Sue's death in 2007. Mike arranged to leave home when Sue returned. Unfortunately, Jackie's sister Cathy always associated my appearance with the collapse of her parents' marriage.

From the second night in New York, Sue and Rabbit started sharing a room. Jackie, all alone, came to stay with me. We felt thrown together; maybe we had cooked it all up. It didn't

matter. I felt that God himself had sent me a very real angel to help me, to make me feel whole.

Jackie, who raised my pulse rate every time I set eyes on her, soon started telling me she was falling in love with me. I started telling her I loved her too. I suggested that she and her mother stay with the tour, and they both jumped at the chance. It was paradise; I had never been so happy. I woke up to this dazzling young woman who launched me into the light of each new day with a stupid grin on my face.

The third date of the tour was at the Riverfront Coliseum in Cincinnati on 3 December 1979, where we played our usual show. On stage with the band I was often quite delirious with enjoyment, which was completely new for me. I had never enjoyed performing as much as I did on this tour.

I was drinking a lot, that's true, even on stage, and smoking, that too is true, and of course I danced. Maybe I did dance like a fool. Who gives a shit? I was inspired. I often made disastrous musical mistakes on stage, but I was stretching the boundaries and taking huge chances with extemporisations. Kenney struggled to keep up sometimes, but always gave me a solid rock bed. Rabbit was always right with me, often taking the lead. John did what he always did. Unflappable, he was always totally in tune with whatever I did. I often played astonishingly outlandish passages, and sometimes when I ad-libbed on stage I cooked up lyrics that I wrote down later and used for new songs.

All this freewheeling was understandably tough for Roger, making it tricky for him to fit in with our musical digressions. I kept taking over the lead microphone and kicking off new songs. My adrenaline on stage was running so high most nights I couldn't control myself.

After the show at the Riverfront we assembled in the band's dressing room. Bill had terrible news.

'Something terrible happened out there tonight,' he said. 'Eleven kids have died. I don't know the exact details.'

'When did this happen?' someone asked. 'During the show? In the crowd?'

'No.' Bill tried to calm us. 'It was at the entrances, on the plaza outside.'

'Before the show?' I got to my feet.

'We decided not to tell you.' he said. 'The crowd couldn't be allowed to leave the building while security was still dealing with the trouble outside.'

Back at the hotel we all gathered in a meeting room and watched the television. Some of us were weeping at the images of bodies laid out, reminiscent of a mass shooting. We didn't say much. We had a few drinks, but I was already numb.

It turned out that eleven fans were killed (and many more injured) in the rush for seating. The concert was sold out, and when the crowds waiting outside in the cold heard us performing the soundcheck they assumed the concert had started and stampeded. Those at the front were trampled to death by those pushing from behind, who hadn't realised that the doors were still closed.

I was reminded of the incident in New York when Bill Graham had decided not to tell us there was a fire. I re-ran the show in my head over and over again. Had I said anything stupid on stage? It was possible. How did the lines 'It's only teenage wasteland' and 'They're all wasted' at the end of 'Baba O'Riley' fit with the rows of bodies outside? Why couldn't we have been trusted to know what had happened?

The answer was obvious. And I'm sure that if I had been in Bill's shoes I wouldn't have told the band either. Poor Bill, having to watch that show with fingers crossed that we didn't make things worse. Our shows were becoming incendiary and unpredictable, and he often described my stage persona during this period as 'malevolent'.

I mishandled the press, trying to be ironic in an interview with Greil Marcus of *Rolling Stone*: I railed at the rock industry for being so stupid it couldn't keep its audiences alive. We made another mistake when we decided to continue our tour. We should have stayed in Cincinnati for at least a few days to show our respect, which we genuinely felt, for those who had died and their families. Instead, we automatically followed the dictum that the show must go on, and flew to Buffalo to perform the very next day.

The first chance I had I chartered a jet to Myrtle Beach, hoping to find some solace from Meher Baba's ever-present spirit. Barney and my friend Geoff Gilbert went to the centre, but I couldn't bring myself to go. Instead Jackie and I walked along the beach until dawn. We slept all day. Meher Baba was with us, much as I sometimes tried to keep him out.

Mo Ostin, chief of Warner Brothers Records, and his wife Evelyn came to AIR studios in Oxford Street to hear the first playback of my solo album on 7 January 1980. They loved it; Mo would carry the word back to Doug Morris and Ahmet Ertegun that they had a hit album. Chris Chappel, my young minder and fashion advisor, and I hung out a bit. I was finding it very hard to be home. A couple of nights when I was working in Oxford Street I stayed at a hotel nearby, where Jackie joined me. She was waiting for me to make a decision about our relationship.

Chris knew of a vacant flat above a shoe shop in the King's Road that I thought might be useful as a bolthole, so I arranged to rent it. I set myself up a record player and settled in. The master bedroom faced the main road and it was noisy, so I slept in one of two tiny bedrooms at the back of the flat.

One evening after work recording my solo album, *Empty Glass*, my friend Jeremy Thomas, the film producer, set up a

screening of *Bad Timing*, directed by Nic Roeg. The film was a masterpiece, in which Art Garfunkel plays a university lecturer who becomes involved in an obsessive relationship with a student, played by Theresa Russell. My song 'Who Are You' was used in various scenes to highlight the turmoil that Garfunkel's character is being thrown into by Russell's much younger character.

Russell was 23, at the height of her beauty, and a completely convincing and committed actor. The film was full of explicit sex scenes. Chris Thomas and I were blown away by her. Jeremy explained that she was in a tempestuous relationship with Nic that had destroyed his marriage. I knew how that felt. I was hawking a version of the *Lifehouse* film script at the time, and there was a possibility Nic might take the project. It seemed like an ideal time to fly to LA and talk to Nic. I called his number and a woman answered. I recognised Theresa Russell's voice at once.

'Hi, it's Pete Townshend. Can I speak to Nic?'

'Hello,' she replied. 'This is Theresa Russell. Nice to speak to you. Nic is actually in Paris.'

'Damn. I'm coming to town and was hoping to meet him.' I paused. 'But while I'm on the phone, I loved your work in *Bad Timing*.'

'That's wonderful, thank you.' She seemed genuinely pleased, as all actors are when their work is recognised and complimented. 'It was my idea to use your song. I've always loved it.'

'Good, good.' I had nothing more to say. I'd heard the voice I wanted to hear, and she sounded fabulous. We said goodbye and I put down the phone.

I stood helplessly for a while, just staring at the carpet. Then I called again.

'Hello, Theresa?'

'Yes, still here.'

'I was going to invite you and Nic to join me and some friends to see Pink Floyd's *The Wall* next week. I know you're alone, but maybe you'd like to come with us?'

'Wow. Wow. That would be great. Maybe you could call me when you arrive and we can confirm then?'

I put down the phone again and danced around the flat.

On the evening of *The Wall* concert I went first to meet my buddy, comedy writer Bill Minkin at Chateau Marmont Hotel. I was nervous about meeting Theresa and had shaved off my stubble for some reason, so my face looked kind of pasty. Bill offered me a small line of cocaine. I seemed to be operating with a completely new rule book: there was no point in trying to control my life.

The coke didn't seem to do much. We drove around the corner to collect Theresa. She let me in to her apartment. The first shock was that her long blonde hair was now short, and looked a little red.

'I fucked it up,' she said, ruffling her bob. 'Too much bleach.'

'You look great,' I said. Jesus Christ. She was without doubt the most beautiful woman I had ever seen. Her eyes were hypnotic and feline. She fussed around the room, uncomfortable.

'Are you OK with this?' I said.

'Yes. No. Yes.' Then she picked up a bag. 'Let's go,' she said, without looking up.

We drove to the Coliseum and were given seats so far back in the huge venue that it was impossible to see the musicians' faces on stage. During the interval we went backstage and I introduced Theresa to Roger Waters. It pleased me to see him make the same bemused assessment he had made when he met me and Karen at the first UFO Club Pink Floyd gig back in 1967. *How the fuck does he do it?* The show was

extraordinary. David Gilmour's rendition of 'Comfortably Numb' will remain with me for my entire life. Roger Waters was spine-chilling, as usual, a towering and formidable presence.

After the show we went to Le Dome, my favourite restaurant on the Strip. We were given a discreet table in the back room, and I tried to impress Theresa. Bill and I did comedy routines. She was quite a party girl, at one point sitting cross-legged in the middle of the table and trying to get Bill and me to sing something. At the bar I pretended to pass out. She shouted my name, over and over, in an adorable American accent: 'Peeder, Peeder.' I can still hear it today. 'Get up, Peeder,' she laughed, hauling me back onto my stool. I pretended my spine had collapsed. I heard her and Bill talking about me.

'He's adorable,' she said.

'He's bluffing,' said Bill.

Later I walked her to her door, where she made it clear I wasn't going to get past the threshold.

'I love Nicolas Roeg,' she said.

'But I love you,' I whined.

'I love you too, *Peeder*,' she laughed, slowly closing the door in my face. 'You're cute. But Nic is the man. He's the *leader*, sweetie.' I didn't fail to notice the rhyme.

The door clunked shut. I knocked a few times before giving up. I slumped to the floor. I felt as though I had been speared in the gut with a lance of fire. I remembered that pain from my childhood – when my mother, who needed to work, had tried to leave me with her mother, my *wicked witch* of a grand-mother, when I was ill. Back then I had howled so loud my mother could hear me down in the street, and she had come back and took me with her.

Back at my hotel, decades later, I howled again, but this time the only response was the hotel manager, calling to tell

me to keep the noise down. I called my driver. I explained I needed cocaine.

'I'm fucking dying,' I moaned.

'Pete,' he soothed. 'Get a grip. She's just a girl.'

The next day was Valentine's Day. I bought a huge bunch of lilies and roses and a case of tequila and went to Theresa's apartment. She wouldn't open the door. I heard her on the phone to Nic, and he was obviously telling her off. She was shouting at him, defending herself, crying. She must have told him we'd gone out the night before.

I left the stuff outside the door and slunk off like a rat to Amigo Studios to write. The drug dealer met me at the studio, and the small amount of stuff he sold me was excellent – not that I was any kind of connoisseur. I worked efficiently and quickly, writing about eight songs and making demos. The lyrics of my song about Theresa say it all: 'I felt like a flattened ant in a windstorm.' At a dinner at Mo Ostin's extraordinary hilltop house in Los Angeles I told the story of Theresa; Evelyn, Mo's wife – almost as much a romantic fool as I was – told me to 'go after her'. That wasn't going to happen.

Deciding that cocaine would continue to help me with my work, I got one of our crew in London to score me a large quantity. It turned out to be cut with rubbish that made me ill, but it cost me so much money I continued to use it. Events with Theresa Russell had shaken me. Things with Jackie were still up in the air. Would I fall in love with every attractive woman I met? Would I become obsessed if I slept with them, and even more obsessed if I didn't?

And what was I going to do about Karen? My two daughters were still little kids, I adored them, I missed them and they missed me. I wasn't the first stupid husband to find myself in this predicament. I was entirely ready to commit to Jackie – I

was nuts about her – but I wasn't ready to leave Karen. It was absurd.

One evening Karen came to see me in the flat in the King's Road. I was on the wrong side of a very bad night with my crap cocaine.

'You've got to tell me what's wrong, Pete,' she said. 'I want to help you, but I can't if you won't talk about it.'

I couldn't explain it, ironic, but true. I can still see her face in that moment: sad, judgemental and pitying.

Nic Roeg eventually summoned me. I found him sitting alone and pensive at a Thai restaurant in Soho. I tried to speak, but he pre-empted me.

'What you did was hurtful.'

'Nothing happened, Nic,' I said. 'I'm sorry.'

'You were a complete bastard to go behind my back.'

He was right. And instead of simply acknowledging my deceit at the time, I had made things worse by not calling him.

'It's your fault,' I said, laughing. 'You made Theresa so fabulous, so erotic in *Bad Timing*. I'm sure I am not the only one—'

As I said this I realised that of course I wouldn't be. Nic was much older than Theresa, and he might always be fearful she could be taken away from him by someone younger. (In fact I was wrong: they remained married for a very long time.)

Nic changed the subject. 'The *Lifehouse* script is quite good. There are some good characters in it, but I don't think it's right yet. I don't think it's going to work for me.'

My heart sank. Had I fucked up the best chance I had of working with a great director on my most audacious project?

The Who went back on the road in March, starting with shows in Germany, Switzerland and Austria. Phil Carson, the head of Atlantic International, had decided to come on tour with me. I'm still not sure why; the only contribution he made

was to arrange an evening at a brothel in Amsterdam. After the show in Switzerland I experienced the most extreme withdrawal, and complained to Bill Curbishley, telling him I needed my cocaine and I was flying home. He just gazed at me like the wreck I'd become, and ignored me. He must have had dozens of such run-ins with Keith in recent years.

Instead of returning to the comfort of our lovely hotel in Bern I walked out of the hall and began to walk the streets. It was freezing. I walked all night, uphill, downhill, through parks and piazzas, getting lost in the countryside, then finding my way again back to the city by following small roadside streams down to the bottom of the valley. Bern is a stunning city. The bear pits are famous, so I decided to take a look. I couldn't see any bears. I shouted for them, then jumped the fence and looked inside the caves. I could have been eaten alive.

When I got back to the hotel the band had flown on to Vienna, and Bill had made Wiggy wait for me. He apologised for having appropriated my crap cocaine to try to help me, and gave me a new supply, this time the real stuff. From that moment on, Wiggy and I were drug-buddies. There is no tighter compact of friendship. There is no greater potential for deceit.

Bern without bears? That could be a song, I thought.

I landed in New York on 10 April to do some promotion on my solo album, and to begin an American tour with The Who. The two tours blurred together for me. I was drinking hard and using cocaine that Wiggy was carrying for me. I had told him to be generous to the crew when the supply was needed. I didn't use a huge amount myself, and rarely during or after shows. It was recreational for me, so I never really got hooked on it properly. I still preferred Rémy, and often slept with the bottle in my arms cuddled like a baby. Sometimes I even sang the green bottle to sleep.

Even so, at the end of the tour the petty cash drawn by Wiggy on my behalf for cocaine was $40,000. I never carried drugs on flights, so I must have thrown a lot away. Hey, I was rich.

As for the booze, maybe I was kidding myself, but most of the time it was about having fun. I spent a lot of time laughing on the road, in the studio and with my friends. Laughter is well known to be a medicine that makes you feel happy, and so even when I was having trouble I would drink, laugh and feel better. I rarely felt angry when I was drunk. I was either funny, a jumping bean, or pathetic. I'd never been the kind of drunk who punched people, though I did break my hand on the first night of the second leg of our tour in June. I was copying Rabbit.

'Hey!' Rabbit shouted. 'Fuck everything!' And he punched a hole in a wall panel.

'Hey!' I shouted, and punched a different wall, only I spent the rest of the tour with my hand in plaster. Strangely enough, it didn't affect my playing very much.

After a marathon seven shows in Los Angeles we went to Tempe, Arizona. Backstage in Tempe, I met a fashion model who liked my hit song, 'Let My Love Open the Door'. I asked her to wait while I showered.

Jim Callaghan was in charge of security on the tour and was responsible for passing each of us money from the merchandising concessions. These concessions were still run by ex-pirates, who paid in cash. We called it cocaine money. Of course none of us had any idea how much was actually being made. We just took the cash, gratefully. After the seven days in Los Angeles, Jim gave me an envelope containing $50,000, the largest sum I'd ever received. I put the envelope in my tote bag and grabbed the model who was still waiting. I could scarcely believe my luck.

That night the fashion model and I arranged to go out to a nightclub where she wanted to show me off; we collected her brother and his girlfriend on the way. He seemed a nice guy, and we had a good time. The club didn't serve Rémy, only a cheaper French brandy, which made me irritable and anxious to score some cocaine. The girl and her brother did their best to make connections, and so did the limo driver. We all failed.

That night the girl stayed with me and the next day she came with me to the airport. 'You have to come to Dallas,' I pleaded. 'You just have to. I'll send you a ticket. Give me your phone number.'

She said she would, we kissed and parted company. My heart was pounding all the way to Dallas.

When we arrived, Roger's minder, Doug, took me aside.

'Roger has left his cash in the safe at the hotel in LA,' he said.

'You'll have to go back and get it,' I explained. 'It's more than you think.'

'I thought that bird you were with could pick it up at the hotel and bring it with her when she comes.'

'I expect she could do that,' I agreed. 'I'll give you her number. Can you organise her ticket for me? Make sure she gets a car? All that stuff?'

Doug nodded.

I was settling into my hotel room when I got another call.

'Problem,' said Doug. 'Can I come see you?'

'She won't come? I knew it.' I figured such a wonderful dream had to be short-lived. Doug came to my room. He looked nervous.

'I called the number you gave me, and her mother came on the phone.'

'And ...'

'She said her daughter wouldn't be coming to Dallas.'

'Bugger.'

'She also said ...' Doug made a face, and this confused me. 'She said we won't get the money back.'

'She didn't already collect Roger's money, did she?'

'No,' corrected Doug. 'That's what I thought at first. But Roger's money is still in the hotel safe. Do you have yours?'

'It's in my tote bag,' I assured him, understanding immediately that it wouldn't be there. I looked, and it was gone. I wrote a song that night – 'Did You Steal My Money?' – and hoped it would be a big earner.

Back in London I hadn't quite abandoned the King's Road flat. Sometimes I ended up at home in Twickenham, or in a hotel, when I should really have gone to Cleeve. When I did go home, finding my door keys was often tricky. Karen wasn't amused, needless to say.

One night, annoyed that I couldn't find the right key and suspicious that Karen had changed the locks, I threw my bunch of keys into the darkness. I heard them fall. I searched for an hour. I tried the Spike Milligan method. *Everything has to be somewhere.*

No luck.

I tried Sherlock Holmes. *Eliminate the impossible and what remains, however implausible, is the truth.*

No luck.

I slept in the garden. At least it was summer.

Bill Szymczyk was producing *Face Dances*, The Who's first album with Warner Brothers. He chose to work in Odyssey studios in London because he needed an American MCI board for recording. We did a test session there in March and it proved to be a good studio for the project. It was there that I met Marvin Gaye, who took over Studio 2 for a few weeks. I think 'Baby Don't You Do It', one of his first hits, is one of the greatest recordings ever made, certainly one of the finest from Tamla. Marvin didn't write the song, but his voice is what

makes the lyric so affecting and moving. *Baby don't you do it, don't break my heart.*

Marvin was in terrible shape – worse than me. He was my hero, and I found it hard to see him this way. In conflict with his old friends at Tamla, he was being courted by the London high-society establishment, and had become involved with Lady Edith Foxwell, so-called 'queen of London café society'. I knew her because she had shares in the Embassy Club, one of my favourite haunts. Marvin was still very good looking, and the London coterie seemed to be showing him off in a way that ultimately seemed to help them more than it did him.

I struggled to process the music he was making: he played all the keyboard parts himself over drum-machine rhythms. When I was in the room I didn't understand what I was hearing, but it was a work in progress, and I, of all people, understood how huge changes can come about. He was producer and engineer on his own record; he had help, but he did most things all by himself.

One night, while I sat with Marvin as he negotiated to buy a rock of raw cocaine as big as a tennis ball, I decided to tell him what his music meant to me.

'The lyric comes from the head,' I said, 'the music from the heart.'

I paused for effect.

'But the voice, Marvin,' I said, delivering a punchline, 'that's from God.'

'Thanks, Pete,' he said, gracious as ever.

He turned back to his keyboard synthesiser and resumed his improvisational noodling. Marvin may not have been a great keyboard player, but if he noodled around long enough he found what he wanted. *In Our Lifetime* was excellent when it was finally released.

* * *

Making *Face Dances* was fun. Bill was methodical in his work, always shooting three complete takes of each track so he could cut the best parts together if he needed to. Rabbit was totally on top of his playing on these sessions, working on the Bösendorfer piano I had shipped in from Oceanic. Once or twice we spoke about our respective marriages, and I realised how much time Rabbit and I had been spending together, and how our karmic worlds had become intertwined. He is a shy, complex man, and can be explosive. His playing is expressive and inventive, but he rarely managed to organise it into song form. Not for the first time I wished I was better at co-writing. Life would have been very different for Rabbit had his genius been more widely appreciated.

Karen and I went to see Queen at Wembley, and I thought they were about the maddest group I'd ever seen. They were bigger than The Who in the UK by this time. John Lennon had been shot dead in New York the day before, and it was all anyone could talk about. I had only met him once or twice, but I felt for Yoko, Sean and Julian.

Bill wanted to mix *Face Dances* at his own studios in Florida. On the way, via New York, I went to see David Bowie in *The Elephant Man* at the Cockpit Theatre. The next morning I awoke to the news that John Lennon's killer Mark Chapman had recently been to see the show. There was something so chilling about this that it instantly sobered me up.

It didn't last long, though: to celebrate the completion of recording *Face Dances* I got drunk all alone in my hotel room. When I woke up the next morning, stark naked, it looked as though a sewer had opened up in the middle of the room. No damage, but I had been violently and profusely sick, had lost control of my bowels, and must have failed to reach either the toilet or the bed, falling asleep instead on the marble worktop of the kitchenette sink. It took me several hours to clean up, sneaking all manner of soaps and disinfectants from the maid's

office down the hall. Trying to come off the booze without medication was having as deleterious an effect as drinking too much.

I was rowing five miles a day on the Thames whenever I could. I was becoming quite powerful and my stamina was good. The week before I set off for Florida I'd experienced some chest pains, and went for a medical. My X-ray was clear. The ECG was perfect. The blood test was OK. I had strained a muscle while rowing. How could it be that I was so healthy?

I had seen first hand the danger of believing oneself to be invincible; Keith had died, in the end, of a very simple misjuggling of medication. I needed to be more careful. Or did I need to be less careful?

ACT THREE

PLAYING TO THE GODS

There once was a note, pure and easy,
Playing so free, like a breath rippling by.
The note is eternal, I hear it, it sees me,
Forever we blend it, forever we die.
'Pure and Easy' (1972)

Behind an eminence front
An eminence front – it's a put-on
It is an eminence front
Eminence front – it's a put-on
'Eminence Front' (1982)

I don't need to fight to prove I'm right
I don't need to be forgiven
'Baba O'Riley' (1971)

21

THE LAST DRINK

It was 1981, four years after Punk. There had been a grand challenge, but the old guard, the Stones, Status Quo, Queen and The Who, were still filling huge venues while The Sex Pistols had splintered, and The Clash, The Jam, The Specials, and Siouxsie and the Banshees were the only Punk bands who still seemed truly dedicated to reforming rock.

For The Who it had been a watershed that seemed to affect us less as a collective than it did me as an individual. Keith had died, and we played on. Punk had been replaced by the New Romantic movement and its many offshoots. Roger and I had even cut our hair to try to fit in. We were both still in our thirties; we weren't ready to remain untouched by the new trends. This was a new teenybopper era, with girls screaming again at good-looking young men like Madness, Adam and The Ants, Duran Duran and Spandau Ballet.

Barriers were being torn down. Where Freddie Mercury tried to keep his homosexuality off the front pages, Boy George was openly and outrageously gay. Mark Almond was working the musical-hall arena that Ray Davies and I had mined years before, bringing it up to date. Devo, Kraftwerk, Visage, Ultravox and many others were starting to use computerised synthesisers and drum machines to produce an entirely new style of music. It was being punted by the critics that the guitar was old hat; I was reminded of the way my father and his clarinet were written off in the same way back in the late Fifties.

While I loved the new sound of The Who with Kenney on drums and Rabbit on keyboards, especially on stage, I knew in my heart that The Who had lost contact with our fan base. This was not so much to do with the sound we produced; but more to do with who we were, what we had become. I'm not sure that we knew exactly who we were playing for any more. Bruce Springsteen seemed to have swept up our old crowd, and The Clash threatened to challenge even him if only they could survive long enough.

In 1964, when The Who had first started moving, we knew soon enough who we were working for, and why. Now our audience of working-class young men had dispersed. Many of them were as lost as we were, not knowing what to make of how quickly the chaotic speed of Punk had turned into the heroin chic of the New Romantics. As an artist, performer and songwriter I could no longer pretend to have a viable patron among the young. 'My Generation' was comfortably moving towards their forties, living in middle-class affluence or – disturbingly – in cardboard boxes around the Waterloo area, only half a mile away from London's wealthy West End.

The Who had started off when there was optimism among working-class youth, who grasped the fact that they had the opportunity to change and develop. 'You never had it so good,' said Prime Minister Harold Macmillan back in 1957 when I was twelve, and it just kept on getting better. For the first time in history a whole generation had the economic and educational opportunity to turn their backs on the dead-end factory jobs of their parents, who, traumatised by two world wars, had responded by creating a safety blanket of conformity.

In this surge of hope and optimism, The Who set out to articulate the joy and rage of a generation struggling for life and freedom. That had been our job. And most of the time we pulled it off. First we had done this with pop singles, later with

dramatic and epic modes, extended musical forms that served as vehicles for social, psychological and spiritual self-examination for the rock 'n' roll generation.

However, by the late 1970s, at the tail end of years of Labour government in Britain, just before the Thatcher Conservative government quadrupled the dole queues, it was the Punks who were able to express the nihilism, fury and contempt of a new generation of youth, betrayed and thrown onto the scrapheap. With no future, no hope, The Who's original manifesto was effectively shot.

This all sounds rather grand, but it's a reading of what actually happened. Things changed under us. Songs like 'My Generation' and 'Won't Get Fooled Again' became anthems for a particular time, but by 1981 a gulf had opened up between The Who and the new younger generation. I had to accept that we had reached our peak of popularity at Woodstock, and however famous and successful we still were as a band, our ability to reinvent ourselves was declining as we continued a long slow descent from that moment when Roger sang 'See me, feel me, touch me, heal me', the sun rose up behind us and my guitar screamed to 500,000 sleep-tousled people.

So who was my patron now? If it was the generation I had grown up with, my solo musical projects might speak to them more directly than did The Who. But I looked outside music, becoming involved for the first time in radical causes and street-oriented charity work. I wanted to be more useful to society. I also wanted to give more creative vent to the literary side of my imagination. I wanted to write books, essays and – if necessary – polemics.

Back in 1968 I had written the music for my friend Richard Stanley's first film, *Lone Ranger*. It was a comedy film and the music wasn't serious, but there was something about the persona of the Lone Ranger, the lost boy who becomes the

masked man and rides up with his sidekick Tonto to rescue those in need, that chimed very deeply with me. At the heart of it, I knew, were two key elements: my rock-star performance was a role I played – I might just as easily have worn a mask – and in the act of rescuing others I was hoping to rescue and redeem the lost boy in myself. In short, I still needed to grow up, to become a man who was valued by society.

In a documentary on *Quadrophenia** I said:

Jimmy is the hero, at last … It's not about The Who, it's not about Roger, it's not about Pete, it's not about John, it's not about the Mods, it's not about Ace Face. It's not about drugs or any of that stuff. It's just about Jimmy, and … that he realises he's been looking outside himself, and what he has to do now is to try to ask a question internally.

To mature properly I needed to reach back to my lost youth, the eight-year-old I still carried within me. This was a long time coming, and even in early 1981 I had no idea how crucial the action of reclaiming my childhood self would prove to be in future years. Yet in the next two years my life would change in quite unexpected ways and I would find real redemption in helping others. That would prove to be the most important way I could find affirmation: no longer just in song lyrics, but in direct action.

For now I had to accept that my days of playing to kids, and speaking on their behalf, were numbered, and my new patrons, at the back of the theatre, in the cheap seats, were still too distant for me to see them, too far back in the past and too far into the future. And for the time being, I appeared to be as lost and as confused as ever. Between performing and writing I was still on a trail of what seemed like endless, mindless

* First screened in the UK on BBC4 on 29 June 2012.

drinking, and this time not just on the road, or alone in a hotel room, but at home with my wife and children.

In the first few weeks of 1981 I was falling into the clichéd behaviour of the hard, resentful drinker. Thank heavens I was never violent. I wanted to be with my family, but the call of alcohol and cocaine was powerful, and Karen suggested that while I was struggling with my drinking I should probably live outside the family home. I joined St James's Club and took some of my clothes, books and guitars there, and some to the house in Cleeve. I ended up living between these two places, and from then on rarely went home to Twickenham.

The Who cavalcade swung back into action with rehearsals in January for the tour that would accompany the release of our latest album, *Face Dances*. John's song 'The Quiet One' and the rest of mine, 'Don't Let Go the Coat', 'You Better You Bet', 'Another Tricky Day' and 'How Can You Do It Alone', were all whipped into shape. We also refined songs from the last two Who albums, *Who by Numbers* and *Who Are You*. Because of Keith's death some of these had never been presented in the way they should have been.

Two shows in Cornwall fell at a weekend, and Karen decided to bring Emma and Minta to the Tregenna Castle Hotel, the scene of happier times on holiday, where they could spend time with their dad. Instead, after the second show I attended a party at the hotel the band were staying in, and ended up crashing in a room there. In the morning my family had left without me. I'm convinced Karen would have throttled me had I not been useful to her. By this time she was deeply involved in raising funds for a shelter for battered wives. A few days later, Karen, knowing I would be susceptible to doing anything she wanted, asked Bill if The Who would do a special benefit concert for her refuge at the Rainbow.

When we played at Lewisham Odeon young Zak Starkey, Ringo Starr's son, came backstage looking worse for wear, with his sister. Outrageously, in spite of my own excesses, I took it upon myself to lecture him. He must have thought I was nuts. The second night Jackie Vickers came, and I played her my demo of 'You Better You Bet', the song I'd written for her at my Soho studio a few weeks before. As the tour rolled on all over Britain, show after show passed by in a haze of wonderment and alcohol.

My book publishing company was growing quickly, with books about David Bowie, Bob Marley, The Jam and Vivian Stanshall's script for *Sir Henry at Rawlinson End*; the list included several books about Meher Baba, of course, and *Joys and Sorrows*, the autobiography of Pablo Casals, the famous cellist. Many of these books had been put together with journalists and photographers I knew from the music press. I myself began to write down the details of things I saw going on around me for the short stories I planned to publish.

In February Minta sent me a card:

Dear Daddy,

 I miss you very much and I wish you would come home. I always feel unhappy when someone mentions your name. I am sorry to hear about the flu. I heard You Better You Bet on the radio and I like it. It's not fair! Everybody else has got a dad who comes home at night. I hope you are not too worn out to come and see us again.

 Love (etc).

Minta.

The poignancy of her plea punched a hole in the semi-fantasy I was living, but I couldn't stop.

* * *

I persuaded my friend Peter Blake to do the artwork for *Face Dances*, due for release in March 1981. It would be the first record cover he had designed since The Beatles' *Sgt. Pepper*. He decided to ask twelve British artists each to produce a portrait of one member of the band. David Hockney, Ron Kitaj and Richard Hamilton – heroes of mine along with Peter himself – were among those who contributed. The album was released to limp reviews, though sales were good. Warner Brothers threw a lot of weight behind radio promotion and it paid off when 'You Better You Bet' became a hit. But something had passed between Roger and Kenney that had affected the spirit of the band. Behind the scenes, Roger pleaded with Bill to persuade John and me to remove Kenney.

Bill called a meeting in spring 1981. Roger confessed to Kenney that he couldn't bear to work with him any more, and blamed him for what he saw as the primary defect of *Face Dances* – its lack of fire. Kenney claimed I had used the best songs available for *Empty Glass*, my first solo album. John blamed Bill Szymczyk, the album's producer. I blamed the songs.

I always spoke to John about everything to do with the band's creative direction, or its make-up. When we talked, the two of us would always summon the two thirteen-year-old boys from Acton with their cheap guitars, sitting together, eating their fish-and-chip suppers, fantasising about being as successful as The Shadows. Now John told me he was pleased with the new band, enjoyed hearing Rabbit's inventive solos and liked the novelty of playing with Kenney, who kept the beat without decorating it. Like me, John was finding more space in The Who's new sound, not less. We both welcomed the addition of brass as well.

If there was a real sense of The Who as a band when John and I sat together to talk, when we sat with Roger there was

more the sense of a gang, with all that implies: loyalty, honour, history, self-sacrifice, courage, hard work and duty. Between John and me there really was no leader, but for the three of us in The Who, whether it was as band, brand or gang, Roger was the unquestionable leader. I controlled a lot of what we did because I wrote most of the songs, and by doing so greatly influenced the direction of the band's music, but Roger was the leader, and always had been.

Why was this new system not working for Roger? Roger literally used to *dance* to Keith's drums. He was balletic in his upper-body movements, just as I was balletic sometimes in my leaps and splits. (I once said to Roger that if you could combine his torso with my legs you'd have a hell of a man.) But when Kenney joined the band, Roger couldn't dance to the music any more. He claimed that Keith had always followed the vocal line, and that he in turn *followed* Keith. And Keith was gone.

As I began to really stretch out on stage, I started to improvise. There was no ego involved, I was simply writing songs again while performing. Roger had an unerring knack for setting up a dynamic that generated an upward curve; we always ended in an anthemic or triumphant climax. He tended to favour the familiar songs that warmed up his voice, but this meant recycling our material from the past.

Below the surface things with The Who had taken a troubling turn, and I had no idea how to set them right. Kenney stayed, but the joy I had taken in the new Who had all but evaporated.

From my base in Soho I might start an evening at the John Snow pub. Bill Curbishley's office was a short walk away and I often dropped in. WEA, the UK arm of our Warner Brothers record label in the USA, was on the same street, and Polydor Records was in nearby Oxford Street. My publishing company,

Eel Pie Books, had offices on the top floor of the Soho studio. In the same building, Nick Logan, former editor of *New Musical Express*, became a tenant of mine, set up his huge art camera and began publishing *The Face*, the trendsetting lifestyle magazine. We were part of the creative and fashionable heartbeat of the city.

One evening, in March 1981, as I was leaving the Embassy Club, I ran across Ron Nevison, whom I hadn't seen since he mixed the *Tommy* movie soundtrack six years before. He was standing on the stairs that led up and out of the club, trying to persuade a girl to go home with him.

She looked as though she was being hassled. She was wearing a white jumper, with broad navy-blue horizontal stripes, and black skirt. Her hair was wild, unkempt and bleached, about shoulder length and gently permed. I could hardly see her face. She looked small, crumpled and down. Ron walked away in frustration. She looked at me for a split second, her eyes misty and tired. She was very pretty.

'Let's go to Tramp's, then I'll take you home,' I said. And that's how my love affair with Louise Reay began – an unrequited obsession that would nearly cost me my sanity.

A few weeks later, in April, I flew to New York so I could do some demos for my second solo album. As usual I stayed at the Navarro. My sessions were at Atlantic's studios on Central Park West, a legendary place where Ray Charles and Aretha Franklin had worked with Ahmet Ertegun and Jerry Wexler in the halcyon days of ATCO records. I cooked up a couple of interesting tracks with keyboards and echo delays, working with Michael Shrieve, the drummer from Santana. And I got to see some of Mick Jagger, who was doing some studio work there for his first solo album.

On the morning of 8 April I woke up at the Navarro to someone pounding at my door with the horrific news that Kit

Lambert had died the night before in London. He had fallen down some stairs at his mother's home. Looking out the window of the Navarro I could see the Dakota on Central Park West, outside of which John Lennon had been shot. My head began to swim. Sobered by the terrible news about Kit, acutely aware of how fragile life could be, I decided to go to the Twin Cities and visit Eric Clapton, whom I'd heard was in hospital there. Alan Rogan, my friend, guitar tech and minder, and Jody Linscott, who played in the James Taylor band, went with me.

When we got to the hospital it turned out that Eric had simply taken too many painkillers. Still, I was glad to see my old friend.

My little posse went from there to Los Angeles. We planned to do some sessions with Jody's friend, one of James Taylor's backing vocalists, David Lasley. I also did a gig with one of Jody's other friends who had a band; it was in the venue on Sunset now known as the Viper Club. While in LA we visited my friend Joe Walsh, who'd played with The James Gang, and then with The Eagles until their break-up the year before. His house was in Santa Barbara. It was a long drive. When we got there Joe had laid out a line of cocaine at least three yards long. Jody snorted the entire line in a single drift from one end of the marble countertop to the other as we watched in amazement.

'That's all there was, Jody,' drawled Joe.

Of course it wasn't.

Kit's memorial service was to be held in Covent Garden on 11 May 1981. I gave a heartfelt eulogy to the tearful gathering. The London Symphony Orchestra played the overture from *Tommy* by Will Malone, 'Pinball Wizard' arranged by my father-in-law Ted Astley, an excerpt from Constant Lambert's *Rio Grande* and the poignant Chaconne from Purcell's *The*

Gordian Knot Untied. It was an extraordinary affair. Everything about it was perfect. Afterwards Chris Stamp and I scored some coke and hung out, which also seemed appropriate somehow.

Mark Macauley, a shareholder in the Embassy Club, had the brilliant idea that he should take me and my daughters to see *Cats* in London on opening night. He had seen previews and loved it. I asked Mark to pretend Louise Reay was his partner, so I could attend without losing a precious night out with her. Louise had done something with her hair, pulled it tighter to her head than usual, and worn a high-neck navy and white polka-dot dress; she looked exquisite and behaved perfectly. But my girls, although only ten and eight years old, saw through the ruse and went home to tell their mother I was with another woman.

Whenever I was separated from Louise I felt a unique anguish. In this case it wasn't just the remembered pain of my childhood and my mother, but rather a longing for what was good about Louise to remain above the high-tide line of our lives. I wanted her to last, to linger as she was that night of *Cats* at the New Theatre in Drury Lane. Even compared to Bonnie Langford, the show's star, who gave me a knowing wink as she meowed and pranced up and down the aisle, Louise was transcendent.

I was desperate to hang on to her, and to have her illuminate my life. I invited her to New York where I thought I might do some more work at Atlantic Studios. We attended a party with Mick Jagger and Jerry Hall, and hung out with Christopher Reeve and Robin Williams. Photographer David Bailey told me his wife, Marie Helvin, was a fan of mine – I think they were drifting apart and he was hoping I would take her on a date.

The partner-swapping mood continued when at the end of the evening Mick asked Louise for her number, and I was

stunned when she gave it to him. She had done this once before when we went to a party thrown by Bernie Cornfeld, the international financier, and he had asked for her number and got a result. The trip turned even worse for me because Karen managed to find out where I was and called my room at the Navarro, complaining I had taken my new crush to *her* favourite hotel. I went to bed depressed, and Louise went out to watch Madness perform alone.

The next day Louise made it clear she'd had a wonderful evening without me. I felt sorry for having dragged her across the Atlantic only to be subjected to my possessive, childish behaviour.

The New Romantics all had glamorous and well-defined images – they had their own looks. Even the bands that defied this vogue, like The Clash, Madness and PiL, nevertheless took part in carefully choreographed photo-sessions. I wanted my next solo album to be part of this vogue. I might be an old rocker when working with The Who, but as a solo artist the field was wide open for me to do whatever I felt like doing.

In my new studio at Oceanic I mixed my demos of *Face Dances* and *Body Language*. Jackie Curbishley – who was effectively my manager, with Chris Chappel providing street cred – liked them, but Bill wasn't so sure. I had decided to mix spoken word and free verse with the lyrics. Sometimes it worked, sometimes it didn't. I was working on a *film noir* idea at the time called *Bilder von Lily*, and all the songs I was preparing for my next solo album were intended to illuminate this story.

Terry Rawlings, the music editor who had been so helpful to me on the *Tommy* movie, went to work on *Blade Runner*, directed by Ridley Scott. In the middle of May he sent me a script to read, and asked me to compose the score. Terry had told Scott I would do a great job. I could see this would be an

incredible opportunity, and was pleased to be asked, but I knew there was no way I could take on a movie when I was about to go into the studio again.

When Bruce Springsteen came to London in the first week of June 1981 I travelled up to Birmingham with Louise to see him perform. I played with Bruce that night as Little Stevie van Zandt called out the chords. There is nothing quite like playing guitar with Bruce Springsteen on 'Born to Run', a hymn to breaking free. My role was to enforce the guitar part with Little Stevie by my side, while Bruce made that special connection with his audience.

A few days later the Oceanic sessions for my second solo album began in earnest, recorded by The Who's soundman Bob Pridden. I'd decided I wanted to record all the tracks live, so the band gathered in the studio where we could all hear each other. I was playing my old Telecaster through a Fender twin amp, Tony Butler and Mark Brzezicki from my brother Simon's band were the rhythm section, Jody Linscott was on percussion, and Peter Hope-Evans on the harmonica and Jew's harp. For these first sessions Chris Stainton, who played with Joe Cocker and Eric Clapton, was on piano and Hammond, while Polly Palmer (from Family) played tuned percussion – glockenspiel, marimbas and vibraphones.

In one week we rehearsed 'Face Dances', 'It's In You', 'Stop Hurting People', 'Dance It Away', 'Man Watching', 'Sean's Boogie', 'The Sea Refuses No River' and 'Communication'. The sound was epic. I didn't drink very much, and although there was cocaine around, not much of it found its way onto the rehearsal studio floor.

Every night after work I'd loon off to the Venue, or some other place, hoping to see other bands. One night I performed with Taj Mahal, who name-checked me as an ally and supporter whenever I went to see him play. It was a joy. I ran into my sister-in-law Virginia at the Venue, and she agreed to

play piano and keyboards on some of the forthcoming sessions. Rabbit had gone to ground, and I couldn't even raise him on the phone. Since The Who shows in March I hadn't seen or heard from him.

Before autumn arrived, I returned to The Temple at Cleeve and invited Mum to come and stay in the cottage there. She had drinking problems of her own, and had isolated herself in the villa in Menorca I'd bought for her and Dad many years before. I thought we might help each other. I suppose this attempt at solidarity in alcoholism was as mad as Mum thinking that sending me off to live with her crazy mother Denny might help me – but I found The Temple a peaceful and restorative place, and I imagined it might help Mum too.

It did help us both for a few days, but I quickly became impatient with Mum's self-obsession. I went to the local bookshop in Wallingford and bought *Remembrance of Things Past* by Proust. I took long walks while Mum cooked food I couldn't eat – usually strange Spanish fish dishes – and did endless crosswords in the puzzle magazine she bought in the village when I wasn't reading.

In September 1981 Chris Thomas and Bill Price started in on my solo album *Chinese Eyes* at Oceanic. We only worked for a week or so before we got stuck. The problem was that the songs I'd written were incredibly hard to perform. Chris had to start work on an album in Paris with Elton, so I was forced to face the fact that I wouldn't make the revised November delivery date Atlantic was hoping for.

I had to find a way of putting Louise out of my mind, and Barney suggested I start dating Krissy Wood, Ronnie's ex. I went to visit her, and she was still adorable and slightly flaky – she lived at Wick Cottage with her son Jessie – and still spoke often of her ex-husband 'Woody'.

I took Krissy out to a trendy club in Baker Street, where I was having a very good time – until I woke up in a Chelsea hospital with a six-inch Adrenalin needle sticking out of my chest. Apparently I had been found unconscious in the club toilets, having overdosed on cocaine. I was technically dead, but luckily for me I'd been resuscitated in time.

I went to Twickenham to let Karen know what had happened before she read something in the tabloids. When I told her she hit me so hard I saw stars. I think she may have been holding a wooden spoon. It damned well hurt. It was the first time either of us had ever hit the other.

'I don't think you had better do that again,' I said quietly. 'There's no refuge yet for battered husbands.'

I wrote to Bill Curbishley on 24 September, saying I needed time off. He replied the next day.

> I feel it is definitely for the best, and I think you need a
> complete break of two or three months. Some sailing, tennis,
> sunshine wouldn't go amiss, and no dope, booze or
> [nightclubbing]. No London or New York and most of all
> you have to *mean* it.

He went on in the most understanding way. The album would be postponed until the spring, everything would be dealt with, and I shouldn't worry.

More people cared about me than I realised (or probably deserved), but there would be no more Who shows that year. Bill set aside his optimistic projections for the planned American tour of autumn and winter.

Still in Louise's thrall, I pleaded with her to give me some time, and we spent a few days hanging out around Portobello. One evening, after I'd been introduced to her sister and her husband, Louise told me the story of her unhappy early

teenage years. When I railed at her that until she had a child she would never be truly happy, she ended up weeping and telephoning an old boyfriend who arrived quickly to smooth things out for both of us.

Louise later suggested we go and spend some time at The Temple. While we were there, playing Scrabble, I got a call from Chris Thomas asking if I would go to Paris to put some acoustic guitar on one of Elton's tracks. I made arrangements very quickly, then suggested to Mum and Dad that they come with me and Louise. In a crazy fantasy I was creating an instant family. When Mum met Louise she said simply, 'She's beautiful' (she approved) and 'She's very young' (she disapproved). Louise was 23 and I was 36, an age gap that didn't seem particularly large to me.

The session with Elton in Paris was superb. I was using a little cocaine and drinking Rémy, and after a few takes I started to feel in the presence of God. My playing got tighter and tighter when the reverse should have been happening, but we kept doing retakes because Chris said the drummer's 'feel' wasn't quite right. The next day Elton, battling his own demons, didn't show up, and I used the time to record the track for a song of my own, 'Vivienne'.

We stayed in Paris for a couple of days. John Entwistle and his entourage were in town, so I threw a dinner for twenty people. Then we went to a club to drink and eat, where I vomited into a champagne bucket.

Home alone at Cleeve, I chatted to the devil himself. He was so close to me – sitting right on the end of my bed – that I could actually smell him. The odour was nauseating. Next morning I called my doctor, who arranged for me to meet a hypnotherapist specialising in addiction and alcoholism treatment, which saved my life. The doctor also prescribed me Ativan and sleeping pills. To celebrate this

good turn of events I bought myself my first Ferrari, which I was certain I wouldn't drive when drunk. I was turning into Keith Moon.

Karen had decided to buy a larger house, still in Twickenham, just down the river, and sold our old house to her brother. I wasn't sure I wanted to sell it, but as I wasn't around there wasn't much I could do to stop it happening. The new house was beautful, and had a pontoon onto the Thames. Karen and the girls moved into it without me in December. I bought them a piano for the house.

As Christmas approached I began freebasing cocaine. On a trip to New York my friend Ike and I spent the entire time cooking up cocaine with Wall Street traders. One morning, as we left the crackhouse with an attractive girl on Ike's arm, one of the Wall Street guys came over to me.

'Tell your friend,' he whispered, 'that girl he's with isn't really a girl.'

I took Ike aside and told him.

Ike looked at me as though I was insane. 'I don't bloody well care what sex she is.'

We'd spent twelve hours in a crack den, and cooked up at least half a kilo of pure rock cocaine. I suppose issues like gender really weren't that important in the greater scheme of things.

By January 1982 I was living entirely alone at The Temple. I drove my Ferrari here and there and met a few new friends, but my heart wasn't in it. I hadn't touched alcohol for two months, but I needed help to break my dependence on prescription drugs and heroin. I was doing very little work. I called Meg Patterson in California and asked if she could help me. She set things up for me to go to a rented house on Balboa Island in California, where she would arrange for controlled withdrawal using her NET system.

Meg insisted that Karen be with me during my withdrawal.
I said I didn't expect Karen would do that, but Meg said that
if Karen didn't join me she might not take any responsibility
for her part in our troubled marriage. Although Karen had
accompanied me when I went to see my hypnotherapist, and
she and I were getting on much better these days, the situation
was different. Karen was living in the new house – porten-
tously called The Anchorage – and my two daughters were at
critical periods of their education. In the end she didn't come,
and I didn't press.

I spent five days climbing the walls and being preached to
by Meg's charismatic husband George. His visions for the
third world were inspiring; his Christian faith was infectious,
but I felt Meher Baba (as a mystical force) had never let me
down. I just had to find a way home, wherever home was.

On my last day in California my minder Alan Rogan and I
drove to Laguna for lunch. It was Valentine's Day. Afterwards
we walked on the beach. My rehab had taken thirty days, and
I was clean at last. Suddenly, in the sand, I spotted one of the
brown medicine bottles used by cocaine dealers in the States.
The first time I'd ever had one of my own had been on
Valentine's Day in 1980, when I'd asked a friend to get me a
supply to help me deal with Theresa Russell's rejection, two
years ago to the very day. I picked up the bottle and unscrewed
the black cap. I tasted a tiny amount.

Cocaine.

There were about fifteen grams. It must have been thrown
into the sea from a boat coming in from Catalina after a
booze-cruise. I put the lid back on and tossed it into the waves.
Alan looked at me askance.

'What?' I thought I'd done a good thing.

'*You* may have given up cocaine,' he said, laughing, 'but
some of us ...'

* * *

In my absence, The Who had started recording at Glyn Johns's new studio in the country, with Andy Fairweather Low standing in on guitar. I felt pressure to jump off the plane from rehab and join them directly, just as I had after my last Valentine's Day mess two years before. This time I didn't, and it wasn't until 3 March that I drove down to meet everyone.

Much had been said in the press about what I had or hadn't delivered to The Who as its major songwriter, but I wanted a brief from them, some guidance. My head was empty. John mined his own creative vein in a way that probably wouldn't change – and would mostly be directed at his solo work. Roger and Kenney spoke about wanting to perform songs reflecting the important issues of the day.

'They're more at sea than I am,' I told my driver Paul as he took me home.

I got together with Louise just once in 1982, my first year of white-knuckle abstinence. We had lunch in order to create a kind of 'closure'. We laughed and talked easily, and then I went back to my studio and tried to write the song I felt I owed her. I saw Louise once again that year, at a distance, as I was leaving my therapist's room in Harley Street. She was clearly on a medical mission. I hoped she was pregnant, and that she would have the child I had thought would redeem her.

Karen and I decided to spend some time together alone, so we went to Venice and stayed at the Cipriani. When we got home we attempted to spend a weekend at Cleeve as a family. It was extremely tense and hard for Karen, and I was full of mixed emotions, as usual.

My first public performance in 1982 was for the inaugural Prince's Trust Concert on 21 July. I had helped organise it, and had asked David Bowie to appear with me. He agreed, it was announced, but then the dates seemed to change under me, or I'd got them wrong, and it turned out he couldn't do it. He

was filming *The Hunger* in London, and his work schedule couldn't be rejigged to cover my error. He and I stayed friends, but his manager was vituperative towards me ever after.

This was the last time I saw Ike, my friend-cum-drug-connection. 'So,' he said when we met backstage, 'you went to the police.' This was an expression used at the time for addicts who had gone into rehab, leaving their old using buddies behind. I made no excuses.

Ike died of a suspected overdose a few months later. When I attended his funeral and met his family I learned that his father had been British Consul to the UK for many years, and had disowned Ike at some point. I felt his family believed I could have saved his life – a couple of his friends had said as much. He had been my closest friend for many months in 1981. I was extremely fond of him, but there was no way I could have saved him; I wasn't even sure I could save myself.

The next Who album, *It's Hard*, came out on 4 September 1982. It nearly wasn't released at all. When Roger heard the final mixes he wanted to hold it back, because to his ear it didn't really feel finished. But with the tour closing in on us we were running out of time, and I persuaded him to let it stand.

There were two extraordinary moments from Roger on this album. The first was on 'One Life's Enough', a slow ballad about acceptance, and the simple pleasure of making love. I thought this would be a song I would sing, as filler really, something to create some relief. Roger sang it himself, beautifully and tenderly. It's one of my favourite vocal performances from him, equal to his discovery of that falsetto voice he had first used so brilliantly on *Tommy*.

The second was 'Cry If You Want'. Again I thought I might have to sing this one, or at least share it with him. I'd tried to sing it a few times for the *Chinese Eyes* solo album and never pulled it off. Roger had learned the torrential stream of words

by heart before he did the vocal, and he nailed it, almost fainting for lack of breath, the words come so thick and fast.

Glyn Johns wanted me to sing 'Eminence Front', probably the most radio-friendly track on the album. He insisted on using the first take, and I always felt I could have sung it better. The album was recorded very quickly indeed, in less than a month. In hindsight it is actually a very good album, but the slightly provisional mood it conveyed was belied by the truth: there would not be another Who studio record for a very long time.

The first Who shows of the tour were in Birmingham for two nights, then we headed for the US. At Shea Stadium we had two performances lined up, and I was interviewed for a TV show in a limo on the way to the gig. I didn't usually ride in ghastly American stretch limos, and accommodating a TV crew while pretending it wasn't there felt terribly contrived. The Who played pretty well on this tour, but it was being billed as our 'Farewell Tour', and I wasn't about to argue.

The tour was highly lucrative, achieving one of the highest grosses of our career. Long before it was over, everyone in our circle knew that I would announce that I was leaving the band. It also became clear that a peculiar crime had been perpetrated. The Who had gone down, but not in flames. There had been no glorious on-stage heart attack, no grandly tragic hotel-room overdose, no suicide; nothing. Nothing I had done on stage had incited Roger to bash my head in; he had never felt the desire to walk off, or to complain to the press about my overly long solos, or any other self-indulgences.

I played according to the rules, and there were no diversions. I wasn't guilty of anything that might have prompted the inevitable end, but neither did I attempt to send us out in a blaze of glory. That could have caused me terrible problems in the *future* – an Elysian place in which I hoped I'd never have to work with The Who ever again.

I had been a bore. At least, that had been my plan, and for quite some time it worked pretty well.

In New York, on 11 October 1982, I was contacted by Henry Mount-Charles, who worked at the prestigious British publishing house Faber & Faber and wanted to offer me his job there as he was moving back to Ireland. I was flattered and intrigued, and arranged to meet Henry's boss Matthew Evans when I got back to London in the short November break. I became friends with Matthew very quickly.

During this time I also had dinner with Sir Freddy Ashton, who wanted to talk about his godson Kit Lambert. I told him how much I missed Kit. 'I need to write about him,' I said, 'not just talk about him and tell funny stories.'

'Then write about him,' said Sir Freddy.

'A love poem?' I was being a little facetious, but Sir Freddy leaned forward and put the ball back in my court.

'If love is the issue, a sonnet would be in order.'

So I wrote this sonnet for Kit:

> My love stands in the archways of my night,
> Come out into the alley of my day.
> Your ghost is mine, in life you stood away,
> Come near let me embrace you near the light,
> To touch your face so healthy, once so white,
> And hold you in my arms is all I pray;
> For long I've plumbed the sadness you display,
> To hear you laugh was always my delight.
> We loved, but never lovers were to be,
> Yet in the darkened city we might meet
> To talk again in sweet complicity;
> Svengali fashioned neophyte Trilby.
> But music, once of heart, is now of street;
> And genius, once of you, is now of me.

With The Who finally laid to rest as far as I was concerned, I was starting the second year of deep psychotherapy, and there were many amends and apologies to be made: many old friends to be taken to lunch, many businesses to unwind, including Eel Pie Books. I was living at The Anchorage now, with Karen, and I converted the basement bedroom into an artist's studio, with a small recording studio in an adjacent room. The emphasis was as much on the visual and graphic arts as composing. Oceanic was being revitalised or reoriented, with a plan to convert the place into a multimedia video lab. I decided to buy a motor-yacht large enough to undertake long passages, so we could have some adventures as a family.

I wanted to build a new creative vision for myself and facilitate it with physical resources: studios, materials, finance and time. At the end of February 1983 I wrote a very simple treatment for my next solo album. I wanted to provide all the necessary artwork myself, so I began painting again in earnest.

On holiday in Cornwall the previous year I had composed a basic musical theme I called 'Siege'. It was fairly simple, but it lent itself particularly well to variations. I had been inspired by the idea of a soul besieged in a magnificent castle, surrounded by the litter of the ages, the detritus of faded wealth. There was no clear plot, but none was necessary for what I had in mind. I was producing music, stories and lyrics, and even took a few photographs again after a long break from doing so, to create a kind of 'mood-board' for the project. With the help of producer Helen 'Spike' Wilkins, I started gathering together my demos of various released and unreleased Who songs, as well as demos of entirely new material, which I would release in a collection called *Scoop*.

I was still writing short stories, or coming up with ideas for them. One from February 1982 is: *Man who makes love to a girl who disguises her orgasm by singing scales.* I don't know whether I was hoping to emulate Jorge Luis Borges or Monty

Python, but the images I produced began to get more light-hearted. I painted several pictures of Pete Wylie of *Wah!* to accompany my lyric for 'Brilliant Blues'. I combined the faces of my wife and her sister Virginia, and surrounded the image with angels. I painted a good portrait of Mr Freedom in the style of Peter Blake. I also took Polaroids from the television screen, and made one good collage called *I Didn't Hear You*, about domestic violence.

I had dropped the Goldhawk Club manifesto, the idea that grew from 'I Can't Explain' and that demanded my work be an empty vessel in which the audience could find itself. Instead, I needed to find *myself*. Painting and drawing had become a cathartic new outlet, but I was still making music in the old manner. I would noodle around on a guitar or piano, then put down a simple cassette demo. At The Anchorage I used my basic four-track cassette Portastudio rig for demos. I still had a professional studio in Soho, the high-end SSL suite at Oceanic and a good studio workroom with a concert grand piano at Cleeve. My work in my new home at The Anchorage was developmental and private, and coming along very well.

Minta, about to turn twelve in April 1983, was always curious when I worked behind closed doors. Sometimes she would creep down when I was out and look through my artwork and stories, perhaps indicating that she was still worried for me. Emma, a couple of years older, was already running a musical band, The Launderettes, made up of friends from St Paul's School for Girls. When I made some recordings with them it was clear that Emma was immensely talented. She was also starting to look very beautiful. The smile at the edge of her eyes had returned. I felt that I was falling in line, and getting things right.

I had found a boat in Mallorca, an old 65-foot Scottish-built Herd Mackenzie called *Ferrara*, capable of travelling several thousand miles. Our first adventure was in the Greek

islands. We flew to Athens to meet the boat, then travelled east to visit two or three islands before the weather got very windy and we became storm-bound in Nisos Syros. Minta demonstrated her skill as a linguist by chatting to the local tobacconist in basic Greek, which she had picked up in a few hours. I felt I was embarking on a new life, in which my pleasures would be – if not strictly conventional – at least not artificially induced.

A few days before my 38th birthday in May 1983 I went to see Roger at his lovely Tudor house in Sussex. Driving there, I thought back to 1962 when I had walked with my guitar case to Roger's doorstep; I remembered his girlfriend staggering towards me, and his nonchalance at her ultimatum. *Sod her. Come in.* I thought of how badly I had wanted *in* back then, and how much I wanted *out* now. This time I confirmed what Roger already guessed: I wouldn't go on tour with The Who any more.

Back in 1962 I had expected Roger to break down in tears that he had been deprived of that angry teenage blonde goddess. But he didn't then, and he didn't now. I said I would consider working on special projects with him – charity shows, musicals, anything but rock tours. He seemed receptive.

Can you play 'Man of Mystery' by The Shadows? OK, see you at Harry's.

It seemed to have ended as quickly as it had begun. I expect the same thought occurred to Roger. In my notebook, I wrote:

'I proceed to freedom.'

22

STILL LOONY

I met Robert McCrum, Faber's managing editor, and we spoke about a press conference to announce my role as editor in charge of a list focusing on 'popular arts'. I liked Robert from our first meeting. He was tall, sharply intelligent, savvy and funny, but capable of real authority, imposing his will when necessary. His father had been the headmaster at Eton, but there was nothing about Robert that conveyed snobbery or superiority. His own writing was serious and dark, but to work with him was inspirational.

After the Faber press conference journalists got out their knives, and the *Sunday Times* was particularly nasty. But I knew I had been given one of the best jobs in London publishing (even though I was only being paid £7,000 a year and a percentage of any bestsellers), and I wasn't going to squander the opportunity.

Much was said about my turning up for work in a limo wearing a suit, but that was how I had been living and dressing for several years. Offstage, even in my worst years, I had taken more care of the way I looked than I ever did on stage. I shared an office with Craig Raine, the poetry editor, who dressed like a scruffy art teacher and swore like a shipbuilder. Frank Pike looked after the plays, and one of my first commissions, with Frank's approval, was to bring Steven Berkoff to Faber as a playwright. His 1986 play *Sink the Belgrano!* would be called 'a diatribe in Punk-Shakesperian voice'.

Faber's chairman, Matthew Evans, enjoyed my notoriety most. 'Pete Townshend,' he would announce with a certain ceremony when I walked into his office, as though introducing me to a new stage. Of course, that was exactly what he was doing. We got on very well, and became great friends.

My PA, Judi Waring, had retired, so I advertised for a new assistant. Out of a large number of applicants requiring someone 'who could juggle chainsaws' I chose Nicola Joss, who had sent a photo of herself juggling chainsaws. It seemed like a statement about the nature of illusion, the dream within the dream, the joke within the joke.

Nicola had worked for my friend Charles Levison, Chairman at WEA, and brought with her a whole new system of working. Suddenly my life was run with a level of efficiency I had never thought possible. Sadly, her first job was to fly with me to LA to tell Mo Ostin I wanted out of The Who deal, because I needed a witness to record all our meetings. This news was received courteously by Mo, but followed soon by a telex from David Berman, Senior Vice President, demanding repayment of advances paid thus far – multiple millions of dollars. If my colleagues in the band didn't agree with my decision, I would pay back their shares as well.

Meanwhile I had started producing an album for my brother Simon. Intended to be a side project, this would become central until September. I loved working on it, and felt we had a chance of a hit with the title track, 'Sweet Sound'.

Karen and I were, to all intents and purposes, living together again as husband and wife, though in my heart my ability to maintain any kind of matrimonial commitment at this stage was fragile and uncertain. In June 1983 we went together to see Bowie perform at Wembley Pool. During the intermission I had an intuition that if I looked very carefully around the vast hall I would see Louise. I spotted a woman sitting with a

child, right opposite us on the other side of the hall. There could be no mistaking the movements of her head, the clothes she had chosen: it was her. I excused myself and went over to Louise to say hello.

'I thought you might be here,' she said. 'I'm with my friend and his daughter.'

The next day I could think about nothing but Louise. I could barely function, and found it hard to breathe. Karen was looking more serene and attractive than ever, but my brain was still wired to the moon. Louise didn't miss me.

My therapy continued twice weekly. Each session concluded with the same quip to my driver, Paul, waiting outside to whisk me back to Twickenham. 'Still loony,' I would say, gathering the seatbelt and settling down for the journey home through many of my childhood haunts.

I was troubled a little by anxiety attacks. Apart from therapy I had no other support. I thought Alcoholics Anonymous, for a celebrity, would be a bit of a misnomer – how would I remain anonymous?

When Minta and I had lunch with my parents Dad looked depressed and tetchy, which was unusual for him. He was usually so cheerful. He had recently closed his little junk shop, and I thought that might be a mistake.

I noted in my diary around this time that *Karen is getting scarily beautiful. Her face and body are coming alive – she is a greater presence now.* When I had been philandering, mainly with women younger than Karen, I had begun to think of her as too old to captivate me again. But it wasn't she who had grown old, it was me.

The other three members of The Who had buried whatever resentments or problems they might have had with me, or with each other – indeed with anyone at all – and were now looking to find some way to carry on with the band, to

continue, in my mind, on some kind of nostalgic sideshow. At a meeting at Bill Curbishley's offices on 15 June, with all the band members, I stood by my decision to leave. Bill seemed to be the only one who could see I wasn't going to change my mind. At the very end of the meeting Bill's wife Jackie turned to me.

'Perhaps you are finished,' she said, not unkindly.

She had worked hard, and would continue doing so for some time, to try to support my work as a solo artist. This meeting was the last The Who would have for a very long time.

Nicola's secretary Joanne took over the business of opening fan mail and setting it out for me to read. Often I found the letters either unthinking or overly analytical. A few were so unkind they could be tossed aside, but some letters demanded replies, and I was often defensive or brittle, which would elicit further attacks. I wanted my fans to understand why I'd left The Who.

One fan wrote, 'This is bullshit. You know your hair is gone? Well so has your integrity.' The writer and I had exchanged a few letters, and I thought I'd handled her pretty well. But I found it hard to accept that many fans would prefer me to stick to the rock 'n' roll code, throwing myself back on the fire again and again until I was eventually consumed like Keith, rather than putting on the brakes and saving my life. But I came to understand that to many fans, although they felt they knew me well, I wasn't quite real.

When Nicola and Joanne arranged a database, sorting the letters by name and address, it became clear that the same few hundred people were responsible for the whole pile. If men sent photos they tended to be family-oriented, fathers and sons, or groups of men at rock shows or baseball games. Women's photos were almost always solo, intended to trigger a connection.

* * *

My post-Who life was continuing to move into new and exciting areas. In January 1984, through the philanthropist David Astor, I met Donald Woods, who had written a book about Steve Biko, one of the founders of the ANC in South Africa. Woods was indirectly fundraising to release Nelson Mandela from prison, and I told him I would do what I could to help. Astor and I continued to build the funding of Chiswick Family Rescue, the refuge for battered wives that Karen believed in and supported. Astor was a true philanthropist, and never afraid to be radical. We became great friends, and occasionally worked together on street projects like Brent Black Music (a music studio cooperative) and Ken McDonald's *Fred* magazine (a pocket illustrated poetry book).

At Faber & Faber, Robert McCrum decided my free time might be better spent working on a book of short stories. I agreed that I would be taken more seriously as an editor if I could establish that I had at least paid my writerly dues. He also suggested I sort through the Faber archives looking for books to bring back in print, and read from the 'slush pile' of unsolicited manuscripts. From the mountain of submissions waiting to be read I took home three every couple of days, so I was reading six books a week on average, and writing six rejection letters. I loved reading these manuscripts, but whether I liked them or not they would never be published by Faber. Very little was published that hadn't been commissioned by the editorial team.

I reissued John O'Hara's first novel, *Appointment in Samarra*. McCrum then introduced me to the artist Brion Gysin, who had suggested to William Burroughs that he try 'cut-ups'. We worked together for several months, always on the phone between London and Paris, where he lived. His writing was impossible to edit, but he was charming and we finally published his book as it stood.

Frank Pike passed me various novels of Jean Genet to try to revive. They were extremely controversial, all recently republished by Grove Press in the States. Genet was still alive (he died in 1986), and my job was to try to meet him in Paris and see what he wanted to do with his backlist. I never managed to track him down, but did arrange for his entire list of plays, essays and novels to be republished.

Once installed at Faber, I contacted Brian Eno about publishing his famously fastidious creative notebooks. I let Eric Burdon live in the cottage at Cleeve to write his autobiography *I Used to Be an Animal – But I'm All Right Now*. I wasn't at all sure he was really all right – me either – but we both worked hard on the book.

I began moulding myself into the editorial team at Faber. P.D. James, William Golding, Ted Hughes, Tom Stoppard, Harold Pinter, Valerie Eliot and many other Faber authors treated me with suspicion but conditional respect, willing to give me a chance. It was exhilarating. I went to Queen Square twice a week, and on most other days held related meetings at Oceanic where I had based my new offices.

I met T.S. Eliot's widow Valerie at Faber. She took me very seriously and made it plain that the vagaries of rock 'n' roll would pale against those of the wild men of the early Faber days. Ezra Pound had been Eliot's editor, after all. I didn't doubt there had been more fireworks in Eliot's life than sitting on the seafront in Margate where I myself had walked endlessly with my crazy grandmother.

Valerie Eliot was earning money for Faber through Andrew Lloyd Webber's *Cats*. In March she and Matthew asked me to accompany her to the opening night of Andrew's new piece, *Starlight Express*. She told Matthew Evans she was nervous about going, but felt she really should. Like me I think she felt a duty through her role at Faber.

I was appalled by the show. Neither of us quite knew how to take it. *Cats* had been a triumph, I thought, a masterful balance between family entertainment and literary brilliance. In *Starlight* the music and lyrics seemed deliberately corny. At the party afterwards I told a few people what I thought, not realising that one of them, Richard Stilgoe, had written most of the lyrics. He was so shocked that I knew immediately what a *faux pas* I had committed.

Every opening is just that, a beginning, often awkward; revisions could change a show completely in subsequent weeks. Years later I saw the same show in revised form in Las Vegas and found it enchanting. I had forgotten I was an entertainer, forgotten what entertainment was for.

Some of the most successful books I commissioned for Faber were rooted in my contacts from Eel Pie Books and the music business. Charles Shaar Murray was working on *Crosstown Traffic*, about Jimi Hendrix; Brian Eno brought in the artist Russell Mills for *More Dark than Shark*; Matthew Evans, after a brainstorm with me, suggested Jon Savage for a book about The Kinks. By June my own book of short stories, *Horse's Neck*, was ready for delivery. McCrum had worked through the manuscript, reducing nearly 300 pages by over half.

'Pete,' he began cautiously. 'You realise that readers are going to think all these stories are about you?'

'They might, I suppose. And some of the settings are drawn from my world. I've only had one life, after all. But what I've written is fiction.'

'I think it would help readers greatly if they were relieved of the burden of trying to second-guess whether the leading character in each story is really you disguised – or someone else, close to you.'

'What do you suggest?'

'Make every story about yourself, and if they have a central character, call him Pete. If any of the stories don't have a central character, make them first-person.'

I took Robert's advice, although the final story closes with a dream sequence in which a rider mounts a horse from behind. I wondered about the implications of putting it into the first person. Later, when the book was released to reviewers, critic Bryan Appleyard stopped me outside the lift at Faber.

'You do know,' he announced, 'that readers are going to think you actually had anal sex with a horse.'

Working at Faber I felt right at the heart of London life. I was grateful to be alive, remembering how close I had come to dying from a careless overdose. My efforts to raise sympathy and understanding for the plight of addicts, and hope for rehabilitation within the National Health Service, brought me in July 1984 to a meeting at the Commons with the Secretary of State for Social Services, Norman Fowler. He agreed to put the junior health minister, John Patten, in touch with Meg Patterson. I believed I was being taken seriously by politicians partly because I had taken a serious role in the Establishment at last through my work at Faber.

My life was also enriched by time spent getting to know some of the more pre-eminent authors on Faber's list. On holiday in our new house in Cornwall, Matthew Evans and his wife Lizzie came to stay, and we met William and Anne Golding at their house in Truro. Bill, as his friends called him, was a fiery, hearty man, generous-spirited and adored by his family. He'd published his classic *Lord of the Flies* around the time that my dad's first record went on sale. I was surprised at how well Bill played the piano. He had taught music, as well as classical languages. We got on very well, and one day I took him sailing in my little Falmouth Bass boat; he hadn't been on

the water for many years after an almost fatal capsize with his family on his small sailing yacht, but he was obviously a natural seaman.

Back in London, in September, my daily life was further enhanced by helping friends and strangers get into rehab, and raising funds for music cooperatives and charities. Karen and I became co-chairmen of the trust for the battered women's refuge when David Astor stepped down.

I spent October winding down some of The Who's business interests. Roger Searle, Mick Double and Alan Smith of ML Executives, formed by our road crew after the *Tommy* movie windfall, wanted to take over the company, and we needed to establish a fair value. It was extremely difficult. It turned out that not only did we have to find a way to give this company and all its assets to our road crew, we also had to sack them and pay them a severance. The final closure was a sobering moment. The Who had the finest crew in the world. As solo artists we had discovered that no longer could we have an idea in the morning and see it executed by the afternoon.

I had persuaded Karen I could no longer live at The Anchorage. I embarked on a publicity tour of Britain doing readings from *Horse's Neck*. Prize-winning novelist and playwright Caryl Phillips was on the same junket, and we hung out a little, going clubbing after readings and having breakfast together. We went to a nightclub and I took a small drink, which happened very rarely; I knew it was dangerous, but it helped with my anxiety. In Sheffield three young Mods sat in the front row wearing their parkas, holding a guitar with a Union Jack painted on it and grinned while I read my tales of decadence. In Dublin I was joined by Irish writer Anne Devlin, and one yobbo in the audience opened his question for me by wondering if her reading was far superior to mine because she was Irish and I wasn't.

I took over The Who's charity Double-O to help in its mission and with fundraising. Within a month I was visiting drug rehab units and sharing my story.

Melvyn Bragg commissioned a *South Bank Show* about me, which Nigel Wattis directed. Shooting began in May, while I was recording music tracks at the boathouse for a new solo album. Suddenly I realised that my life hadn't changed as much as I thought. Nigel wanted to capture on film a piece of everything I was doing at the time. I was to be presented as a kind of Renaissance man, but it made me aware that things were veering out of control. I was recording music for a new solo album, working as a book editor with several distinguished titles in development, launching a new charity, working to spring Nelson Mandela from prison, chairing the most important women's refuge in the world, publishing my own first book, looking for a new home, making my first film and trying, but failing, to write songs for Roger Daltrey.

This time I wasn't drinking, or abusing any other substance. I was using my first drug of choice – overwork.

A few days later The Who reunited for a one-off event: we were on the same stage for Live Aid. I did it for Bob Geldof, the charity's charismatic creator, whom I adored – and still do – but at one point, when Bob sensed I might refuse to appear, he took the gloves off. 'If The Who appear we know we will get an additional million pounds of revenue,' he said forcefully. 'Every pound we make will save a life. Do the fucking maths. And do the fucking show.'

I wandered around a little, feeling out of place. The press was flocking mainly to the young black singer Sade, whose sultry beauty was intoxicating. Backstage there was a great sense of community. I talked to Bono, who was never afraid of waxing lyrical at such times. We all felt proud to be there. Bowie had wheeled out a suit from his younger days and was

delighted to explain to me how well it still fitted. David Bailey was doing the photos and took a splendid one of me after the show, my working shirt drenched in sweat, looking handsome and weary, which ended up on the wall in the fashionable Caprice restaurant.

At the end, as he battled to find a place to stand on the stage, it was I who moved to lift Bob Geldof up to join us for the finale, and it was Paul McCartney who moved to my side to help. That was a good moment for me. As for our performance, The Who were out of practice and should probably have left it to Queen and George Michael, who stole the show.

A few months earlier Eric Clapton and I attended a screening of Prince's film *Purple Rain*. I was inspired by the way Prince had folded autobiographical references so elegantly into his film. I decided to create a film of my own, combining street scenes from a London district north of Shepherd's Bush and music sequences.

Walter Donahue, an editor at Faber working on the film list, recommended that we also screen a film called *Strikebound*, directed by a young Australian called Richard Lowenstein, whom I would eventually approach to direct my next project, *White City*.

I imagined the narrative would be carried by images, and the words would be lyrical, almost an inner dialogue. In researching the project I spent time in White City, which despite its name was an uneasy mix of many diverse ethnic groups settled in London. A Romany clan had been moved from a camp by the White City stadium, and some had been given homes in empty flats. There was a substantial Caribbean population, which had been there since I was a kid. But there were also newly arrived Asians and Somalis. The entire area was full of streets named after the swan-song days of the British Empire: Commonwealth Road, India Way, Canada

Day Way, Bloemfontein Road and so on. Ironically, nowhere was it clearer that the days of Empire were over and a new way of life was beginning.

The story I wrote worked for me, but not for Richard Lowenstein. He read my script, interviewed me and then presented me with a revised treatment that incorporated my answers.

The narrator was Pete Townshend the rock star, who has returned to his home town and is talking about his young friend Jimmy. Almost every traumatic moment in my childhood was included, although I'd originally wanted a musical play about my neighbourhood, my family, my friends and the people I was coming into contact with in my new life in the mid-Eighties. Richard hadn't followed all of my suggestions, but he put together a very tight shooting script, and I finally approved it. I was used to this happening. With every conceptual music project I'd ever worked on I allowed the ideas to come into focus by osmosis rather than through advance preparation. In most cases (*Lifehouse* being the exception) it had worked. This time the artwork, paintings, drawings and long tracts of writing I'd done were all subsumed in the film.

The work Karen and I were doing for Refuge brought us face to face with heartbreaking stories. My sympathy was always with the women and children who suffered at the hands of violent men. But I also felt empathy for men, too; many of those I met often seemed like badly behaved boys in big men's bodies. But they could never be tolerated, or forgiven. *White City* allowed me to inhabit my own truth, and that of many of the families around me, especially those in my old neighbourhood. Jimmy's story wasn't my story, but my story had a bearing on his.

* * *

I wanted *White City* to be entertaining and colourful as well as real, and although *Purple Rain* indicated how that might be achieved it offered no clear blueprint. Prince, as an artist, was deliberately romantic and distant – he offered a pathway to his inner self only through his music. In *White City* the swimming-pool scene with its synchronised swimming sequences, and the fundraising show for the local women's refuge, were intended to be entertaining while still contributing to the central themes.

My old friends drugs and alcoholism had returned to my daily life, but now, instead of using them as a means of survival, I put them to work in aid of others. The male hero in *White City* is a drunk, not to make Jimmy appear helpless or disenfranchised, but to explain his anger and frustration when his ex-wife begins to empower herself.

The work I was doing with Donald Woods and the Lincoln Trust to free Nelson Mandela also informed *White City*. Apartheid in South Africa was easy to criticise, but I identified many shades of what could be called apartheid in my own life, and the lives of the people I had chosen as subjects for my project.

My own therapy was deepening at this time. My analyst had urged me to write about some of my childhood experiences, especially the time with my grandmother from six to seven years old, and my suspicion that I had been sexually abused. She was a Jungian analyst, so my dreams were useful to her, and I had started to try to record them. By the time I related my dreams to her I had usually worked out for myself what they meant, and was often disappointed when she gave me her interpretation.

I wrote down every dream I could recall and was writing more freely about my abstract thoughts and ideas. When Karen told me she had read some of what I'd written, I pruned and destroyed dozens of notes I had produced, and a number

of photographs I had taken throughout the Eighties. One was
of Louise and me on our second date. When I'd finished
destroying them, I told Karen. She looked sad.

'You didn't need to do that, Pete,' she said. 'All this stuff is
yours, it's your life.'

When it came to *White City*, I occasionally spoke with
Claire Bland, a smart junior secretary at my office, about the
way the themes of sexual abuse might be treated as well. With
her advice I retreated from a number of explicit scenes I had
documented in conversations with recovering addicts, alco-
holics and victims of domestic violence.

As a collection of songs, the *White City* album (which
accompanied the film) was almost entirely free and clear to be
enjoyed as just that.

My solo career solidified, and I enjoyed my seeming status
as a godfather of rock. I decided to do three shows for
Double-O, the charity I'd founded, at Brixton Academy, using
a new big band based on the one from *White City*. That had
been called Deep End, a name suggested by the swimming-
pool setting, and I stuck with it. I also wanted to film the three
concerts.

I had written the title song, 'Life to Life', for my friend
Harvey Weinstein's first film as a director, *Playing for Keeps*.
I had first him, and his brother Bob, in Buffalo in December
1979, our first show after the Cincinnati tragedy. The
Weinsteins were still music promoters in those days. They
used the profits from their company, Harvey & Corky
Productions, to start the film distributor Miramax. *The Secret
Policeman's Other Ball*, their first acquisition, benefited
Amnesty International and helped make the human rights
organisation viable.

Playing for Keeps may not have been the same kind of
success, but the whole business had drawn Harvey and me

closer. Bill Curbishley arranged for Miramax to shoot the Deep End shows and put out a video.

I surprised myself with my ability to hold the attention of an audience as a singer, without an electric guitar, and how effortlessly I remembered the lyrics – something I'd convinced myself I would never be able to do.

We had trouble selling out all the concert tickets, so we used the first night for a soundcheck and camera line-up. Seeing me on stage again disturbed Karen, and she skipped the following night.

I took Deep End to Cannes in January 1986 to perform at the MIDEM conference for musicians and artists, putting myself before almost every leading light in the music industry. The band was the same as in Brixton, featuring David Gilmour on guitar, Simon Phillips on drums, Rabbit on keyboards, Peter Hope-Evans on mouth organ, Chucho Merchan (from The Eurythmics) on bass and Jody Linscott on percussion. Kick Horns – a five-piece brass section – and Billy Nicholls, leading a group of backing singers, enlarged the music to the point I had wanted all those years ago with Roger.

Tony Smith, who managed Phil Collins and Genesis, said it was the best show he'd ever seen. My representatives at Atlantic were excited, and hoped I would take the band on tour. After years as a guitar hero I was now a front man. I looked good, sang well and the music – gathered from a wide range of sources as well as my songs for The Who and my solo albums – was terrific. And for once in my life I knew when to draw the line: I told Atlantic International I would take the band no further.

The music computer had landed in two forms. There was the Fairlight CMI, a synthesiser/sampler workstation beloved of New Romantic bands; by the time I started work on *White*

City I had bought my own. The other system was the Synclavier, a digital FM synthesiser with a microprocessor-controlled sequencer. I realised these developments meant I would soon be able to compose and orchestrate very seriously, without the expense of using real orchestras or the barrier of working with orchestrators like Raphael Rudd or Edwin Astley. I found this incredibly exciting, although I have to add that nothing I've ever heard has surpassed what I heard in my imagination as a boy.

My brilliant Uncle Jack (Dad's older brother) had always been a rather shy and quiet fellow, and for a period after the war was subject to the Official Secrets Act for his work in the USA on the development of radar and later big-screen television. Uncle Jack introduced me to a colleague of his who demonstrated how digital data could be stored on tape using streams of analogue audio 'noise'. I could see that digitisation was also going to change the music industry.

The CD was well established, of course, and digital audio recording had been demonstrated to me at EMI by Tony Lumkin back in 1975. The Mellotron, which used a form of analogue sampling, had been employed by The Beatles and Bee Gees back in the mid-Sixties. Digital sampling had been pioneered by Fairlight, and by Ray Kurzweil, who reserved his first invention for Stevie Wonder. Once I got my hands on a Synclavier, though, I saw that the composer, already king, would become omnipotent, freed from working with session musicians and arrangers and producers for hire. And as soon as the technology arrived to offer the compression of digital music, it could be transmitted down a telephone cable, and artists like me wouldn't even need record companies.

I wanted to make an album about dancing, light-hearted and colourful, to be developed into a theatrical musical. My inspiration was Ray Davies's 'Come Dancing'; I was never ashamed

to emulate that particular hero of mine. While on holiday in Venice I knocked together a list of possible songs. My working title was *Beguines, Tangos and Love*. 'All Shall Be Well' was the leading song, about the inevitable end of South African apartheid in new political fire, but also about the fire of an illicit kiss.

My colleague at Faber & Faber, Craig Raine, had given me a poem about perfume to set to music. It was a fabulous image: a suitor tells his inamorata that because of her wonderful perfume he senses her prevailing presence as a kind of ghost when she leaves the room.* Indeed, I had proposed a small album of such poems set to music, each with its own video. 'Save It for Later', 'Put a Spell on You', 'Boogie-Stop-Shuffle', 'That's All Right Mama', 'Barefooting', 'Night Train', 'Cool Jerk', Miles Davis's 'Walkin' ', Mingus's 'Don't Let Them Drop that Bomb on Me' and a number of other standards I'd performed in Cannes were on my list.

Deep End had rehearsed all these standards, and they were immensely powerful. I dug into my demos and lyrics for unrecorded material and fixed on 'Foreign Languages', 'Join My Gang', 'Ragtime in C', 'Still Life', 'Larry the Lonely Cowboy', 'Can You Really Dance', 'Love in Limbo Land', 'Love Is an Emergency', 'Playing Hard', 'Your Kiss Is an Echo' and 'The Roxy'. Every song was intended to inspire a video dance sequence. On 20 April 1986 I put together an impossible schedule that started the next day and ran until 18 June. I was planning a stage musical that could be televised.

As I tried to hang on to this project, I performed at a concert to raise funds after a volcano had ravaged Colombia. Two session players for The Eurythmics, Chucho Merchan and his partner Anna, a classical cellist, had organised the benefit.

* My version was never finished, but much later the general idea was used by Rachel Fuller for a song called 'Ghost in Your Room', told from the girl's point of view.

Annie Lennox, Dave Stewart and Chrissie Hynde all performed. I was reminded of the finale of Live Aid, when David Bowie, Freddie Mercury and George Michael tried to force their way through the mêlée of artists on stage to get to the front. George had won that time. At the Royal Albert Hall the same thing happened, only the cause was Colombia and the winner was Annie Lennox.

At the Faber summer party I met the poet Ted Hughes for only the second time. I was hoping to create a musical based on his story for children *The Iron Man*. When I enquired about the status of the rights, I was told they were tied up in some way by a film deal in Australia. Matthew Evans stepped in with the producer Robert Fox, and we persuaded Ted to let me begin to develop the book for a pop musical. I started to scratch out lyrics: 'Heavy Metal', 'A Friend Is a Friend', 'Man and Machine' and 'Over the Top'. There was even a scratch lyric for a song called 'Fake It' that wouldn't surface on an album until 1993.

Rob Dickins, who headed Warner Brothers in the UK, pulled *White City* – he stopped pressing the CDs after 25,000 had been sold. It had done far better in Germany and Australia than Britain, and fairly well in the States – especially on radio. When I went to see him he gave me a *White City* neck scarf after keeping me waiting for more than ten minutes. 'You've gone all whiter than white and squeaky clean,' he said. 'Your fans don't know who you are any more.'

Had they ever known? Even now I'm still trying to find out who I am.

As a result of my meeting with Rob Dickins I decided to repudiate my contract with WEA, the UK arm of our Warner Brothers record label in the USA, for the territories outside the USA and Canada, and WEA were happy to release me. Simon Draper at Virgin, who had built his career (and, some would

argue, the founding fortune for Richard Branson) on Mike Oldfield's concept album *Tubular Bells*, was excited to work with me on *The Iron Man*.

The deal Virgin gave me – we signed the contract later that year, in December 1986 – was terrific, and I used some of the large advance to order my own powerful Synclavier system, and to convert my office above the studios at the boathouse into a new composition suite.

I was lined up to perform a solo set in June at Giant's Stadium for the last show on the Conspiracy of Hope tour, in support of Amnesty International. This would be my first solo appearance in the USA, and I was a little nervous, wishing I had Deep End to support me.

While backstage, waiting for a soundcheck, I got a telephone call that Dad, who had been resting in his little villa in Menorca, had been taken seriously ill. I quickly arranged a charter plane to get Dad back to London, informed the show producers and ran to JFK to catch the last Concorde across the Atlantic. This was the only time in my entire career I put my family's needs above those of my audience. And I knew I wouldn't be missed much. The amazing bill included U2, Sting, Bryan Adams, Peter Gabriel, Lou Reed, Joan Baez and The Neville Brothers. I wondered if I would have been able to run to my father's side so easily if it had been a Who show.

At Central Middlesex Hospital I asked for my father. The receptionist couldn't locate him and told me to wait. Instead I dashed away and frantically searched the entire building, eventually finding Dad lying half-naked on a trolley in a basement corridor; he had lost control of his bowels and had been abandoned by whoever had been pushing him. It was pitiful.

I raised hell and a bed was found. Dad had had a tumour removed from his colon but the remaining cancer had spread

very quickly through his body. Seeing Dad in such a dreadful state – months before, he had still seemed vital – threw me over the edge.

Dad, like his parents before him, had avoided doctors. He had been ill for a long time with what Mum called 'the squits'. Mum's answer was to drink heavily, and then rage at him. She had been raging at me too, over the phone, often late at night, and then calling again the next morning having already forgotten. Mum, who had probably done far more for me in practical terms than Dad, was difficult to love, but loving Dad was always easy.

After a few days the surgeon took me aside and said they wouldn't do any more operations. The cancer was spreading quickly, and Dad was put on morphine. He talked about the small cacti my brothers had brought for him as gifts, which he loved because they reminded him of the villa in Cala'n Porter in Menorca; he told me over and over again how happy he had been there, and how grateful he was that I had provided it. He reminisced happily about his life, including the girls he had known. Then, on Saturday, the evening of 28 June, I arranged to go and see him just before he went to sleep. When I arrived at about eleven the ward was quiet. Dad had been moved into a side room. I went in, expecting him to be asleep; he was very still, and lying stiffly.

'Are you OK, Dad?'

'No, I'm not OK,' he barked. 'And I've done enough for you.' He turned onto his side, then turned back and looked at me reproachfully.

I was wounded, but Dad wouldn't say what he meant. I left, still confused. He died later that night.

The death of my father made me acutely aware of what it is to be an ordinary man turned parent, with all that responsibility. I also became more cognisant of my role in The Who. If Roger

led the gang, in charge of the blood, I was its father figure, in charge of the transfusions.

By summer 1986 I had been home behaving as a dutiful father for over four years. My family and I were used to each other again. My relationship with Karen seemed to have settled down. I knew that the period of our separation had hurt her deeply, and I had worked hard to make amends. Karen was always easy to adore, and by now I was feeling more secure, less prone to fantasy and negative projection about the future. I lived in the present.

Emma was seventeen, Minta fifteen. They were great kids, intelligent, funny and loving. I knew they both sensed that I was still finding my feet, but things seemed relaxed between us at last. On holiday in Cornwall, life was fairly straight-cut for me as a dad – the swimming pool, the beaches, the rowing boats. At night I was still writing until the early hours. I wrote about the perils of stardom; about the way I had watched from an early age the sexual dalliances of my parents and my grandmother, and how I had been eroticised by them.*

I was getting to grips with my Synclavier music computer. To be honest, I had no idea what I was setting myself up for by moving into the unknown world of musical theatre. I had studied orchestration back in 1967 while I was working on *Rael*, but nothing I'd composed had been recorded by an orchestra. I began to put together a very tight programme for work on *The Iron Man*, knowing full well it would take me at least two years to crack it. The deal with Virgin required the delivery of the album, a double, by March 1989. I had enough time.

* * *

* I am using the word 'eroticised' here as it is used in therapy as a way of describing the way children's sexuality is distorted by seeing sexual scenes too soon in their lives.

In September 1986 I decided to put Mum into rehab at Broadreach in Plymouth. She had attempted suicide a couple of times, and was worrying the entire family. I took her for an assessment and she was booked in, after which I wrote a letter to my brothers Paul and Simon and to my Uncle Jack, filling them in on the situation. At least Mum didn't have to make an adjustment to our new home in Tennyson House.

At Faber Valerie Eliot invited me on 26 September, among a very small group including Ted Hughes, Harold Pinter and Antonia Fraser, to the unveiling of the English Heritage blue plaque for T.S. Eliot. Harold spoke to me about what he saw as growing problems over discrimination against the Kurds in Turkey, which was one of his passions at the time.* I wasn't sure what he was talking about, but he was very courteous to me.

Through my editorial role at Faber I was discovering a different side of myself, and it was a privilege to be exploring it. My last meeting of the year on Faber business was with the comedian and actor Max Wall. I wanted his autobiography. He had played the lead part of Davies in Pinter's *The Caretaker*, and told a story about taking the playwright aside one day.

'What the fuck is this about, Harold?'

That seemed amusing enough, with no other punch line, and we laughed. I tried to tell Harold this story.

'I met Max Wall the other day,' I said. 'He told me about his conversation with you about *The Caretaker*.'

Harold looked at me with his Darth Vader expression.

'Yes?' he demanded. 'What? What?'

I had to give up. 'Nothing. Enjoy your evening.'

He wasn't a man for small talk. I'd seen a version of *The Caretaker* at the Young Vic in the *Lifehouse* years and regard it as Pinter's masterpiece.

* This was to be an underlying theme of Pinter's 1988 play *Mountain Language*.

Max Wall told me he once pursued Mum when she was a young singer. We got on to the subject of music; the friend who accompanied him to our lunch was a trumpeter and played Louis Armstrong-style jazz – what we called Dixieland or trad jazz.

I told him I had only seen Ken Colyer once, and how peculiar the audience had been. I explained that Colyer was probably the real fount of modern music in Britain, and that it was a shame he was no longer with us.

'I'll inform him of his death when I see him after his show tonight,' said Max's friend.

It felt unjust. Dad was gone, but Colyer – terrible old seagoing lush that he was – was apparently, and incredibly, still alive and performing.

My therapy, my analysis, seemed to be over. I'd got to the point where, if I couldn't remember what happened in my time with my grandmother, it seemed there was no point continuing. I didn't wish to unlock memories I didn't really have. I had been attending regular twice-weekly therapy sessions since March 1982, five years with only a few short breaks. In December 1986 I had my last session of analysis. What had I learned?

I had a problem.

23

IRON MAN

Ted and Carol Hughes lived near Chagford, Devon, on the edge of Dartmoor, one of the most strangely beautiful places in England, with its mischievous wild ponies and wandering sheep that slept in the road. The wooded area around Chagford is exceptional: the light, falling in shafts through ancient trees onto bubbling rivers, sets them to sparkle. I am always inspired by the area, especially by the upper parts of the river Teign.

Part of the joy of working on *The Iron Man* was the time I got to spend with Ted. He was a giant, socially speaking, and I found him inspiring company. He was also a big man, physically, with a large handsome face and a full head of hair that crept down his neck and sprouted in his ears. He held court like the Yorkshireman he was, witty and bluff, with no patience for anything that didn't fit his own literary or philosophical brief. His wife Carol was earthy in the way of a country girl, but dark and sophisticated, an extraordinary mix that was perfect for Ted. A wonderful raconteur, he could hold his own on any topic – his fellow poets, the Greek myths, the Saxons, post-modernism – without coming off as a patronising knob.

My daughter Emma enjoyed his company especially, comfortably sharing her own formidable knowledge without feeling she was showing off. Ted's book *The Iron Man* had become a set book for teenagers studying English Literature for exams. It presented itself as a children's story, but its

themes were powerfully challenging: the mechanisation and computerisation of war, ecology, friendship between different nations and races, even the mythology of the music of the spheres.

On every level this story engaged and excited me. One very personal resonance was my childhood fantasy, as a ten-year-old, of living inside a large, robotic machine that would carry me to and from school in safety every day, allowing me to be remote from everyone around me.

The description of the celestial music created by the Iron Man's enemy, a Space Dragon, chimed with the music I had heard as a child sitting with Aunt Trilby, and on the Thames with the Sea Scouts. There was also in Ted's book the idea that men who had endured war responded to almost every mystery in militaristic ways; it was hard to convince them that there could be a mystical layer to life, but the beauty of the music of the Space Dragon (who reveals that he is in fact a peaceful Star Spirit, a singer of 'music of the spheres') is finally able to spiritually transform mankind and create lasting peace throughout the world.

In Ted's story it is the friendship between the Iron Man – the war machine – and the boy Hogarth that solves the problems. Ted's book connected with me at many levels. It was a post-war book, attending to the futility of the nuclear age: when a single bomb can wipe out an entire country, all conflict is suicidal. By putting a young boy at the centre of his tale, I was also working with the system I knew best: the problems of growing into manhood at such a time, when being a brave soldier was suddenly a counterfeit currency.

Away from therapy I still used the techniques I'd learned, writing more diary entries than usual, as well as bitterly honest letters I never sent. I was in a creative frame of mind, but, instead of writing fiction, this time I thought seriously about

writing my autobiography. I didn't envisage a conventional book so much as a collection of almost random images, poetry and unpublished lyrics, essays that touched on how I saw the unfolding social politics of the West in my lifetime, where technology might take us, and what artists might do in the future. One short story that I'd written, 'The Limousine', formed the basis for a lecture I was asked to give to students at the Royal College of Art.

'The Limousine' is a dark murder story in which the evil man who owns the limo fills the airtight passenger compartment with tantalising music combined with poisonous gas. Then he robs, rapes, murders and dumps his customers. I told this tale to an initially rapt audience of about 200. Once I had them in the right frame of mind I got to my theme: when music, converted into digital data, could be compressed sufficiently to pass down a telephone line, music as we knew it would end. We would feel as though we were in control, but we would merely be helpless passengers. Composers and musicians would feel they had a direct line to their customers, but they would also open doors to all kinds of mental and spiritual pollution. This was the *Lifehouse* vision become real.

Vinyl discs, already endangered, would disappear, as would analogue tape. The CD would be unnecessary. We would use computers, some as small as a watch, to listen to music and share it, and we would be overwhelmed by the sheer volume of sounds we were exposed to. Unable to distinguish good from bad, we would, in the matter of music – metaphorically speaking – be gassed, robbed, raped and murdered. Our luxurious, comfortable limousine was really a hearse.

Perhaps I was being too dramatic. Maybe it was just shit. But one thing I could see clearly: by the time I got to my punch line most of the audience had walked out.

* * *

I worked through Ted Hughes's *The Iron Man*, making personal annotations. Steadily I broke down the book into sections, experimenting with my own variants on the plot line without departing too much from Ted's story; I was simply trying to set the stage for a brief for each song.

In April, in Cornwall, I began to work earnestly on completing the lyrics. As I shared my ideas with Ted, he was enthusiastic and encouraging. He particularly liked my image of the Space Dragon as a creature from whose wings hung hundreds of stolen children. I didn't try to produce a musical that would work only for kids; I responded to Ted's story from my own childlike heart, and scribbled. I hoped that children who came would enjoy it, but there is no avoiding that *The Iron Man* is a dark tale, and I wanted to be faithful to that.

On 30 May 1987 I bound a few copies of the first draft of my musical play – in two columns, lyrics and music on the right, and action on the left, like Ken Russell's script for the *Tommy* film, and distributed them. McCrum responded economically. 'Impressive word-processing, Pete!'

While I had been working on *The Iron Man*, Spike Wilkins had put together a second *Scoop* collection of demos, unreleased tracks of interest and musical oddities. This had been released very quietly by Atlantic in July (as *Another Scoop*), was hardly selling and got little press, and I was curious as to why it had been neglected by the label. Doug Morris had expressly asked me to let him release it so everything was under the same roof. It was a side project for me, but one I took seriously.

Jackie Curbishley wrote to me on the subject, commiserating circumspectly, then raised a topic from her end-of-year appraisal letter.

Iron Man should be a Who project. We can then announce
that Pete Townshend has been writing an opera for The Who
for the last four years in great secrecy. And the world would
be reminded that you did it first, with *Tommy*. We could get
millions of dollars for a Who album of this nature (if it's as
good as I feel in my bones it is going to be) then I can buy
another house, and so can you. John can keep Quarwood
[his grand country house in Stow] for another year and
Roger can postpone his Pepsi Cola advert.

You know it makes sense. I am serious Pete. It would be
fun. There would be no danger of touring if it were for the
stage. You said recently that you always seem to find yourself
writing for Roger's voice from habit. If you knew, absolutely,
that Roger and John would jump at the opportunity, what
would you say? You wouldn't need to sign any long-term
Who deal. I have discussed the fact that I have urged you to
make *Iron Man* a Who project and Bill endorses that. He
thinks it would be a brilliant move. The way I see this is: Pete
Townshend at Brixton was one thing. Pete Townshend and
Wembley Pool would have been another. Pete Townshend's
Iron Man would be one thing. The Who's *Iron Man* would
be another. You told me categorically that you never listen to
me, so I have no fear that you will take this seriously.

The problem was that the music I'd composed so far was defi-
nitely not suitable for The Who, and I knew Roger would hate
it. The last song I'd unwittingly written for Roger's voice was
'After the Fire'; in his hands it became an equally unwitting
anthem of regretful nostalgia for the halcyon days of his youth
as a rock star. The song, written alongside 'All Shall Be Well',
was actually about the end of South African apartheid.

* * *

'Who is that stunning-looking woman behind us?' Emma whispered to me.

We were at the première screening of John Boorman's *Hope and Glory*. I looked around and it was Theresa Russell, sitting with Nic Roeg. They both smiled at me. After the film I made introductions, but not before Theresa had taken my face in her hands and kissed me affectionately. It was hard for me to forget the crazy days. What great people, and how kind they were, those two, but I wonder what Emma thought of it.

It was a very happy time for me with my family during this period. What is taken to be quite normal for most people was a novelty to me. Taking the girls to and from university, planning dinner parties and being entertained by friends and neighbours – I was fitting in, and it felt good.

I remember the striking daughter of one of our neighbours interrogating me cheekily about what I knew about T.S. Eliot, showing off her own knowledge, and when she was chided by one of her parents because I was an important writer myself she made it clear she had no idea who I was. I loved this. That might seem surprising, but at last I felt I was being valued for who I really was, not for who I once had been.

Karen's sister Virginia's daughter Florence was born on 14 December, and it was a delight to have a new baby in the house again. She was a radiant child with chubby arms and legs. Tennyson House felt filled with light. Perhaps unsurprisingly, Karen, who was now forty, soon wanted another child before it was too late.

But I worried that our having more children would leave Virginia and baby Florence in the lurch, especially after my promise to help. I had imagined myself as a constant godfather to Florence, seeing her often, reliving my good times with my own two daughters, maybe catching up on some of the things I'd missed with them when I was on the road. I wouldn't have much time for her with a baby of my own.

I also worried about spending two or three years focusing on child-rearing instead of work. My two studios were only just breaking even, and the boathouse needed an expensive new mixing desk. Without the tours I depended entirely on record advances and my publishing income to keep everything moving. Things were getting tight. I had already spent a year working on *Iron Man*. Karen had completed full-time teacher training and was working part time, but I was still the principal breadwinner. Could I afford to take a three-year break? I doubted it.

I loved being a hands-on father, but that wasn't easy either. Minta was a normal teenager, pressing my buttons, climbing out of her bedroom window at night, staying out late. She was a great girl, but I became distressed when my patience with her ran short. I didn't want to get angry with my kids, not ever. Emma reminded me of myself as a teenager – a little lost, torn between impulsive creativity and academic life. I couldn't sort out my feelings so, in an attempt to articulate them, even to myself, I wrote to Karen.

Dear Karen,

I know it is very upsetting to be subjected to my manic behaviour: in a kind of ecstasy one day and seeing dark edges around the windows the next. But there is something about being with the *family*, just we four, that reminds me of what I am.

You said the other day that I look like someone who needs to be sad, to let the sadness come and go. But the sadness is so enormous, there is so much of it, and it belongs to a six or seven year old boy – I just haven't got the equipment to express it any more.

This letter didn't require a response; it was an apology.

* * *

We were trying hard to have a child in the time-honoured manner, but it wasn't happening. When we began to consider adoption, I spoke to Jann Wenner who had adopted a boy the year before, after which his wife had become pregnant. Effectively they'd ended up with two new sons very close in age, and the boys got on really well. Chucho Merchan (who had played in Deep End) and his partner Anna found us twin baby boys in Colombia ready for adoption. We began proceedings, but soon abandoned the idea when we were told by one agency that we were too old, by another that we were too eccentric and yet another referred to my much-publicised drug use.

One condition of my commitment to having another child at 44 was that we have full-time help. I was still working flat out, every day. Karen agreed we would hire two nannies; she may have had her fingers crossed behind her back, but she agreed.

The financial budgeting thrown up by all this led me to consider downsizing my companies. This would mean selling or leasing part or all of my studios in Isleworth and Soho, moving my offices somewhere less grand and reducing staff. I burned through my advance money for *Iron Man* very quickly. This was a habit of mine; I always used every record advance to make the record in question, and in this case I was working more intensively and meticulously than ever before.

Rabbit, whom I had not seen for nearly four years, had finally re-emerged and I began using him and Chucho to help with arrangements and orchestrations. Billy Nicholls was working almost full time on backing vocals and as music director in that department. I brought in Simon Phillips, the highest-paid session drummer in the world at this time, to do drum programming on the Synclavier, and some overdubs

with real drums. When I used Bill Price as an engineer, and I wanted him full time, he charged top rates. I still hadn't settled on a cast for the album, though my wish-list at the time was promising: John Lee Hooker, Lou Reed and Nina Simone had all responded with interest. When the time came to contract star singers I would have to pay substantial advances, royalties and expenses to record in the UK.

Despite the pressure, I loved working on *Iron Man*. At some points I felt like a film director, slowly building a story that would come together in the editing and make sense. Wherever necessary I drew on Ted Hughes's original text, both at the preparation stage and even in the final libretto, to advance the story.

Even with a double album I was concerned I might not have enough time. The CD format allowed more time than vinyl, but in 1986 record companies still released both, so I was constrained. At best, I had 75 minutes. The average musical ran for 135 minutes, and *Phantom of the Opera* ran for three hours. So I was working on two versions of *Iron Man*: a soundtrack that would work as a freestanding version of the story, and a longer theatrical score.

I worked through the summer. Simon Draper was still fully committed to putting out a double album, but Doug Morris in New York had become unsettled. Doug and Bill Curbishley were very good friends, and what they both wanted from me – and for me – was hits, not smartass musicals. They knew I would always want to innovate, but they were looking for something from the *Iron Man* project that I didn't think it could deliver – hit songs that would get radio play.

In September 1988 Bill Curbishley and I spoke about making a new album with The Who to celebrate their twenty-fifth anniversary in 1989. This was as much my idea as Bill's. At Faber editorial meetings I'd lost count of the number of

anniversaries of famous writers that triggered new campaigns or new books.

There was mounting pressure on me to return to The Who. Live Aid and a one-off performance for the BPI (British Phonographic Industry) had created sparks. Neither show was great, but they set the cash registers ringing. And I wasn't at all sure that without The Who I could generate enough money to give a new child the chance of a good life and a decent education. My two daughters were growing up. We were not a perfect family, but by the appalling measure of show business we had done OK. We'd survived, and that was the main thing.

My first suggestion to Bill was to make a record with Chris Thomas producing, and maybe record songs not written by me but selected from among the favourites John, Roger and I might bring to the table. Bill approached MCA records, who still owned the majority of The Who's back catalogue. They offered $1 million for a new record, which didn't seem enough to me, although I couldn't speak for Roger and John. Chris Thomas's manager asked for a high percentage and a very large advance. Bill Price's engineering would cost at least as much over a twenty-four-week schedule, possibly more. Studio charges, even if we used Eel Pie – my own studios – at cut rates, would take care of what was left.

Bill said that if we toured we could expect double or even triple the amount. If The Who were to tour, say twenty-five dates over six weeks, not only would the record advance increase, but corporate sponsorship could be tied to the twenty-fifth anniversary. The dates themselves could net each Who member $1 million each week. After tax and deductions I could end up with £4 million, and be set up for the future; so would the child Karen and I still hoped to have or adopt. This windfall would also allow me to continue my intensive work on *Iron Man*, for which I was having trouble finding an ending.

I finally completed *Iron Man* with vocal sessions from John Lee Hooker in New York, and Deborah Conway and Nina Simone in London. John Lee was great to work with as the Iron Man; we did it pretty much line by line. Nina was magnificent, and did a fantastic job as the Space Dragon. Doug and Bill had persuaded me to make one track on the album a Who track, and I chose Arthur Brown's song 'Fire'. It nearly fitted.

Atlantic wanted a single album, instead of the double that Virgin had contracted me for, so the project of culling the songs was one I completed with clenched teeth. I had the feeling this was a terrible mistake, but felt I had no choice. *Iron Man*, after two years' solid work, felt as though it was being set aside and The Who were crashing back into my life yet again.

By 1988 my studio at the boathouse was no longer an amusement or place of refuge and creativity (it isn't wrong to say that musicians 'play' together). It had become a business. The Synclavier cost as much as a house; the Focusrite desk would cost as much as an even bigger house. I loved putting studio equipment together, and was proud of my business, but didn't feel I could 'play' in my studios any more.

So, never much interested in cars apart from their ability to transport me quickly and safely, I turned to boats – my new train set. I bought *Blue Merlin*, a 46-foot motor-sailer with roll-away sails and a powerful bow-thruster, so it could be sailed and manoeuvred singlehandedly. I sold a lot of precious guitars to make the deal: two De Angelicos, the Gibson Flying V that Joe Walsh had given me (boy, was he pissed off when he found out), the Guild Merle Travis, a double-neck white Gibson and a few lesser ones.

This gave me the deposit, and *Blue Merlin* became the yacht that would finally allow me to become a real sailor. My new toys would almost certainly cost me as much as my old ones,

and be far less obviously useful in my career. But I loved boats and the sea, and my time sailing was like a meditation.

On 22 September Bill told me that most American promoters he'd spoken to thought there was no need for a new Who album. *Why spoil a good thing?* All we had to do was tour. They predicted The Who would be the number one ticket in 1989, overtaking Led Zeppelin, whose last tour had been in Europe in 1980. The offers for sponsorship were very good, which meant we could afford to have a larger band like the one I'd used with Deep End, which had created an immensely forceful sound, but at decibel levels less than half those produced by The Who. I was still experiencing hearing trouble, tinnitus and occasional pressure problems, and I wanted to hang on to what I had left.

'I am superstitious,' I wrote in my diary on 4 December 1988. 'The last attempt I made to work with The Who coincided with Minta's hospitalisation for pneumonia. When I tried to play in New York for Amnesty, my father died. When I played in Cannes a terrible *mistral*-cum-hurricane threatened my televised concert. At Brixton, Karen became ill. The Who have their collective karma: Cincinnati, Keith, and Kit. Do we really have the right to celebrate a 25th anniversary?'

The former members of The Who met the next day for seven hours. Bill Curbishley was there, and Frank Barsalona and Barbara Skydell from Premier Talent, who would produce our tour, were over from New York to advise us. Frank was just as twitchy as he was when he bullied me to play at Woodstock twenty years before. Bill looked tanned and relaxed, as he spent a lot of time in Spain. Barbara Skydell played the role of soothing matron, belying her true power and influence in the music industry – putting together tours for some of the biggest names in the business, Tom Petty, Keith Richards and The Clash.

Roger shifted in his chair, and John slid his finger up and down the side of his nose as he always did at such times. There was an air of expectancy and tension in the room, but this was a friendly group – we all liked each other, and there was affection akin to love in this reunion. Still, my heart was beating so fast I felt dizzy.

Several times John said he had produced a new set of equipment that would enable him to play quieter. Roger revealed he had written songs with someone called Nigel; they felt society needed 'unpolitical' material of the kind The Who produced in the late Seventies. But I could tell that Roger was worried. He may have felt this whenever he contemplated a new tour, but it was a new feeling for me.

After many hours of discussion, clearly very concerned that the meeting might end without a conclusion, Bill asked that we stay at the hotel until we'd made a decision. He suggested various sponsors for the tour, such as General Foods, and when we rejected them he suggested we could give half the money they gave us to various charities – which could be as much as $8 million.

The unending pressure of the meeting began to make me feel manic, so we took a break. Back in the room, I became more and more unsteady. At six o'clock something strange happened: the atmosphere became charged anew: Roger became more attentive, Bill sped up the pace, and sheets of paper appeared with numbers and dates written on them. Rehearsals would begin in May, possible warm-up gigs in June, then away for the tour with a gap from 1 to 17 August.

By 6.20 I was hallucinating: people were developing auras. I didn't want to do this. We were actually talking about tour scheduling. At 6.25 Roger was going to leave – he had to go. Where, I wondered. At 6.30 I was feeling sick. I wanted drugs. I was anxious. I wanted to see Karen. At 6.33 Roger was leaving; he would miss the final resolution of the meeting. At 6.40

Karen rang, wanting to go to her archaeology class. Minta was ill in bed; when would I be back?

A few minutes later Frank asked me if I was all right; I said no. Barbara asked me how the plan looked, and I said it looked terrible, I felt scared and I wanted to die. She laughed: apart from that, how did it look? I got up to leave, said good-bye to all those nice people, and left. By the time I got in the car I already felt much better. Booking a tour like that can feel a little like knowing that you will soon enjoy a lottery win.

A couple of days later my emotional pendulum swung yet again, and I spoke to Bill and told him I couldn't go through with any tour plans. I wrote to Roger and John saying that everything had felt all right when it was hypothetical, but once I started hearing about cities, towns and stadiums I began to feel nauseous. My last word was that The Who were finally, completely, irrevocably over.

Of course it wasn't true.

Karen and I travelled together to New York at the beginning of 1989, where I was inducting The Rolling Stones into the Rock and Roll Hall of Fame. Being there, especially meeting Little Richard, who was inducting the late Otis Redding, made me feel that continuing to perform with The Who might not be such a bad thing after all. Little Richard was still so alive he seemed to be wired into the city's electricity grid. His induction was extraordinary, conducted entirely in Otis Redding's voice, which he brilliantly mimicked. Keith Moon writ large.

I began my Stones induction speech by saying: 'Keith Richards once told me that I think too much. The truth is, I talk too much, but I don't *think first* ... The Rolling Stones are the only group I have felt unashamed about idolising. Each one of them has given me something as an artist, as a person, and as a fan. It would be crazy to suggest here that all the things they gave me were wholesome, practical and useful ...'

I carried on in a similar, deeply affectionate vein, and meant every word of it.

While in New York I had a meeting with Ina Meibach, our attorney, who had done some basic maths. If I agreed to do the tour and made a new Who album, it would be hard work but in the year ahead I would be generating £14,000 every day. I wondered – and I'm not joking – would that be enough, but I very quickly came around. I couldn't pass up this kind of money. My emotions oscillated once more as I considered that this windfall would also keep Roger and John secure. Finally I decided to commit.

'I've had enough, Pete,' Karen said. 'We can't go on like this.'

She took her dog Blue and went off for the entire day, not returning until late. She had been to Stonehenge to think things through. She was seriously thinking of leaving me, and I could understand why. This wasn't the first time Karen had threatened to leave. She had sat with me through a number of dramatic mood-swings and was probably beside herself with confusion about whether I was in charge of my own life, or at least the part of it that I wanted to share with her. When she was angry she said that when our girls left home life with me alone would be pointless, that we lived alongside each other, not with one another.

I didn't disagree. In fact I had actually tried hard to live a parallel life, so I could do my work and Karen could conduct her own life in her own way. This seemed ideal to me. In any event, she wasn't happy.

This was ironic, because from where I stood things in the family were still looking and feeling pretty good. Minta was 18, taking a year off school before going to university. She found it hard to get up in the morning, as I did, but once she was up and about she worked hard every day. Emma was at King's College, Cambridge, studying Economics and History.

Her boyfriend James was an organ scholar.

The difficulties Karen and I faced were resolved – at least for a while – when she became pregnant in March.

The Who tour was announced in April. I did a week of PR in New York, and the rest of the time I spent plugging *Iron Man*, which had been released to critics that month. Coca-Cola had shown interest in using one of the songs, 'A Friend Is a Friend', for a summer ad campaign.

During rehearsals for the tour I was worried about my hearing, and insisted that the drums be placed in a booth during rehearsals. Instead, Bob Pridden put me in a booth with my guitar, which made me feel that my problem was not really being taken seriously enough. We rehearsed for several weeks, learning over fifty songs, many from my solo career.

Before I left for the tour Karen went for an ultrasound scan. When she came back I was still in bed.

'It's a boy,' she said, and started to laugh.

I leapt up. Fuck, I was happy. How did that work? This was the affirmation I had been hoping for: I really had been getting my family life right after all. Karen and I had hiccuped a few times, but that was to be expected. As Paul Simon said, 'When something goes right, it's likely to lose me, it's apt to confuse me, it's such an unusual sight.' Emma, Minta, and now a son. Actually, I wasn't just happy. I was euphoric.

In mid-June the band moved to Glens Falls for six days of technical rehearsals there. Our first show was at the Civic Center. The band sounded good from the start, even in the echoing, empty hall. I was travelling with seventeen pieces of luggage, much of which was my portable recording studio. I had two young men working for me as porters to transport it and set it up at each hotel.

Rabbit got drunk a lot, and I nearly had to fire him. He thought that after eight weeks' rehearsal he was indispensable,

to which I responded by threatening to replace him. The set list was wide-ranging, including a selection from *Tommy* and *The Iron Man*, John's 'Too Late the Hero', Boudleaux Bryant's 'Love Hurts' and a range of new songs from the 1980s. The show lasted more than three and a half hours, and I sang about ten songs of my own.

'New music, new shades, each song a new challenge. That's what I like,' I wrote after the first show, but by mid-July I was feeling the strain. My ears were ringing badly, so I had to use earplugs for the loud numbers from then on, which made me less effective. I told myself that the most important thing was to be happy; to play and dance with abandon was more fulfilling than to play well.

The reviews of the critics were piling up, and I tended to focus on the bad ones. 'Roger will be pleased at being described as "godlike",' I wrote. 'I am unhappy at being described as "looking like a churchman".'

He may have appeared godlike, but Roger was in a state of near-collapse from exhaustion. After Bill called me with this news, I rang Roger to cheer him up. He'd been to a hospital, had had a thorough physical and had been told he was all right. This upset him even more. He knew something was wrong. On 10 August, after three consecutive shows in Atlanta, Roger wrote an open letter to the entire band and crew.

> Dear All,
> This is to tell you that since the beginning of the tour I have been suffering from immense personal and physical problems … it is a battle I am winning. I have great admiration that you all have made sure the shows are a great success, and that my times on the stage during this tour have been the most enjoyable and memorable of my career.
> Allhamdulia
> Roger

The letter worried me more than it soothed.

Roger had been obsessed with his health, taking an eccentric German yoga masseuse with him, and all kinds of strange medications. And yet it was I who nearly brought this massive rolling megalith to an end. In Tacoma, Washington, I speared myself on my guitar's whammy bar – it went right through my hand. I went into shock, but fortunately Karen was there; she met me backstage and whispered to me tearfully as my trolley was being rolled to the medical station backstage. '*Now* will you stop all this stupid shit?'

I didn't know whether she meant swinging my arm or touring.

Mum arrived on the day of our special *Tommy* concert at Universal Amphitheater on 24 August 1989. Within an hour she was causing trouble, drunk, jetlagged and getting locked out of her room every few minutes. My entire family – my two brothers and their children, my brother-in-law and his wife – were there, and tried to look after her, but it was a real distraction.

Elton John missed the soundcheck and sent a note saying he was ill and wouldn't be appearing as the Pinball Wizard, but at the very last moment he showed up, did a line or two of coke and put on the most amazing performance. I adore Elton; he's not just a talented musician and composer, he's also an amazing trouper.

Our other guests were Steve Winwood, Patti LaBelle, Phil Collins and Billy Idol. The night was wonderful. Lionel Richie and Madonna were in the audience. This was another charity event, and the proceeds were added to the monumental sum of money we'd raised in our shows at Radio City in New York.

The Universal Amphitheater itself is a large room, yet from the stage the performer could see every face. The sound was

excellent. My best moment was being fêted afterwards by the hugely talented and slightly tipsy Whoopi Goldberg, who surprised me by being rather flirty. It felt like a great Hollywood gathering, a celebration of what the band and *Tommy* had meant to all the assembled agents, lawyers, promoters, actors and backroom boys of the movie business. At the party afterwards I met Lionel Richie and his now famous daughter Nicole, who was a sweet little kid. He suggested we work together in the future, but living 6,000 miles away I knew this was unlikely to happen. Still, all in all it was a triumphant day.

Throughout the tour I had been accompanied at every step by two policemen from Cleveland, Officers Baepler and Kunz, both named Greg. Bill Curbishley had persuaded me to accept this protection, which was very expensive indeed, but Bill had given me no reason why I needed it. In the past the presence of my former bodyguard Jim Callaghan had been welcome when I had been drinking, and once or twice he had probably saved me from a beating in a nightclub, but two guys carrying guns seemed a little over the top, now that I was eight years sober. But Bill insisted.

In LA he came to see me. 'There's a problem,' Bill said, producing a bulky file of handwritten letters decorated with childlike drawings from someone who had threatened to shoot me during the tour.

'This is obviously someone very disturbed,' I said.

'We know who he is, and that's why we're taking this seriously.' Bill was looking a little shaky.

'Why can't he be arrested?'

'Because before the tour got started he went missing.'

'You don't know where he is?'

'We do now,' said Bill gravely. 'He's somewhere here in California. On and off through the tour he has been sighted

by our detectives, but we've always lost track of him. He's been following the tour, Pete.'

'He's here in California?'

Bill nodded. 'But we've lost him again ...' So that was why he'd insisted on police officers to guard me.

The man's letters had been sent to The Who's New York office, and allowed to pile up. If they had reached me I would simply have replied, and possibly defused the situation. I'd dealt with my share of the mentally ill, and had often made lifelong friends of people whose first letters to me had expressed a desire to string me up.

The drama heightened with the discovery that the suspect was a trained marksman, a sniper. At our forthcoming show in Oakland the layout of the neighbourhood would be perfect for such a person to get a shot at me while I was on stage. Bill arranged for part of my family to go to George Lucas's Skywalker Ranch as guests until the man was apprehended. The rest of them were sent home to the safety of England.

Not surprisingly, the review of my performance was bad: I had been more than a little preoccupied, waiting for the sniper's bullet to kill me.

After two shows in Texas, one in support of the Special Olympics, where we were honoured by the presence of our own stalwart Mike Shaw in his wheelchair, we returned to the UK. A dense clutch of shows had been put together: four at the NEC in Birmingham (the UK's largest exhibition centre), four at Wembley Arena and two to finish at the Royal Albert Hall.

At just after 2 o'clock on 21 November 1989 my son Joseph was born. I was by Karen's side, and when I drove home I was soaring on an incredible drug-free high. Even in the absence of money worries I still felt that urgent need to provide once again.

For Christmas 1989 I bought myself an *AgendA*: a personal digital assistant. Within a few days I could type entries without looking, with the device itself out of sight in my pocket, under a table, or by my side if I was driving. The third entry I made was:

Fr29Dec89 01:15 – I approach the year with mixed feelings ... I let Iron Man sink so I could do the Who tour. But the tour was a triumph in many ways, most of all for the way it brought together the families of Daltrey and Townshend.

24

PSYCHODERELICT

The Who were inducted into the Rock and Roll Hall of Fame on 18 January 1990 at the Waldorf Astoria Hotel in New York City. We were in good company. That year other inductees included Hank Ballard, The Four Seasons, The Four Tops, The Kinks, The Platters and Simon & Garfunkel. This was the highest honour in the rock industry, created by Jann Wenner, Ahmet Ertegun and other truly wise brokers in the business.

Before our 1989 anniversary tour we had pledged $500,000 towards the ground-breaking of the proposed building of an *actual* Hall of Fame, which would be a museum in – of all places – Cleveland.

In my acceptance speech I chided record companies who were trying to censor the lyrics of rap artists.

I sat with Ina Meibach and was upset to realise too late that Chris Stamp, who lived in New York, hadn't been invited to the induction ceremony. Later in the evening the celebrity divorce lawyer Marvin Mitchelson came to our table. Roger's wife Heather leaned over and whispered to me, laughing,

'Get me his telephone number.'

* * *

On 1 April 1990 I wrote to Roger, John and Bill Curbishley.

> I want to take this opportunity to say that I will remember
> 1989 as one of the happiest of my life and career. There are
> lots of factors, but the most important element was the
> friendship I felt enhanced every aspect of the tour: front of
> stage, in the band, in the management team, in the crew, and
> in the audiences ...
> Good luck in 1990.

I returned to my work at Faber with a vengeance. I pushed hard to get the Faber editorial group to investigate the emergent market of CD-ROM, especially for educational projects. I was experimenting with an animation program called Macromind Director (now Adobe Director) and saw it not only as a way of producing interactive programs based on books and plays, but also as the forerunner of a kind of theatre in itself. The latter would require the fast-evolving internet.

I stayed up very late into the night working on these projects. Karen again yearned for the man I would never be. I spent hours in fantasy, sometimes painting Karen from memory, and embellishing her image as I saw fit. My studio, which I called The Cube, became affectionately and disparagingly known as my 'garden shed', in the sense that it was where I went to hide away with my thoughts, my toys and my tinkerings, like a working man with his fishing flies, train sets, or dismantled motorcycle engine.

The *Orlando Sentinel* published a story on 8 November 1990 that I was bisexual, prompting our Catholic cleaning lady to quit. My old friend Danny Fields, editor of *16* magazine, had described our night together back in 1967 in a rather more romantic way than I would have done myself. For a while I was angry, but Danny and I had been lovers, even if he had given me the Sixties version of Rohypnol. I didn't feel

inclined to defend myself then, or now. For a public figure like me this was a flea bite. It might even help me appear more complex and interesting than I actually was. On top of all that Danny was a cherished friend, and I didn't want to do anything that would change that.

In one of those letters written to the gods that were never delivered, I wrote to my son. 'Be a pessimist,' I advised Joseph on his first birthday on 21 November. 'It is the safest, most pragmatic way to be. Being an optimist may enrich the lives of others (with good cheer and smiling), but it leads you unaware to danger.'

By the end of the year, taking my own advice, I was in a very dark frame of mind. The best thing was how much I was enjoying Joseph. He was deeply attached to me, was very funny and we had a lot of fun together.

I had always wanted to be there for my wife and children in a way that my parents were not always there for me. But the childish, devilish, selfish-sod-bastard artist deep inside me didn't give a toss for fatherhood – he needed freedom. I knew I had to be careful. I loved my son, and would work hard to be a good father to him and try never to break any promises I made him. But I also knew I already carried a gene within me that demanded attention, and if ignored it would become dangerous.

One evening in December I tested the strength of my sobriety by drinking a tiny amount of cognac. Immediately I felt as though I had seen God – not the Jewish or Christian one, but Dionysus or Hedone, the gods of rock 'n' roll.

Be happy, the god whispered in my ear, *have sex, go to the theatre, have dinner parties, be happy.*

As the year ended, Karen stayed awake early into the morning while I was downstairs writing. When I got into bed beside her, she spoke.

'We must do something about our life.'

* * *

How I wanted to do something about our life. I wanted to throw myself back into it, to be proactive and positive. I was determined to take charge. But I couldn't drink. I knew that if I drank all bets were off. At our New Year's Eve party I poured wine all evening for my friends, flirted with some of the women and wondered what it would be like to live the reptilian life of a retired rock star, trapped in an inner world of pain and self-doubt.

In my life, of course, the idea of retirement was purely wishful, the decadence poignantly imagined rather than acted out, but the inner world of self-doubt was all too familiar. Very soon afterwards I started working on songs for my new solo album that would eventually become *Psychoderelict*. To do so, I spent time in Cornwall working on 'The Glass Household', the story that would provide a backbone to the album. It took a number of turns, and I was working it and reworking it. McCrum read an early draft and was encouraging, feeling I'd found a voice.

The album began to take shape musically in summer 1991, and was due for delivery to Virgin in July. The reworked story was loosely placed in the setting of my years of lonely exile ten years before, in my house at Cleeve. It was the biography of Gabriel, the reptile I had fantasised about, a retired rock star who enters into a disastrous email-based relationship with a young female fan. It wasn't meant to be about me or my life but I wanted to introduce to the world the character-type that I knew most intimately.

Going to work on the story every day I felt I was battling with a living, writhing animal. It wouldn't stay in one place. With every revision I found myself diverted into darkly erotic territory, or whimsical forays into the heady, dystopic techno days of *Lifehouse*. The discipline I'd managed while working on *Iron Man* had given way to a more protean process.

Frustrated by the distractions of other artists working at Oceanic's recording studio, I'd created a new studio for myself

on *Grand Cru*, the barge outside Oceanic, which turned out to be one of the most effective spaces since the tiny rooms in the little Georgian house in Twickenham. It had a large Synclavier, a 32-track digital tape machine, a wonderful vintage Neve desk, a grand piano, two of my old electric organs that were usually in storage, and enough space to work with drums and vocals. When the tide came in, the barge would rock slightly in the wind. I started working through the night again.

By February 1991 I had access to a whole set of Apple computers for music, graphics, animation and word-processing. I had been interested in multimedia platforms for years, ever since art college, and was fascinated by the potential in combining the aural with the visual. *Psychoderelict* was initially planned to be a radio play, but my experiments with Macromind Director demonstrated that it might be possible for me to create a DVD to accompany the CD, which would be very useful should I ever decide to bring *Psychoderelict* to the stage. I was also beginning to write basic computer code and designing my own logging program so I wouldn't lose track of the various digital files I worked with. All this high-speed creative wrangling did help generate music, by osmosis, chaos, discovery and the power of noodling.

On the negative side I was sleeping badly, and was out of synch with Karen, which caused constant tension – sometimes confrontation. Karen and I knew each other too well (and perhaps in some ways not at all): when Karen looked at me she remembered her failed hopes of a dependable, faithful friend, lover, husband and father. When I looked at her I saw all the ways I had let her down, and how it was becoming too late to put them right. My time with Joseph, in contrast, was like a vital breath of real life.

* * *

The bleak themes of 'The Glass Household' – of depravity, solipsism, retirement, disappearance, privacy, loneliness, alienation – weren't new ones for me. However, this fictional scenario that I wrote in March 1991 would have a creepy parallel with real events in my life a decade later. In the story, the rock star's redemption from isolation was triggered by an investigative journalist who intercepted his email and set him up to look like a paedophile. Faced with this devastating attack on his character, the rock star was forced to engage the larger world – and fight. (In real life it would be through the work of one particular investigative journalist that I would manage to achieve some kind of closure after being similarly accused.)

Probably the most powerful song I had ready by spring 1991 was 'Don't Try to Make Me Real'. The use of the word 'real' here was loaded. My rock-star hero was trying to resist being brought down from the heady clouds of celebrity into the kangaroo court of tabloid journalism.

> *Make me of clay, make me of steel*
> *But whatever you do don't try to make me real*
> *Make me your dream, a secretive deal*
> *But don't ever scheme to try to make me real*

Karen encouraged me to sail – it probably seemed healthier to her than me hiding in The Cube, the studio at Tennyson House where I was currently recording. I wanted to sail faster than *Blue Merlin* would allow, so I found *Pazienza*, a good Laurent Giles design from 1956, built in wood by the eminent Italian yard Beltrami, and made the swap. *Pazienza* was a fast, classic sailing boat. We christened her on Nicola's birthday on 18 June.

Karen bought a timeshare for a house on Tresco, in the Scilly Isles, for August, and I decided to sail there. On Friday

the 13th, after an exhilarating day of sailing, I went ashore, rented a push-bike and cycled off to the cottage on the opposite side of the island.

High from the holiday, and holding a VHF portable radio, careering downhill I hit a pothole and went over the handlebars, scraping along the rough concrete, ripping the skin off my shoulder. As I came to a halt the bike smashed into my right arm, near the wrist. I had never broken a limb before, but I knew what had happened was serious.

A helicopter took me to Truro Hospital where I was given a powerful sedative, but my operation was postponed because an injured baby had been rescued from a car accident that had claimed both of its parents. By the time my surgeon got to me it was nearly three in the morning. He had saved the child's spine, but he crossed his fingers about what he might be able to do for me. He did tell me he couldn't afford to wait another day; the damage to my wrist was very bad.

To strum a guitar the palm is vertical, to accept change the palm is horizontal. So which did I want? He said it was *either/or*. I decided to have my wrist set so that I could play the guitar. I'd have to have someone pass the hat if I ever needed to ask my audiences for change.

For a month I had all kinds of stainless-steel wires and splints to immobilise my hand while it healed, and I still have a long titanium plate in my wrist. As for my guitar playing, I cannot flourish flamenco-style in quite the way I once could, but in some ways my playing has improved because I worked so hard to regain my facility. Looking back, there's a temptation to fly the priestly helicopter very high and imagine an irritated God flicking me off my bike merely to stop me, to bring me to my senses.

* * *

I was pleased with the way the solo album was turning out, but couldn't do any more work on it with my hand as it was. I wanted to deliver it to Virgin and be paid, so I played my work-in-progress to my manager Bill Curbishley, who felt most of it was pretentious and overly precious. I stood my ground. I felt that once the songs were set against the story they would sparkle and make more sense – as they almost always did – but Bill could hear only what I was able to play him. Or perhaps he was looking for the punch of another classic Who anthem.

With *Iron Man* I'd overworked the songs so they sometimes came across without enough edge, and seemed almost lightweight. With the new songs, set against the dark story of 'The Glass Household', I felt I was really getting the balance right. As usual, I had made the mistake of accepting advances from two record companies who, despite their commitment to my broader ambitions, weren't in the business of funding musicals for the stage. They were putting up millions of dollars, and wanted successful radio tracks. And I'm sure Bill longed for the 1970s, when even substandard Who records sold millions. I couldn't blame him for that, even if it wasn't a longing I shared.

By November 1991 the painkilling drugs I was taking were producing huge mood-swings. My damaged hand felt like a claw, and my forearm felt wooden and heavy. Karen and I argued often, sometimes quite bitterly. She didn't like having my office in the house, which led to a lot of coming and going. She also said it created more tension for me, as I never seemed to be off-duty. Karen decided to buy a flat in Bath, and it seemed to me she was doing it to get away from me. But I told myself that the problems of success hadn't exactly snuck up on us. Our first kiss had been after a Who show. The Who had a record in the charts on our first date. We

made love for the first time in my posh pop star's flat in Belgravia.

From 1992 through to the 2000s there were a number of revivals, re-stagings and adaptations of both *Tommy* and *Quadrophenia*, not only on Broadway and in London's West End but internationally.* The first of these, in 1992, was a new staging of *Tommy* by Des McAnuff, artistic director of La Jolla Playhouse, near San Diego, California.

I wouldn't return to *Psychoderelict*, as I had started to call it, for about a year (when my Atlantic delivery date required me to cough up). Roger visited me and made one final attempt to persuade me to go back to The Who. In an early version of *Psychoderelict* the reptilian washed-up rock star Gabriel is visited by his good old buddy Ray High, whom Gabriel has left behind, and I couldn't help feeling Roger was playing Ray High to my Gabriel. He wanted to know what my plans were for The Who in 1992, and whether I wanted to play in Australia and Japan.

I was in a financially pragmatic mood, which made Roger sad. My point was that my two solo deals were excellent, hugely lucrative, and were not performance-based – they were guarantees – and I wasn't going to make the same mistake twice and blow them out the way I had the Warner Brothers deal. What Roger then offered was, on any new record deal, to let me recoup some of what I lost when I forced him to end the Warners contract in 1983. He said that he and John were

* I was still very proud of both *Tommy* and *Quadrophenia*, and my involvement in and commitment to these new incarnations was extensive, but I don't propose to write any more about them in this book, except in passing, where they related to other events in my life, not only for reasons of space but because, in spite of their importance for me in my work, they essentially belonged to the past as far as this narrative of my life is concerned. Anyone who wants to read about these adaptations and my personal involvement in them can find them on my website at www.TheWho.com

prepared – if I did a new Who contract with them – to recompense me some of the one-million-dollar loss I'd suffered at that time. He was very sweet to me, and his passion for The Who was as evident as always.

That evening, as we lay in bed, Karen asked what Roger had wanted. She'd said nothing all day. I was concerned that she would be afraid I would go back on tour.

'Don't worry,' I said. 'He was very kind, but I can't help him, not now.'

'It isn't Roger I'm worried about,' she replied.

In La Jolla, working on the *Tommy* musical in June 1992, I was still having manic-depressive episodes, and any time alone in my hotel room saw me climbing the walls. These had crept up on me since my son's birth, perhaps a backswing of that terrible pendulum that had been stopped, poised, for a while for the first year of his life. I was occasionally experimenting with very small amounts of alcohol, but I believe the problem was my pain medication, which I had begun to turn to for emotional relief after the physical pain from my wrist was long gone.

So it was no surprise for me to wake up to find a diabolical gremlin literally shaking my bed. As I bounced up and down, I shouted, 'Just fuck off, will you', and rolled over to go back to sleep. But I could hear the chandelier tinkling, and when I sat up I realised the room was swaying. I went to the window and saw the building across the street shaking the way a large animal might dry itself upon emerging from a river crossing.

It was an earthquake.

I quickly pulled on some clothes and walked down the fourteen flights of stairs to the lobby, which was full of shocked people wandering aimlessly. It was very spooky. We were far away from the epicentre, but the hotel – built on rollers to survive extreme quakes – was still lurching back and forth,

and continued to do so for much longer than I imagined the architect had intended.

Later, when I drove to the theatre, there were cracks in the road, and constant aftershocks made everything feel apocalyptic.

Back in London I was still keen to complete the work I'd started with Ted Hughes. I had contacted the Youth Coordinator at the Young Vic Theatre about the possibility of doing a version of *Iron Man* as part of their children's programme there. They were very interested, so I started editing and pulling together all the songs as they related to my original dramatic scenario. It became clear very quickly, having done the work with Des on the 'book' for *Tommy*, how far I'd managed to get and what would and wouldn't work on stage. It was also glaringly obvious that I needed a narrator. I was very keen to set Ted's prose to music, and every line fell easily into my musical experimentations.

I was also engaged in a songwriting/recording project with my two brothers, Paul and Simon. They were both very talented, but had struggled. We decided to do a kind of *Rough Mix* together. It was an inspired idea: our voices blended together very well when we sang backing vocals, and we each had a different style of songwriting. We hoped to write together if possible, or at least collaborate in some way. I paid both my brothers an advance; I'm not sure either of them felt my heart was completely in the project, but I loved working with them, partly because I loved them so much.

In May I returned to *Psychoderelict* with a vengeance. I was now working with a much tighter story, with more humour and irony. I'd combined the two leading male characters (Ray and Gabriel), and lightened the mood of the piece. I'd introduced a specific reference to *Lifehouse*, calling it 'Gridlife', which felt a little contrived at first but allowed me to dip back

into the reservoir of ideas and music experiments I'd accumulated.

I had known Liz Geier since 1979. I first met her when Barney invited her and her friends to meet me in the hotel room we shared in New York. I was doing an interview for *Newsweek*. In the big group of pretty, teenaged girls, she caught my eye, or her amazing eyes did. She was very tall, with a deep voice, a strident personality and a wonderfully dry sense of humour.

I saw her again a few years later in New York in 1981, and we went to see Genesis in New Jersey and hung out in Studio 54. She was always great and glamorous company and I was smitten by her. Later that year, facing the winter alone in Cleeve, I invited her to London, got her a ticket on the Concorde, and a real affair began that would always be halting and difficult because we lived in different cities. I was on medication to stop drinking, and was often ill and rather numb.

From the spring of 1982, after rehab, while I tried to repair my marriage, I continued to stay in contact with Liz, writing occasional letters, a poem or two, and some song lyrics. Though I say so myself I wrote her some good stuff. David Gilmour recorded two of the lyrics on his solo album of 1986: 'All Lovers Are Deranged', and 'Love on the Air'. I simply couldn't let Liz go, or perhaps it was the fabulous *idea* of her I hung on to. I was sure she did not feel the same about me, or at least that she didn't completely trust me. In 1989 we spent a few days together on the twenty-fifth anniversary tour in what I hoped would lead to some closure between us.

We didn't meet again until January 1993. By this time I felt there was no romance between us anymore, I simply couldn't get past her scepticism of me. I was hoping only for friendship and she always seemed happy to see me. 'Now and Then', on *Psychoderelict*, was about our affair and was inspired by what I saw as our unhappy, unfulfilled friendship. Suddenly, here

was a real love song at last, one of the few I'd ever written, and it was about a frustrated affair. I was proud of it, and still am. It's one of the most honest songs I've ever written.

I was eager to give Liz a copy. She was managing the bar at Cafe 44, a few blocks down from the Royalton where I was staying in New York. I held court there with the famous Helena Kennedy QC, who had worked with me for Rescue to change the law on domestic violence. When I had consumed my sixth Coca-Cola I asked Liz if she had any of that 'alcohol-free beer' we have in Britain. Someone behind the bar had just dropped a glass into the ice and the glass had shattered, and she was distracted, making sure every scrap of ice was thrown away. She said she only had low-alcohol beer, and gave me one.

It took just a few seconds for me to realise there was enough alcohol in my glass to breach my very low tolerance. I hadn't taken a drink in public for eleven years, since October 1981.

'This isn't alcohol-free beer, is it?' I held the bottle up to the light. I was being ironic, I was already starting to feel a sense of warmth spreading through my body.

'I never said it was.' She laughed with me, though I could see her concern for me. 'It may as well be. It's what we call a 3.2.'

It was not her fault. She knew I had been 'dry' for a while, but I certainly wasn't biblical about it. I just hadn't drunk in public. I'd asked for beer and she'd given me one.

I didn't drink any more. I had barely had a mouthful, but I was starting to see God.

An hour later I was on my knees in my room praying. My prayer was not, however, for help with the accident I'd had, what felt like a minor slip, nor did I pray for help to keep me away from another drink. I prayed, sincerely, to thank God for showing me what I needed to feel complete, for giving me back the only sociability medicine that had ever worked for me.

I was literally weeping with happiness. Cafe 44, 3.2 beer and Liz Geier – it all seemed a match made in heaven.

25

RELAPSE

I didn't start drinking again immediately the way I had in the past. Indeed I didn't drink again for several weeks, but I knew pretty well what had happened. In the eleven years I'd stayed dry I'd read a lot of research about the way alcohol works in the brain of those who like to call themselves helpless alcoholics.

The theory was that the 10 per cent of the population predisposed to alcohol addiction produced disproportionate amounts of endogenous neurotransmitters when they took alcohol. I hadn't drunk enough 3.2 beer to make myself even slightly drunk, but I'd imbibed enough for my body to scream 'poison' and flood my brain with endorphins.

It's possible that I might not have had the slip at all had I not been tiptoeing around Liz Geier, pretending that one day she and I might suddenly work out. So my problem was not only that I was an addict, but also a romantic fantasist.

The disciple who had brought me closest to Meher Baba, Delia DeLeon, died on 21 January 1993. Her funeral five days later was not at all a sad affair; it was a celebration of what Mani Irani, Meher Baba's sister, called Delia's 'freedom'. Delia had always behaved as though *Tommy* was something she had played a part in bringing to fruition, and in a sense she was right. Meher Baba would always be a presiding presence over my work on *Tommy*, in whatever form.

After the wake Barney and I went to my studio barge and started to sharpen the script of *Psychoderelict*. Barney was a perfect collaborator on this project, able to keep the story light and funny, but also attest to the parts of it that were authentic and real. The *Lifehouse* strand started to feel as if it really fitted, and I added a few of the outtakes from my 1971 electronic demos. The songs Bill had found so unsatisfactory the previous year suddenly seemed to come alive when set within the body of the story, just as I'd hoped they would.

Ruth Streeting, my fictional journalist who conspires with Ray's manager to get the ageing rock star back on the boards, does so by abusing Ray, not praising him. She knows how to trigger him. Ray has been lost in the comforting glow of the few fawning fans who still write to him. Streeting gets him into the world by setting him up with a seductive young fan who sends him a salacious photo at the moment he finally, after years of frustration, seems to be cracking his 'Gridlife' project.

This was a transparent dig at my own lingering obsession with *Lifehouse*, as well as my tendency to romantic fantasy. Barney had felt no obligation to dissuade me from parodying myself, and other old rockers, in this way. And Ray was a mix of two kinds of rock star; one part of the creative concoction – the nostalgic old trouper yearning for the good old days – was most emphatically not me.

I delivered the album to Atlantic on 27 February. Bearing in mind how unhappy Doug Morris had been with *Iron Man* I was delighted when he told me he thought *Psychoderelict* could be the biggest album of my solo career. The play-with-music form was new to him, but with *Tommy* in the neighbourhood, and rumours already afoot that the Broadway show would do well, Doug was ready to embrace *Psychoderelict*. We started putting artwork together for a sleeve, and arranged a photoshoot.

* * *

I flew in and out of New York so often that spring that my assistant Nicola finally just stayed behind to be there each time I returned. My work was very exhilarating. I could walk to Broadway if I wanted to take in the bright lights. *Tommy* had a neon sign in the big square at that time. But I was increasingly aware that my marriage to Karen contained a large element of fantasy, which meant that it could come crashing down on me at any time.

In what proved to be a serendipitous event, I missed my plane back to London and decided to stay in New York overnight. At a party thrown by Tommy Hilfiger, a blonde girl walked over to our table and sat next to me. 'I've come to kiss you,' she said.

After the party Barney suggested we go to a bar called Lucky Strike in the Village. The girl who had kissed me was with her boyfriend, a social worker teaching children with mental disabilities, a good-looking man with long dark hair. While he and I talked in the taxi downtown, his girlfriend who had wanted to kiss me (it had been a bet, she said later) looked out of the window.

Her name was Lisa Marsh, and she was a journalist working for a fashion magazine. She and her boyfriend Michael had been seeing each other for a while. I couldn't help myself.

'You are incredible,' I said.

'I am?' It's what incredible women always said. They rarely said, *That old line will get you nowhere …*

'Your nose is perfect. It has a bump.'

'I do have a bumpy nose.' She touched a flattened spot below the bridge.

'It's your best feature.'

'You like my bumpy nose?' She laughed. 'That's good.'

Before the evening was over, chatting back and forth, she told me she wanted to write a book. I told her I was a publisher, and we exchanged phone numbers.

* * *

Emma flew in to New York with her friend Rose on Sunday, 18 April, to hang out and see previews of the *Tommy* show. They met me in the lobby of the hotel, where I sat talking to Lisa, having given her some books. I especially wanted her to read *The Blindfold* by Siri Hustvedt. Later Emma told me that what made her suspect I had intentions towards Lisa was that I was giving her books.

Karen came to New York for the opening night of *Tommy*, sat next to me during the show, and shuddered when she heard 'I Believe My Own Eyes', the new song I had contributed about the breakdown of Tommy's parents' marriage. Afterwards, at the party, Karen was looking around anxiously. I was still just playing out a loose fantasy, but I had underestimated Karen's intuition. She sensed something was going on.

That night we received early editions of the reviews, starting with Frank Rich, the 'butcher of Broadway'. His review was good. Very good. Rich wrote:

> 'Hope I die before I get old,' sang the Who in 'My Generation,' its early hit single. A quarter-century or so later, Mr. Townshend hasn't got old so much as grown up, into a deeper view of humanity unthinkable in the late 1960s. Far from being another of Broadway's excursions into nostalgia, *Tommy* is the first musical in years to feel completely alive in its own moment. No wonder that for two hours it makes the world seem young.

The mood of the party quickly ratcheted up, and we were all rocking until nearly dawn. Karen left to catch an early flight home in time for Minta's 22nd birthday, while I remained in New York to enjoy the reviews and the sight of tickets flying out of the box office. I flew back home two days later.

In the first week of May I worked with David Thacker, Artistic Director of the Young Vic, on *Iron Man*. We were

working through Ted's original text, placing my songs where they made most sense. I began to feel the play might really work. Then I was back in New York to work with George Martin and his son Giles to record the cast album of *Tommy* at the Hit Factory. Lisa came to visit at my invitation, making a face when I leaned down to embrace her after I'd smoked a cigarette. We hadn't even kissed.

Karen knew I had started drinking again, and, in Cornwall for my 48th birthday, was trying to let me know she didn't mind too much. She'd arranged oysters and champagne for my birthday, and for a while it seemed like she and I might be OK.

What was different about this new drinking was that I could only drink a very small amount before I felt very drunk. My tolerance, once quite beyond belief, was now very low. Before the light faded I took the dogs for a walk in the woods. At the top of the hill, when my mobile phone found a signal, I called Lisa.

She told me she planned to travel to France in August, that I had a sexy voice, that I was crazy, that I was funny, that she liked me better without a beard, that she liked talking to me, that I was stimulating. Her voice on the phone was almost better than her bumpy nose. She didn't mention her boyfriend.

My wedding anniversary was the day after my birthday. Karen and I had been married for twenty-five years. I felt like a shit for thinking about Lisa that day, but I reminded myself that while Karen and I had endured some awful stand-offs, coldness and compromise, we had also been happy sometimes. We had had two amazing daughters together, and now a son, who was three and a half years old. Every second I'd spent with him had been a happy one. The problem was that I wasn't rebuilding intimacy with Karen.

We talked about Joseph's education, and Karen was keen on the posher schools in Salisbury and Wells, which might

require us to move. I was willing to investigate schools and look at property, but Joseph seemed very happy in Cornwall with friends his own age, and the state schools in the area were way above the national average. We considered keeping our house in Twickenham but living permanently in Cornwall. Sailing, and boating in general, lifted my spirits, restoring me like nothing else. I loved the wide beaches, the coastal paths and the secret woodlands, but most of all Cornwall for me was about the sea.

Karen couldn't attend the Tony Awards ceremony because Joseph's nanny was ill. At a previous Oscars ceremony I had sat with an empty chair beside me, so this time I told Karen I wouldn't go to the Tonys alone. There is no question that I set this up; had Karen been by my side in New York for the Tony Awards I might not have gone through with my pursuit of Lisa.

I called Lisa and asked her if her boyfriend would mind if she was my date for the ceremony. He was aware I was on a romantic mission, but he agreed. On the day of the ceremony we met at the Royalton, and I gave Lisa a small diamond brooch in the shape of a star. She persuaded me to wear leather trousers, something I'd never done in my entire life.

On the evening of the ceremony I sat in the Royalton restaurant with Des McAnuff and his wife Susie, and had a glass of wine. We were nervous. Des had been nominated for Best Director of a Musical, the two of us had been nominated for Best Book, and I was nominated for Best Score, but we had stiff competition: *Kiss of the Spider Woman* was highly regarded by ticket buyers and critics. The time came to leave for the awards ceremony, but Lisa hadn't arrived. Then she suddenly appeared at the door of the restaurant, her hair in ringlets; she was wearing a silk trouser suit and took my breath away.

Des won Best Director; I shared the best score award with Kander and Ebb, not a bad business. *Tommy* went on to have a very impressive showing that night, as choreographer Wayne Cilento won Best Choreography, Chris Parry took Best Lighting Design and John Armone was awarded Best Scenic Design. Back at the Royalton, Lisa's boyfriend Michael took me aside; he said I could give Lisa things he never could, and that he was backing off. The reality of what I'd set in motion hit me. Up until now I'd been flirting, but it seemed things were about to get more serious.

When the time came for the guests to leave, I imagined Lisa would stay with me, but instead she took Michael home, since he had got very drunk. If he was drowning his sorrows, he was not alone. I experienced that old familiar wound of being abandoned, and had an anxiety attack that saw me pacing the pavement outside the hotel. I was practically howling.

After commissioning Nicola to start looking for a New York apartment for me, I flew on the Atlantic corporate jet with Jann Wenner and Ahmet Ertegun to Cleveland for the ground-breaking ceremony of the Rock and Roll Hall of Fame. The architect I.M. Pei would hold the shovel. In addition to the $500,000 donated by The Who in 1989 I had given a substantially larger personal donation.

Chuck Berry and I sparred to make the wittiest speech. When I tried to introduce myself to I.M. Pei, and get a pat on the head for having contributed so much money, he ordered me to get out of his way. Suddenly I was desperate for a drink, but none could be found.

Pychoderelict was released a week later. I proposed a stage play with songs based on the album, and invited Barney to co-direct with Wayne Cilento, the choreographer on *Tommy*. They were already working with the lighting director Wendell Harrington, who had done the back-projections for *Tommy*,

which was good news. For my show we were going to rely entirely on the back projections, using a nine-projector system controlled by computer.

Band rehearsals began at Bray studios in the UK on 26 June. Because there were no plans to do any shows in London, I decided to do an acoustic workshop of *Psychoderelict* for the press and media at the Mayfair Theatre on 3 July. I was up half the night adapting and rehearsing the songs, not all of which translated well for acoustic guitar. The three actors from the recording – Jan Ravens as the journalist Ruth Streeting, Lionel Haft as the manager and John Labanowski as Ray High – read their parts from the script and afterwards I took questions. It almost worked.

The tour kicked off on 6 July with technical rehearsals at the Brooklyn Academy of Music. The band was just about my perfect pick. I had two first-rate guitar players in Andy Fairweather Low and Phil Palmer, Pino Palladino on bass, Simon Phillips on drums, Rabbit on keyboards, Peter Hope-Evans on harmonica and playing court jester, and Billy Nicholls and Katie Kisoon provided backing vocals. I sang, played acoustic guitar sometimes, and despite my damaged hand, which was still healing, played some edgy Fender Telecaster solos.

The music sounded amazing. It was never too loud, I could always hear my voice and I enjoyed performing. I had decided on a 'tripartite' show, with some songs selected from The Who and my solo catalogues, then *Psychoderelict*, then a closing rock thrash. I had never done a two-hour show in which I not only played guitar but sang every song, but as long as I didn't drink I would be OK.

By this time it was clear to everyone who knew me that Karen and I were in serious trouble. I squired Lisa Marsh in and out of the theatre on a string of awkward dates. One night, after

several dates with me seeing her home and ending up on my knees outside her apartment, she said, for whatever reason, that I could stay over. We got drunk, had sex and it was everything I had imagined.

I wandered out onto Broadway at six in the morning and was intercepted by a young black girl wearing a thin T-shirt. I put my hand in my pocket, thinking she was going to ask for money. Instead she held her hands up to my face.

'You have the most beautiful eyes,' she said, and walked on.

Lisa had a good friend in Robert Kirk, a photographer working on most of Lisa's fashion shoots, who took photos of my show during rehearsals. He had family experience with troubled drinkers and his presence helped me stay sober at first. Lisa had also continued to operate as my informal stylist, encouraging me to wear black jackets, tighter trousers than I was used to, and to be clean-shaven with something hanging around my neck – sometimes a slug of silver, sometimes a Celtic cross.

At the first *Psychoderelict* show in Toronto, at Massey Hall on 10 July, many in the crowd already knew the words to all the songs. Others had come hoping to see The Who. My three actors found it strange to work with a rowdy rock audience who not only parroted their songs, but shouted constantly that the show was rubbish, or that they loved it, or that they wanted 'Magic Bus', or for me to smash my guitar. It was affectionate but disrupting; it was also very cool somehow. The actors soon got used to it; I was shouting above the rabble, playing to the lip of the stage, pausing between lines to let the crowd have their say.

The tour was the most fun I have ever had in my life on stage, and if it hadn't been for a 'slip' on my part I might have continued with my solo career in happy sobriety. One day when I turned up at the *Tommy* stage show tour rehearsals at

890 Studios in New York, one of the doormen who had seen my show at Jones Beach the night before described it as 'The best fucking rock 'n' roll show I have ever seen in my fucking life – that includes The Who, Springsteen and Neil Young.' I felt great about that.

The slip? A little context first. I was falling in love with Lisa very quickly. I found her funny, I liked her friends, they tolerated me, she liked to drink, to eat, dance and have sex. She was glamorous, well dressed, smart and really pretty. The bumpy nose was a killer for me. She travelled with me to Chicago, and before I went on stage two things happened. One was that the drummer Buddy Miles was backstage with his bad leg, telling stories about the last days with Jimi Hendrix. The other was that I saw a girl from the 1989 Who tour. Her name was Mary Beth Nawa and she and I had started a long, affectionate friendship with a boat trip on the lake and bleary sex in Chicago while I was doing heavy meds for a bronchial condition. I should have had no difficulty introducing Lisa to Mary Beth, but suddenly I started having an anxiety attack, while Buddy went on and on.

I should have asked everyone to step out and give me a moment alone, but I knew Buddy would be offended. It was great to see him, and at any other time it would have been great, but I was shaking as my anxiety threatened to become full-blown panic.

Just before my call to the stage I asked a crew member to get me a bottle of vodka, planning to settle my anxiety as I had many times before. It didn't occur to me that I hadn't done this for over eleven years. I slugged down half the bottle, straightened up and walked on the stage. That's pretty much all I recall. What I heard later was that quite a few fans were upset to see me falling over and ranting. A large number asked for their money back.

* * *

During a break in the *Psychoderelict* US tour I joined my family for a week in the Scilly Isles. I had my own bedroom, and things were uneasy for Karen and me. I was still fielding phone calls from Lisa, and not trying very hard to hide from Karen that I had a new girlfriend.

At our house in Twickenham I had moved into my studio, The Cube, aka the 'garden shed'. It lacked a real kitchen, the bathroom was dowdy and the bedroom tiny. Joseph would wander down to see me there, and we played happily together, but otherwise I was a portrait of misery. And Karen hated the fact that I wouldn't live in the house with her. On one night when I tried to, I had the most shocking nightmare about my time with my grandmother, a door opening and someone entering ...

The second leg of my solo tour began with two shows at the Wilshire Theater in LA, where I did an interview for *Playboy* magazine in which I revealed I had begun 'controlled' drinking again. The journalist David Sheff seemed more worried about it than I was, and followed up with a concerned personal letter to me.*

After a show in San Francisco I talked to Eddie Vedder, the lead singer of Pearl Jam. He was having problems adjusting to fame and was thinking about going back to being a surfer. I gave him my philosophy: we don't make the choice, the public does. We are elected by them, even if we never stood for office. Accept it.

I returned to New York to play two shows at the Brooklyn Academy of Music, one for television. The TV people wanted me to play the entire show in the afternoon for their camera line-up, which I did, but by the evening show I was tired and

* David later wrote a terrific book about his son Nic's meth addiction: *Beautiful Boy: A Father's Journey Through His Son's Addiction* (Houghton Mifflin, 2008).

my voice was very rough. I sounded like Rod Stewart. Happily there were not very many high notes in my set.

I went back to Cornwall to spend time with Joseph, do some sailing and try to work out what to do next. A few months short of four years old, Joseph was game for anything. We went crabbing, swimming and rowing. He loved being on boats and wanted to get a wetsuit so he could snorkel in the icy Cornish waters; it was fun shopping for the very small one he needed.

Around this time there was the most awful tragedy. Joseph's nanny's baby died in a cot death. She had been bringing the baby to work while she looked after Joseph, and we all knew and loved her. We were heartbroken.

I was dividing my time between London for *Iron Man* rehearsals and the States for the continuing *Psychoderelict* tour. I flew back and forth so often I lost track of time. *Iron Man* required a new last-minute recitative from me, and I enjoyed writing it, but I often didn't remember having made changes when I attended rehearsals. I was coming close to nervous exhaustion and ended up being carried to my limo at a Madonna show at Madison Square Garden. I was drunk again after drinking almost nothing that day. I do remember that it was an incredible show, until I blacked out.

By the time *Iron Man* opened to the press in November I was beyond exhausted. The show was extremely ambitious musically. The parts written for the cast were very demanding, and there was a lot of running around that affected their breathing. After a few shows we added drums to the band, which helped drive things along a little. We also added bass guitar. Yet the music never felt quite right. Some of the recitative sections were very moving and I was pleased with them, but a couple of the songs were excruciating, and I didn't have the energy or will to fix them. David Thacker, artistic director

at the Old Vic, was a real believer in the piece and wanted to transfer it to the West End, but I was reticent.

I asked Tom Stoppard to come and see it, and he gave me some very helpful but sobering suggestions. Frankly, he felt there was far too much to fix. Richard O'Brien, who wrote *The Rocky Horror Show*, was a fanatical supporter, coming for almost every show in the first couple of weeks, and was very kind to me about the problems we faced. Many of my friends loved it, though, and accepted it as a work-in-progress.

Michael Foot, the former Labour leader, who had become a family friend, took his grandchildren and wrote me a note saying how powerful he felt the 'message' was. Ted Hughes himself seemed to enjoy the show, especially the huge robotic Iron Man that the designer Shelagh Keegan had constructed of old junk. The show wasn't a hit with critics, but most were at least encouraging – everyone in London always wants the Young Vic to do well. The show did very well at the box office, running through Christmas and beyond. But when the decision needed to be made about what to do next I was blacking out almost every night and knew I couldn't be trusted to think clearly.

A sense of darkness had truly descended on me. Everything felt as though it was shutting down. Back in England, just before Christmas, my friend and property advisor Perry took me to look at a house Roger Waters was selling facing the sea on the south coast. It was a bleak day. The house was almost unfurnished; a few old sofas looked out on the greyness as the first winter snow fell. I had a vision of myself alone, like Gabriel, my washed-up psychoderelict rock star, gazing at the distant Isle of Wight, freezing on the beach, yearning for New York.

* * *

By 1994 I had completed the recording of *Psychoderelict*, done my first solo tour, put up the Broadway production of *Tommy* with Des McAnuff, an award-winning hit; the cast album had been a great coup, one of the last major projects George Martin would produce; I had at last managed to get *Iron Man* to the theatre; and I'd helped cast, rehearse and promote an American *Tommy* tour.

Although my marriage was failing, I had a beautiful son as well as two beautiful daughters who were both doing well at university. I had fallen in love, and the girl I had found was slowly falling in love with me too. And I was rich. So what was messing me up?

It would be easy to point to alcohol, but the problem wasn't the booze; it was the fact that it no longer worked as a medicine to fix the dire consequences of my self-obsession, overwork, selfishness and manic-depression. Back in London around New Year's Eve I attended a party at Ronnie Wood's house on Richmond Green; it was a hoot as always, but I was shocked to wake up the next day and find my Mercedes outside my studio. I had no memory of driving it there. I promised myself this would never happen again.

I could hear a distant echo from 1962 in the White Hart Hotel in Acton, where I first got drunk as a 17-year-old. The bartender's words as the pub prepared to close were definite, and final.

'Time, gentlemen, please.'

26

NOODLING

I stopped drinking on 6 January 1994. I started seeing a professional counsellor in London twice a week, and found an informal group that gathered two or three times a week in my neighbourhood for group-therapy sessions and mutual support. I began meeting dozens of men and women who had all suffered as I had, either because of the ravages of drinking or because it had stopped working for them as medicine. I started feeling better very quickly, though I had created a lot of chaos in my life that needed sorting out.

I was living in The Cube, my studio at the bottom of the garden, and I began looking after Joseph more regularly.

Lisa and I had discussed my drinking back in December when I had been really having problems with it. She was always supportive and had introduced me to a friend of hers who gave me some telephone numbers of people I might look up in London who might help. Back in August Eric Clapton had reached out to me as well, and through him I met a professional relapse intervention counsellor and was carrying his card in my bag. One night at a party after the *Iron Man* show in London Karen had been introduced to two of Lisa's friends at the bar, and realising who they were – or possibly mistaking one of them for Lisa – Karen left abruptly, and I had exploded. Lisa had been wonderful to me, but even before I stopped drinking I knew what I had to do.

I wrote to Lisa to say that I couldn't see her again, and that she couldn't come to London. She responded by sending a book by Pete Hamill, *A Drinking Life*, with a note inside. It began sadly, then became angry, and closed with a sting.

'I hope you find what you're getting is worth what you're sacrificing.'

I would ponder this often in the years ahead.

Roger had committed to an orchestral tour performing Who songs, to be called *Roger Daltrey Performs a Tribute to Pete Townshend*. At some point in December, bleary with overwork and black-outs, I'd told Roger I would perform with him at the first show in Carnegie Hall. In the new year I realised this event was filling me with utter dread. It was a lovely idea and I was greatly flattered, but in my fragile sobriety I was suddenly filled with an unusual anxiety at the prospect of performing.

When I called Roger and told him I didn't think I could fulfil my promise, he went ballistic. When Nicola tried to explain on my behalf he raged at her. In a poignant coincidence, while all this hysteria was going on, I heard that Harry Nilsson had died. The secret to being a successful hellraiser, it seemed, was to stop raising hell before hell razed you. I was doing my best.

The last time I had stopped drinking, back in 1981, I talked all about it in the press, then entered therapeutic analysis and kept quiet. Like so many addicts I'd thought that if I could only sort out my life I could then sort out my drinking. It was a revelation to see that it would be simpler the other way around.

I took a deep breath, called Roger again, and agreed to appear. The concert was set for 23 February. Roger was rehearsing in London in January, and there would be a further rehearsal with the orchestra and a soundcheck in New York in the early part of February.

I threw myself into counselling sessions and group meetings. I tried to look after myself, eat well and see old friends. Although my life in The Cube was very basic, my fast-launch *Zephyr*, a river commuter boat I had had built with my friend Bill Sims who sold me Oceanic back in 1976, provided a welcome bit of peace. I had a few business meetings in London in the first part of the year, and enjoyed the luxury and peace of commuting on the river rather than by train or busy road.

Karen and Joseph accompanied me to New York for Roger's concert. I had recently been prescribed spectacles, and wore a suit for the show. I'd decided to play two of my favourite songs solo, knowing they would sound superb with Michael Kamen's orchestrations – 'And I Moved', along with an acoustic version of 'Who Are You'. On the night my nervousness disappeared. What I did seemed magical, although I felt very detached from it. Lisa Marsh was sitting in one of the boxes with a group of friends, and Karen was in another close by.

My friend John Hart said I was magnificent, and that everyone else on the show looked like rock throwbacks, but that wasn't the prevailing view of fans or critics. One critic said I could have been Roger's father. A fan wrote that she had been disappointed with me, having paid $1,000 for her ticket, because I had failed to have fun. She urged me to enjoy, not to worry so much. Roger went on record complaining I had deliberately chosen not to play any hits.

In the background Roger and I were in legal conflict over the *Tommy* Grand Right document,[*] and how much he and John were earning from the show. Roger also didn't like what Des and I had done with the play of *Tommy*. With John he had hired his own lawyers, while Ina and Sam acted for me.

[*] For more details on the subsequent legal wrangling over this, see www .TheWho.com.

Fairly soon we would go to war – it was in the air between us every time we met.

Karen and I had separate bedrooms in our large suite at the Four Seasons. There was an undercurrent of sadness between us, tinged with her irritation and the occasional outburst. But Joseph, five years old, was such a calming soul that he always seemed to keep us civil. Maybe Karen thought that because I wasn't drinking we'd be able to rebuild as we had back in 1982; maybe she'd just had enough. I wasn't capable of divining what she felt, and we weren't getting along well enough to talk about it.

Tommy productions were still rolling out faster than Des and I could handle them. John Hart had commissioned one of the first CD-ROM interactive applications, which would go deeply into *Tommy* using music and video as well as hypertext links and material from my archive. We were both very excited about it.

Des and I were trying to build what he called a 'clean-sheet project', an entirely new play or musical, or even a music-theatre installation (for Las Vegas or Disneyland) that might be built into the fabric of a themed hotel. We were also hoping to persuade Ted Hughes and Matthew Evans to allow us to approach Disney and Warner Brothers about making an animation film of *Iron Man*. Both companies were interested, but Disney wanted to own the music – that was how their system worked – and I wasn't ready for that.

The theatre production of *Iron Man* closed on 14 February, with tickets still selling fairly well. Ted Hughes arranged for the giant junk-robot man from the Young Vic show to be hung up in a shed at his home in Devon, where I hope it remains today.

In early March 1994 Karen and I had two sessions of couples counselling. We had both agreed to give it a try.

Obviously it was partly for Joseph's sake, but there was still great respect between us. Whether we were to stay married or not, we needed help. The first session was all right, but the second was less successful.

Of course the work never stopped, nor did I really want it to. It was a welcome distraction from my personal troubles. I made my first visit to Frankfurt to meet the producers of the proposed *Tommy* show, which was to be sung in English. The theatre was in Offenbach, on the opposite side of the river to Frankfurt, which evoked memories of lonely times on the road in Germany with The Who.

At Frankfurt airport I was instructed at security to remove my jacket. Since I wasn't wearing one, just a shirt with nothing underneath, I refused. A huge argument kicked off, and my own security man stepped in to try to quieten things down. I duly took off my shirt, and everyone had a good laugh, including me, and we all shook hands.

'*Alles ist in Ordnung*,' I said. '*Kein Problem. Grüss Gott.*'

This had been the first real challenge to my ability to stay calm in the face of mindless authority since I'd stopped drinking. Back in London my recovering friends explained that this kind of encounter often surfaced for ex-drinkers, and that there would be more on the horizon. They all cited road rage as a real challenge – simple exchanges with other car drivers that could turn into out-and-out fist-fights. The secret was acceptance, they said. Only a few months sober, I really didn't know what they meant.

I became fascinated with astrology around this time, particularly the predictions of Patrick Walker and Shelley von Strunckel. I rarely acted on what I read, but it comforted me. Some nights I'd wake up, alert and buzzing. Sometimes I'd go to the window and see a fox in the moonlight. I was reconnecting with my psychic, intuitive, animal side.

The *Tommy* CD-ROM and meetings about the Toronto show took me back to New York in June. By the time work began in earnest in Toronto, Lisa and I were trying to salvage things despite my renewed bouts of anxiety – and I was also suffering from withdrawal.

I headed back to LA twice in July for more work on *Iron Man* (now called *Iron Giant* to distinguish it from the famous American comic of the same name), and to help launch The Who boxed set (*Maximum R&B*). I flew back home for Minta's graduation from Exeter University (she'd taken French and Italian), which was a lovely occasion.

In August I raced *Pazienza* in the classics rallies. There was a really bad storm one day after a race, while I was sleeping alone aboard *Pazienza*, and I spent the entire night fighting to keep the yacht from smashing itself up on a dock. I decided to buy a larger motor yacht to use as home base in Cornwall, and sent *Pazienza* off to the Mediterannean with a live-aboard crew.

In Nice I found an adorable little boat, *Nuovo Pensiero*, owned by Bjorn Borg's ex-wife. I now had a floating home in Cornwall so I could entertain Joseph without too much discomforting contact with Karen, and have space to live comfortably. I thought I had reached an agreement with Karen that she would stay at our house in Cornwall, and that when I returned to London I would take over Tennyson House. When the day arrived for Joseph to start school in Cornwall, however, he didn't show up and and lost his place there.

I called Karen to find out what was happening. She was coming back to London. I moved back into The Cube, and called Fran Bayliss, the High Mistress at Ibstock Place School in Roehampton, where Emma and Minta had been. There was a last-minute place available. Jose could once again run down the garden to see me any time he wanted.

The Cube had been my composing studio when we first moved to Tennyson House. I was now using the small, narrow room once dedicated to electronics as a sleeping cabin with a single bed. There was a Yamaha piano in the large room, and since my wrist accident I had been using piano practice to loosen up and restore flexibility. My piano playing was improving, especially my ability to pull off basic chromatic runs and some fairly eloquent patterns around the black notes. I allowed myself to drift into creative reveries, recording hours of free-form piano and guitar, something I hadn't really done much since winter 1981.

Aunt Trilby had encouraged me to enjoy noodling, a word that is now in the dictionary: 'informal: improvise or play casually on a musical instrument'. Now, back in The Cube, I noodled.

I had found myself a one-to-one counsellor to work with, but continued to attend group-therapy sessions. In autumn 1994 I had a call from Alice Ormsby Gore, who was in rehab. She said it was hard to deal with the group therapy on offer because she felt she couldn't speak openly about her time with Eric. I told her that if she didn't speak about it she wouldn't get clean. As much as I loved Eric, I told Alice to take care of herself for once. She stuck to her guns and died, tragically, the following year.

My counsellor lived in Teddington, further up the Thames from Twickenham. It was a short drive, but often after our sessions I went off to find lunch locally. In January 1995 I met a remarkable young man there, collecting for a charity in the street. He explained he was working to raise money for the orphanage where he grew up, in Moscow. We spoke for some time, and he told me about his background. The story he recounted was to greatly affect the course of my life over the next few years.

His parents had been addicts, and both had died when he was an infant. He was taken to a State orphanage where boys got up to mischief, stealing, buying and selling small amounts of drugs, running wild. If they were caught by the police they wouldn't be arrested, simply ordered back to the orphanage where the men in charge would shoo the children out again so they could drink their vodka in peace.

At the age of twelve the young man ran away from the orphanage to one run by an organisation funded by the Russian mafia. Conditions in this orphanage were far better. The boys were treated well, but were trained in the art of pickpocketing, selling hard drugs on the street, carrying drugs and so on. The girls were kept separate; their fate was bleaker because they were usually coaxed into prostitution.

The young man's name was Oleg; he said he was collecting money for a new orphanage in Russia that hoped to fill the gap between the State and criminal facilities. I gave him a few pounds and took his phone number. We shared the same area code.

I had received an offer to license *Psychoderelict* as a movie as well as a show. I didn't know how to respond. There was an irony in all this. Whenever I started work on a new song-cycle or rock opera, I saw myself moving through story, songs, recording, workshop, performance, shows with a new cast and then movies. Finally, I saw each piece as an orchestral score, outliving me for centuries, being performed all over the world. Although *Psychoderelict* was one of my favourite pieces, I was slightly bored with it, bored too with *Iron Man*, *Tommy* and *Lifehouse*. Des and I wanted more than anything to come up with a brand-new idea we could collaborate on, but we were both caught up in the spin of our personal lives, careers, and trying to manage the future of *Tommy*. At some point the creator has to let go, and in my life I had never been

able to do that – indeed I had been discouraged from doing so by the rock system of endless recycling of old hits.

Ticket sales in New York for *Tommy* waned. The show could have survived if we'd been able or willing to reduce running costs; on Broadway a minimum number of musicians is required, so we were paying for five who stayed home every night. The computer-controlled scenery required a larger technical team than usual, and strong New York trade unions made sure every small job was done by a separate backstage crew member. The fact remains, though, that the incredibly slick production in New York was what made the show so good.

Bill Curbishley had always said that in the New York area The Who had a very solid fanbase of around 450,000 souls who could be relied on to come and see us play, a proportion of whom would support whatever any of us did as solo artists. I'm not sure every Who fan went to see *Tommy* at the St James Theatre, but by the time it closed in June many more than 450,000 people had seen it.

I retreated to *Nuovo Pensiero* in Falmouth Marina in Cornwall whenever I could; I had more civilised living facilities on the yacht than in The Cube. Occasionally I took the boat to the Helford river to be closer to Joseph, who loved spending time on the water. I had a TV set with videos to watch, and a small jet-ski he and I rode around on. The sea is the last bastion of freedom and liberty from restrictions for both kids and old geezers on the water – at least it was then. I began to think seriously about whether I could live on a boat in London somewhere.

Joseph had started at Ibstock Place School, and when it was my turn to run him to school he liked listening to Jazz FM on the radio. He began to listen to jazz albums at home, digging into my large vinyl collection, and became particularly fond of

John Coltrane. I don't know how he remembers our time together but I had a lot of fun, and we made each other laugh.

Joseph's favourite game was 'Obstacle Course': I would rearrange furniture, drape blankets that formed tunnels and climbing steps, and keep the time as he attempted to break his personal record for getting around the course.

Paul Simon and I were respectful friends, introduced by Mo Ostin, but had fallen out over his breaking the artists' boycott in South Africa. He had been forgiven by Mandela, and he was reaching out. He is a towering songwriter, and I appreciated his desire to reconnect to me. He invited me to perform at a charity event for a children's ambulance and paramedical service of which he was a patron in New York.

I agreed, then pulled out, then decided to perform after all. He was gracious about it. I was nervous, I suppose – I had no band assembled. I called Billy Nicholls, who still worked as my music director when required, and explained that I had been playing piano almost every day since I moved into The Cube, and I'd like to play piano at the show. I had never played it in public before, and to do so at such an event was a leap of faith.

Paul's band was put together by the jazz great Wynton Marsalis. I was using a MIDI piano that allowed me to add other sounds to the piano itself. In New York the rehearsals were pleasant and easy. Paul is a perfectionist, working long hours, but is also a supreme team leader.

The show wasn't recorded, but I enjoyed performing, especially being on stage during 'Call Me Al' with the brass playing the famous chorus kick between verses. I played 'Eminence Front' on piano, with a fair bit of extemporisation. I'm sure the musicians on stage, mostly Juilliard scholars, regarded my noodling as just that, but it felt good, and the audience liked it.

I was wearing the same musical cloak as when I performed with Roger at Carnegie Hall, but this time I really was solo. The Who were not summoned, and it seemed that people were not only more forgiving of experiment, but anxious to see me do something different. Paul and I played 'The Kids Are Alright' together. Afterwards Des and his wife congratulated me and a girl grabbed me and whisked me away.

My beloved mentor Sam Sylvester told me that if I was really living in a 'garden shed' I had only myself to blame. I deserved better. I went to view the very grand Petersham House near the Thames. I liked the idea of using its ballroom as a studio. It was a fantastic property and the price seemed reasonable.

'I'm surprised you haven't viewed The Wick,' the agent said. 'Isn't it large enough for you?'

'The Wick?' I didn't know it was for sale, but it turned out to have been on the market for a while. 'How much is it?'

'About the same as Petersham House.'

'I'll buy it.'

'Which one?'

The agent wasn't used to rock 'n' roll.

'The Wick.'

'But you haven't viewed it,' she cautioned.

'I don't need to view it,' I said. 'I'll buy it.'

My counsellor told me I was mad; another trusted advisor warned me I'd be 'rattling around like a ghost in a great big empty house'. What I felt I needed was somewhere I could start writing the book you're reading. I wanted a retreat, somewhere to keep all the files, press cuttings, photos and memory-joggers I might need to tell this story.

There was a more critical issue: I had wanted to buy The Wick several times in my life, and it had always been Karen who discouraged me. She hadn't liked the idea of the *rock star house on the hill* that it represented, and when we were

together I had respected that. But now I could fulfil my dream. Ronnie Wood had lived there, and Mick Jagger and Jerry Hall lived just down the street. I could hardly believe the house was available and that no one had snapped it up. It seemed like a wonderful portent.

It also forced me to face up to something. Until now Karen and I had shared the same address and made our entrances and exits from the same property, even if I was living at the bottom of the garden. If I did go ahead and buy The Wick, I would be making a very obvious statement that I was no longer cohabiting with my wife and family.

27

A NEW HOME

During rehearsals for the London *Tommy* I did a deal with Windswept on my song publishing. This was to be a good relationship: they worked my catalogue deeply, emphasising less well-known songs. The deal allowed me to settle down to another long period of creative work – with the long hours of staring at a blank sheet of paper that always entails. It also meant I would be able to buy The Wick.

Nick Goderson, in-house accountant for me at the boathouse in its heyday as a commercial studio, suggested the company could buy The Wick's lower floors for use as recording studios and offices. Of course by making this purchase I had ended the marriage. The *done thing* was that Karen would get the family home. In this case she would get both family homes, but looking back I have to say 'quite right'.

Meanwhile, in what felt to me to be an affirmation that I had become somehow newly cool, Rei Kawakubo of Comme des Garçons fashion house invited me to be the mature model in her catwalk show in Paris during Fashion Week, January 1996. She was showing a Mod-inspired collection and wanted me to lead a posse of younger men and boys in a kind of street gang. My lieutenant was Jimmy Pursey, lead singer of Sham 69.

Much of the fitting was done by Japanese women who hadn't been prepared for the fact that I was no longer a stringbean youth. There was a lot of letting out at the waist. After the first fitting I decided I couldn't hack it, but before I could

escape Rei pleaded with me to carry on. The fashion crowd were just about the worst audience I had ever performed for in my life. I had never experienced the cold, sneering imperiousness of people with such absurdly high self-regard, and I had imagined a livelier event, like the one in London I'd attended for Fashion Aid.

One important thing I learned: I might be *perceived* as cool by someone like Rei Kawakubo, but I didn't *feel* cool. Cool is definitely something that can be superimposed onto a person. James Dean was seen to be cool although he was a mess of insecurity. On stage as a musician I was capable of doing something I couldn't manage in any other part of my life – I could act a role. I could perform using an exaggerated aspect of my character that at other times was hidden. No one had ever successfully argued with me on stage, not even Roger Daltrey. Offstage, truth be told, I am a mouse, albeit a mouse with mood-swings.

The London *Tommy* previews began on 20 February. The last preview before press night on 4 March was dedicated to the Teenage Cancer Trust. This was the first time I had facilitated any kind of donation to TCT. The charity was the brainchild of my doctor, Adrian Whiteson.

TCT was dedicated to providing scanners for clinics treating young cancer victims. Cell division is very fast for the young, and if cancer cells aren't found quickly patients can die within a few months. I added money to the ticket receipts and planned to present the cheque myself at a reception at the Armoury Hall in the City after the show.

The young actor Alistair Robins, playing the role of the father, took me aside.

'Could I present the cheque?'

'No, you can't,' I said, laughing. 'This is mostly my money and I'm the one donating it.'

'It would mean a lot to me,' he persisted.

'It means a lot to me too.'

'I'm a survivor of teenage cancer,' he said. 'I was within inches of death and the youth cancer team at St Thomas' saved my life. We all called St Thomas' *Tommy's*, you know.'

I looked at the handsome, vital young man. How could it be possible? That moment tied me to the work of TCT until the present day.

And of course Alistair Robins proudly presented the cheque on behalf of the entire London *Tommy* company.

The day after I signed a contract to write my autobiography in May 1996 I completed the purchase of my new house, The Wick. It was a momentous occasion: there would be no going back for me in my marriage. The house needed work and I began by creating the study in which I would begin to write this book. (Yes, I know, it has taken a very long time, so I hope you enjoy it!)

When I viewed The Wick I discovered an amazing thing. Back in 1973 when my company Trackplan was building home recording studios for the pop and rock performers of the day, one commission had been to create a room for Ronnie Wood in his home – then The Wick. I had recommended a Neve BCM10 desk, like the one I used at home, and an eight-track analogue machine. The cables had been laid and the room soundproofed with noiseless air ducting and heavy doors.

Ronnie had made a lot of music there with The Faces, Bobby Womack and the Stones. When he decided the Neve wasn't right for him, he ordered a Helios and sold me the Neve, which I still had in storage. Nothing had been changed since Ronnie left. All I needed to do was wheel in a tape machine and the Neve mixing console and I could start using the studio straight away. I decided to keep this studio pure

old-fashioned analogue, my only concession to digital recording being one of the first RADAR recorders you could hide away in a rack, for use only when we needed more tracks than usual.

I was still looking for a place for my huge Synclavier rig. I decided to use the oval garden room in which Ronnie, Steve Winwood and I had rehearsed for Eric Clapton's Rainbow concert in 1973. This was a large room, big enough for a grand piano, all my old analogue synthesisers, the Lowrey Berkshire organ I'd used for the *Who's Next* tracks and a bunch of more modern MIDI racks.

I was excited about my new home but deeply regretful for what it declared about my failing marriage.

My solo 'Best of' album, *Cool Walking*, was to be released in May; to support it, I appeared with Peter Gabriel and Michael Stipe in Los Angeles for a VH1 TV show for *Witness*, a human rights organisation. On the same trip I did two solo shows at the Hard Rock. Jon Carin was my sideman, covering backing vocals, rhythm loops and effects, backing tracks and playing keyboards. Together we sounded like a band. I did a couple of other such solo events in San Francisco and at the Supper Club in New York.

A celebrity concert performance of *Quadrophenia* was held in Hyde Park in June 1996 for the Prince's Trust. Harvey Goldsmith was organising the show and Phil Daniels, who had played Jimmy in the movie, was the narrator. I agreed to invite Roger to sing the lead, and he agreed subject to John playing bass and Zak Starkey playing drums.

Oh dear. This was The Who again, however you branded it.

The show was fun, but clunky. Stephen Fry was the Hotel Manager, and the Bellboy was played by Ade Edmondson. Harvey Goldsmith had suggested Gary Glitter for the Godfather, whose first contribution to the show was to get

overly hyped up during a soundcheck: swinging his mike stand around, he bashed Roger in the eye so hard it broke his eyesocket. Roger simply wore a patch and soldiered on.

We also did a week of *Quadrophenia* concerts based on the Hyde Park production at Madison Square Garden, New York, in July. The shows were superb. Phil Daniels dealt with the bawdy audience just as my actors had done in *Psychoderelict*, by shouting louder over it. Karen brought Joseph. He'd never seen me perform before. The next day he took me rollerblading in Central Park, and taught me how to build up speed simply by lifting alternate skates, and how to stop by dragging one skate.

In September 1996 the *Daily Mail* revealed that I had left the family home in Twickenham and moved to The Wick, a sign that my marriage was over. I was still living in The Cube, and wouldn't move my home base until November, but the news was out. Despite the joy of having a new home where I could cook, bathe, dress and live in comfort at last (with plenty of room to play with Joseph), I fell into a depression.

This time there were no manic swings. This was conventional depression. It was appropriate for me to feel sad about what was happening. This was the end of a long struggle for Karen and me to remain connected through marriage. I knew the bleakness would pass eventually.

Rehearsals for the US tour of *Quadrophenia* were conducted at Nomis studios in Shepherd's Bush. During the week I chatted with the extremely attractive studio receptionist, who seemed to like me. On the last day, 4 October, I looked up to see Zak Starkey with a girl who at first I took to be his wife. She was young, mid-twenties, with the most extraordinary eyes. One thought crossed my mind: I don't care whose wife she is, I really want to get to know her. After all my romantic fluttering in the States I felt as silly about this as I expect I

appear now, but I was absolutely certain she would be in my life one day.

Later she approached me. Her name was Rachel Fuller. She was a sparky, edgy girl, self-possessed and alive, extremely attractive and very funny. She gave me some kind of quack ear medication to pass on to my friend, the songwriter Billy Nicholls.

'What are you doing here?' I asked her.

'I'm doing some orchestrating,' she explained. 'For Ute Lemper,' the famous German chanteuse and actress. Then she was gone, working a room full of more interesting men than me.

I didn't see her again that day, but before we broke down our gear I wrote her a note asking whether she'd be interested in working with me on some orchestrations while The Who were on the road in America – a preposterous ploy, even though I really was in the market for a good orchestrator. Still, it might work. I gave the letter to the receptionist to pass on.

The North America *Quadrophenia* tour was a blur for me. Karen brought Joseph to Vancouver and then LA. Karen had tried her damnedest to understand me, but it was hard for both of us. We both felt terribly sad for our children, especially for Joseph, but he seemed happy enough. Of course he loved it when we were all together, however tense we felt sometimes. I remembered that feeling from my own childhood at age seven when I returned from my time with Denny and my parents were awkwardly rebuilding the family.

The press maintained that The Who had lost their way. I played acoustic guitar most of the time; my playing was what really held the rhythm together and defined its subtlety. Acoustic was far better for this purpose than electric. Who fans were irritated by me, however, and there was much talk

of everything being much improved if only 'Pete would strap on an electric guitar'.

I had insisted the tour be advertised as *Quadrophenia* and not 'The Who', but with the three surviving members on stage every night there were moments of that old magic – which for me seemed enough – but from the audience's point of view such sparks seemed to ignite an old hunger that needed to be further fed. Certainly the orderly procession of music that was *Quadrophenia* left little room for anarchy or spontaneity.

We worked for a couple of days back at Nomis to tighten up sections of the show, and to try reducing the number of brass. While I was there I asked the receptionist about the letter I'd given her to pass on to the girl who was working with Ute Lemper.

'Are you mad?' She was looking quite fierce.

'What?'

'You spend the whole week chatting me up, then ask me to pass a letter on to some other girl, probably half my age. It went in the bin.'

One evening, having taken Joseph to Karen's house and put him to bed, I fell asleep watching MTV in my studio at the bottom of the garden. It was a kind of psychedelic video show, with fractal animations set to rap music and modern R&B. I woke in a dream-state and tried to remember what I had been dreaming about.

It quickly came back to me, as did another dream that didn't replace the first one, but, oddly, ran alongside it. Then another dream, then another, each dream vivid and lucid and ongoing. I lost track of where I was, and in an attempt to record what was going on I sat at my piano and recorded myself speaking about what was happening. Later, I called this piece 'Wired to the Moon'.

After several hours whatever natural chemicals were flooding through my brain slowed down, and I was able to sleep. It was terrifying and overwhelming. I wondered if it was some form of Alzheimer's or, even worse, that I had progressed to full-blown schizophrenia.

When this didn't happen again for a week or two, I took it to be an aberration, and got back to work. I was committed to the idea of developing a conventional, serious Broadway musical. It seemed to me that this was my true destiny.

My vision for the internet was as a kind of theatre. I saw the ideal website as a venue for rehearsals, workshops, plays, performances, readings, interviews – all the stuff of my career gathered under one cyber-ceiling. Television had been doing this for years, but the internet might one day allow individual creative people to run their own small broadcasting companies.

Broadband wasn't yet available in 1996. The internet was still accessed by phone line, and at first text and low-quality photographs was all it was good for. As always, my deep cynicism and pessimism led me to believe – as I had predicted in my soporific Royal College of Art lecture – the porn industry would drive technical advances, just as it had for the domestic video market back in the mid-Eighties. I was amazed at how quickly organisations like *Hustler* and *Playboy* had managed to establish credit-card systems providing membership to online magazines. There was obviously big money in it.

I was still determined to keep working as a producer to set up new music-theatre projects. John Scher, one of a handful of promoters Bill Curbishley trusted completely, was still pushing hard to get me to develop *Psychoderelict*, either for the theatre or as a performance vehicle for me. I flew by Concorde to New York to meet him and Kevin McCollom, director of the

Ordway Center theatre group in St Paul, Minnesota. I awoke from napping when a loud bang shook the plane. The plane continued to shake; it got worse and worse until the wheels touched down in Halifax and we were ferried by another plane to New York. I was surprised to find that I'd stayed calm throughout.

Elton John and his partner David Furnish were on board, and when I walked over to the replacement aircraft with them Elton told me that a rabbi had created a panic by trying to get into the cockpit. He was holding a small casket which, he said, 'absolutely must get to New York, otherwise the consequences could be apocalyptic'.

'More important than me leaving dirty underwear in the basket back home then,' I quipped. That, absurdly, had been my main concern as I faced what seemed to be almost certain death. I wanted to commiserate with Elton about a hysterical woman who'd started screaming.

'That was me, darling,' he confessed.

The *Psychoderelict* meeting went well. We discussed the need for a new script, and possible directors. As I sketched out the piece to Kevin McCollom, he immediately saw problems. If the story was treated lightly, allowing the music to create all the shades and nuances, those who couldn't access the kind of music I wrote would find the story too inconsequential. If the dystopian messages carried in the heart of the piece were pushed forward it could come over as pretentious. Somehow we'd have to strike a balance.

Meanwhile *Tommy* was closing in London. It had run for a few weeks under a year, plagued by indifferent audiences and by the IRA choosing the first day of previews to blow up the lobby of the nearby Cambridge Theatre. Attendance fell all over the West End, which was disappointing because, as with the American tour (which did much better business), the

reviews were all very good, and very well deserved. As the producer, André Ptaszynski, said in his regretful announcement, the cast deserved better audiences.

I flew to Miami to spend a few days with Lisa to achieve closure, a desire stemming from her psychoanalysis. We were determined to remain friends. We had such a good time that I decided to adopt the concept I facetiously called 'postponement of closure', and invited her to join me in Germany and Austria when The Who performed *Quadrophenia* there in May. She accepted, and I looked forward to her company, unsure whether I wanted closure or reopening.

I flew to Courchevel to watch Joseph take his first skiing lesson. I actually chartered a plane from London to Chambéry and a helicopter from there to get in and out. It cost a fortune, and I wondered how I would maintain this high lifestyle. I had been approached to do a solo tour in the UK for a fee between £1,500 and £2,000 a night, but I was concerned it wouldn't pay nightly hotel bills for myself and my crew, let alone any charter flights to maintain my Tuesday and Thursday schedule with Joseph.

The European tour of *Quadrophenia* was fast approaching. There was a rehearsal at Billy Nicholls's new home in Twickenham to start blocking new guitar arrangements and divisions. Billy mentioned that Rachel Fuller, the girl from Nomis, had worked with him on a couple of his solo tracks. My intuition was telling me to be very careful. I saw Rachel as another Theresa Russell, who could rock my world – for better or for worse.

Rachel is a bomb, I wrote in my diary. *Dangerous.*

The tour started with two shows in Scandinavia, then moved to Germany. I had some fiscal sense at last, and told Karen there was no way I could do the tour and continue to see

Joseph in the normal way. I reduced the number of charters I'd considered, and took mostly scheduled flights.

In April 1997 Lisa sent me the kindest letter. She seemed to remember only the good times between us, and I had been longing to see her since leaving her behind in Miami. She was going through some difficult childhood issues; almost everyone I knew seemed to have at least one dark tale to tell. Her closure-advising shrink was suddenly facing divorce from her own wayward husband. I repeated my invitation for Lisa to join me in Vienna for a few days. It was a long haul for her, but I was glad she came. Her shrink had told her that two ex-lovers couldn't sleep in the same room and not have sex. Sadly, we managed to prove her wrong.

The day before my 52nd birthday we played our last show on the *Quadrophenia* European leg at Wembley Arena. At the after-show party a tall, voluptuous girl approached me apologetically.

'Do you remember me? I'm Laura. I just wanted you to know I didn't steal your money, but I know who did.' It was the girl from Phoenix whom I suspected of having stolen my $50,000 out of my tote bag all those years ago. She explained that one of her brother's friends (who has now passed away) had spotted the cash and taken it; their mother had found out about it and panicked. Laura still had the poem I wrote for her. The poem was entitled 'The Tall Richard' (Cockney rhyming slang: Richard the Third – bird).

Suddenly, standing beside her, was the girl from Nomis. It was Rachel and they were friends! What an extraordinary coincidence. Rachel took me aside to tell me something important, then just placed her two palms on my chest and told me to be true to my art. She looked very beautiful that evening, but I had already promised a neighbour a lift home. I scanned the room to see if I could make another arrangement with my neighbour, and when I turned back Rachel was gone. I made

a few calls to try to track her down, and thought about invit-
ing her to join me on the forthcoming Who tour. I forgot all
about the $50,000.

Then the US tour of *Quadrophenia* began, from 17 July to
17 August. I managed to persuade Rachel to come to New
York to spend time with me, and when it emerged that Laura
knew Wiggy I invited her as well, with Wiggy to be their
minder.

My one-to-one counsellor suggested that I was insane in
this venture. It was certainly not the best idea I'd ever had.
Ensconced in the Royalton lobby, Laura was convinced I was
still interested in her, and had I been less exhausted by my
romantic absurdities of the past few years she would have
been a worthy cause. She was quite spectacularly sexy, with a
Jerry-Hall-like Southern belle elegance. I also remembered our
time in Phoenix with real pleasure.

By contrast Rachel was, I had decided, troublesome; she
was demanding and egotistic. Both she and Laura had met
Ahmet Ertegun through Laura's music-business boyfriend,
and I had a sense that I had probably been displaced in the
matter of Rachel by the great philandering record man. She
told me she knew him, and he had entertained her at Tramp's
one night in the recent past. He wanted to sleep with her, but
she turned him down.

After this I decided to sell *Nuovo Pensiero* and use the
proceeds to buy a modest house near Karen in Cornwall. I
found a converted barn in Mawnan Smith over the Helford
river that was secluded, but a short dinghy ride would connect
me to Joseph. On 6 September 1997 I noted a landmark event
in my diary: Joseph slept in my new home at The Wick for the
first time! I was delighted, and the swimming pool was great
for him and his friends after school. I was grateful to Karen
for making this happen.

That same month I had a few meetings with Rachel. I wanted to work with her as an orchestrator.

Or that was what I told myself.

On 1 December I took Rachel on a proper date, dinner at Riva, a restaurant near my home in Barnes. There were some music-business friends at a nearby table, some of them family friends. Rachel looked very lovely, and something felt different between us. She seemed suddenly grown up. There were fewer jokes, less teasing, less showing off. That night we made love for the first time.

I felt like Dustin Hoffman at the end of *The Graduate*, having stolen the girl he wanted from the altar, and driving away with her on a bus, both of them knowing they could never go back, but not sure whether going forward would work out.

I was swept away by Rachel, but it felt different to me than such moments in the past. There had been that instant attraction I had felt with other women, and perhaps if I had worked hard on any of those love affairs – or even my marriage – I could have made a go of it. But Rachel was especially talented, and this allowed me to hope she would understand my creative need for time and space of my own.

She was also young, and I felt I needed that. I still tended to have grand mood-swings and manic bursts of energy, to leave people around me in my wake sometimes, and to be impatient if they didn't keep up. Rachel would keep up, I was certain of that. I could only wonder whether I could keep up with her. So, after one amazing night of talking and making love, every aspect of Rachel's character that had troubled me seemed to become an asset. I felt at last that I'd found someone who could cope with me as I was.

Having girlfriends in America was all very well: they could never upset Karen, and that was important. But I loved some

of the psychic risk Rachel posed – she still seemed wild and independent in some ways – and I realised that for once in my life my drive to be with this woman was not so much about wanting sex as her company, humour and energy. I would try to start a serious relationship with her; at least we were both musicians, and if it worked, great. If it didn't, I would live the rest of my life an abstinent bachelor.

In the spring of 1998 Ethan Silverman, who directed *Bill Graham Presents*, sent me a film he had submitted to Sundance called *The Waiting Children*. In the documentary an American couple travel to Russia to adopt a child; there are harrowing scenes of awful conditions in some of the orphanages they visit, and we follow the sad waif of a boy that the couple brings home. It was very moving and I thought of Oleg, the Russian boy I'd met in the street in Teddington. I'd tried the phone number he'd given me without success, but this time someone replied.

'You are the person who left messages last year? There's no one called Oleg here, never has been.'

I still wanted to follow the impulse to donate money to one of these orphanages. I'd never been to Russia, and it wouldn't hurt if my first visit was to do a special show for an institution looking after abandoned kids. Or I could just write a cheque.

I opened up my Toshiba laptop, went into my browser, selected a search engine and typed a few simple words:

russian orphanages boys donations

Search-engine results soon filled the page. I clicked on the first, and within a few minutes (in those days images loaded very slowly indeed) my screen was covered in images of young boys being sexually abused.

I was stunned. Like most men I had used the primitive inter-
net of the time to look at pornography – it was the novelty of
the period – but I had never seen anything like this.

I began to sweat and feel anxious. Images flooded before
my eyes, but in these scenes I was the principal figure, a young
boy, lying face down on a bed. My anxiety was quickly
replaced by rage.

28

LETTER TO MY EIGHT-YEAR-OLD SELF

By the spring of 1998 I had stayed away from alcohol for four years. Although still receiving mail and dealing with Faber business, I hadn't attended many editorial meetings since the Broadway production of *Tommy*. My involvement gradually receded. In 1995 Robert McCrum had suffered a massive stroke and left Faber the following year to join the *Observer*, and these two events somehow marked the beginning of the end of my Faber career. I had loved being involved in Faber editorially, but it was time to move on.

The knots in my life were untangling. Joseph was at school with new friends and seemed happy. Emma had made a record (*Winterland*), Minta had worked on a really great movie (as production assistant on *The English Patient*). The Des McAnuff incarnation of *Tommy* was almost over. *Iron Giant* was in Warner's hands. The concert touring version of *Quadrophenia* had been laid to rest for a while. I had a new home in Richmond, and a practical retreat in Cornwall.

I had reached a degree of closure with Lisa and some other girlfriends, and was excited about Rachel. I looked forward to indulging myself a little, both creatively and in my charity work. Tom Critchley started work for me as creative facilitator (a term I invented) and took over *Lifehouse*. Spike had started compiling a third *Scoop* collection, a two-year project, and I planned to prepare some new pieces especially for the collection.

Who offers were still coming in, but tended to be one-offs. I planned to do a couple of charity events, returning to Chicago for Maryville Academy, this time with Eddie Vedder. Believe it or not, I felt a little calmer and quieter, and I was looking forward to the year ahead. I was still having bad days, often when I lost track of Rachel, heard she was out with friends or found she wasn't answering her phone.

One night in March 1998 Rachel brought a friend and her children to my house for safety after some trouble with her friend's ex-husband. They brought a lot of wine, and Rachel got very drunk. I had never seen her drunk, and she frightened me, creating such a scene that I put a stop to the relationship. Finding Rachel and making such a deep commitment to her, then realising I'd picked a girl who could get so crazy, shook me to the core.

I consoled myself by wiring up the keyboard studio in my house, the therapy I enjoyed most.

Linda McCartney lost her battle against cancer and Paul asked me to give a eulogy at the memorial service. A little later Karen rang to say that her father Ted was going fast. He died on my birthday. Another death that stung was Ted Hughes. Carol, his widow, was distraught on the phone and there was nothing I could say to console her.

With proverbial fingers crossed I had started seeing Rachel again, as she was orchestrating 'Tragedy' for *Lifehouse*. I arranged for her to get a flat in a building in Kew Road, wanting at least for her to be near me. I took her to New York where I bought her a new VW Beetle and prepared to see her whenever I wanted, but she turned out to be very hard to pin down.

After a month or two of paranoia on my part I discovered she had been secretly drinking all the time we'd been seeing

each other, sometimes heavily, and that explained her absences. It was another last straw, and I wrote to her to end our relationship. She called shortly after to say she had decided to get some professional help, and agreed that we needed to take a break.

During the month in which Rachel was away I wrestled with feelings of disconnection, loss and loneliness. My Uncle Jack had fallen down the stairs in his house, and after he came out of hospital he came to live with me briefly and I looked after him. Perhaps Uncle Jack's presence stirred up feelings in me about the past and my family. Or maybe I had projected too much hope onto the idea of Rachel being the one and my desolation was due to my belief that our relationship wasn't going to work out.

I was still raging to anyone who would listen about my exposure to the child-porn images I had seen. Nick Goderson contacted me to say that Matt Kent, a Who biographer and computer geek, wanted to help me run my personal website. That, I decided, was where I would break the true story about what was happening on the internet. I envisaged running the first internet theatre. The plan was to get the website going in the summer. In the end it didn't happen until much later.

Matt was creating two websites for which he would serve as webmaster. One was www.eelpie.com, dedicated to a mail-order and downloading service. The other website was www.petetownshend.com, dedicated to what nowadays we would call a blog. The bigger idea – for a kind of web-based music-theatre venue – would have to wait for faster broadband speeds and larger server spaces.

I had funded Gustav Metzger's first major UK show at MOMA (the Museum of Modern Art, in Oxford), and one of Rachel's best friends Melissa More curated the opening night for us. I remember driving to Oxford, determined I was going to do something soon about the sudden whirlwind of news

about child pornography on the internet. I remember feeling that being on my own, spending time with Gustav again, who was so saintly in a sense, set up a determination in me to do something profoundly impetuous and brave.

Uncle Jack died shortly after, which was incredibly sad. I was extremely fond of him. He left his money to Mum, who spent most of it building a large swimming pool for her little villa in Menorca.

I had found Julia Cameron's book *The Artist's Way* so useful in kickstarting my creativity that I bought twenty copies and gave them away. I started doing the 'Morning Pages' in *The Artist's Way*, which recommended writing three pages every day to clear out the mind to give creative ideas some space. Another exercise the author recommended was called 'An Artist's Date', which involved setting part of a day aside for whatever one's 'inner artist' fancied doing. Whenever I closed my eyes and asked what I fancied doing, I got the same answer.

'I wanna go outside and sit on the pavement,' the voice of a six-year-old boy said, 'with my dog.' I didn't have a dog, but I did go and sit on the pavement, which was great fun. I'm still not quite sure why.

Julia Cameron also suggested writing letters to oneself, and during this period I wrote one to Pete Townshend, aged eight. It proved to be a crucial act of affirmation that eventually helped to heal the pain and hurt I had been harbouring all my life: it started me on the path of becoming more at peace with myself over the next decade, and of forgiving myself for whatever it was that still intermittently caused me anxiety, guilt and shame.

Yet it was also to trigger a series of events that in the short term and in the next few years were to rebound on me in a completely unpredictable way.

* * *

It was sobering to be shunted from the humiliations of my early childhood to the financial difficulties of my old friend John Entwistle. The news came in the form of a letter from Bill Curbishley on 26 May asking if I would agree to do a tour to help.

> His situation is pretty dire. The bank have been bouncing cheques on him, he's already topped up his mortgage to the absolute maximum and his credit cards have been blocked. He lives by selling his guitars, but he can only leak those onto the market to maintain price/supply/demand. Not good. For you and I it's a case of 'but for the graces of God ...' In the end I came round to the feeling that if it was me in this situation I'd pray I had the friends to help me. [...]
>
> If there was ever a case of 'all amends in one basket' this is it! It would mean going away, it would mean doing what you don't want to do, and it would have to be promoted. No doubt, any shows would kick-start the BBC *Lifehouse* album but the angle would have to be a Who farewell/Millennium/ celebration/survival theme and fuck the critics! This is honestly the last thing I expected or wanted to be doing. I had my year sort of planned out and I'm still struggling a bit on the health front, but I'll go with your decisions whatever it is.

In June I wrote to Bill agreeing to do a tour to help. He was right; I wasn't keen. I was enjoying the prospect of pursuing my *Artist's Way* vision over the next eighteen months. A visit from Roger helped me decide. I couldn't let John go down. I set down all kinds of conditions and side issues, but these were flimsy, really; I was just trying to make myself feel better.

* * *

Back in February 1995 Des McAnuff had called me after a meeting with Warner Brothers' heads; he'd also met the executives in charge of animation. They liked our ideas for *Iron Giant* and wanted the rights in advance of starting their own creative process; they were envisaging a $50 million budget.

I had flown to Los Angeles to go with Des to meet Brad Bird whom Warners had suggested direct *Iron Giant*. Brad was keen but he hated musicals, and hated what Disney was doing with Elton on *The Lion King*. I recommended Michael Kamen to do the conventional orchestral score, for which the budget set aside was far too small. Michael did it as a favour for me, using talented junior associates to do the work quickly and efficiently. I had worn myself out with *Iron Man*. I still had my Young Vic version, and I thought one day I might revisit it and pull it into better shape.

I went to LA in July 1999 to see the finished *Iron Giant*. It was beautifully animated with hand-coloured frames – one of the last animation films to be made that way. The film came too late for Ted Hughes himself, but his daughter, to whom the original book was dedicated along with her brother, loved it.

The *Lifehouse* play was recorded at BBC Maida Vale in a studio dedicated to the task, with a proper kitchen to rattle around in, car doors, creaking chairs to sit in and light switches to manipulate. Jeff Young, who wrote the play, later married the director's assistant.

Rachel and I went to my house in Cornwall to watch the solar eclipse on 11 August. The sky was so cloudy we saw nothing. She was always uneasy in Cornwall. She saw it as Karen's territory and hurried home the next day. She called me, distraught: her mother had died suddenly from a deep-vein thrombosis on a plane back from Bali. It was a terrible shock.

* * *

I saw some progress on my new websites in the autumn of 1999, which was exciting, but I felt the designs were lacklustre. This was my first indication of how sensitive Matt Kent could be. I saw him as webmaster, but he was (and still is) a very creative man, and he saw much of what he was doing for me as creative in its own right, not just a facilitation of my needs.

In November The Who played their first show at the Chicago House of Blues for Maryville Academy. During the rehearsals Roger began talking about global conspiracies – one of his favourite themes – and my lack of engagement in what he was saying annoyed him. Upset, he started to walk out of the theatre, but I managed to stop him. The next day I wrote to him.

Dear Rog,

I have been thinking about our communication blip yesterday at rehearsal. I know your response was emotional, and after you became upset I'm so glad you stayed around long enough for me to get to you to talk. I care about you very much and I hate to feel that as adults we can so easily fall into old behaviour like that. But we do love each other today, and I think that means we will be able to stand some ups and downs, at least I hope it will. [...]

Don't be too emotional about what may or may not happen with The Who. As you said yesterday, what we have today is more than we thought possible. What makes me proud is that whether or not we make another great record, whether or not we knock them dead in some new way, we are loving friends today. That is our example as men to those who trusted us with their dreams. We've come through. I'm proud of both of us.

The tiny House of Blues venue was not a good place for the new Who band. The main problem was that on such a small stage the drums were too close. It was deafening. Ears ringing, I spoke to Eddie Vedder afterwards.

'I can't do this any more,' I said. 'I'm blowing my brains out.'

'Well, then, stop, Pete,' he said simply. 'You've done enough.'

Reviews of my performances referred more to the way I conducted myself on stage than the way I played. My solo shows had encouraged me to talk to the audience, which didn't always go down well in the context of The Who. Roger, especially, had always looked uneasy when I took over the front of the stage and started to rant, but some of our exchanges were great; he was becoming very quick-witted in his on-stage repartee, and often made me laugh.

'I'm just trying to keep the bastards in check,' I told him when he frowned at me for telling the House of Blues audience to shut up. He came back at me in a split second.

'They've kept you in cheques for long enough.'

On 5 December 1999 the *Lifehouse* play was aired in the UK on BBC Radio 3. David Lister, the *Independent* newspaper's Arts Editor, gave the front page to the event. Not everyone was so encouraging. In the week leading up to it there was a lot of press about the break-up of my marriage, which seemed old news to me, but was surprisingly comprehensive. I was worried Karen would be upset by it, but she was fairly sanguine.

That week Rachel and I went with recently separated Mick Jagger and Jerry Hall to see Bowie perform; the tabloids printed a photo of Rachel and me together, the first published. Rachel was pleased to be described as 'stunning' in the *Sun*. I was less pleased, having been described by one critic as

looking like a vicar, but I felt good about Rachel and my creative life. I still believed I had great work ahead of me.

The Who did a couple of shows at Shepherd's Bush Empire. The tickets had sold out in under thirty minutes. I played well, and threw myself into the shows. The sound was very loud again on stage, but this time I was ready for it. Grander concert events had been touted, a new album was being considered, but for me two nights with our old Bush fans was the best way to bring in the new year and whatever would follow.

I also brought in the millennium by getting two dogs. Flash was a Border collie and Sally a cocker spaniel. It was a mistake to buy two pups at the same time, since this made them impossible to train. I soon found a good home for Sally and kept Flash. I still have him today.

All my older women friends insinuated that Rachel was a gold-digger. All Rachel's older women friends suggested I was just after her body – otherwise, where was the ring? The truth was that I was deeply smitten with Rachel. The love between us was real, and deep. I gave her a ring and we pledged monogamy.

Rachel played me a couple of old demo tapes she'd made with her friend Mikey Cuthbert. They had been sixteen or seventeen, sharing a flat together and recording songs on a battered cassette Portastudio with only three working tracks. The songs were obviously the work of open, unencumbered musical minds and hearts. I encouraged her to work with Mikey again. He had a truly bluesy voice, and his own songs were eccentric. By contrast Rachel's voice was pure in a way that reminded me of Joan Baez. I realised that if my remarks to Marvin Gaye were correct – that the voice comes from God – Rachel had a very pure spiritual system running behind that edgy, funny Southend exterior.

We started work in the studio built for me in my house by Darren Westbrook, an assistant engineer at Oceanic in its heyday. For some time I lost myself in working with Rachel, which helped me become familiar with the equipment, and reminded me of the good old days of working with Thunderclap Newman and The Small Faces in my home studio back in the late Sixties.

I began a new project called *The Boy Who Heard Music*, partly inspired by my childhood experiences, of course, but also a vehicle for yet another reappraisal of the issues raised in *Lifehouse*. Additionally, it was an attempt to create a setting for what I was now calling the Lifehouse Method – the automatic creation of tailor-made music for individuals over a web portal. I used the characters Leyla, Gabriel and Josh to draw together some of the elements of my original *Lifehouse* story, *Stella* (an unpublished play I'd written about Arthur Miller's childhood) and *Psychoderelict*. The elements included a murder, a lunatic asylum ghost, dark sexual intrigue, jealousy, manipulation and skullduggery – and of course celebration. I wasn't about to let the dark stuff get me discouraged.

By February 2000 www.eelpie.com, the e-commerce site, was up and running. Spike and Jon Astley remastered my first two *Scoop* albums, and we began selling stuff online. Despite my neoteric bent, my site wasn't the first to allow downloading of free tracks. Several bands had realised the power of having their own websites, not only to sell directly to their fans but to harness fans as a phantom congregation and inform them of upcoming shows, new releases and gossip.

There was to be a concert of *Lifehouse Chronicles* at Sadler's Wells Theatre on 26 February. Rachel and Sara Lowenthal worked on their wonderful orchestral scores, and Dave Ruffy (once of The Ruts) added click-tracks (audible metronome beats) to my old *Lifehouse* demos so Jon Carin on

keyboards could add drum loops. As with some of my recent solo shows of the year before, I didn't want to use a conventional drummer.

We rehearsed in Ronnie Wood's old snooker room in The Wick that once belonged to Sir John Mills. The atmosphere was (and still is) full of the benign ghosts of rock 'n' roll, Pinewood and Hollywood. Keith Richards's blood was on the ceiling, Bob Dylan had passed through, Laurence Olivier and Vivien Leigh had practically had sex on the baize. There were nine of us in the band, a mixing board, keyboard and guitar techs and two studio engineers. It was hot and cramped, but exhilarating; the house felt as empowered as it had when Woody and I had worked with Eric there back in 1973.

Our performance at Sadler's Wells was every bit as satisfying. The sound there is perfect for acoustic music, and on some of my solo songs I felt almost as though I could have done without a microphone. The audience were quiet and respectful, something I hadn't expected, and for which I was grateful.

Reviews of my recent efforts as solo performer, and as originator of *Lifehouse* for radio, were disappointing, but the work I'd done in 1999 had been incredibly fulfilling and nurturing for me as an artist. I felt I was creating musical installations, rather than merely conforming to the notion of what a classic rock band member should or should not do. This creative latitude was probably the reason why, when I returned to the old-style Who for what took up almost the rest of the year, I went on to do mostly good work.

More importantly, I found a way to enjoy what I was doing, and to revel in the fact that, just nine years after an accident that I thought would prevent me from playing guitar ever again, it was the electric guitar that I would rediscover as my true voice. Of course, not every fan or critic thought that was a good thing either.

So off we went – Roger, John and me – to New York for a press conference to announce that we were going to do some shows that year, and make a new record. No one among us said we were doing it for the money. None of us offered that I hadn't really wanted to go deaf in order to save Roger and John from being forced to live in smaller houses. I tried not to even think about it.

My only hope of surviving the work ahead without drinking was to enjoy it. Roger shocked me by telling the assembled press that we planned an album for which we all would contribute songs; it would be more of a creative team effort than ever before, and that he had several songs in the pipeline, as did John. I had never successfully co-written a song in my life, at least not in a rehearsal room. There too I was going to have to make some inner changes just to get along.

With Rachel alongside me, keeping me in a good mood, The Who tour started in New York on 6 June with a charity bash at the Jacob K. Javits Convention Center for the Robin Hood Foundation. Gwyneth Paltrow sat on someone's shoulders, rocking out. Rachel, not to be outdone, was wearing an absurdly expensive low-cut dress. Doug Morris was charmed enough to offer her a record contract a few days later, with the caveat that I should produce it.

The tour ran, with three good holiday breaks, until the end of November. It started in Chicago and ended at the Royal Albert Hall. All the way through I entertained myself by writing blogs on my new www.petetownshend.com website. Sometimes I put up short videos I had shot on stage, or in my dressing room. The learning curve wasn't too steep with regard to editing, but bandwidth in hotels was still very slow, and a short video would often take all night to load. Sometimes they didn't make it.

* * *

On 29 December, with Joseph on a sleepover, I wrote a diary entry last thing at night.

> Jose and I are doing well. We went late to Kingston and bought a model car which he made for me without much fuss. It worked straight away. A paint-job today and we can race. With bigger wheels than him I believe I might win. I wonder if the small wheels are what was making his car overheat? Anyway, he is brilliant at this kind of thing.

I was happy. Things with Rachel were rich and real and nourishing for us both. My son was thriving. And we had a remote-controlled model-car race to green-flag.

Tom Critchley had moved his efforts from *Psychoderelict* to *Quadrophenia*, and managed to persuade Joe Penhall to work up a treatment for a stage version of the same. I continued producing new pieces of music for *Scoop 3*. I decided to move key staff from my house at The Wick to a new place off Richmond Green. I'd been using a small office there as my postal address and I took over the whole space. This meant I could convert the office back into a kitchen, and get myself a proper housekeeper.

My grandest plan was for what I called a Cyberorgan. I wanted a multi-keyboard console, with a full foot-pedal array and lots of pistons, switches and levers. I saw myself like Bach, driving a huge organ that could fill a cathedral with divine music. My dream was to start noodling, then push some buttons and take flight. I was hoping for more 'Baba O'Riley' and 'Eminence Front' moments. Those Who songs, and many others, had started life with me sitting at a home organ intended for entirely different purposes. I hoped that some aspects of the Lifehouse Method might also find themselves incorporated: phrases and canons that looked after them-

selves, triggered by a single key or foot pedal to provide automatic background for extemporisation.

I continued to work on *The Boy Who Heard Music*. Some of the themes surfacing in the story were complicated by my desire to reflect – as in *Tommy* – on the shifting power balance for young people in the modern world, and the difficulties that might bring. I spent a good part of the year working to refine the story, improve the characters and give myself a really solid playscript to underpin a new rock opera.

The Who were a working band again. That meant that the only thing we really ever had to worry about in future was the inevitable good and bad nights that Roger would have, because the human voice isn't something that can simply be restrung every night. Towards the end of the previous August Roger's wife Heather was concerned that he was becoming anxious. Roger was especially fearful about cancer, the curse that had struck down his beloved sister (and my girlfriend from our teens) Carol while she was still so young: she had been just 32. His fear was later justified as he had problems with his throat during this period. Since finding this out he has been treated, his voice is now fine and he has worried a lot less.

Roger always found long tours tough. The Who at their best and worst were loud, hard-driving, played long sets, and the old hits had been written for the voice of younger men, boys in fact. He wouldn't countenance lowering the key, so he was always battling, but that battle was part of what made his time on stage so riveting.

In the wake of 9/11 The Who performed at Madison Square Garden at the Concert for New York that Paul and Heather McCartney had conceived while grounded on their plane on the runway at Kennedy Airport, watching the distant smoke rising from the World Trade Center. As the lights went up I

was stunned to see that most of the audience were in uniform; police, firefighters, paramedics, men and women, were tossing their hats in the air to 'Won't Get Fooled Again'. Many of these very tough guys were weeping.

I watched Mick Jagger and Keith Richards sing an acoustic version of 'Wild Horses'. If there was an afterlife, we had been here before. The highlight of the evening for me was James Taylor, always gentle, his approach calm and firm, his music entirely American but without any rabid patriotism. The event was full of defiance, but also sadness and camaraderie. New York would always be the most diverse, open, cosmopolitan city in the world, despite the best efforts of a handful of crazy zealots.

In the dressing room after our set Elton came in to congratulate us, and to urge me to make a new album as The Who. Our record chief Doug Morris was there, nodding. 'You will never see anything like that ever again,' Elton said to Doug.

George Harrison died on 1 December. It's hard to explain how much this affected me, and everyone who knew him. He was a quiet, loving man, settled at last into a spiritual family life that all of us had wished for him. His *Traveling Wilburys* album had let each one of us – his fans – into his home via his recording studio in Friar Park out in Henley. I decided that one day I would do what George had done, and share with my fans the house and studio they had permitted me to enjoy privately thus far.

In February 2002 I resolved to exorcise whatever impotence and rage I was still feeling by rewriting *The Boy Who Heard Music* as a novella. I spent two weeks writing longhand with pen and paper. I loved doing it, and it did liberate me. Before I'd finished I heard that David Astor had died; we lost in him a great philanthropist, and I determined to try to fill some

small part of the void left by his passing. The Queen Mother died around the same time, and in her case I decided it was time to forgive her for having my Packard hearse towed away when I was a teenager.

The Who now had another tour booked, and with yet another 'best of' album due for release, *Then and Now*, we went into Oceanic to rehearse and record at least two or three new songs to add some *now* to the *then*. My song was 'Real Good Looking Boy', a piano-based ballad borrowed from Elvis Presley's hit 'I Can't Help (Falling in Love with You)'. Roger submitted 'Certified Rose', a C&W song I liked very much – it had the feeling of a Ronnie Lane song about it. John had a number of songs ready, but pretty much refused to share them. He told me privately that he couldn't bear to have his work subjected to Roger's critique.

The recording was rather strained. John was clearly not in good health: his hearing had gone completely, and he was wearing two powerful hearing aids even while performing. He was taking heart medication but still smoking, and drinking the occasional glass of Rémy in the middle of the day. Because he sometimes became very alert and animated, Roger and I worried he was probably using cocaine as well, but as always John played brilliantly, and wasn't too loud. That wasn't true of the drums, so I spent most of the rehearsal lodged in a small acoustic booth to protect my ears.

In June I was staying at the Bel Air Hotel in Los Angeles, ready to fly to Vegas for The Who's warm-up show at the Hard Rock. Our first big show was to be the Hollywood Bowl a few days later. Rachel and I had connected with friends Kathy Nelson and John Cusack, done some silly shopping, and were light-hearted and happy to be in California. Life was grand.

All that swiftly changed on 27 June 2002, as recorded in my diary.

Around midday Lisa Marsh called Nicola to say she had a 'scoop' that John was ill. We had heard nothing. Bill then called me. 'Are you sitting down, Pete? John is dead.' It feels like a cruel joke. The timing is crazy. I call Roger. He shouts 'What!' down the phone, hoping for a moment it is a hoax, then quickly realises I would never play such a joke on him. He sets out to come to the hotel.

Rachel talks me through the first hour. I am in shock. I speak again to Bill. John had been using cocaine and had been with a girl. Later it emerged that she was a pickup and that she had reported his death. I feel horrible based on the fact that I had prayed for some way out of this tour. This was not the price I had in mind.

John has gone. I truly loved him so much. He was the best, oldest, most supportive friend I ever had. He is utterly irreplaceable. Could I have intervened and saved him? Pointless now to speculate. John was an alkie, an addict, and an obsessive compulsive – one more wonderful human being who has gone astray.

I spent the night pacing. Tragically, I now had the best possible reason to turn my back on The Who for ever. But thousands of loyal fans had bought show tickets, and travel tickets, and had paid deposits for hotels. Our fans would understand if we cancelled, but they would all lose hard-earned money. If Bill's fear was right, our insurers would resist paying out because of the circumstances of John's death, which meant our crew would never get paid. Their families would suffer.

We had no choice. We simply had to try to make the tour work. I had no idea how we were going to pull it off, but we had to try. I had been 'born in a trunk', as the saying goes, into a show-business family, and this was the way I knew how to respond. I was hard-wired to believe that whatever happened, if humanly possible, the show must go on.

Once I'd decided I called Bill. We'd need someone to play bass, and my first choice was Pino Palladino. He had done some solo shows with me, was very quick and wouldn't be compared to John. He was an equally iconoclastic bass player in his own right, but very different in his approach. Pino flew straight to LA and, as we sat by the pool of the Sunset Marquis, George Clooney, fresh from an evening at the bar, waved his sympathy.

In June 2012 I wrote:

It's ten years since John's shocking death in Las Vegas. I have to say that this is not a particularly special time for me because I remember John every day. [...] I always felt a strong sense of loving friendship from John, and I think I will cling on to that memory even though Queenie, his late mother, once got angry with me for being angry with John about the way he died and told me that John had never loved me at all. In fact a couple of times John had actually told me he loved me. We were usually alone, and he might have been a bit drunk, but sometimes when we're drunk we tell the truth. I accept that sometimes we stretch it, so I reserve the right to stretch it and believe that John was not stretching it.

When we speak about loving someone, there is always something unsaid. We love people we do not like. We like people we can never love. We might even marry or go into business with someone we neither like nor love and have a wonderful life or career with them. This is especially true for bands. It isn't always easy to know what is the truth, and of course – if Queenie is to be believed – feelings between two friends can be intense but not necessarily equal. For me, with John, the situation is clear cut. There are no difficulties, no blurred images. I loved John, I liked him, I respected him, and I miss him. I don't think he ever put a foot wrong in our relationship. He never said or did anything that I can look

back on and fan embers of even the smallest resentment towards him.

On stage with The Who I often look across and expect to see John standing there scratching the side of his nose and taking a resigned deep breath in that characteristically thoughtful way that often presaged a funny story or a blistering bass passage. [...]

Some people are utterly without peer. When they are gone they leave an immense vacuum. So it is with John: When he died he left a void that can only be filled with good memories, affectionate recollections, and some healthy and critical review of his occasionally crazy behaviour and extraordinary sense of humour. We met at school, but although we were only twelve years old John was almost a man by then, while I would remain a little boy for many years to come; we've all known such friendships in our school days.

I sometimes say that when we met I was eleven years old because that's how it felt; John was like a fifteen or sixteen year old to me. What is extraordinary is that John took me under his wing so kindly when we first met, and was always a supporter of mine even when I goofed. He was never patronising. I never felt he had to work at it, his support came naturally, and didn't seem to be a part of any agenda.*

John's funeral was in his home town of Stow-on-the-Wold on 10 July during a break in the tour. As the black limousine drove me from the crematorium to the nearby hotel, I felt grateful to be alive. Suddenly the driver pulled the glass division aside.

'You don't remember me, do you, Mr Townshend?'

'I know your face. Have you driven me before?'

* For the full text, go to www.thewho.com/john-entwistle.

'At the funeral of your father-in-law, Edwin Astley. I gave you an address and you sent an autograph for my father. Thank you for that.'

'No problem.' I slumped back into the seat.

'So are you a Mason as well then?'

'Pardon?'

'It's OK, sir.' He was reassuring. 'Mr Entwistle and I were in the same Lodge.'

'I didn't know John was a Freemason.'

'Ah yes,' said the driver. 'All his life.'

The Who tour continued in late July 2002 across the East Coast. The enormous noise John used to make on stage was gone for ever. Pino's sound was smoother and quieter, yet Roger was still struggling to hear himself. Maybe he'd been wrong all along about why he'd had trouble.

At the end of the tour Roger came to say goodbye. He was looking into the future and I think he was worried about what I was thinking.

'Do you want to do any different stuff next time?' He was looking anxious, smiling, quite gentle, really.

I obviously didn't look excited enough.

'How are you enjoying it?'

'It's OK,' I replied.

Roger's face fell a little. 'Just OK?'

'Yes,' I tried to make the word sound as positive as I could, 'OK.'

'That's it then?' He was on the verge of getting irritated with me. 'Just OK?'

I said I had no complaints. I didn't elaborate. He knew then that I was not going to continue.

29

BLACK DAYS, WHITE KNIGHTS

My anxiety and concern over the issue of child pornography on the internet had been triggered by that simple online search in 1998 for ways to donate to Russian orphanages. Its impact on me was also, I'm convinced, connected to the panic attacks I had been experiencing for the last few years, and the way it disturbed me was not purely altruistic. It had churned up memories that further convinced me that I myself had been abused.

So with a clear mind and serious mission, back in May and June 1999 I had set aside some time to look again at the internet and the issue of child pornography. Since my shocking exposure to it the previous year things didn't seem to have got any worse, but neither had anything improved. According to the broadsheets, police and new protection agencies were doing good work tracking down end-users, but nothing much could be done to prevent children being exploited at the source in foreign countries. In a financial chain that ran unimpeded from the Russian mob all the way to our high-street banks, big profits were being made by doing terrible things to children. For the tabloid press it was a good story. For most normal folk it was an issue no one even wanted to think about.

My plan was to run a story on my website illustrating that online banks, browser companies and big-time pornographers were all complicit in taking money for indecent imagery of

children. I used my Barclaycard once on a site with a button that (rather ridiculously) said 'Click here for child-porn.' The charge was $7, which I immediately cancelled, not wanting even this small charge to benefit banks and credit-card companies that allowed the transaction in the first place.

I also selected a site I was certain was a sting – in that way I wouldn't be passing money to criminals – and kept a careful record of the transaction. (I had a colleague in Boston who did what I did, so we could support each other. He told me which sites were most likely to have been taken over by the FBI or US Postal Service.)

The point was to show that a bank was taking my money. I would use my personal website to publish a long essay, and eventually a small book, on the dark side of the fast-evolving internet. I felt I was an expert, I had seen it all coming in *Lifehouse*, and I was prepared to speak about the unspeakable – child pornography – from the position of someone who had suffered abuse and knew how deep the scars could be.

Recently there had been talk that the Home Secretary, David Blunkett, planned to change the law retrospectively to ensnare anyone who had ever searched for child pornography on the internet. I guessed that might include me, but several years had passed. I had put it almost to the back of my mind, and although I'd published an essay on the internet I hadn't done anything about a book or newspaper article. Even so, I wasn't concerned, not at first.

I now had three close friends in my group-counselling sessions who had suffered much more explicit sexual abuse than I had, or remembered it more clearly.

Alice was worried that images of her own abuse – as an eight-year-old she had been photographed by her abuser – may have found their way onto the internet. When her own daughter turned eight she started to get extreme anxiety attacks.

Robin had flipped when his life had suddenly come good, with a lovely new partner, a new baby and a happy life. He couldn't handle it. Like me, when he tried to speak about what had happened to him as a child he went into a panic.

Jenny, a middle-aged actress, was the last of the three, her story the most disturbing of all. She had been ritually abused by her own father in a religious order beginning when she was a baby. The more she talked about it, the worse she felt. I planned to concentrate on raising money to create a new kind of practical, sympathetic, no-shame therapeutic care for adult survivors of sexual abuse.

I helped set up a research programme for a new support system for survivors of childhood abuse with therapists at The Priory and Broadreach. A telephone helpline as a starting point for such people could be more useful than all the moralising that had started to kick off in the newspapers. The first three subjects were Robin, Alice and Jenny (not their real names), all of whom had cried out for some kind of help facing their demons.

On 29 January 2000 I got a phone call. Our first subject, Robin, the young man I had put into treatment, had completed his two months of expensive rehabilitation, gone home to his loving family and his new baby, grabbed some money, travelled to Manchester, checked into a crack den and overdosed. He was dead. He had phoned me a number of times while in treatment, having taken issue with the way he was being dealt with, and felt I was wasting my money. He had reached out for help and I had been able to finance treatment, but now it felt like all we'd done was to inadvertently fast-track his death.

Ironically, despite the fact that Double-O, the charity I'd established, had paid for Robin's treatment at Broadreach, they would (correctly) not release his case files, which would have been helpful in trying to understand what had happened.

Luckily, John Fugler, a friend of mine who ran Closereach, the long-term secondary rehab unit at Broadreach, suggested that maybe what Robin had come face to face with in his recent therapy had been too much for him to bear.

Badly shaken, I still hoped to complete the trial with the two remaining subjects. Rachel had met Jenny and knew her awful story, and that I had offered her a stint with a senior therapist at The Priory when she was ready. One day Rachel returned from having spent some time with Jenny, who was very upset. Jenny's father (her abuser) had remarried, and his young wife was pregnant, expecting a daughter.

At 45 Jenny was behaving like an infant, projecting fearfully that her father would do to his new baby daughter what he had done to her. Jenny eventually went into The Priory in December. When the time came for her to leave she collapsed, overwhelmed by intense panic. With the therapist's guidance I extended her period of treatment. This was no small matter: it cost £75,000 in all, enough to run a small charity for several years.

Jenny committed suicide on 7 January 2002. It was heartbreaking, and sobering. All I had proved was what I already knew: the impact of sexual abuse on children, especially infants, needed far more attention, and opening up the past was potentially life-threatening.

There was now only one subject of my Survivors project left – Alice, who had done a stint at The Priory too. I am happy to say that she is alive and well and doing OK, and has now been sober for two years.

I posted 'A Different Bomb' on my website on 17 January 2002. The essay related Robin, Alice and Jenny's stories to the issue of child pornography on the internet. I still wanted to write a book about this – or publish a long essay online – so it was a minor shock to my rock-star ego to discover that a very sober and effective book already existed.

Beyond Tolerance, by Philip Jenkins, Professor of History and Religious Studies at Pennsylvania State University, had been published in 2001, although I didn't find it until the time of Jenny's suicide. He had written everything that needed to be said. Jenkins had done the good work I had hoped to do myself.

In spite of press interest, including an offer from the *Guardian* to publish 'A Different Bomb', I began to see that back in May 1999 I had made a bad mistake: according to Jenkins, 'it is not necessary for a prosecutor to show that an accused individual knew that pressing a link would produce a suspect image', so I had placed myself in danger of prosecution by admitting to having pressed a link. The fact that I had not looked at any images, only at the home page of a website, might be immaterial from a legal point of view.

I suffered from 'White Knight Syndrome' writ large.*

There had been an extraordinary ramification to John's death. When Roger and I agreed to continue the tour, neither of us had imagined that John's share of the tour proceeds would be ours. We imagined there would be huge costs and damages associated with the cancellation of various shows, and that John's estate (his family) would remain entitled to a large payment. But Roger and I did benefit financially from John's death, and substantially.

For me, this promised to be a huge blessing. I was still committed to raising awareness of the way internet child pornography could indirectly lead to the premature deaths of particularly vulnerable individuals like Robin and Jenny.

* *The White Knight Syndrome* by Mary Lamia and Marilyn Krieger suggests that 'though most white knights feel that they are selfless and sacrificing, their rescuing behaviour is often misguided'. Helping others can cause delusions of grandeur – everything can be fine until someone the white knight is 'helping' falls by the wayside.

Salacious newspaper stories about paedophiles sold well, but greatly disturbed and triggered the adult survivors of abuse endured during childhood. I had found two organisations I felt might do better work than Double-O had managed. One was the NSPCC, to whom I'd made a number of donations in the past (Rachel had noticed their STOP IT NOW! campaign). The other was NAPAC, the National Association for People Abused in Childhood, which specifically focused where I felt work most needed to be done, and were planning to offer a telephone helpline. A friend of mine (an advocate for Alice in her triumph against her abuser in Ireland) was on the steering committee of trustees.

Early on the morning of Saturday 11 January 2003 Nick Goderson, who was now in charge of my business affairs, called to say that according to the front page of the *Daily Mail* a nameless millionaire rock-star guitarist was in the list of names sent to Operation Ore – a computer-crime investigation focusing on child pornography. The FBI had given Operation Ore 7,000 names of British people who had visited sites that had been infiltrated.

'That'll be me then,' I said.

30
TRILBY'S PIANO

At first, I wasn't worried. But after I hung up with Nick I looked out of my window and went into a panic. The house was surrounded by reporters, television satellite vans, camera crews, photographers and curious observers. At that moment, as I told a reporter later, if I'd had a gun I might have shot myself just to escape the lynching. I turned to Rachel. 'You have to leave, and save yourself,' I said. 'There's no way this is going to turn out well for me.'

'You've done nothing wrong, Pete,' she replied. 'I'm staying. Let's put a statement together.'

The shock really started to sink in when I was shown a copy of the *Mail*. Since my name was being withheld, there could be no mention of my work with The Priory and Broadreach, no mention of Double-O or 'A Different Bomb'. I longed to redress the imbalance. The fact was that I had probably kept a little too quiet about my various charitable activities, but that was all irrelevant now.

Emma called. 'At least you're alive today, Dad,' she said. Maurice Gibb of The Bee Gees had died overnight, leaving his family and brothers adrift and distraught. I explained the details of my situation to Emma, who was working as a journalist. 'If it was research, then that's what you must say, Dad,' she urged. 'You must tell the truth.'

I took Emma's advice. Rachel and I knocked out a statement that she read to the assembled press in the street outside.

Then we drove to her house in Teddington, where I spent the weekend quietly.

It was a very tense time. My lawyer said the police had intended to interview me informally, but were now forced to make an arrest because in my statement to the press I had admitted using a credit card. Once was enough. They made an appointment to see me at my house on Monday 13 January. They searched the house and my offices in Richmond meticulously. They were respectful and considerate, but took away family photos, videotapes, dozens of zip and optical drives, and eleven computers.

Later in the day I went to Twickenham police station. The last time I'd been in the interview room was after driving home drunk in 1972. Nothing had changed in thirty years, except for the video cameras everywhere. I was shown a cheque signed by me to pay a Barclaycard bill that included a charge for £5 to an organisation called Landslide. I didn't remember the name, but by this time I was becoming too numb to know what was happening.

Over the weekend I had received calls organised by Jerry Hall and Keith Altham, Mick Jagger, David Bowie, Sting, Bob Geldof and dozens of friends. By Monday morning mail began rolling into my house, some of it bad, a lot of it good, but I was too exhausted to respond to it – I simply hadn't slept.

After I made a statement, during which I was filmed and recorded for a forthcoming television documentary,* a detective went out and bought me a hamburger. I'd spent the whole day making tea for the police in my house, and hadn't eaten.

* Bob Long was producing a BBC documentary series called *Police Protecting Children*, commissioned as a result of the publicity surrounding Operation Ore. I believe that Bob Long and his team were following the work of the Metropolitan Police's Child Protection Unit as they made various arrests, one of which happened to be mine. The filming of my statement was included in the second episode, screened a year later on 30 March 2004.

'Eat that, mate,' he said, as he tucked into his own. 'We know you're on the side of the angels.'

Never has such a simple act meant so much to me.

'You know why I go straight to the sports pages when I pick up a tabloid newspaper?' he went on.

I shook my head.

'Because everything that's wrong with society is on the front page, and everything that's good about it – endeavour and simple human achievement – is on the back.'

I had most definitely been on the front page, and it would be a discussion topic for months to come.

I was out on bail. The forensic examination of my computers could take as long as a month, or longer. The police had taken my studio computers and hard drives containing music, lyrics, recordings and pretty much everything related to *The Boy Who Heard Music* while I was right in the middle of working on it. I could start new music, but I didn't even have my laptop. I simply had to be patient.

I knew nothing incriminating had ever been on my computers, and although I was aware of the possibility that images could easily be planted, I was more worried that excerpts of my personal diaries would get out and I would look like a self-obsessed prat, whose only interest was which car or boat I might buy next to cheer myself up. This was sheer vanity, but I was still embarrassed by it.

I was worried too that if anyone placed images on any of my computers there would be nothing I could do about it. It was a case of *mea culpa*: I had already admitted to an infringement that Professor Jenkins had made clear would have no excuse in any court. Curiosity, research, understanding, perspective or even therapy wouldn't ameliorate this particular crime. And yet, in getting to know some of the Operation Ore squad, I knew they were honest, and my fear of being

'fitted up', or framed, quickly left me. At a bail meeting in the second month, I asked the Chief Investigating Officer why the forensic work was taking so long. He said it was because there were so many computers. But he also said they wanted to allow a long enough period for anyone I might have abused in the past to come forward.

Dozens of people spoke up on my behalf, but Roger was the most vocal, allowing himself to get angry about the absurdity of my arrest. Clearly, his own future was at risk if I was convicted, but he went further than he needed to on my behalf. His solidarity with me, his faith in me and his rage at the injustice against me is something I will never forget.

While I waited, I hired security to keep guard on my house twenty-four hours a day and continued working at Oceanic, mixing a surround version of *Tommy*. I decided to buy myself a house in the South of France. My legal bills would be huge, but I didn't want to give up my long-standing dream of a house by the sea. I was, of course, also running away to get some peace from the press.

Letters still arrived – my staff sorted them so any particularly nasty ones were probably set aside – but 80 per cent were supportive. I began to reply to each one with a short hand-written card. 'Thank you for your faith in me. I will never forget you.'*

With nothing to do but wait, I decided to schedule a long-overdue hernia operation, having pulled a muscle while riding a pushbike in the park. When I was under anaesthetic my surgeon also did a colonoscopy, and he found a large pre-cancerous polyp that would almost certainly have taken me on

* So many letters came that I have not replied to them all. If you wrote, I will never forget your kindness. I still have your letter.

the same path as my father had it not been discovered. So there was at least one major upside to my arrest.

I was finally given a date when I was to be re-interviewed by the police: 7 May. On that day I would either walk away a free man, or be charged and arraigned. Or, if any skullduggery had taken place on the part of my accusers, I might even be jailed. Then I received another missive. Bhau Kalchuri, once Meher Baba's youngest nightwatchman, now Chairman of the Avatar Meher Baba Trust in India, wanted to have lunch with me on 20 May. It seemed a very good omen. I could think of no better birthday present.

These past few months had passed so slowly that I began to wonder about the nature of time itself: when you get past the age of about 45 time begins to speed up, and it takes a while to get used to it, the years suddenly falling away faster and faster. Waiting for my computers, time crawled by interminably. At least it would all be over soon.

News began to leak out that I would be offered a caution. My lawyers and I attended Kingston police station and the officer who had arrested me seemed ill at ease. It quickly became apparent what was going on. My computers were completely clean, all eleven of them. In the enormous quantity of other collateral taken from my home, only a few photos of my own two infant daughters running naked in Jamaica had been set aside. The grease pencil circles over their bodies made me weep. But at least I would be vindicated.

This was not to be. At Kingston police station I was offered a choice. I could accept a caution and low-profile listing for a limited period of time as a sex-offender, or go to court. My case was too high profile to be dealt with in any other way, despite the fact that there was a prevailing sense that I had been well intentioned. If I went to court I could safely tell the truth, and the truth wouldn't incriminate me, but after waiting four and a half months for my computers to be scanned I was

utterly exhausted; I was in no frame of mind to live through another eternity – this time in court. Even though it might do some good for the cause I still longed to shout about from the rooftops, I didn't think I would survive it.

I wish now that I had gone to trial, but perhaps that is a foolhardy notion. Instead, I have relied on my friends and the general public to speak for me – until now.

Vindication for me emerged a couple of years later, when the investigative journalist Duncan Campbell forensically examined the hard drive for the Landslide website. He reported that he could find no evidence I had entered it, or subscribed to it. I had, he said, apparently admitted to something I didn't do. It's obvious now, since credit-card companies were persuaded to refuse payments to Julian Assange's WikiLeaks in 2011, that all along they could have refused to take payments for questionable porn sites. Ironically, that's probably what they did in my case.

As I feared, the sex-offender label came back to haunt me at the 2010 Super Bowl in Miami, when protest leaflets were distributed by local children's advocates that picketed at the stadium. At a press conference in Miami I said:

It's an issue that's very difficult to deal with in soundbites. It's a big thing, and it's sad. I feel like we're on the same side. I think if you know a family that has suffered the issue of childhood abuse or anything of that sort, you know that common-sense vigilance is the most important thing, not vigilantism. [...] If anybody has any doubts about whether I should be here or not, they should investigate a little bit further. Everything you need to know, funnily enough, is out there on the internet.*

* I could have added 'and in my forthcoming memoirs'.

I wondered how to thank all those who had supported me and decided I should get off my high creative horse, stop worrying about my hearing so much, and make a record and tour with Roger. In 2004 we played in Japan, for the first time, and Australia, which we hadn't toured since The Who's disastrous 'hiccup' in 1968. This time our shows in Australia were a triumph – for me a renewal and for The Who's ancient career a kind of rebirth. I received my updated American visa on 30 December 2004.

Rachel had stood by me through my whole ordeal and our love has continued to deepen to this day. Her writing with Jo Youel of the pop band Scarlet was going from strength to strength; having obtained a record deal with Doug Morris she began to make plans for recording, and her album *Cigarettes and Housework* was released in 2004 to great reviews.*

She also began *In the Attic*, a live weekly chat and acoustic music webcast, taking over a small studio in Oceanic, arranging the room with a single camera. It was great fun, something to look forward to every week, and Mickey Cuthbert and my brother Simon both became regulars. I did a walk-on most weeks, and often played an old song, and joined in with guests like Martha Wainwright.

I was still trying to create songs to help advance the story of *The Boy Who Heard Music*. These songs sounded different to almost everything I'd written in the past – except perhaps some of the writing I'd done for the stage version of *Iron Man*. I was doubtful any of them would work on a Who album, and

* 'Her songs are elegant and graceful affairs musically, and wonderfully gritty, vulnerable slice-of-life stories lyrically. The combination of the two creates a kind of emotional tension that pulls the listener in many directions, making equanimity all but impossible. [...] This is adult music. It looks at the pop song as a way of expressing what is normally felt but nearly always hidden away; its expression of hope and willingness is tempered and strengthened by its wondrous candor and musical sophistication.' (www.allmusic.com/album/cigarettes-housework-mw0000686253)

I needed Roger to allow me very broad creative space if I was to include them. 'In the Ether' was a song for the voice of an old man, a ghost, singing from beyond reality. 'Heart Condition' (still unrecorded) was about a man's helpless love for the partner of his best friend.

'Trilby's Piano', written for *Stella* some time before, sounded like a show tune, but the person who inspired it, who had been the first person to encourage my noodling and tell me I was a 'real musician', had been so important to me. The belief she instilled in me had kept me going through my darkest days.

31

INTERMEZZO

On 19 May 2005, my birthday, Jerry Hall bought me a miniature Yorkshire terrier; I named her Wistle after John and his dog Scruffy, who had listened to our first rehearsals in his home in Acton when we were twelve or thirteen. Two months later I was still thinking of John and missing him when The Who performed with Pink Floyd and Paul McCartney at Hyde Park for Live 8. The Who's set was incendiary, far better than Live Aid, and I enjoyed seeing Bob Geldof smiling happily on the side of the stage.

The press made much of the competition between The Who and Pink Floyd, but the atmosphere backstage was friendly. It was good to see the towering Roger Waters working with David Gilmour again, and it was the last time I got to see Rick Wright, who had purchased my big Bösendorfer piano from me when I closed my studio years before. We all wondered if Floyd would reunite and tour. Their show was perfect, I thought, but Roger and David never quite reconciled. It was remarkable that they joined together this one last time, and I felt privileged to be in their midst.

In summer 2005 Bob Pridden, Billy Nicholls and Myles Clarke started work on *Endless Wire*, the forthcoming Who album. The album was ready to put together by spring 2006. By that time we were rehearsing, anticipating one of the longest tours of our entire career. I continued to work on the album

throughout the tour, carrying a complicated mobile recording studio rig. I had complete control of the record, something Roger regretted because he had wanted to record as a band, but it did give me the opportunity to take some chances.

Including songs like 'In the Ether', 'Trilby's Piano', 'You Stand By Me' and 'Marty Robbins' allowed me to divide the vocal work almost evenly between Roger and myself. In so doing, I deferred going directly on to a solo music project or, for the time being, pursuing my music-theatre projects. It meant a lot when Dave Marsh told me he thought it was a good album. I wanted it to feel as though there was a continuity with The Who's previous albums, but also from my own solo albums.

We would begin touring on 17 June 2006 at – appropriately – Leeds University, and the last show was to be on 9 July 2007 in Helsinki. Rachel came with me, doing *In the Attic* live webcasts from many of the shows, and also pioneered *Attic Jam*, an acoustic music event she and her assistant Carrie Cooke put together. I loved having Rachel with me on the road, though we both found the travelling and the intense schedule arduous.

Endless Wire, The Who's eleventh album, was released on 30 October 2006, and it was the band's first new album of original material since *It's Hard* in 1982. I really enjoyed making this album, and it's one I'm proud of. It also garnered the best reviews of any Who album since *Who Are You* in 1978. It underpinned the first world tour worthy of the name by The Who: over three years we performed in support of it on every major continent except Africa and South America.

'Fragments', a kind of homage to Baba O'Riley, was based on a harmonic maths system developed by Lawrence Ball for what I was now calling the Lifehouse Method project, which involved the automatic creation of tailor-made music for individuals over a web portal. Many strands were drawn together

on this record; it felt like the best-balanced creative outing for me for many years, combining many of my own private ambitions, but also underscoring the long-established fact that my greatest achievements had always been under the Who umbrella. Most the album's songs were also used in the musical adaptation of *The Boy Who Heard Music*, which I had been working on since 1999. This débuted as part of the Powerhouse Summer Theatre workshop series at Vassar College in New York State. The idea for this was again floated by the stalwart Ethan Silverman. One day we will stand together in the stalls and watch a show we have put up together.*

Roger started having real health troubles towards the end of 2006. In Chicago he collapsed on stage, then hurried off, and I had to carry the last twenty minutes of the show alone, *Psychoderelict* style. I was worried about him and told him so.

After a holiday break we embarked on the third and final leg of the tour, which would take us from Reno to Florida, and on to Mexico and South America. In Tampa Roger finally hit a wall and announced before the show that he couldn't perform. Rachel and I had an *Attic Jam* planned in Austin at South by South West, and decided to spend longer there while Roger recuperated in a Miami hospital.

Roger had been struggling with throat problems, which later turned out to be due to pre-cancerous lesions. At the time none of us knew what to do, but Roger battled like the fighter he is to do good shows. This made it all the more stunning when he finally admitted he could go no further, and shows were cancelled. It might seem strange, but I was glad that at last he had given himself permission to fail, knowing that none

* *Endless Wire* reached the top 10 in both Britain and the States. More details on the album are available at www.TheWho.com.

of our fans would have wanted him to hurt himself. My feelings for Roger had matured – I loved him and wanted only the best for him – and I sensed that was what he wanted for me too. It would always be difficult for each of us to help the other, but we would find a way to do just that in the future.

Roger's medical breakdown was a wake-up call. The Who owed some South American shows to the tour promoters, so we made recompense with another fairly long sweep in Europe. This was another opportunity for Rachel and me to do live webcasts, using a dedicated Airstream caravan equipped for the job. We started in Lisbon, performing in Madrid for the first time – I played the best guitar of my career at that show – and also a number of festivals. I loved the whole tour. It not only inspired me but gave me great hope for the future.

Nick Goderson, still effective chairman/president of my companies, had been diagnosed with cancer of his neck, and was undergoing chemotherapy. Without his benign hand on the reins, I splashed out, attempting to indulge my inner artist and get some music flowing. In 2008 I bought myself a creative studio in a wooded area of Surrey, a fifty-minute drive from my home, and leaving the largest room otherwise completely empty I put a Yamaha Concert Grand Disklavier piano in it. This allowed me to improvise, recording the mechanical performance when I felt ready; I could then listen to the piano playing back what I'd recorded as I stalked around the room, singing whatever lyrics came into my head.

This is where the first music for my new opera *Floss* began. *Floss* is hopefully going to be a kind of *son et lumière* event – *The Wall* meets Cirque du Soleil. I have already composed some good music, written some lyrics I am pleased with and arranged special studio systems to help me tackle the technical challenges I see ahead. This is another *Quadrophenia* for me,

almost as technically challenging as *Lifehouse*, but today I do have the computers I need to overcome almost every technical obstacle. I am still working on this as I write this book, and it is proving to be one of the most ambitious projects I've taken on.

It's a dark tale of a young man called Walter Doxtader, who puts his pub-rock career behind him to create a labyrinthine garden. He starts to hear the almost musical sound of the shared anxieties of all the middle-class families around him who fear for their children's future. His young wife is Florence Spritzler (Floss). Her tempestuous story is the other strand at the heart of the tale; a horse rider, she is loosely based on Louise Reay, but I don't want to give too much more away. I'm very excited about this project.[*]

Nick finally passed away in 2010. He was a much-loved friend, and it is an understatement to say that I miss him. He was fundamental to my career for so long, joining me in 1983 as in-house accountant for my music-publishing company and studios, moving on to being a commercial manager who worked closely with Who managers Bill Curbishley and Robert Rosenberg. At his funeral I met his baby daughter for the first time, whom he named Aminta after my own daughter.

[*] I have been focusing much of my musical energy on *Floss* since 2008. In the summer of 2011 I produced the director's cut of *Quadrophenia*. This included remixed demos, some surround-sound tracks and copious notes which were easier to write because I had gathered all my papers together again to write this book.

32

WHO I AM

I was invited to give the first John Peel Lecture at the BBC in November 2011 in honour of the great broadcaster and DJ.* I talked about Peelism, the approach of someone who had actually taken the trouble to spend time listening – and I had first really learned the supreme importance of listening from Roland Kirk in the 1960s. I talked about my own inner artist and pointed out that my £6 fee would be passed to the Musicians Union Benevolent Fund.

When you get to my age, charity work becomes a necessary fact of life, but through it we old rock stars get to stay in contact with the rigours of the real world, and also get to meet many new people. It is service of the most humbling kind, and one of the most levelling aspects is being ticked off by press diarists who seem to believe we only do it for some selfish, self-serving motive, to which I can only say: if you don't like my trumpet go try blowing one of your own.

Three years earlier, in December 2008, The Who had been guests of George W. Bush and the Kennedy Center Honors Committee. This is an honour given to artists, and has nothing to do with politics. But I have to accept that it is doubtful I will ever be offered any similar kind of honour in my home country now. I will be denied that Pinteresque moment of being able to explain why I am turning it down.

* www.guardian.co.uk/media/2011/nov/01/pete-townshend-john-peel-lecture.

Nevertheless, I trust in Britain and its democratic process. I am proud that what I do provides jobs, and although I am wealthy and privileged, in my heart and my actions I am still a socialist and activist, ready to stand by the underdog and the beaten down, and to entertain them if I can.

It would be disingenuous to say that I haven't been affected by the perception of me shown by people who do not know me or anything about me apart from what they may have read in tabloid newspapers around the time of my arrest in 2003. I have long since abandoned my White Knight efforts in that department, but I am still painfully aware of the repercussions this might have had on the charities in which I had played an active part, and in which I am now obliged to maintain a low profile.

Just one click of my mouse to prove a point has caused a mountain of misunderstanding.

I have moved on. I have always carried within me a defiant, sometimes argumentative and combative pride. It still sits very close to the surface of my psyche, just under the skin, ready to flare up in anger, to leap out and fight. It is in my soul.

What happened to that kid brother inside me? The letter I wrote to my eight-year-old self is still one of the most important affirmations in my life. 'Remember,' I told him, 'that the bad feelings you sometimes have today are helping to make you strong and talented and empathetic to the pain that other people feel. But you have a good heart and you will be OK in the end. Life can be hard, and what you will find hard is accepting how wonderful the life you are going to have actually is. This is because for some reason you don't feel you deserve all this.

'You have a brilliant mind. Unfortunately you are not going to exercise it quite as much as you should. Your self-esteem is too low and you will lapse into laziness that will slow you up. You have a brilliant imagination, and that will suffice to some

extent. But you must be careful to try to respect facts. You cannot simply make up what you have failed to learn. Your academic failure has been a fundamental part of the engine that drives you to artistic inspiration.

'When your mother criticises or demeans the way you look she is conveying how she feels about herself. She felt her mother must have had some reason to leave her. You too will go through an awkward adolescence. But today you are adorable, a lovely boy. Respect yourself. Try to remember that not everything in life can be perfect. You will make mistakes. That's inevitable. But you are not ugly. You will only be ugly when you behave in an ugly way.

'Enjoy life. And be careful what you pray for – remember, you will get it all.'

APPENDIX

A FAN LETTER FROM 1967

I am about to open for the first time a small blue envelope addressed to me and posted to The Who's fan club forty-five years ago, on 16 January 1967. There's a little arrow over the letter 'o' in 'Who'.

It is very peculiar to be opening this letter to me from so long ago, from the halcyon days of the explosion of the pop-culture revolution of the Sixties. If a group of sixteen-year-old girls had written to me when I was, say, in my mid-thirties, I would have replied. By the time I hit my early forties I employed two secretaries to help me process the thousand or so letters I received every month.

The letter in question is from Anne, who writes in a familiar way.

How are you? You were great on Top of the Pops *last week. Keith looked knockout, and dig your crazy coat. Fantastic!*

She goes on to say that she's gone off 'Jack' ('Happy Jack'). She hates it. It is on its way out of the charts. She also advises 'Mooney' to come clean about being married to Kim, an event that hadn't happened yet. She observes accurately that she's not sure she believes the rumours because *Keith is the sort to say anything for publicity.*

She also chides John Entwistle for keeping secret his engagement to his school friend Alison. She then asks if I read *Disc* the previous week – a correspondent had said I was beautiful.

Anne then lines up twenty-two 'ha ha's to indicate how funny she thought the idea. *Fascinating looking, but not beautiful. Do you think you're beautiful? Does Karen?*

She closes her letter by saying *my time is short, and you're so BEAUTIFUL.*

The secret that I had a partner was obviously out; our insider fans already knew her name, and Anne was clearly an insider. She seems annoyed that I too am out of the running as a prospect, even though she also makes it clear she is attracted to Keith and John too.

She doesn't mention Roger once in her letter. Roger had secretly married Jackie way back in 1964 – and Anne, of course, knew it. So he was completely out of the running, as far as Anne was concerned.

What I could never have seen, which I can see easily today, is that Anne loved me. I don't mean that she was in love with me, or even that she desired me sexually, but she loved me.

That important adoring mist rising from between the lines of her letter, hidden between threats of withdrawal if we made records she didn't like, and insistence that we didn't try to hide our paramours from her, would have been almost invisible to me in 1967. My life would have been very different if I had been able to recognise genuine, loving adoration and concern when it was demonstrated.

Two months earlier, in November 1966, The Who played at the Winter Gardens, Malvern. Val from Worcester writes in January 1967 to thank me for taking her and her friend home afterwards. She hopes I can remember her – Val, the blonde one who sat next to me.

Val closes with twenty kisses – two less than Anne's 'ha ha's.

CODA

I dedicate this book to the artist in all of us.

This is as much a note to myself as one to you. Play to the gods! In showbusiness the 'gods' are the seats right at the back of the theatre, the tough ones, where people got in cheaply and can't see or hear properly, and chat between themselves and eat lots of popcorn.

For the artist 'the gods' is the universe, the big, abstract picture, the unknown, the open sky and sea. Focusing on the infinite universe might seem rather grandiose, or utterly aimless. In fact it's as small or as large as we want it to be. Some of us believe there is nothing out there. Some of us believe we are surrounded by attentive angels. Whatever.

Play to the gods, or – if you prefer – to a small basket full of stuffed toys, or sing into the mouth of a hot-water bottle, or turn the knobs on a chest of drawers and pretend to be 20,000 leagues under the sea.

It's all the same thing. If in doubt, just play.

AFTERWORD

I wrote a book and I'm glad I did so. I have since spoken about the book on a number of occasions. Most interviewers begin by asking me why it took so long. The truth is not that I hoped to die before I got old, but that I was waiting to die so I wouldn't have to bother getting the book published. Some people I mentioned in the book didn't feel comfortable with the way I remembered them; others were happy to be remembered at all. Some were happy to be left out. Some – included at length but then reduced to footnotes in the brutality of an editing process that cut down 1000 final pages down to closer to 500 – were baffled at what remained. Generally those who have reached out to me have enjoyed it. I doubt anyone would toss aside a book and then write the author a note to say so, but from what people have said to my face or in the mail or online to me, the response seems good.

In the first few months that this book was on sale in 2012 I was on tour with The Who. This was not exactly an accident, but it has meant that I have eventually fallen into the familiar *Groundhog Day* rhythm of roadwork with a band, and not the rather more stimulating and surprising times I enjoyed in the first week of PR in 2012 when, at the New York Public Library, I was treated like a visiting professor. At all the bookstore signings and readings, I was surprised how much I enjoyed meeting fans face to face. They're less scary when they aren't going nuts at a Who show, but then so am I.

Eventually, when all the PR was over and I was back on tour with the band, I fell from the heights of hallowed halls to the squalid pseudo-sustenance of endless chocolate bars from the minibar in the middle of the night. At least there was the magic of music and cheering audiences to sustain me, but that adrenalin also fed my body chemistry and kept me awake after a show, sometimes until eight in the morning. With a flight to the next city at around midday, I sometimes didn't get enough sleep.

And yet I felt better, and looked better, than I do as I write now. I'm working twelve- to sixteen-hour days. I am back at the rockface in my home studio in London, wading through the ninety-five items of music I have accumulated since I started work on my current music project in June 2008. Yes, there really are ninety-five items on the list. I've found a few duplicates, but not many. I've found some junk, but not much. Since the tour ended I have managed to listen to, and in some cases – by adding some guitars or keyboards or sharpening up a lyric – either advance or eliminate fifty-eight of them in the list. At worst I make some comment, and add the item to the work-in-progress group.

Last night, with my partner Rachel safely in bed with Wistle, our miniature Yorkshire terrier, I worked until midnight. This was my last diary entry:

SAD SONGS – "080612-2". I've already singled this out (in an earlier listing). There is MIDI recorded so it can be edited. There are several versions that look as though they've already been edited in MIDI. **080612-2 MIDI only edit bars 1-100 B.** It has been done perfectly. **READY for MORE.**

This is a fascinating thing. It might not appear so at first sight, but let me explain. In the early summer of 2008 I sold Eel Pie Oceanic, my large commercial studio near my home. It had become a distraction, and third-party business was bad,

and although it was wonderful to have a large, soundproofed and air-conditioned room in which to gather musicians (and even audiences sometimes) to make live recordings, I felt I needed something new.

So with part of the proceeds I bought a house in the country, not a Great English House, but a comfortable one, in an exceptionally quiet area of woodland last used in anger when Russell Crowe and his Roman centurions set light to some pine trees for the movie *Gladiator*. The house is situated in the middle of a large sweeping field of rough grass, within an hour's drive of London. Courtesy of a good deal with Yamaha I installed a concert-size Disklavier grand piano. The room I chose was a large, parquet-floored living room. It wasn't Carnegie Hall acoustically speaking, but it was interesting and vibrant. I'm nowhere near deaf, but my ears are tired, and I need a bright and stimulating sound to get me going. On the first day, pretending I was Keith Jarrett or Chopin – or even Thunderclap Newman – I started to bang away.

Now a Disklavier is one of those machines that you sometimes see noodling away like a robot in the lobby of a hotel or at a party. What is not commonly understood is that – as well as performing real Chopin pieces – these machines will record what you play. On 12 June 2008 I recorded fifteen individual pieces. Some of them were so audacious and ambitious – so far beyond my scope as a pianist – that there were inevitable bum notes, but I kept playing. Occasionally, I would play one of the performances back and the great piano would fill the room with sound as I strode around, circling the piano like a feral cat, howling, singing, sometimes even moving to the keyboard and adding a few extras. Some of these performances I recorded using a special surround-sound microphone called a 'Soundfield'. This is a British invention, and when the recording is played back in a studio the listener is transported to the very room in which I was working on that first day.

There is an added technical advantage to this process. The recordings in the Disklavier are saved as data in its own computer, and those performances can be edited. So my bum notes can be corrected. So later, I can set the Disklavier playing again, record what I've done again, sing along again, and grin like a kid. This is all a lot of fun; I hope you can sense that.

I've always loved using technology – especially in my home music studio – to help my composing, but also to inspire me to new heights. While on the road with The Who I can scarcely manage a few minutes' practice on the guitar, let alone the necessary two or three hours' piano work that enable me to play a one-handed diminished arpeggio or a decent right-hand rhythm pattern. So the machines have arrived to save me. After a long tour leg, I stagger home from the airport, fire up my computers and my ancient tape machines, and I'm back in paradise.

So that is where you find me this morning in March 2013. The paperback version of my memoirs is what you now hold. I am trying to create a link from the way the main body of the book (published in October 2012) ended. In a set of acknowledgments there I attempted to bring my life up-to-date, and bring last-minute news of many of the characters in my life. Mike Shaw, Chris Stamp and Frank Barsalona, cited there as beloved and cherished friends and colleagues, all passed away within a week of each other in November 2012 while The Who were still on their North American tour. My grandson Kester turned three. Spud – Rachel's 'first born' golden retriever – had to be put to sleep, and the trauma haunts her. Even in such a short time there have been many changes.

Writing my memoirs has led to a number of old friends, with whom I had completely lost contact, appearing from the mist. One, The Who's first roadie Neville Chester, I literally called out to in the pages of the book. He was with the band

in Monterey, and went on to work with Jimi Hendrix for a time after he left us. He now lives in New York. This kind of reconnection was possible partly because The Who were touring the USA. We tour the UK in June this year, and I'm hoping for a similarly happy coda. It's good to know that not every old relationship or friendship needs to be subject to either 'closure' or forensic analysis.

This is a very happy time for me. I am growing old of course, but I am still in the early stages of disintegration, and regarded as just about cool enough by some fashionable young people to be permitted to think aloud.

I live, however, with the uneasy wisdom of almost three score years and ten. Time itself is the secret to life. Time is all that needs managing. Time is all that matters. Living in the present is an elusive spiritual practice, impossible with time stretching either way backwards and forwards. As I get older, and happier, I begin to panic. I have a few good years ahead of me. I have the courage to take on ambitious new projects, and also the carelessness to be as audacious as I wish. I have the resources to provide myself with an empty room in a country house containing only a grand piano, in order to inspire my noodling. What I don't have is infinite time.

In my book I speak about my early days, stumbling between my interest in the Indian master Meher Baba, family life and the rigours of rock 'n' roll. I have ended up somewhere in the middle. The almost blind belief I carried when I was a young man – that, as Meher Baba taught, consciousness itself was all *Creation* consisted of, and that consciousness is what evolved, not matter or particles – seems scientifically nonsensical to me today. Yet I still question who I am, where I came from, and where I might be going. I am still following Meher Baba, but my fingers are crossed behind my back.

After forty-six years it would be a little disingenuous to

suddenly go all Richard Dawkins, or even the late (and once wonderful) Christopher Hitchens. Unlike these two brilliant atheists I respect the spiritual and religious faith of others, and demand the same respect for myself. The problem is that as I get older I don't feel I want to know what is on the other side: I really, sincerely do not want to know. When, at the age of about twenty-two, I first understood that many Eastern faiths depend on the notion of reincarnation as the central tenet to their integrity, I panicked. Who really wants to live forever? Every morning I wake up and I am still 'me'. Sometimes that's a good thing, sometimes it's not so great.

All I know is that the horrific dilemma of passing time is only overruled by happiness and love. It is sometimes transcended by music, and that is baffling when you consider that music itself depends on the division of time, the spanning of it, the passing of it. So here I am, still unsure whether life is really a spiritual journey or that the universe has ways of making us laugh. Music is all I can do right now.

If I ever write another book I doubt it will be a memoir. I'm not quite bored with myself, but I am tired of trying to explain that – whatever I said when I was an eager eighteen-year-old, or a heroin-smashed thirty-five-year-old – I refuse to carry those two young men anymore. Nor will I apologise for them. One was brilliant and tireless, full of energy and hope, a little sad sometimes perhaps, but the future stretched ahead and the clouds always passed. The other was exhausted, falling in love with strangers, chasing shadows, and luxuriating in tragedy, but continued to produce and perform and sometimes made people laugh.

I swear I am not trying to romanticise myself, or my life; I want to do precisely the opposite. Today, things are simpler for me, and I am happy. I am content to roll along. I still have my own teeth. Most of them. I can still jump like...

I'm stopping this now. I hope you enjoyed this book.

ACKNOWLEDGEMENTS

This book has taken me such a long time to write. There are so many people to thank, and to acknowledge not only for their encouragement, but also for their friendship. I'm not very good at friendship, not very sociable, and this is a chance for me to reach out to some of the important people in my life, especially those who have had some part to play in the book. If you are not mentioned, and you think you should be, let me know. I always like to be reminded who my friends really are.

Firstly I want to thank my agent, Ed Victor: he's stayed with me through several major hiccups, and been a joy to work with. I also feel grateful to my publisher in the UK, Carole Tonkinson, and her entire team, including the intrepid Simon Gerratt who coordinated everything at HarperCollins UK. Their enthusiasm and support from the very beginning has kept me going when the empty pages taunted me. Jonathan Burnham, my US publisher, has been forthright and meticulous, keeping me alert to the fact that he and I both want this book to entertain, but also to convince. My US editor David Hirshey, and his associate editor Barry Harbaugh, have enjoyed some great brainstorming sessions that reminded me of my own days as an editor. Working with words on the page sometimes leads to fine conversation – words leading to more words. My first editor when I started was Robert McCrum, and I am still grateful to my publisher Michael Pietsch of Little, Brown for believing in me back in 1995, but also for

permitting me to give up two years on when I found it too hard.

My personal assistant, Nicola Joss, has been invaluable to me on this project, creating a chronological boxed archive for me that I have been able to access on a whim. My long-time friend and aide-de-camp Paul Bonnick has also been essential, helping organise storage systems, shelving, moving weighty collateral back and forth – indeed many of my staff have put in hundreds of hours helping me with this book in the past year, but like Ed Victor, Nicola and Paul have stayed with me working or waiting for seventeen years.

My first webmaster, Matt Kent, came to the rescue to gather, date and credit photographs, and there is no one better qualified – his own photographs are wonderful and he is a guardian of Who history.

Martin Noble, yet another cherished new Jewish buddy for me, has been my hands-on editor here in the UK, and has connected wonderfully with us all. He is to me now like an angel, leading a seventh cavalry to rescue me from the complexities that arise when you try to cut 1,000 pages down to 500. He has worked like a demon, eighteen hours a day sometimes. I fear for his health, and for his marriage – but if his wife loves him as much as I do today he should get the right kind of chicken soup. If not, I will make it for him. Martin, let's get that photograph together.

Roger Daltrey has been lovingly concerned about this book, wanting most of all to protect me from myself and my big mouth. I hope he doesn't mind me giving my side of the Who story. He is one of the most important men in my life, and obviously the most important in my career. One day I hope he will write his own story. Meanwhile he has to sing the stories I write for him. No one does it better.

Another beloved and vitally important man in my life is our surviving manager, Chris Stamp, seriously ill at the time of

writing. He doesn't get perfect press from me about the early days in this book, but in the past twenty-five years, away from The Who's affairs, we have been fellow music publishers and loving friends, and Chris is a shining and spiritual man. He is now a psychodrama therapist. I've learned by watching Chris learn. He calls these confusing days of getting older 'The Gravy'.

My lawyer John Cohen deserves more than a mention here; so much more than a legal guide, he is a friend and ally, and has been a mentor and protector.

In preparing this book I have needed time and space, the toughest currencies to generate, something my accountant and dear friend Richard Rosenberg has helped me achieve. In Nick Goderson's painful absence he has made the impossible seem possible. Indeed, the book is done, so he pulled it off.

My manager Bill Curbishley is a major protagonist in this book, and his friendship and loyalty to me and Roger is precious and valued in a way that simply cannot be quantified, but every time we work together we try to quantify it! I can't imagine my career, or my life, without him. His ex-wife Jackie, who managed me as a solo artist, now lives happily in Barbados. Bill's partner Robert Rosenberg is less well known outside music business circles, but is another vitally important man in my life. With their support and that of their team I have found time to complete this book.

Friends have come and gone. Jimpy, the last time I heard from him, was still alive and kicking, being a grandfather a long time before I made it. Barney is good, living with Nikki (my son Joseph's ex-infant school teacher), and we were reunited recently with Irish Jack Lyons to confer on all things Mod for the *Quadrophenia* documentary recently on BBC TV. Lisa Marsh is married with children and did indeed publish a book (about Calvin Klein), and is still a working journalist in the fashion industry. Louise Reay also has several beautiful

daughters. She still rides horses. Jackie Vickers is married to Reg Meuross, and lives in Somerset. Reg is a talented folk musician, and I am a great fan. They have two wonderful children. I have three godchildren: Benedict, Bob Pridden's son, who is in real estate in Yorkshire; Claire Forlani (the Hollywood actress), married to the actor Dougray Scott; and Claire's brother Christian, who is an adventurer.

Chris Chappel and Helen Wilkins are in my story but have also been vital to me in my career and were great partygoers with me. Carrie Cooke and Paul Curran work with me now creatively, and they have been important pillars in getting this book moving, and will assist in keeping it in the marketplace.

I want to thank the two major music producers in my life, Chris Thomas and Glyn Johns.

Bob Pridden, The Who's soundman since 1967, has been my strongest supporter, through thick and thin, on the road, in the studio and all my wildest experiments. He's been the best-behaved member of our travelling asylum – always a gentleman, mostly with his trousers on.

Alan Rogan has been with me as guitar technician and stalwart friend and aide-de-camp since 1975. No one has done more to help advance me as a guitarist; he has brought me many wonderful instruments I never thought I needed, and now cannot live without.

Mike Shaw recovered from his car crash. He managed to get some use of his hands, and was one of the idiots who worked at Track Records in its Jimi Hendrix heyday. Later he was involved in many special projects for The Who and other artists associated with Track. He now lives facing the wild Cornish sea in St Austell.

Two people who might be surprised to hear this from me are the Lords Matthew Evans, my old boss at Faber & Faber, and Melvyn Bragg, who commissioned me to write my first

real play (sadly never filmed). Both have recently helped me to believe I could do this book, and make it work at more than one level.

I want to thank my doctor, Adrian Whiteson. As of now I am in good health, but he has been more than a doctor to me; he has been a friend and guide in my charity work, steering me (and Roger too) in one of the greatest challenges we have ever faced together, to help him fight the battle against cancer, especially in its most unfair manifestation, when it hits young people.

My two brothers, Paul and Simon, have growing families. Paul and his wife Sandy have Jessie and Jacob. Simon and Janie have Ben (recently married), Josh and Hannah. They both still live at the Townshend family home in Ealing. Paul is a fastidious painter and decorator; that's where his artistic temperament has taken him. Simon is a musician, with a solo career, and tours with The Who.

Aunt Trilby died many years ago. She was my creative angel.

My wonderfully tempestuous mother Betty died last year. We were all around her bedside. Somehow, as she breathed her last few breaths, we all wondered how she would manage to continue to create havoc from the other side. Some of my nephews and nieces are certain she is still dropping coins onto their shoes, something she did when they were infants. Pennies from heaven.

My ex-wife Karen's sister Virginia Astley is still making music, and also working on a book about the river Thames at the moment. Her daughter Florence is also a musician, playing classical piano and harp.

Karen's two brothers are still close to me. Gareth is a serious sailor, as is his older brother Jon, who has worked closely with The Who since 1976. We have all sailed together on some great adventures.

Karen's mother Hazel, who taught me how to properly spend Sunday in the English countryside, still lives in Goring-on-Thames where *Quadrophenia* was mixed while the river glistened. Karen's late father Edwin Astley – Ted to us, and a wonderful composer – is remembered here so fondly; he took me seriously as a composer.

My daughter Emma lives in Ealing, and now writes a gardening column for the *Independent on Sunday* magazine. She has published a book about Darwin's dogs, but doesn't do music professionally any more. She presented me with my only grandchild so far, Kester, who is now two, and thankfully very keen on boats. I have an excuse to paraphrase a line from *Jaws*: 'We need a bigger boat.' Her partner William is a graphic designer who works in publishing. Aminta, still a fine linguist, no longer works on feature films, but is still involved in media, at the moment for a growing internet events company. She lives in Shepherd's Bush, Who stamping ground. My son Joseph is at Central Saint Martins College of Arts and Design and I'm glad to say I see a lot of him. He is full of the most exciting ideas and works really hard with them. He lives near Kennington Oval.

This leads me to my greatest supporters and allies – my fans and those fans of The Who. Thank you for giving me a day job, and not sacking me when I didn't show up for work. You've been the best boss a man could ever have.

To those who are gone, Kit Lambert, Keith Moon, John Entwistle, Ronnie Lane, Brian Jones, David Platz, Keith Grant, Ahmet Ertegun, Ken Russell, Bill Graham, Nick Goderson, Denny, Trilby, Horry, Dot, Mum, Dad, Uncle Jack, Jenny, Robin, Delia DeLeon, Ivy Duce, Meher Baba, Adi K. Irani and the guy who stole my $50,000, I can't wait to catch up with you wherever you are.

Finally I must acknowledge my partner Rachel Fuller. We've been together for fifteen years, and she is one intuitive romantic hunch that came right for me. Beautiful, funny, sexy,

talented and completely nuts, Rachel has enriched these years that Chris Stamp calls 'The Gravy' to such an extent that I am sometimes described by cynics determined to mix metaphors as looking like the cat who got the cream. She plays Chopin like Chopin, and sings like Baez to my Dylan. Rachel and I have written songs together, so she broke my hex there. We don't have children, and it is too late for me now, but Rachel has made up for it with seven dogs – Flash, Wistle, Spud, Harry, Barney, Cracker and Skrapovski (a Russian Yorkshire terrier who lives in Cannes).

PICTURE CREDITS

All photographs courtesy of the author except:

SECTION 1
Page 1: (middle left) Pete Townshend/Don Townshend; *Page 2:* (top left) Pete Townshend/Don Townshend; *Page 3:* (bottom left) The Entwistle family; *Page 4:* (top) LAMedia Collection/ Sunshine/Retna Ltd, (middle right) Trinifold Management Ltd, (bottom left) Dewar/Trinifold Management Ltd, (bottom right) Richard Barnes; *Page 5:* (top) T. Spencer/Colorific, (bottom) Tony Frank/Corbis; *Page 6:* (top left) Chris Morphet/ Redferns/Getty Images, (middle left) J. Barry Peake/Rex Features, (middle right) Jan Olofsson/Redferns/Getty Images, (bottom left) Beat Publications; *Page 7:* (top) Chris Morphet/ Redferns/Getty Images, (bottom) Ron Howard/Redferns/ Getty Images; *Page 8:* (top) Andrew Maclear/Hulton Archive, (bottom) Mirrorpix.

SECTION 2
Page 1: (middle left) LFI, (middle right) Jack Robinson/Getty Images, (bottom) Henry Diltz/Corbis; *Page 2:* (top right) Chris Morphet/Redferns/Getty Images, (middle right) Chris Morphet, (bottom) courtesy of Mike McInnerney; *Page 3:* (middle right) LFI, (bottom) Chris Morphet; *Page 4:* (top left) Chris Morphet; *Page 5:* Neal Preston/Corbis; *Page 6:* (top

right) Chris Morphet; *Page 7:* (top right) Robert Kirk, (bottom left) Neal Preston/Corbis; *Page 8:* (top left) RCA Victor publicity shot, (top right) Robert Kirk, (middle left) Matt Kent, (second from top, right) Gary and Melissa Hurley, (third from top, right) Patrick Semansky/AP/Press Association Images, (bottom right) Terry McGough/Rex Features.

INDEX